ABANDONED
PALACES

ABANDONED PALACES

MICHAEL KERRIGAN

amber
BOOKS

First published in 2019

Published by Amber Books Ltd
United House
North Road
London N7 9DP
United Kingdom
www.amberbooks.co.uk
Instagram: amberbooksltd
Facebook: www.facebook.com/amberbooks
Twitter: @amberbooks

ISBN: 978-1-78274-862-5

Project Editor: Michael Spilling
Design: Gary and Trudi Webb
Picture Research: Terry Forshaw and Justin Willsdon

Printed in China

Contents

Introduction

The French poet Joachim du Bellay (1522–60) had some advice for classically-inspired contemporaries who, setting off in search of ancient Rome, were disappointed to find it nothing more than a ramshackle ruin. 'These old palaces, these arches and these walls you see – these are what we call Rome.' There was no point, he insisted, in seeking some essential shrine that would reveal the eternal

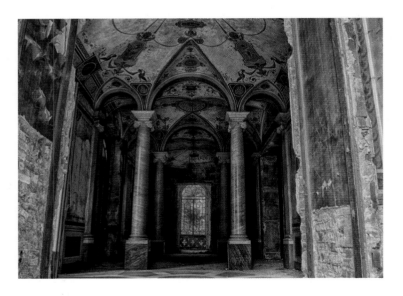

spirit of the Eternal City – this was it. 'Rome itself is the sole monument of Rome.'

Much the same is true of less celebrated ruins in less august locations. Their dereliction in some sense defines them, delineates their connection with their own past; all that dirt and damage represents the wear and tear of history. There's something especially poignant about a palatial ruin, whether that of an actual palace or of a prestigious hotel or townhouse. All masonry is not born equal: those buildings that have a higher status to start with do have further to fall than humbler houses, factories or office blocks.

ABOVE:
Abandoned House, 1800, Novi Ligure, Piemonte, Italy
What lives might have been led, what dramas acted out in a splendid, spacious interior such as this? Through what tragedy (or farce) did it come to be abandoned?

OPPOSITE:
Muromtzevo Castle, Sudogda, Vladimir Oblast, Russia
No enemy action caused this damage – just the attrition of successive Russian winters on a comically climate-inappropriate structure. But Muromtzevo has its history all the same.

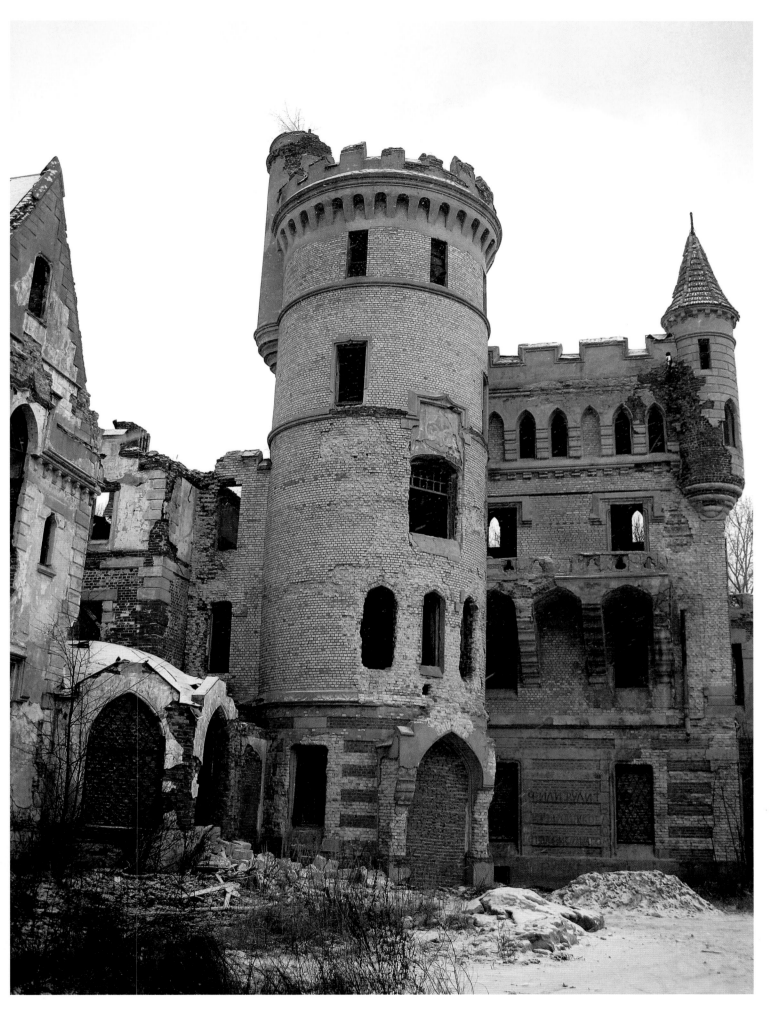

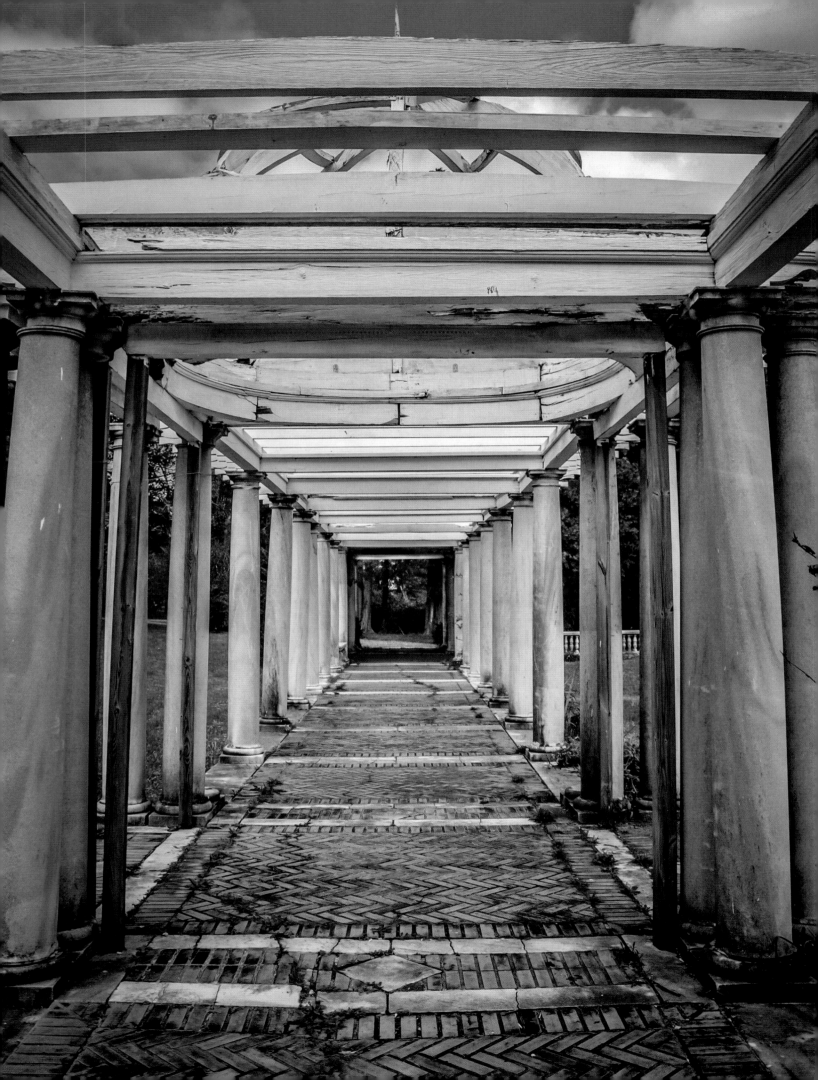

The Americas and Caribbean

New World, new money. An oversimplification, granted…. To almost all intents and purposes, though, it's true. The ruined 'palaces' we see now in the Americas and Caribbean were overwhelmingly built as status symbols, by colonial planters who hoped to live like kings or by 'robber barons' of the industrializing era.

The indigenous peoples of the Americas did leave some spectacular ruins behind them. But the stone-built ruins of Mesoamerica and the adobe-built pueblos of the US Southwest are the exceptions. For the most part, these earliest communities left only the lightest of archaeological footprints. The impact of the post-Columbian conquests was, therefore – through genocidal war or unwittingly introduced epidemics – brutally to blank the scenic slate.

'How beautiful it would be if the Isthmus of Panama could be for us what the Isthmus of Corinth was for the Greeks!' So wrote Simon Bolívar in 1815. Even for Latin America's liberator, it seems, the standard of civilization had been set in Europe; all the New World could hope to do was strive in emulation. Accordingly, we have a sense in the region that the most opulent palaces, mansions and public buildings represent an essentially imitative, secondhand construction culture – which only makes its ruins more melancholy.

OPPOSITE:

Garden Pergola, Swannanoa Palace, Afton, Virginia, United States
It wasn't enough for the entrepreneur to 'make his pile'; he also had to build it as an enduring monument to his success. Its design distinctly reminiscent of Rome's Villa Medici, this impressive residence was built in 1912 by the lawyer, politician and railroad magnate James H. Dooley (1841–1922).

Sosneado Hot Springs Hotel, Mendoza, Argentina
Once these hallways rang with the cheerful greetings of exclusive guests; once these pools were set echoing by their happy plunges. But this spa, opened in 1938, was abandoned only 15 years later. All is still and silent now, in an empty, austere landscape, the snow-shrouded Andes brooding in the background.

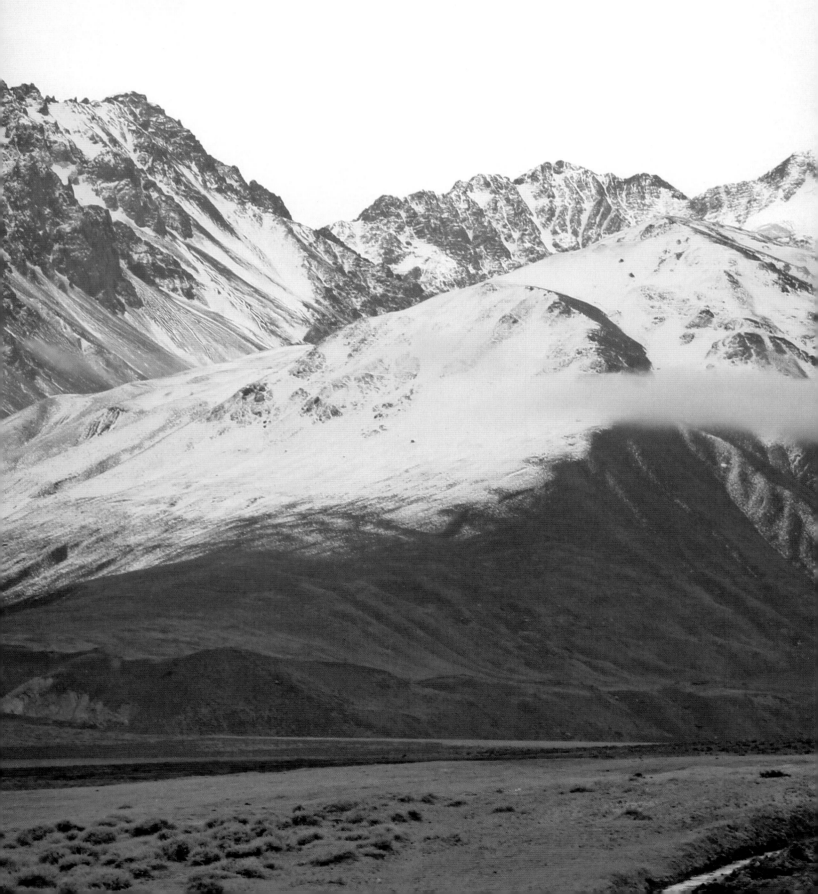

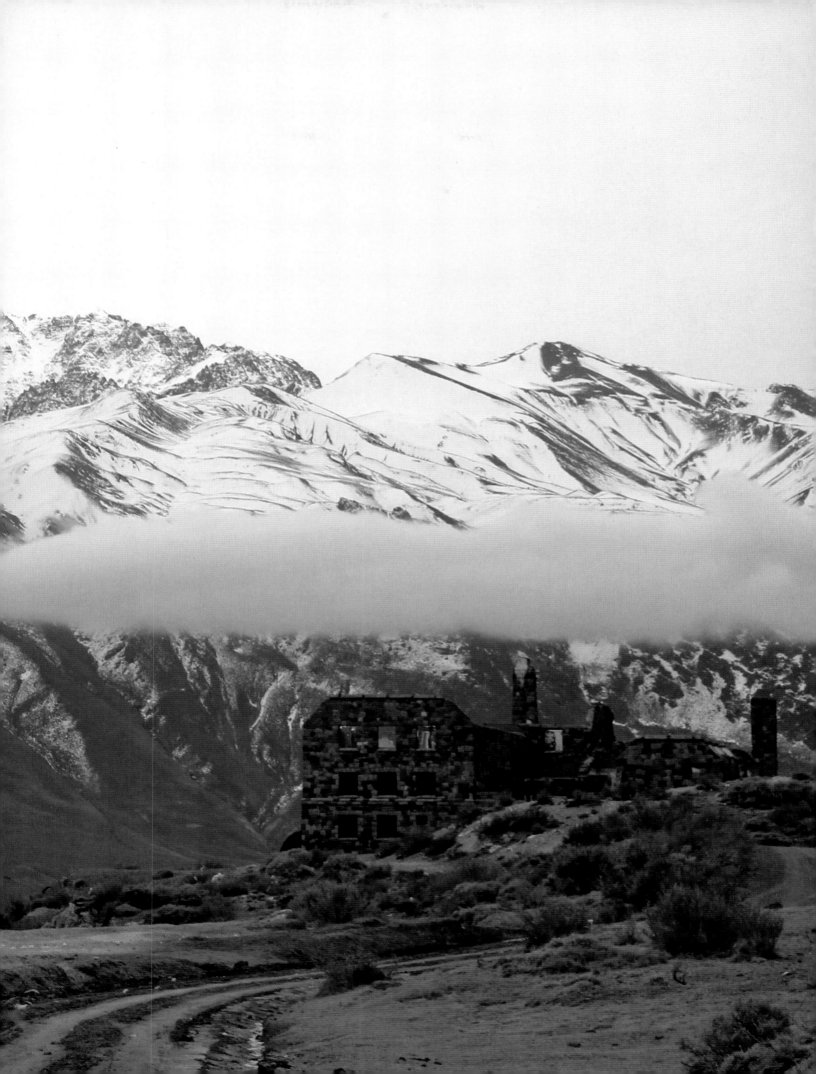

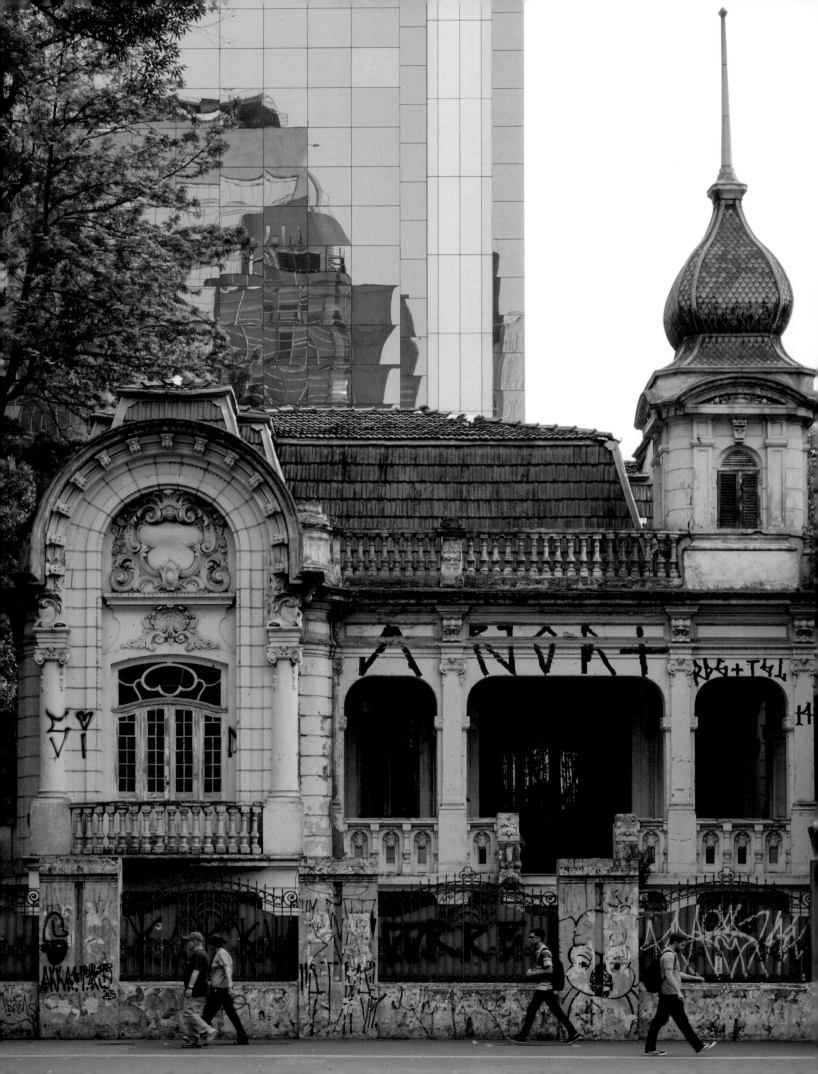

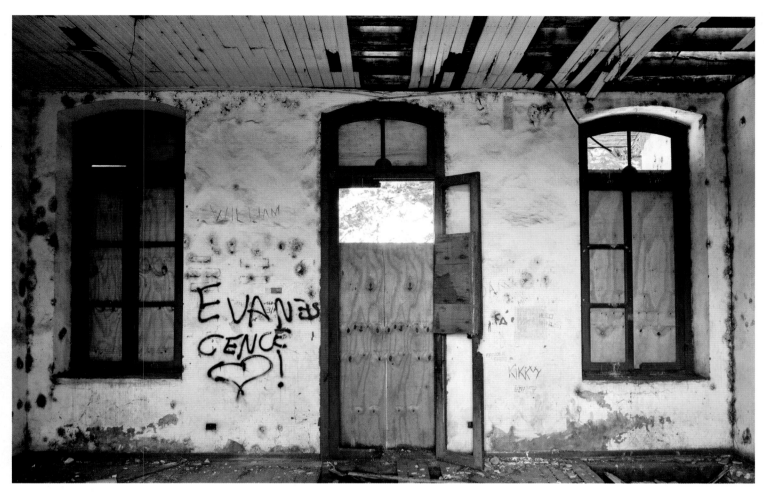

OPPOSITE:
Palacete Franco de Mello, São Paulo, Brazil
The wealthy landowner Colonel Joaquim Franco de Mello had famously founded his own city in the west of São Paulo province, which he had named for his wife, Lavínia. This splendid 35-room residence, occupying over 600 square metres (6458 sq ft), and with extensive grounds, was a modest project by those standards. Built by his children in 1905, it seemed set to endure as the dynastic seat of one of the city's leading families. By 1992, however, it had been condemned; though a campaign was launched for its preservation, and legal action taken, it has gradually been going to rack and ruin over that time.

ABOVE:
Emperor's Palace, São Paulo Province, Brazil
Built in 1858, this was the Emperor's Palace only in the sense that Dom Pedro II (1825–91; reigned 1831–89) ordered its construction. Conditions in what was really no more than a military barracks were at best Spartan. 'Fort Itapura', as it became known, played a vital role in securing the strategic Triete River crossing during the war with Paraguay (1864–70). Peace prevailed in the decades that followed. The installation outlived its usefulness and finally, in 1896, it was closed down. For more than a century it has endured as, effectively, a monument, a *memento mori*. All flesh is grass; the strongest masonry ultimately dust. 'Evanescence', as the graffiti artist observes.

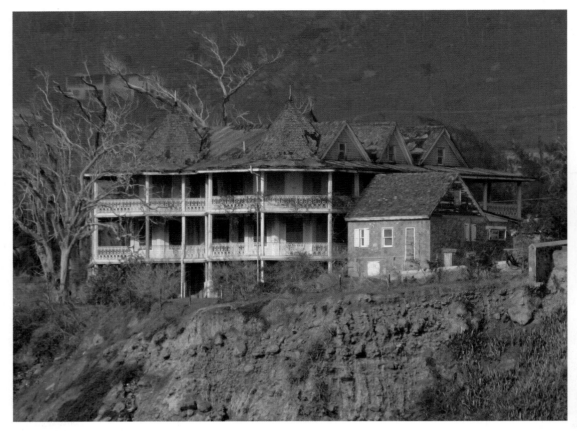

ABOVE:

Governor's Residence, Plymouth, Montserrat
One of the Leeward Islands, in the Lesser Antilles, this British Overseas Territory had to be largely evacuated after the eruption of the Soufrières Hills volcano in 1995. Several thousand islanders were resettled in Britain. The capital, Plymouth, was substantially destroyed and reconstruction and resettlement since prevented by continuing volcanic activity, including showers of ash, toxic exhalations and lava flows. While efforts have been made to develop new settlements in the northern part of Montserrat, much of the island's southern half remains off limits.

RIGHT:

Hotel del Salto, Santandercito, Colombia
This hotel was spectacularly situated beside the Tequendama Falls, on the Bogotá River 30km (19 miles) west of the Colombian capital in Santandercito region. Literally, the 'Hotel of the Jump or Leap', it was originally built in 1923 as a private mansion, becoming a hotel just five years later. Water management and construction work nearby left the river hopelessly contaminated and the hotel was forced to close its doors in 1940. It remained in its abandoned state until 2014, when it was renovated for use as a biodiversity museum.

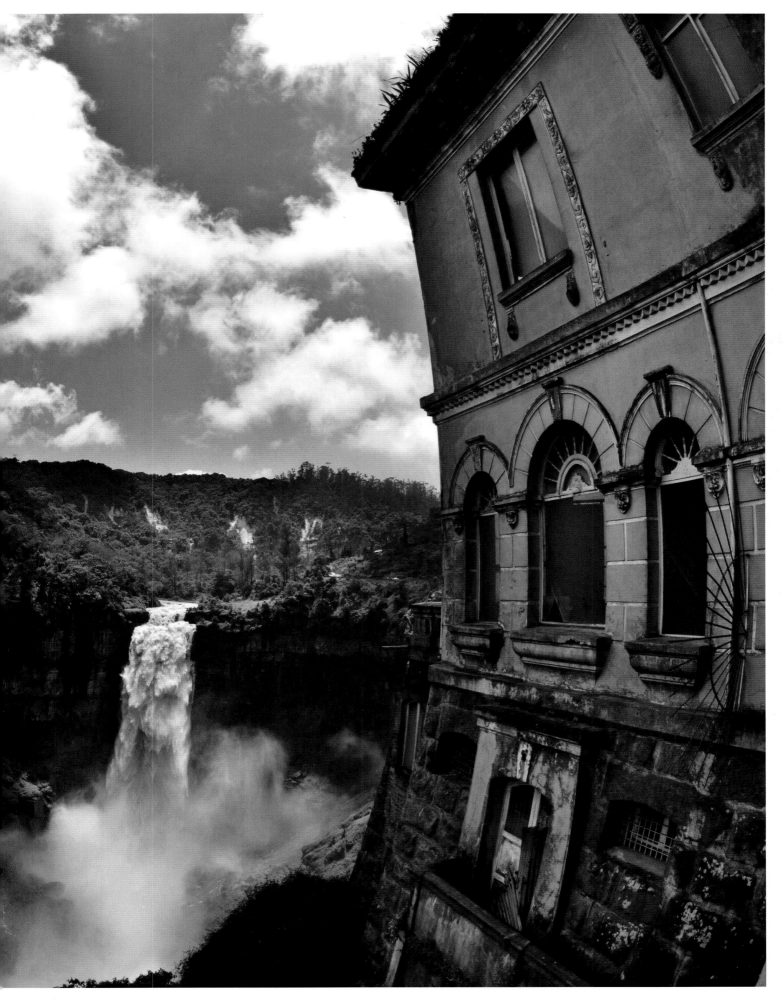

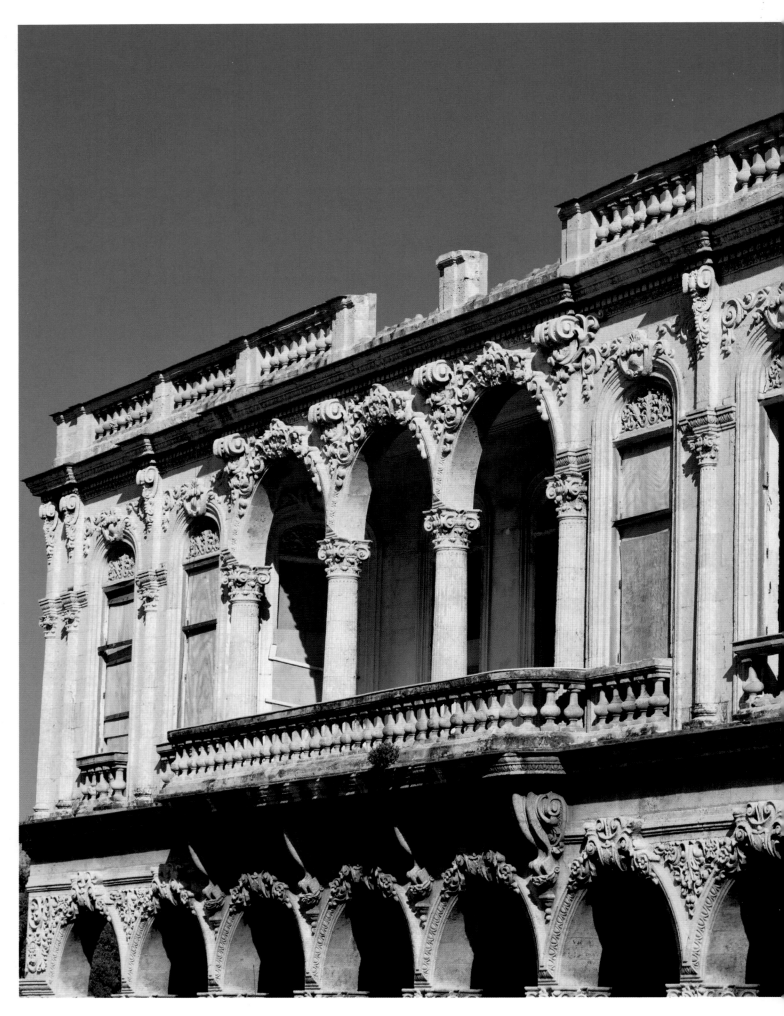

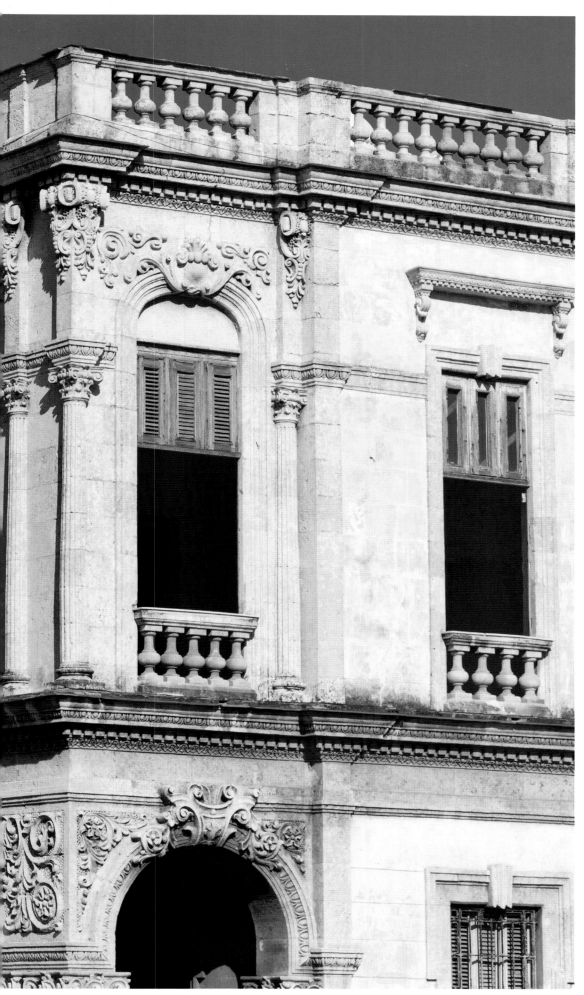

LEFT:
**Baroque building,
Havana, Cuba**
Like Havana's classic cars,
endlessly and ingeniously
repaired and reconditioned,
the city's down-at-heel, even
dilapidated, buildings have taken
on a talismanic role. To the more
ideologically minded visitor,
their condition has signalled the
revolutionary regime's resistance
to the US trade blockade; for the
more frivolous tourist, they have
simply lent a raffish charm. Either
way, the end of the Castro era
could hardly have come too soon
for an architectural heritage that
is surely well worth saving.

OVERLEAF (ALL):
Sans Souci, Milot, Haiti
King Henri Christophe (1767–
1820; reigned 1811–20) had this
palace built. A former slave, he'd
played a leading part in the fight
for freedom against the French
colonizers. Elected president of
an independent Haiti, he had then
turned tyrant, founding his own
kingdom in the north of the island
state. Sans Souci ('Without Care')
was just the largest of his many
royal residences. In 1842, it was
badly damaged by an earthquake
and abandoned.

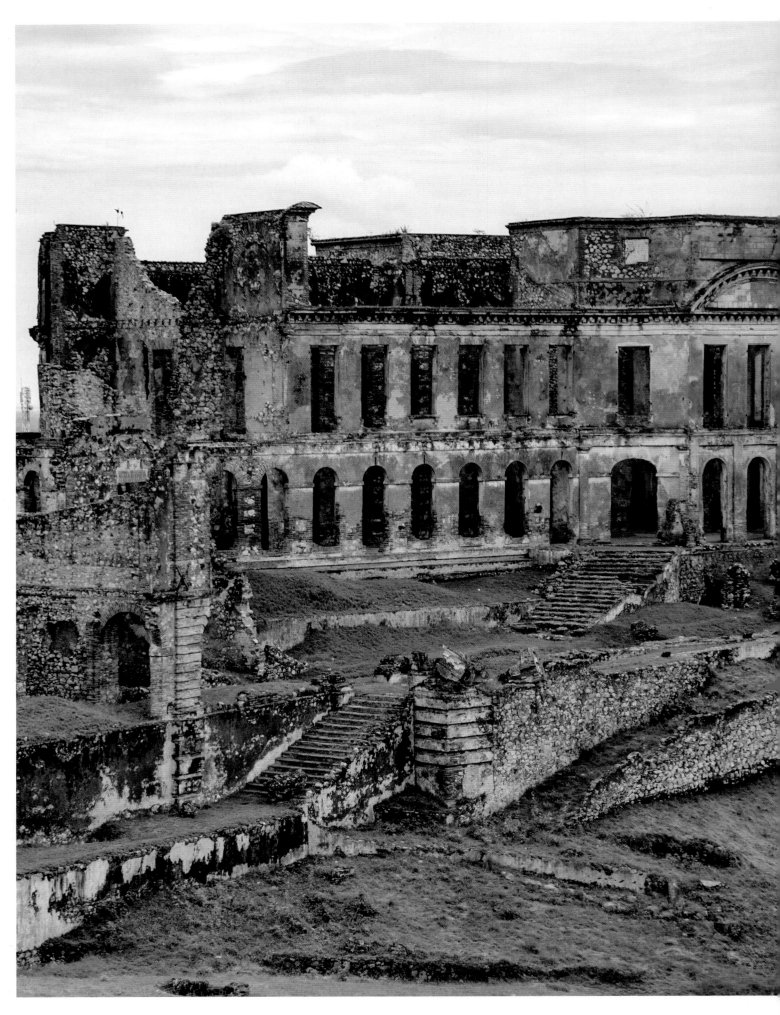

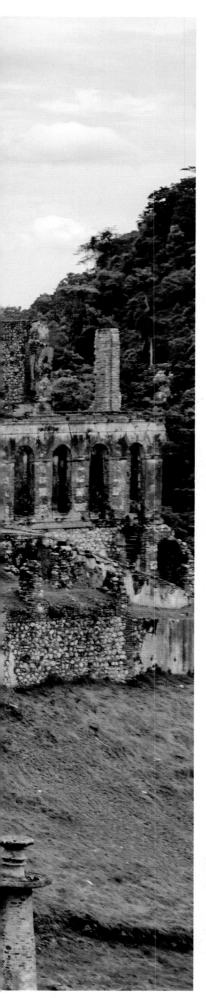

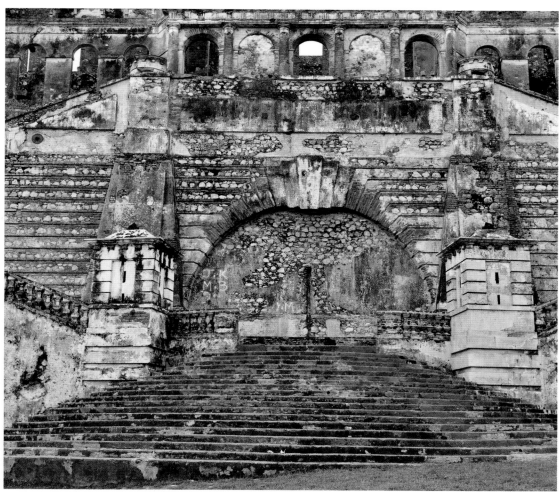

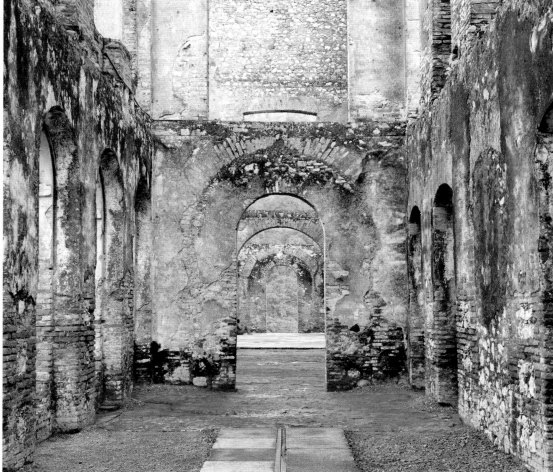

**Presidential Palace,
Port au Prince, Haiti**
After a powerful earthquake
hit Haiti in January 2010,
the collapsed cupola of the
presidential palace became a
fitting emblem for a country on its
knees. Many tens of thousands of
lives were claimed by the disaster
itself; hundreds of thousands
more as, in the weeks and months
that followed, disease and
disorder took its toll on what
was already the poorest country
in the hemisphere.

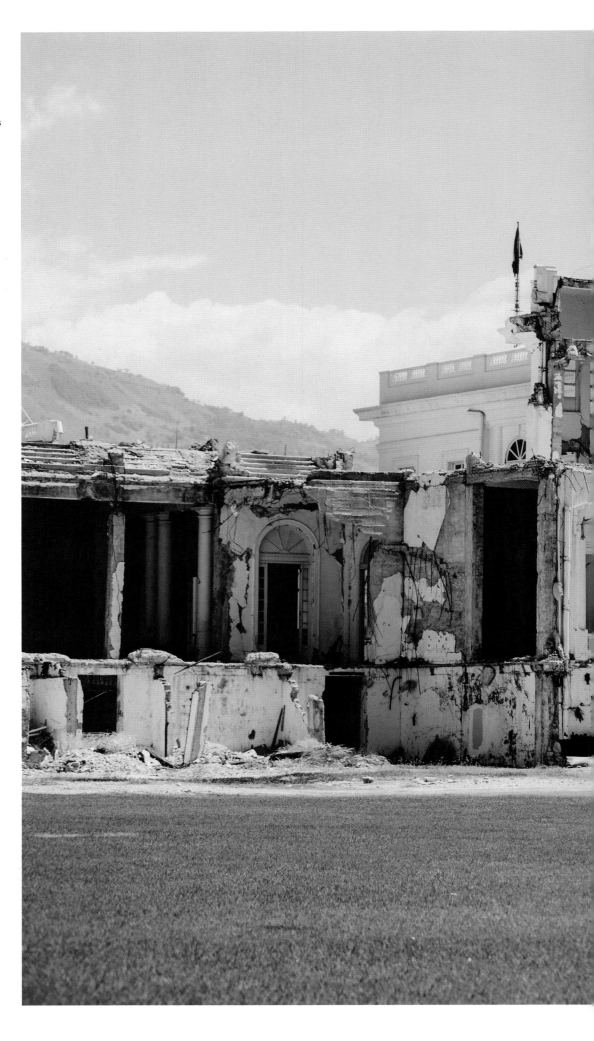

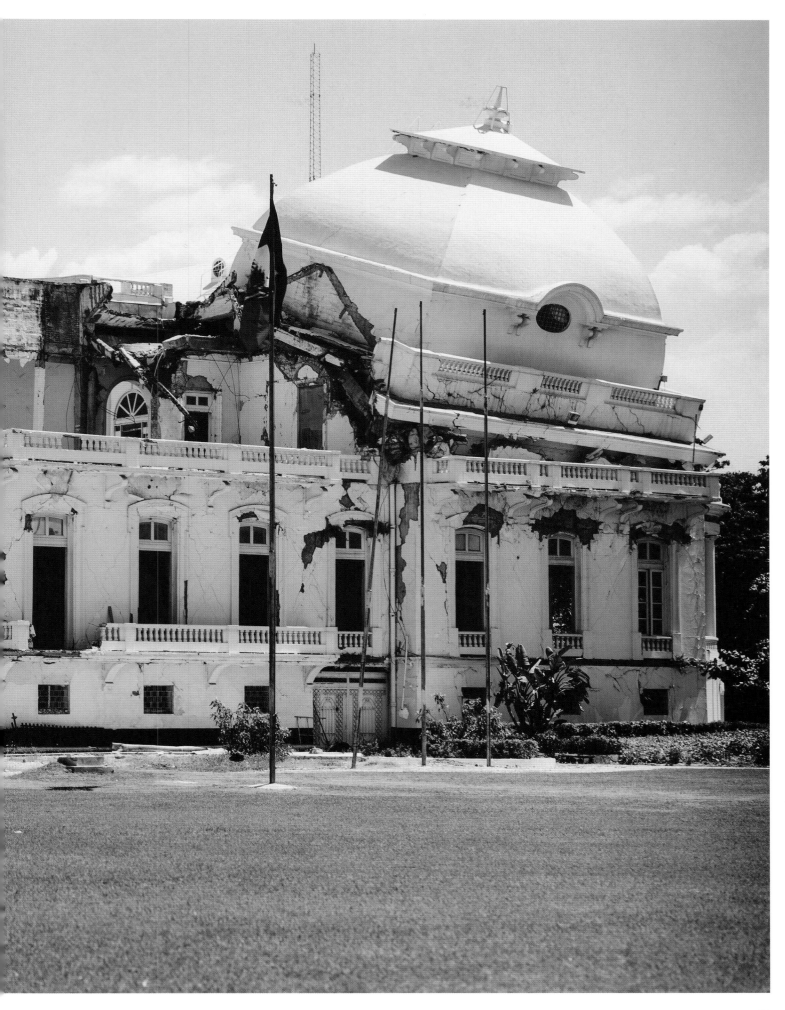

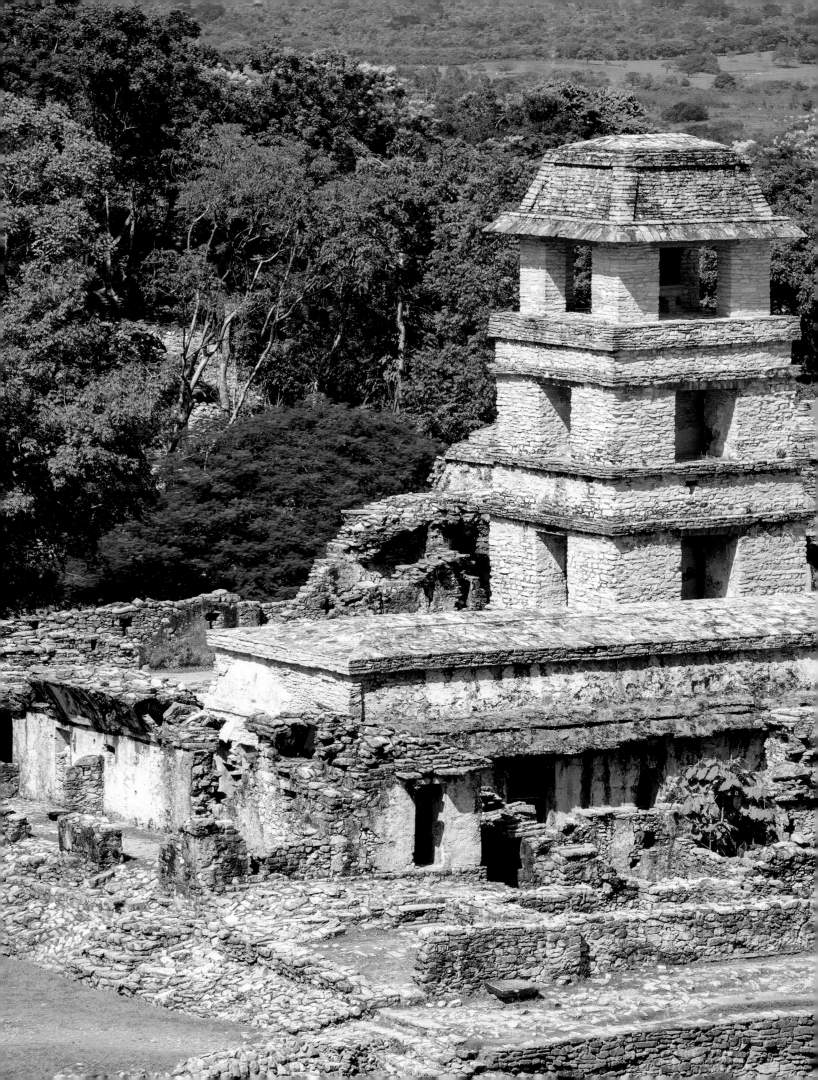

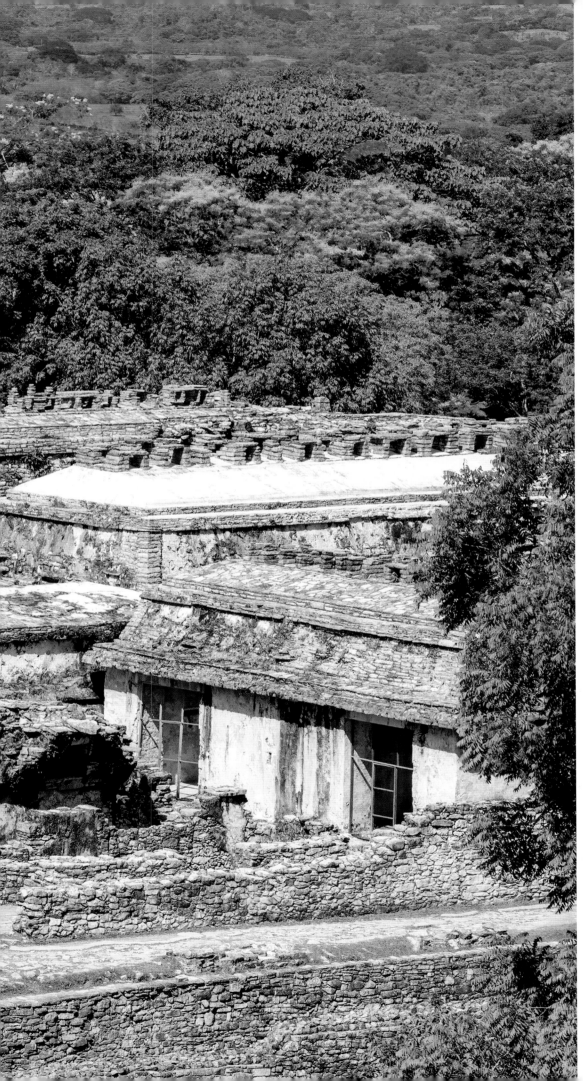

Palace of Palenque, Chiapas, Mexico

An honest-to-goodness ancient ruin, the Palenque palace complex was built in stages between about 200 and 800 CE as the centre of an important Mayan state. Much about the site remains mysterious. It is dominated by what has become popularly known as the 'Observation Tower' – though its actual function is essentially unknown. Beyond it, what appear to be residential, administrative and temple buildings are grouped around courtyards – including one in which a ritual ballgame is believed to have been played.

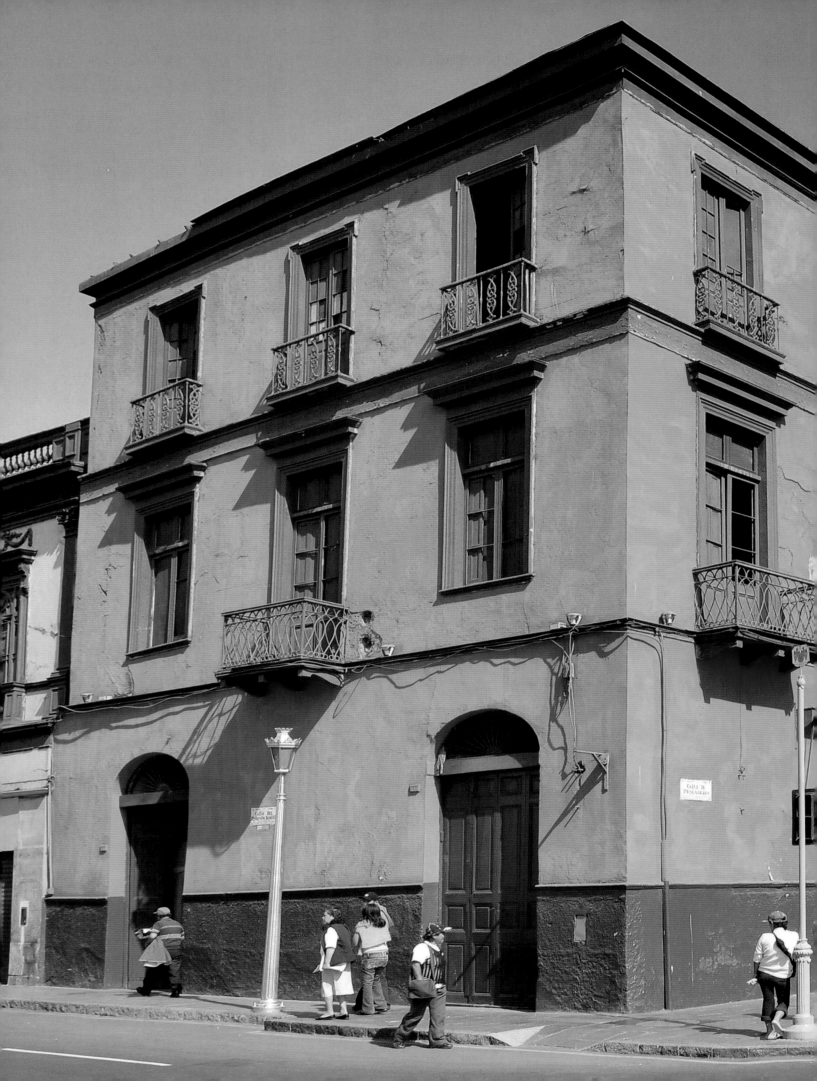

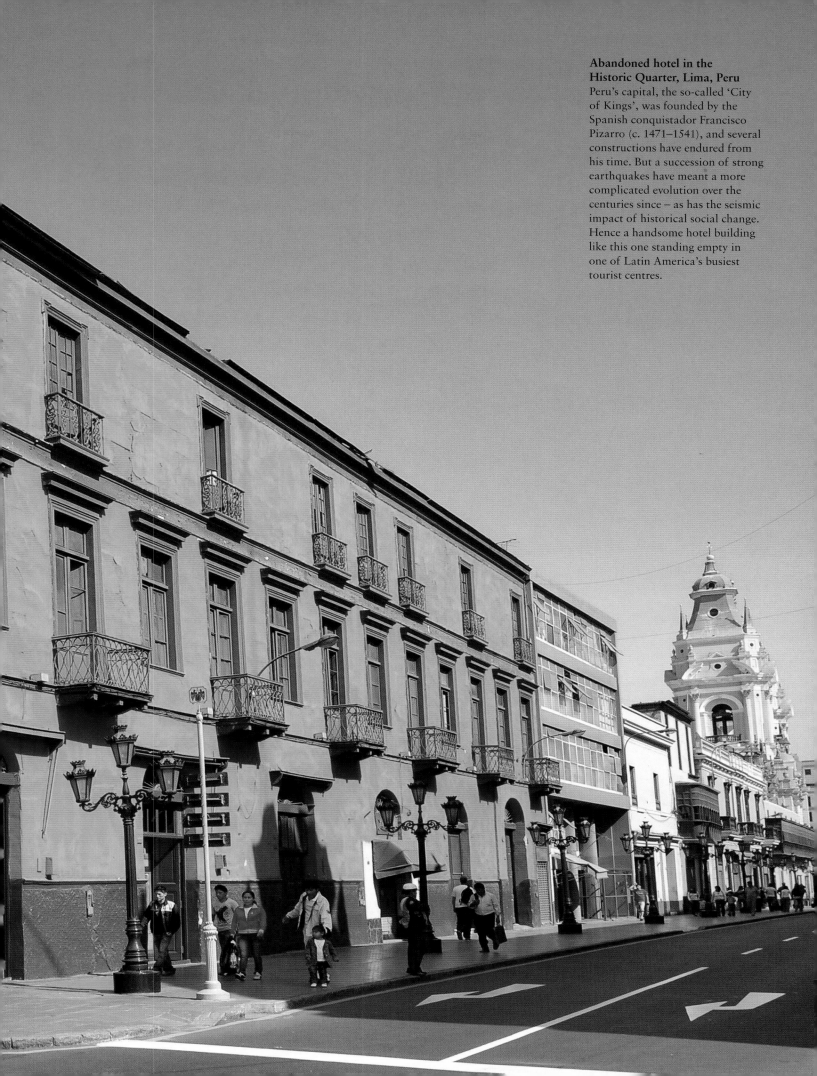

Abandoned hotel in the Historic Quarter, Lima, Peru
Peru's capital, the so-called 'City of Kings', was founded by the Spanish conquistador Francisco Pizarro (c. 1471–1541), and several constructions have endured from his time. But a succession of strong earthquakes have meant a more complicated evolution over the centuries since – as has the seismic impact of historical social change. Hence a handsome hotel building like this one standing empty in one of Latin America's busiest tourist centres.

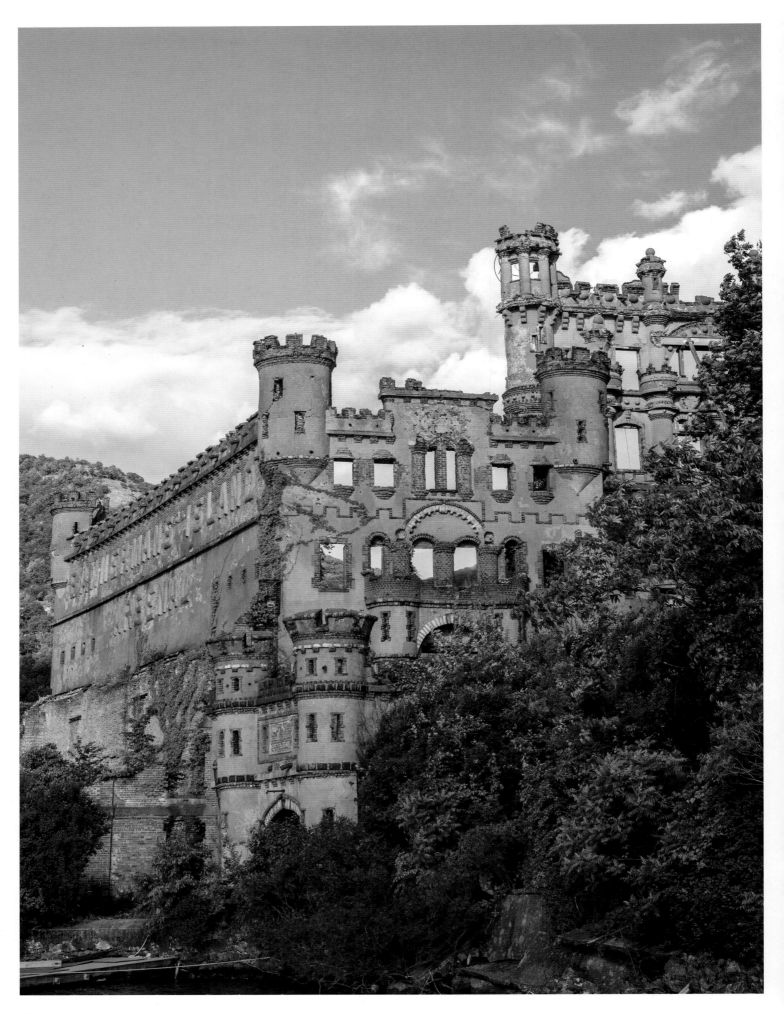

OPPOSITE:

Bannerman's Castle, Pollepel Island, New York, United States
This imposing pile stands on a small island 80km (50 miles) up the Hudson River from New York City. It was built by Francis Bannerman VI (1851–1918). A Northern Irish immigrant, he had made his fortune trading in military surplus equipment: he bought the island as a safe place in which to warehouse hazardous munitions. In keeping with the military theme, he had his arsenal building elaborately castellated. In 1920, perhaps inevitably, an explosion tore the heart out of the building.

ABOVE:

Bells Mansion Carriage House, Brenton Point State Park, Rhode Island, United States
This carriage house and its associated stables are all that remains of one of Rhode Island's most prestigious homes. Theodore M. Davis (1838–1915), by profession a lawyer but by passion and renown an Egyptologist, built the mansion he called The Reefs on this great estate in 1876. Later renamed The Bells, it was confiscated in World War II as the site for a coastal battery. Though restored to the family, it remained empty; after a fire in 1960 it had to be demolished.

RIGHT:

Harry Flavel House, Astoria, Oregon, United States

The archetypal American 'haunted house' does indeed have a few (figurative) skeletons in its closet. Built in 1901, it was bought by Captain George Conrad Flavel (1855–1923). His grandson Harry lived here with his sister Mary Louise from the 1940s. For the most part they kept themselves to themselves, while the local community left them alone. They were well advised to do so: on one occasion Harry took a hatchet to a neighbour, while in 1983 he stabbed a motorist in a dispute and was imprisoned.

OVERLEAF:

Halcyon Hall, Bennett College, Millbrook, New York, United States

The daughters of New York State's elite spent the halcyon (or, at least, formative) days of their young womanhood at Bennett, once a highly prestigious college. It had, however, undergone a long decline through the mid-century as mixed education became the norm and finally gave up the ghost in 1978. Its main building, dating from 1893, had been distinguished in its day: it certainly makes an atmospheric ruin.

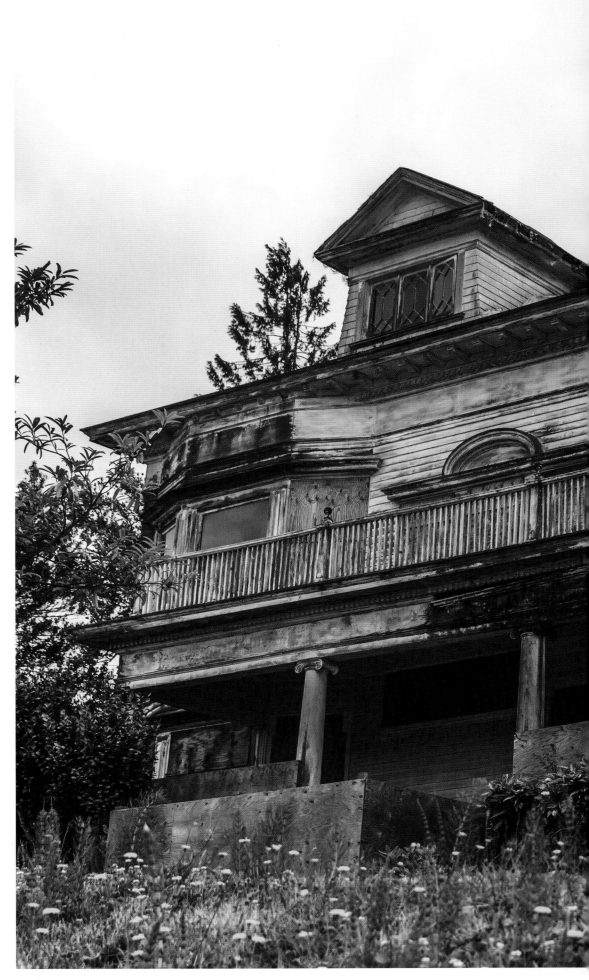

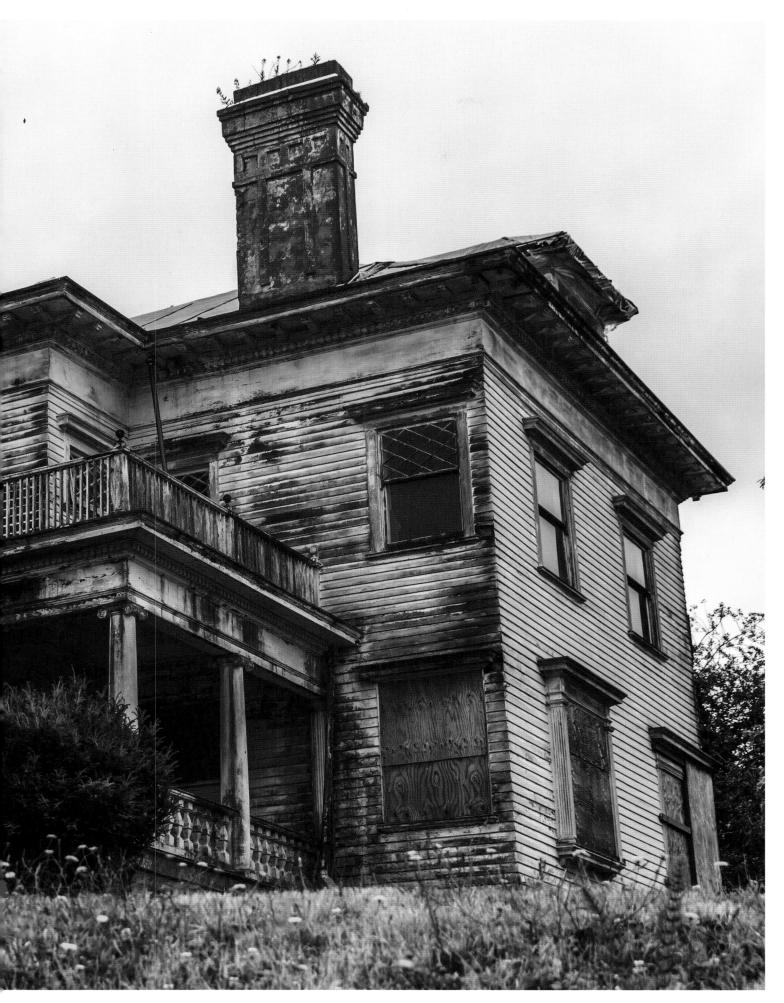

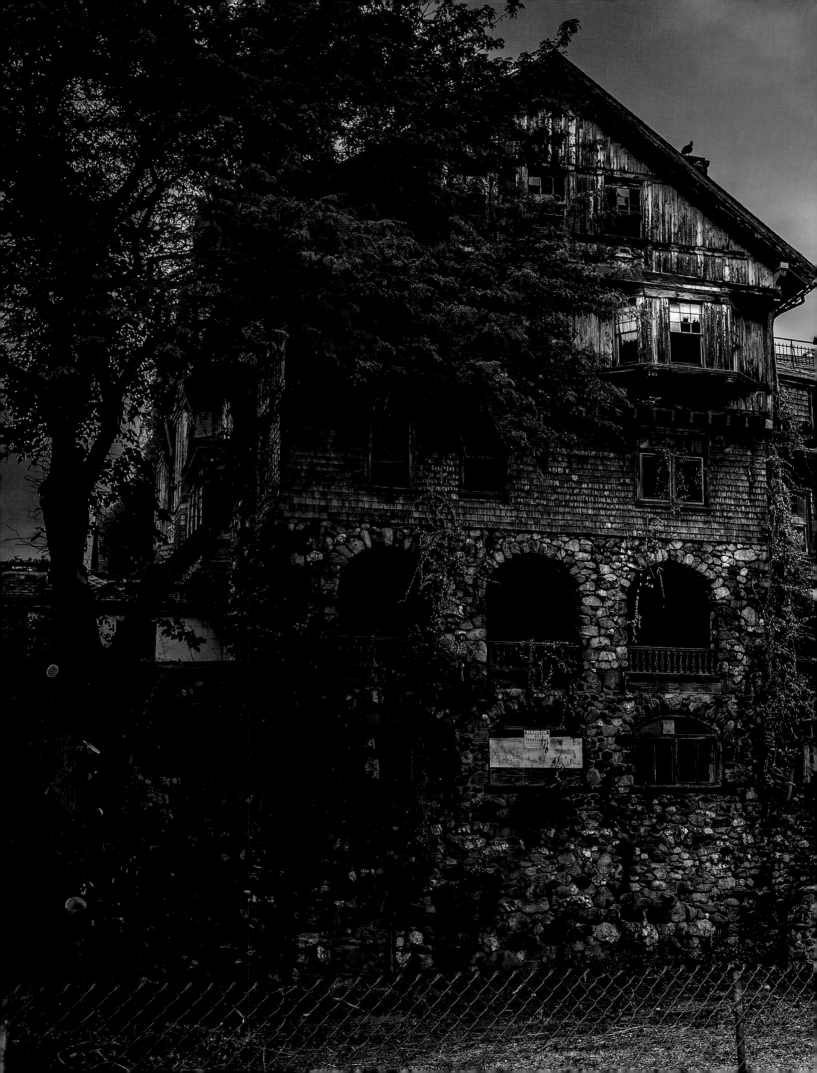

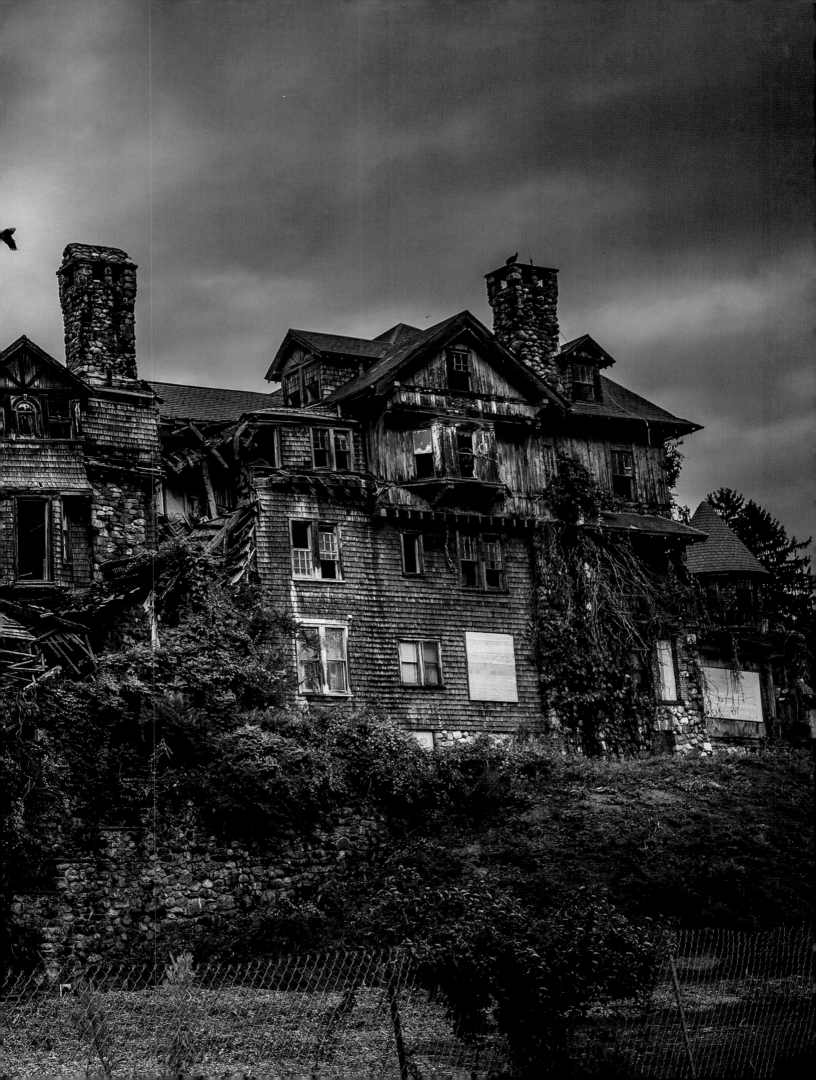

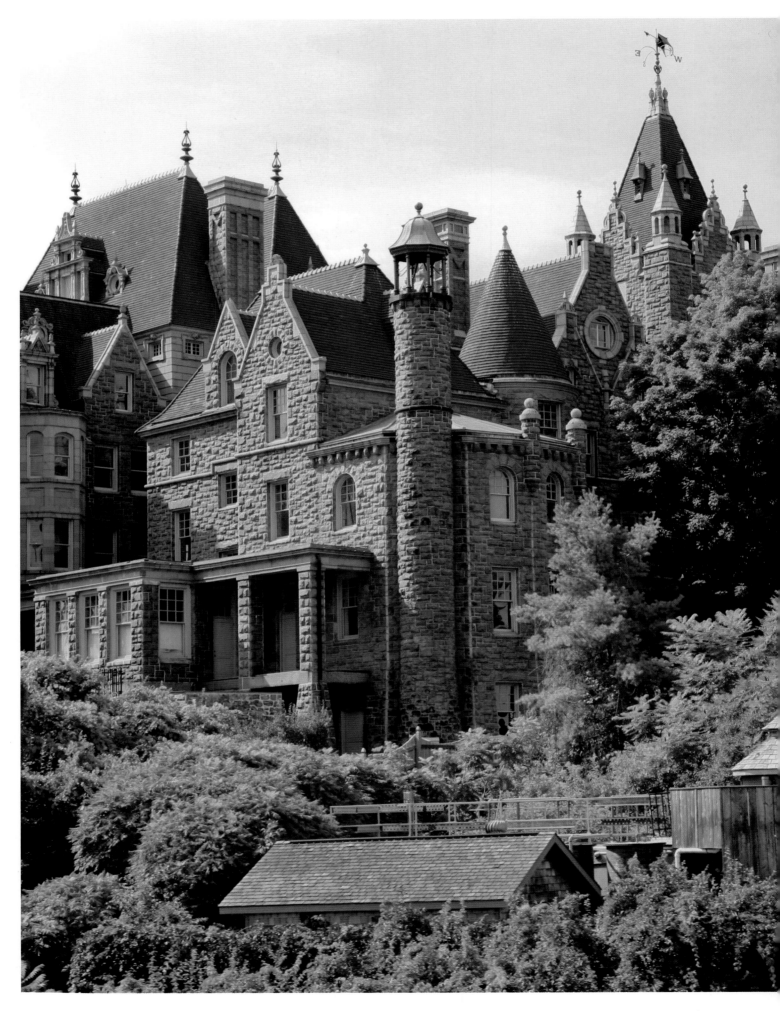

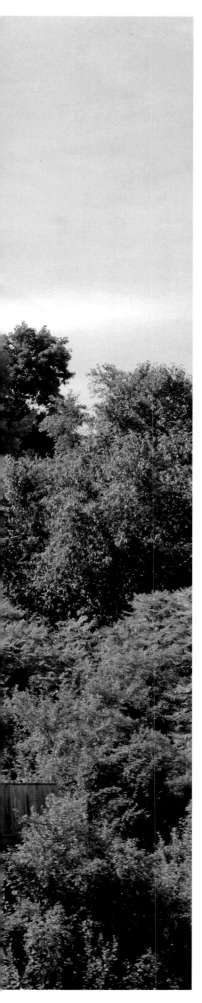

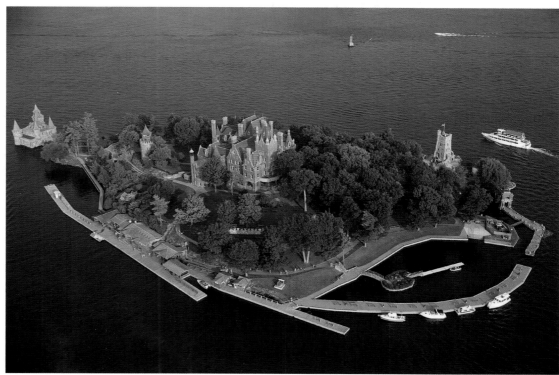

LEFT AND ABOVE:

Boldt Castle, Heart Island, Alexandria Bay, New York, United States

Heart Island is one of the 'Thousand Islands' strewn across the open waters between the United States and Canada where the St Lawrence River flows out of Lake Ontario. The wealthy hotelier George Boldt (1851–1916), fresh from founding New York City's Waldorf-Astoria Hotel, built this 'castle' as a present for his wife, Louise. They'd met at the Philadelphia Club, where he had been a dishwasher and she was working as a hostess. She had been not only a beloved wife but an important business partner, with ideas of her own about the hospitality industry. Grief stricken when she died in 1904, Boldt abandoned his labour of love: it became a ruin without ever having been completed.

In the 1970s, however, it was taken up by the Thousand Island Bridge Authority, who restored Boldt's monument and opened it to the public: it has proved a popular attraction ever since.

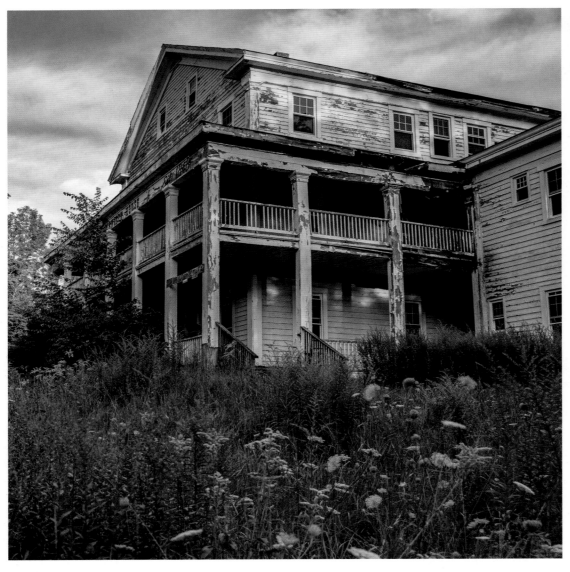

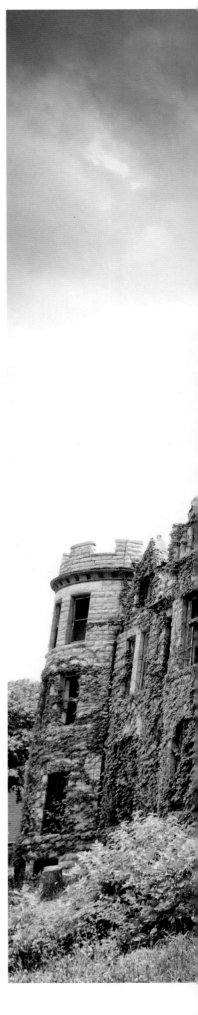

ABOVE:

Ruined resort, Catskill Mountains, New York, United States

Afternoon fades to evening on one of many abandoned resorts to be found the length and breadth of the so-called 'Borscht Belt' of upstate New York. Middle-class Jewish families flocked here from the 1920s to the 1980s. At that point it began to be eclipsed: first by Miami and Florida's Gold Coast; and then by the wider, more exotic world which was opened up by cheap air travel.

RIGHT:

Derelict mansion, Detroit, Michigan, United States

Over several decades of steep decline, America's 'Motor City' has acquired a very different distinction as the country's capital of post-industrial decay. Its landscapes of scorched earth, gaunt factory shells and weed-choked railway sidings have become familiar to magazine readers worldwide. As this melancholy photo shows, though, it isn't just the industry that has gone or the working-class who have been affected – a bourgeois way of life, established over generations, has been lost too.

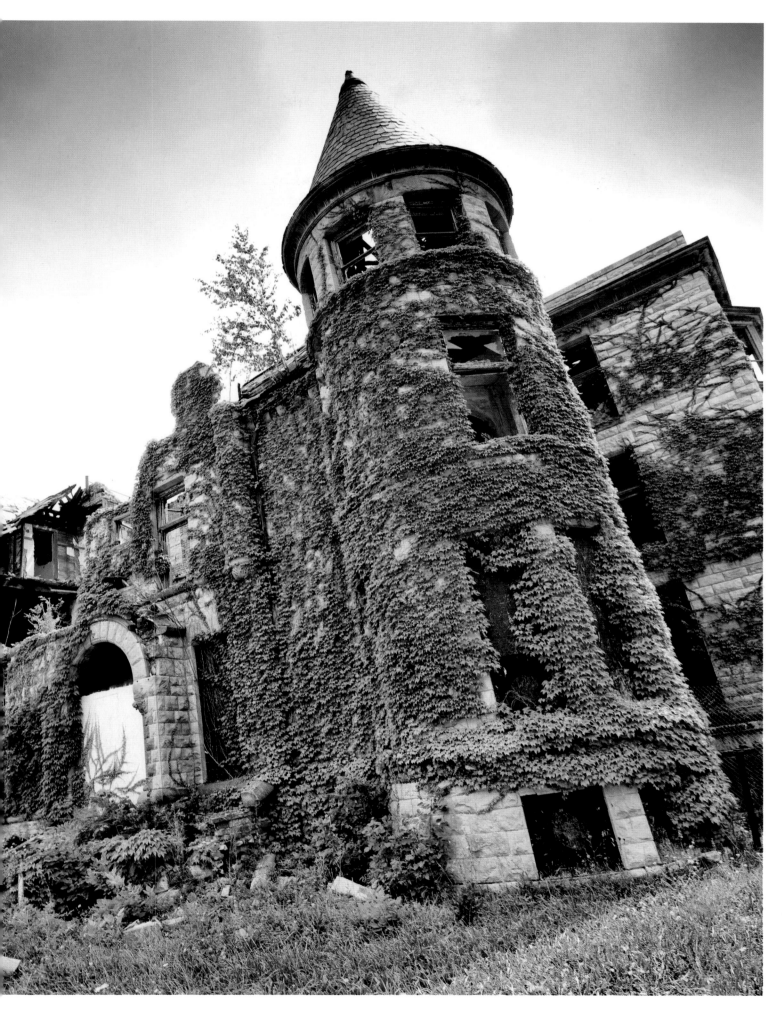

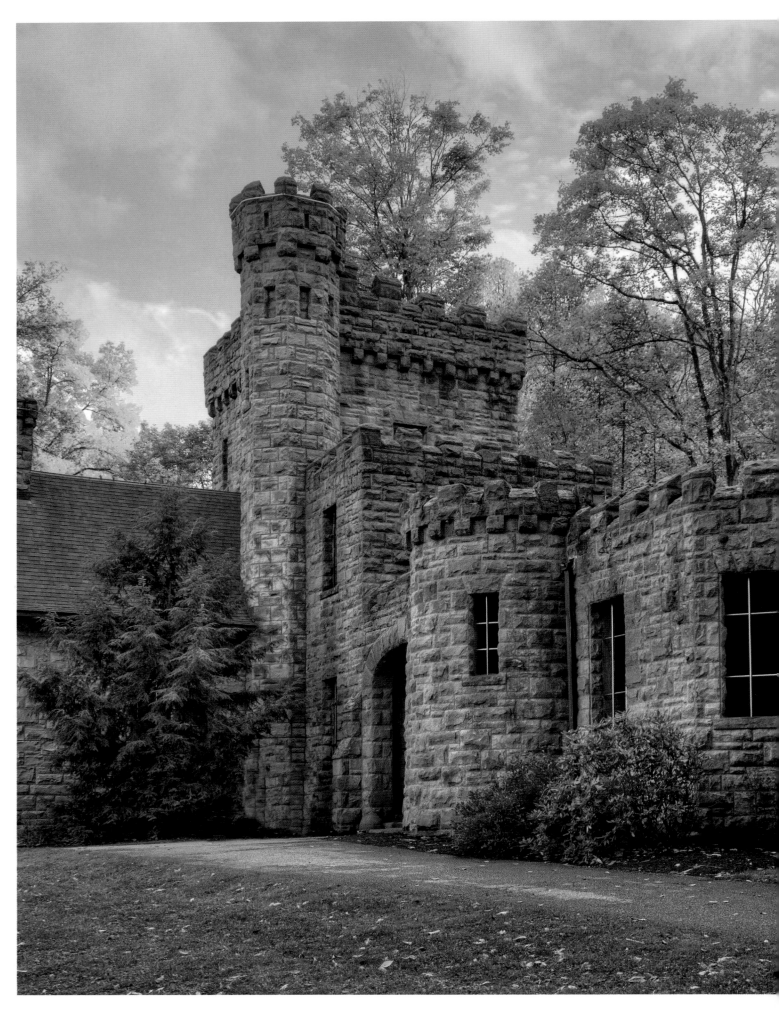

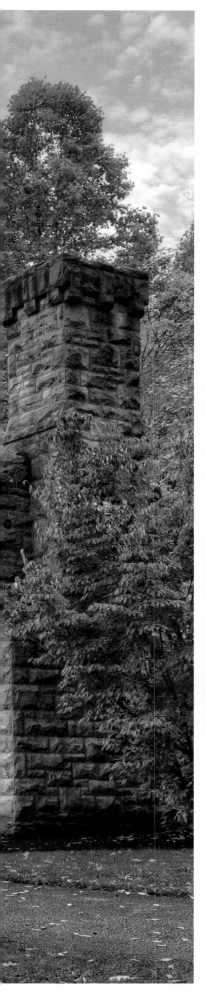

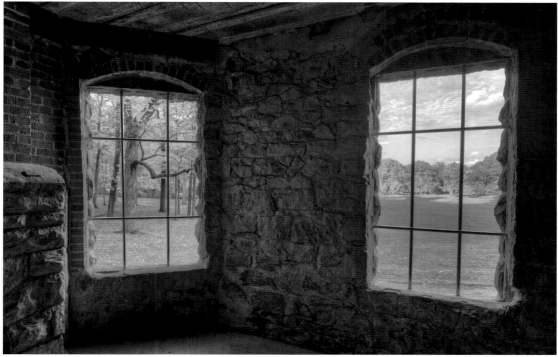

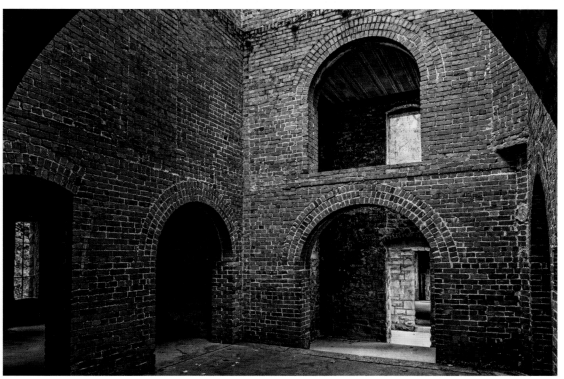

ALL PHOTOGRAPHS:

Squire's Castle, North Chagrin Reservation, Cleveland, Ohio, United States

This impressive pile was intended to be just the gatehouse for an English-style stately home surrounded by an extensive country estate in the Chagrin Valley just outside Cleveland to the northeast. The plan had been hatched by Feargus B. Squire (1850–1932), who planned to live here with his wife Louisa and their daughter. Money was no object for an executive of Standard Oil. Impatience was, though: the construction of the 'big house' itself was hampered by difficulties in getting hold of key building materials; the Squires were losing interest before the work had really started.

And while the gatehouse, completed in 1897, did some service as a weekend cottage, it didn't really match the Squires' expectations. Its imposing exterior is arguably outdone by the inside, with its austere Romanesque arches and its stunning views across a lovely open park. Even so, the Squires were disappointed. They had looked forward to living and entertaining on a much more lavish scale and soon stopped going to North Chagrin altogether.

In 1922, Squire sold up: the 'Castle' stood empty and neglected and has remained so all the way down to the present day.

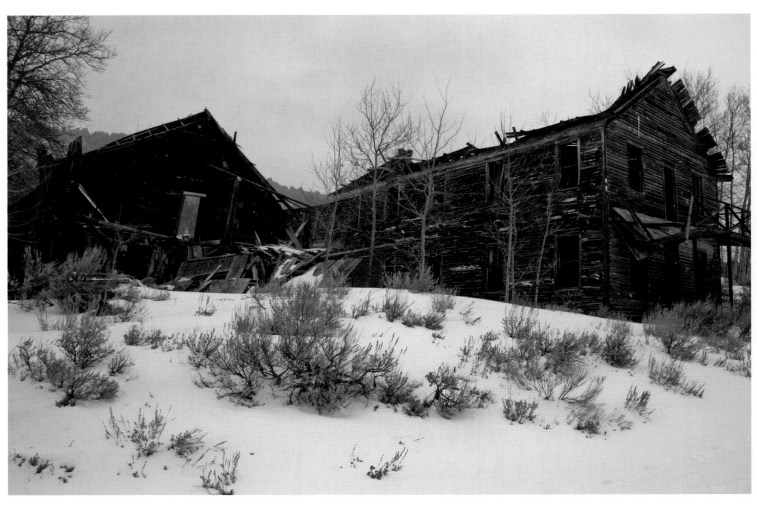

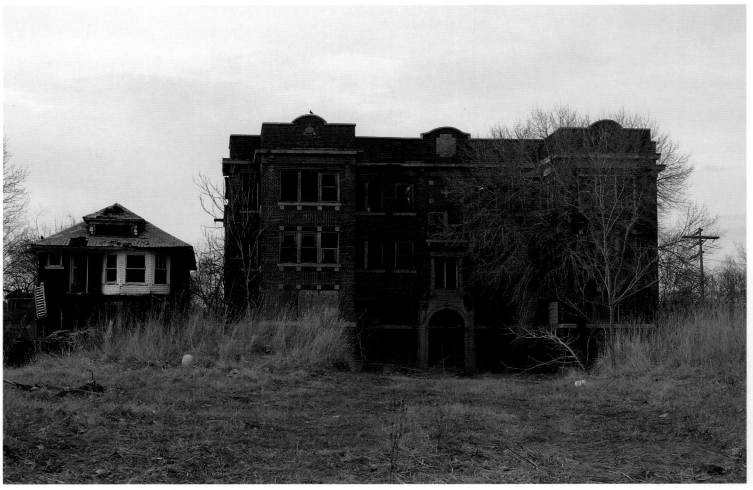

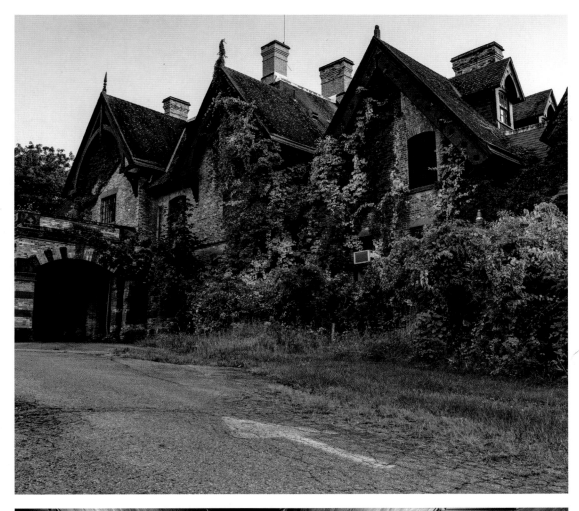

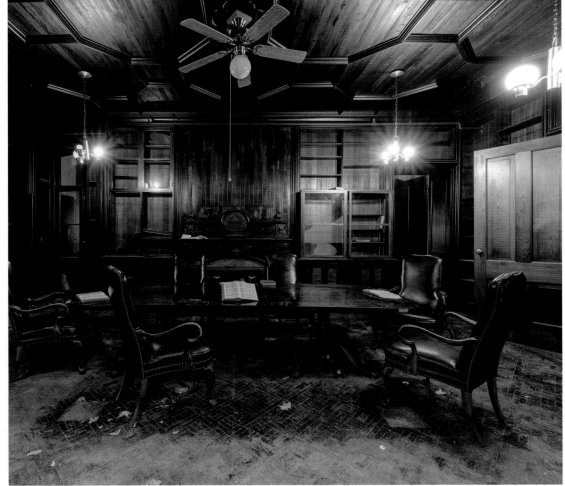

OPPOSITE TOP:
Abandoned hotel, Comet, Montana, United States
Gold was struck here in 1874 – silver, zinc, lead and copper were quickly found in the Comet mine. Within two years a town had been built and by the 1890s it was booming, with 300 full-time residents and 20 saloons. By 1900, though, the boom had been and gone: this has been a ghost town ever since.

OPPOSITE BOTTOM:
Deserted mansion, Detroit, Michigan, United States
If Detroit has become the destination for 'dereliction tourism' in recent times, that's not simply because it can boast so much blight, with some 70,000 abandoned buildings. It's the quality of all this stock; the pride and prestige it so clearly stood for – just a few years ago – that makes the fall seem so sublimely tragic.

LEFT ABOVE AND BELOW:
Tioronda Mansion, Beacon, New York, United States
General Joseph Howland (1834–86) was born into stupendous wealth, his family having made its fortune in the China trade. He gave much of it away, as a lifelong philanthropist, endowing libraries and hospitals in the vicinity of Beacon, but the estate at Tioronda was a present to himself. After his death, however, it became a mental hospital until it was abandoned in 1999.

Howland's hope had been that Tioronda would be a kind of rustic retreat where he could live in quiet comfort in the style of an English squire. It wasn't to be: his peace and quiet were first interrupted by the Civil War (in which he fought bravely and won his rank as a general) and then by public duties (including a term as State Treasurer for New York).

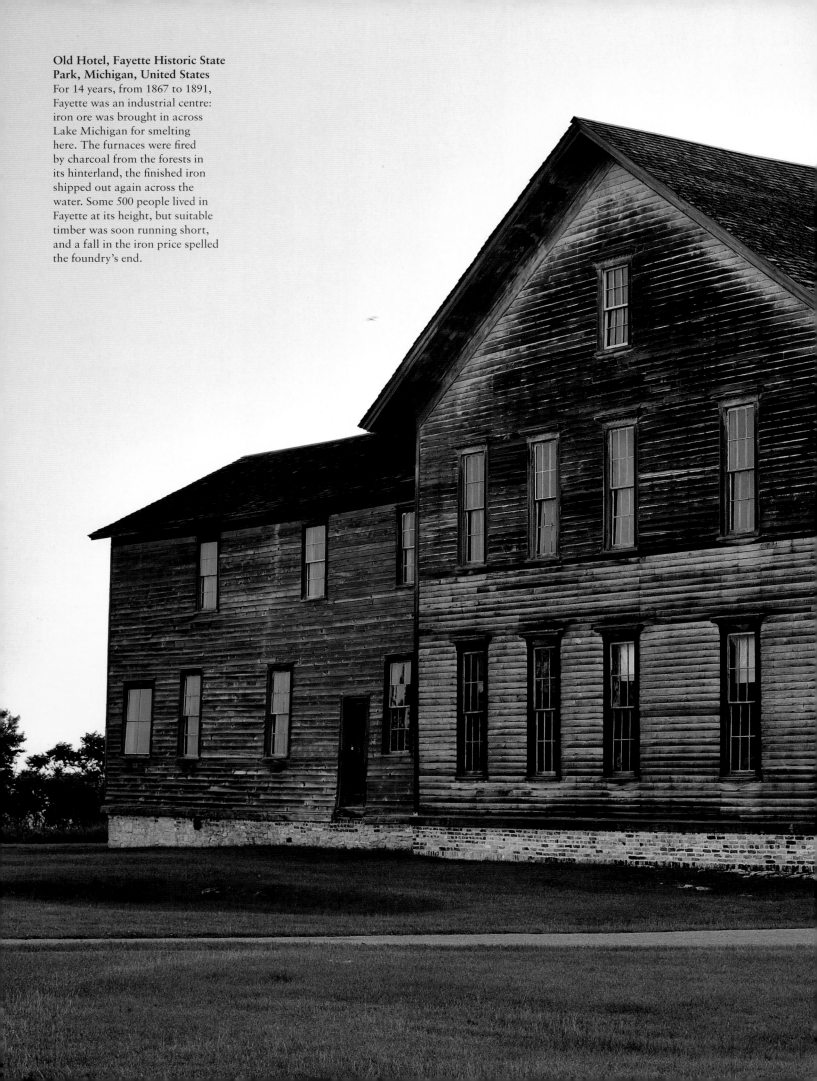

Old Hotel, Fayette Historic State Park, Michigan, United States
For 14 years, from 1867 to 1891, Fayette was an industrial centre: iron ore was brought in across Lake Michigan for smelting here. The furnaces were fired by charcoal from the forests in its hinterland, the finished iron shipped out again across the water. Some 500 people lived in Fayette at its height, but suitable timber was soon running short, and a fall in the iron price spelled the foundry's end.

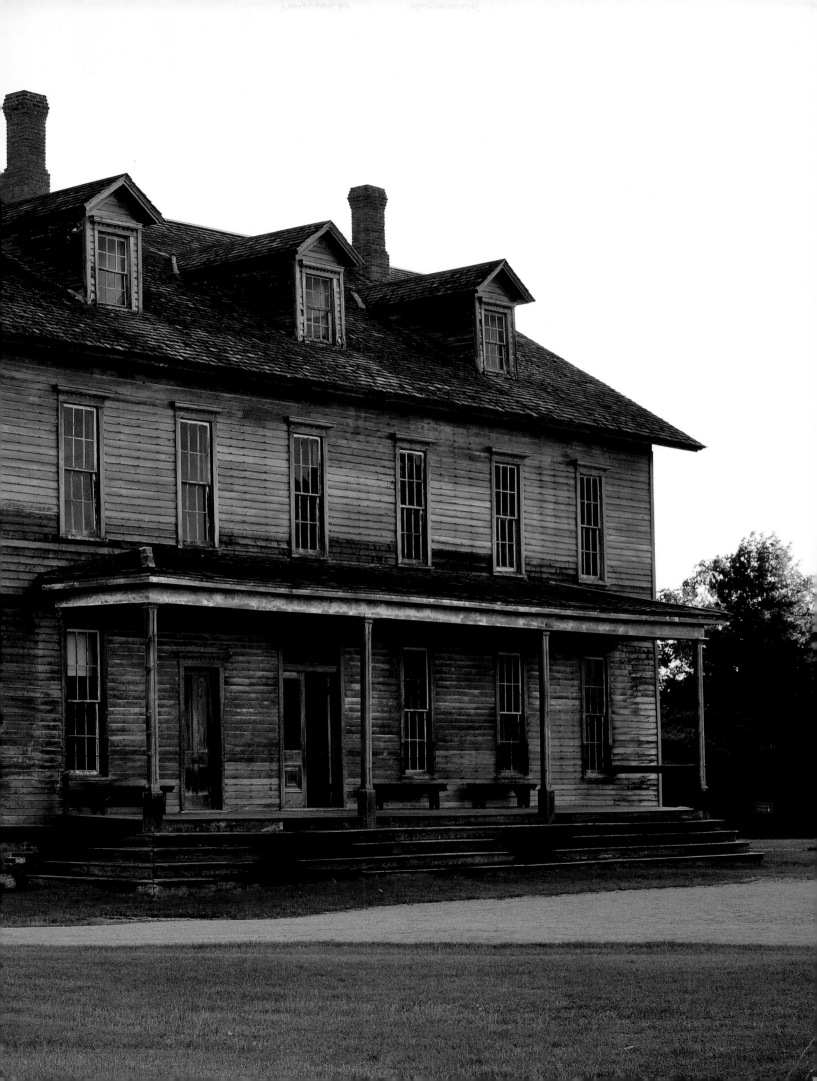

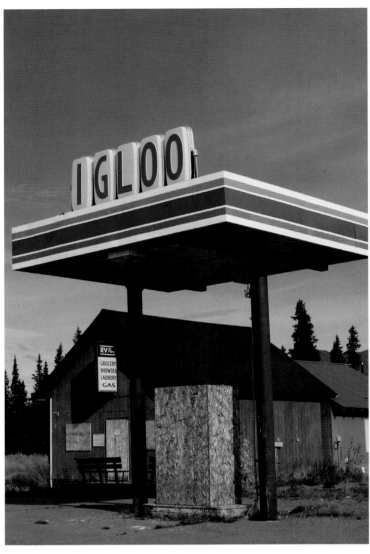

ABOVE AND RIGHT:

Igloo City, Cantwell, Alaska, United States

There was never a functioning hotel here, still less the 'city' the 1970s developers envisaged – just this gas station, itself now derelict.

The giant concrete igloo was supposed to tempt tourists to break the 580-km (360-mile) journey between Fairbanks and Anchorage; and so it might have done, had its builders only been able to meet the required regulations.

Standing 24m (80ft) tall and 32m (105ft) wide, this freakish concrete structure was lined with plywood. Local entrepreneur Leon Smith (1921–99) started trying to achieve his vision in 1972, but state bureaucrats were to dash his dreams. Inspectors looked askance at the lack of windows, essential though this was to the 'igloo' effect – but there seem to have been several other violations, too.

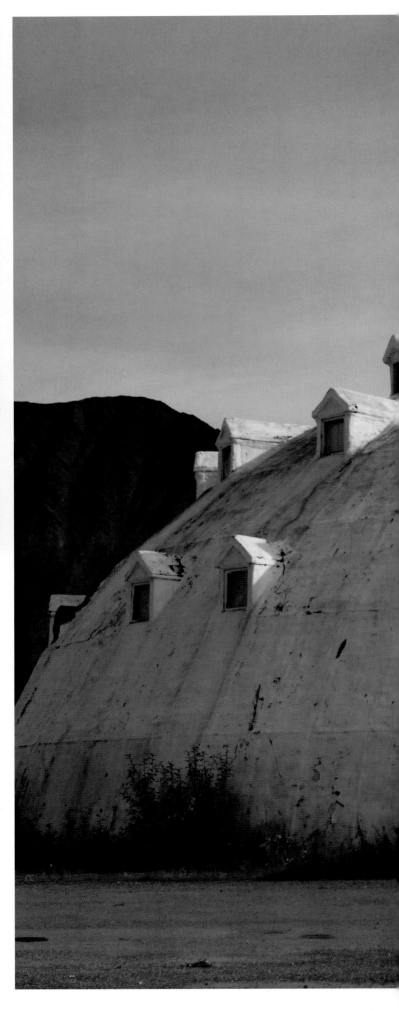

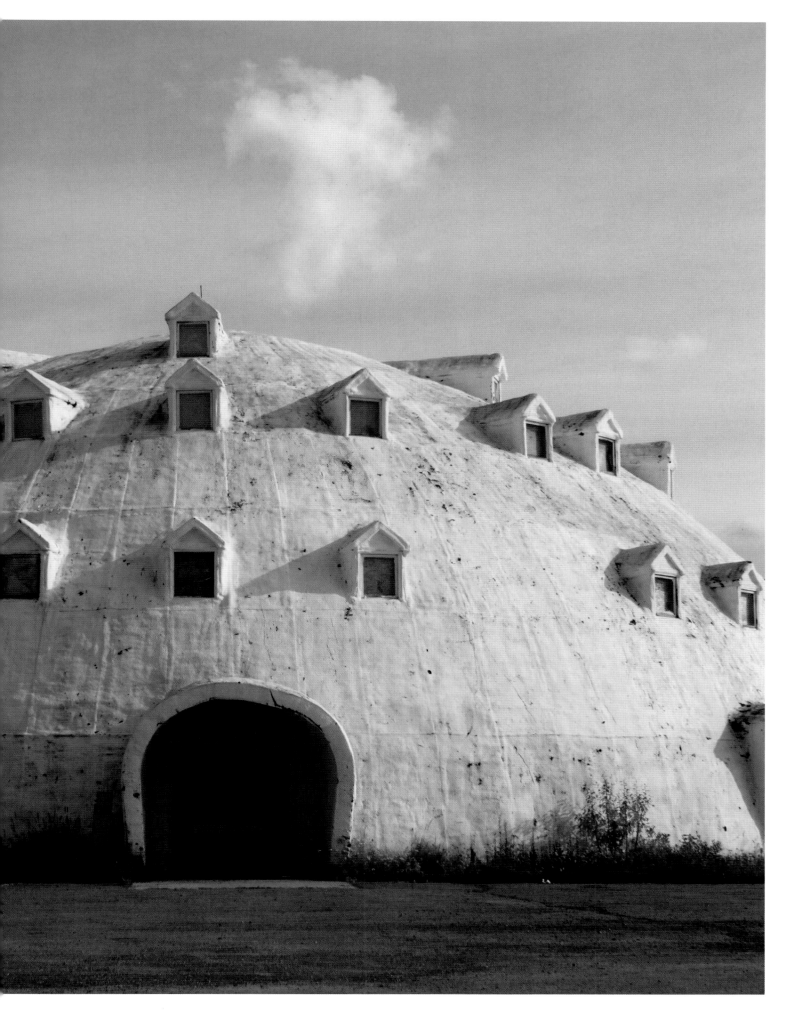

ABOVE:
Wolf House, Glen Ellen, California, United States
Jack London (1876–1916), bestselling author of *Call of the Wild* (1903)
and *The Sea Wolf* (1904), had joined the Klondike Gold Rush and sailed
the Pacific as a seafarer. He'd been a war correspondent in Manchuria
and reported from London's East End slums. Wolf House was to be his
place of peace; in 1913, two weeks before he and his wife were to take up
residence, it burned down and had to be abandoned.

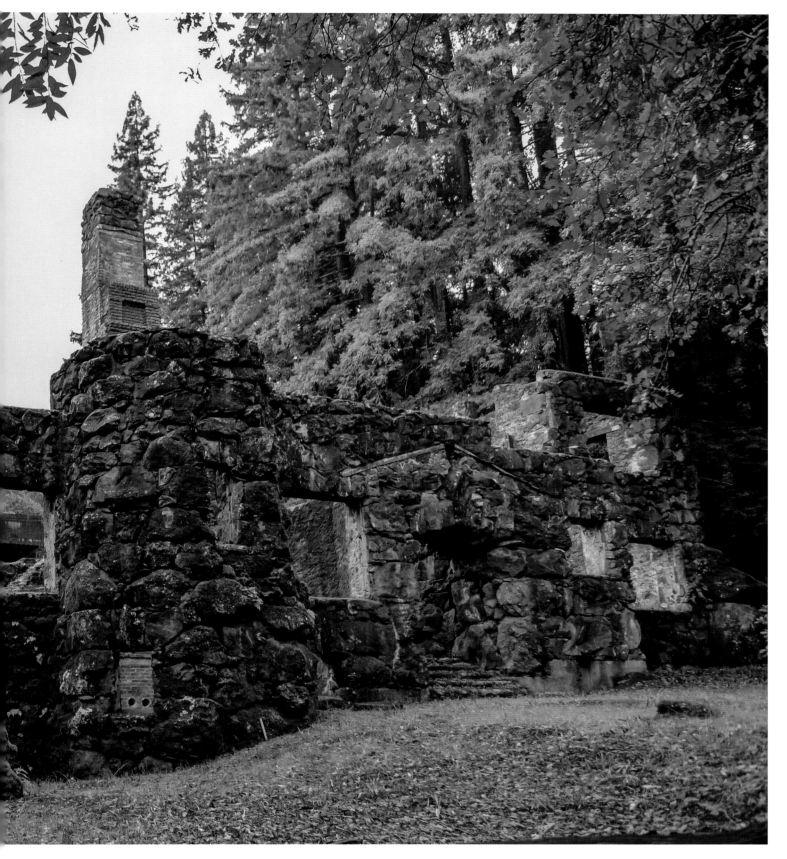

Swannanoa Palace, Afton, Virginia, United States
Renaissance Rome came to the Appalachians when railroad magnate
James H. Dooley decided to build his Medici-inspired summer residence
here on a hillside above the tracks at Rockfish Gap. Standing in 240
hectares (590 acres) of grounds, Swannanoa remains spectacular – even
in its long-abandoned state.

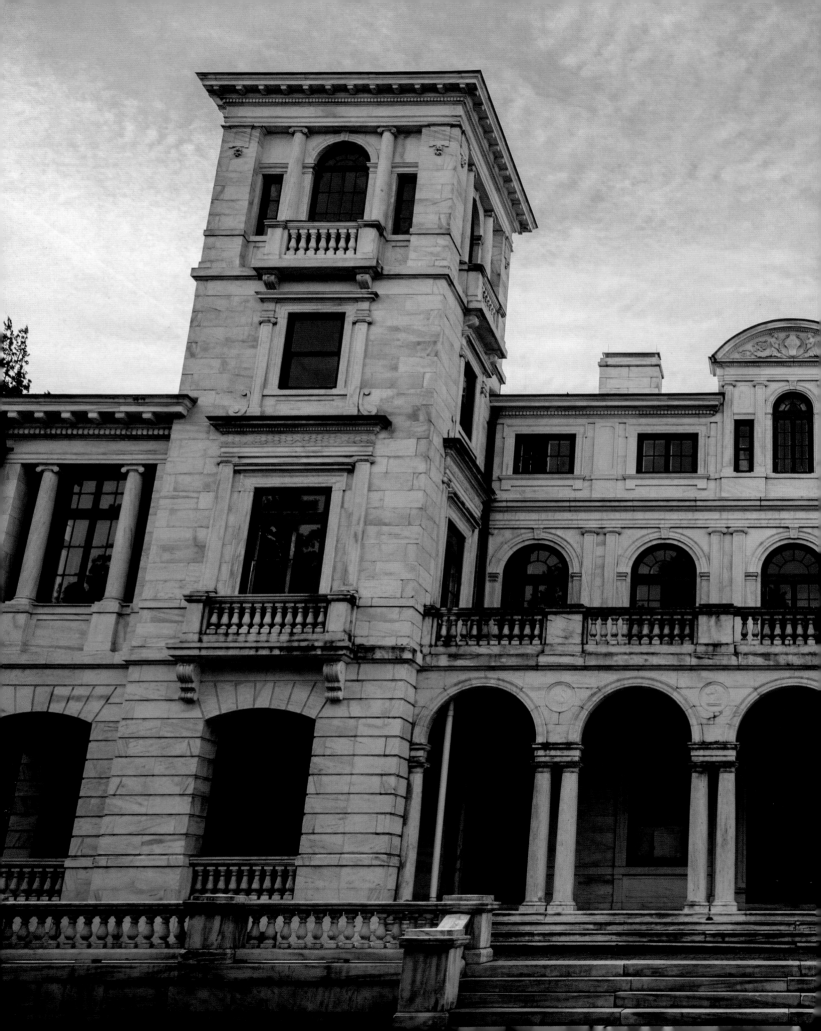

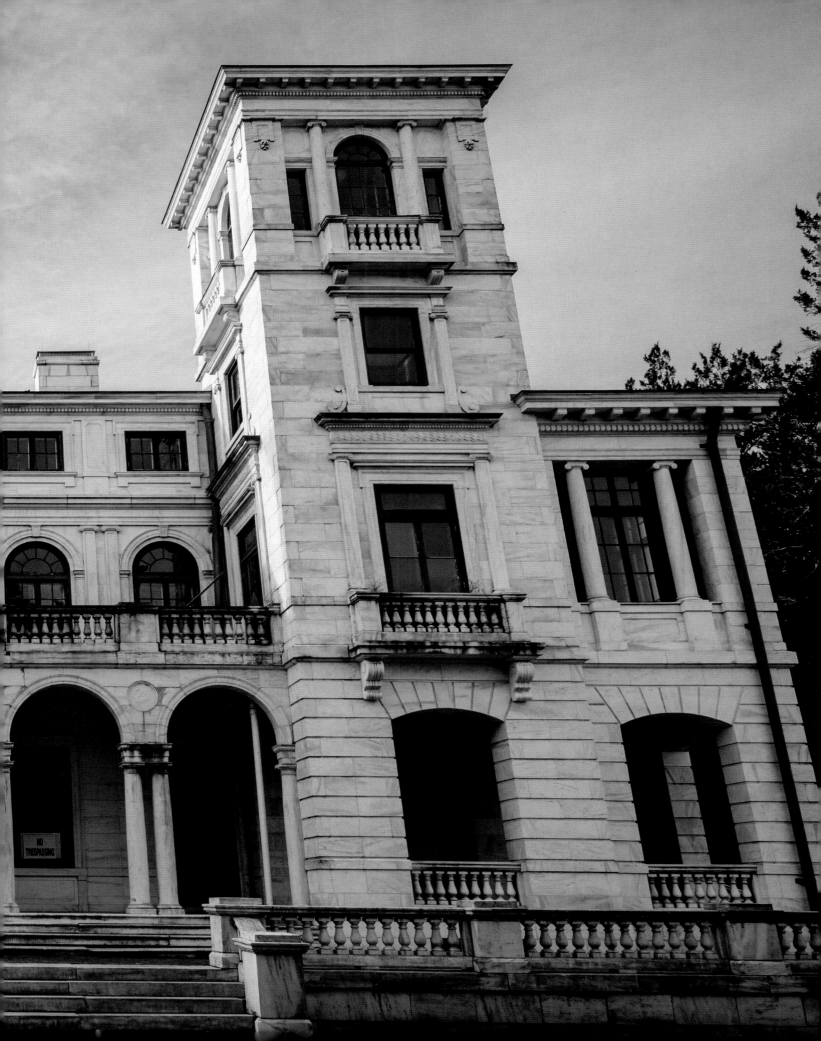

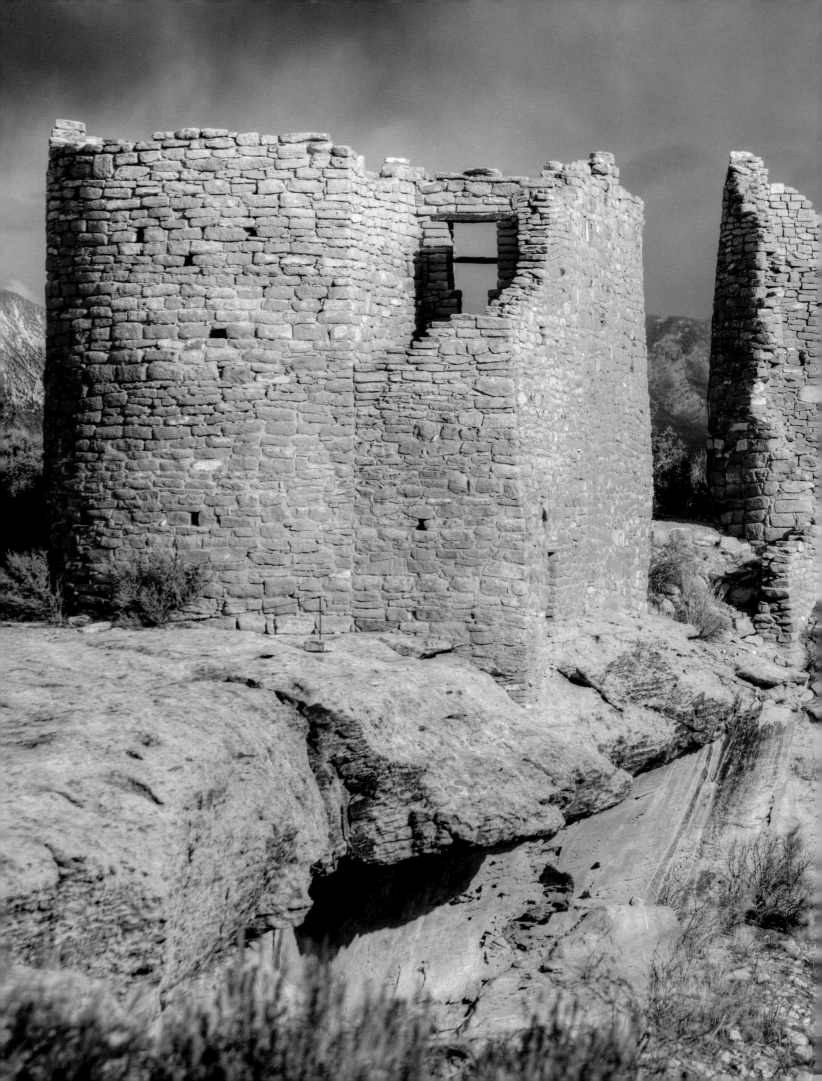

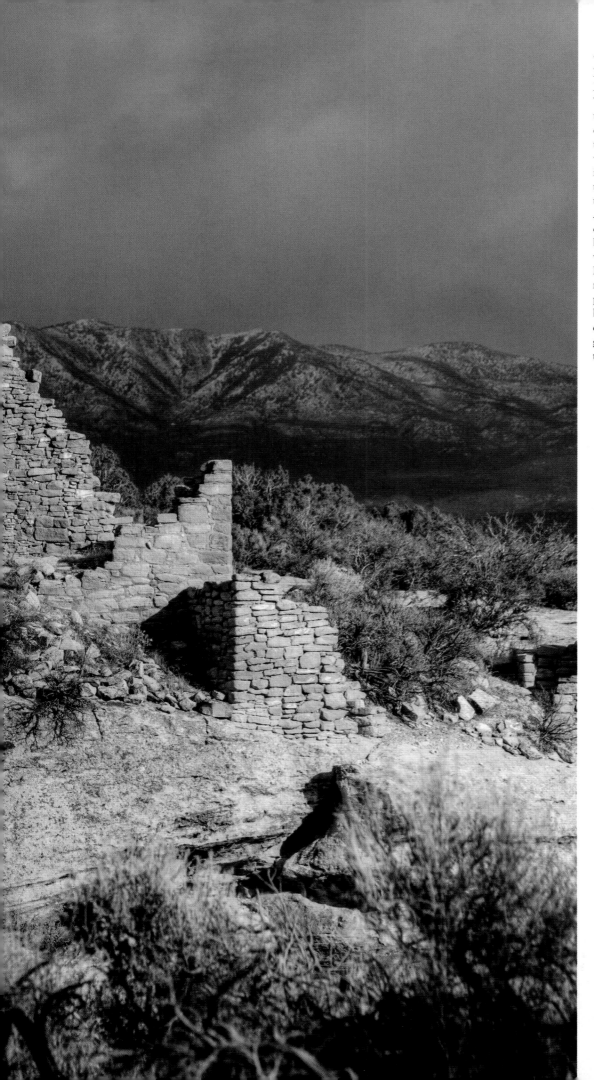

'Hovenweep Castle', Hovenweep National Monument, Utah, United States
This stone-built structure seems to date from about the twelfth century, so is contemporary with the kind of European castles for which it is popularly named. What its actual function was is unclear, though. Archaeologists believe that a pueblo (village) of up to 500 people probably lived here, cultivating maize, squash and beans. The Pueblo communities who built the settlements at Hovenweep seem to have left them not long after this – dislodged, perhaps, by water shortages brought on by overpopulation and climate change. They were long gone, then, when the first Spanish traders and conquistadors arrived.

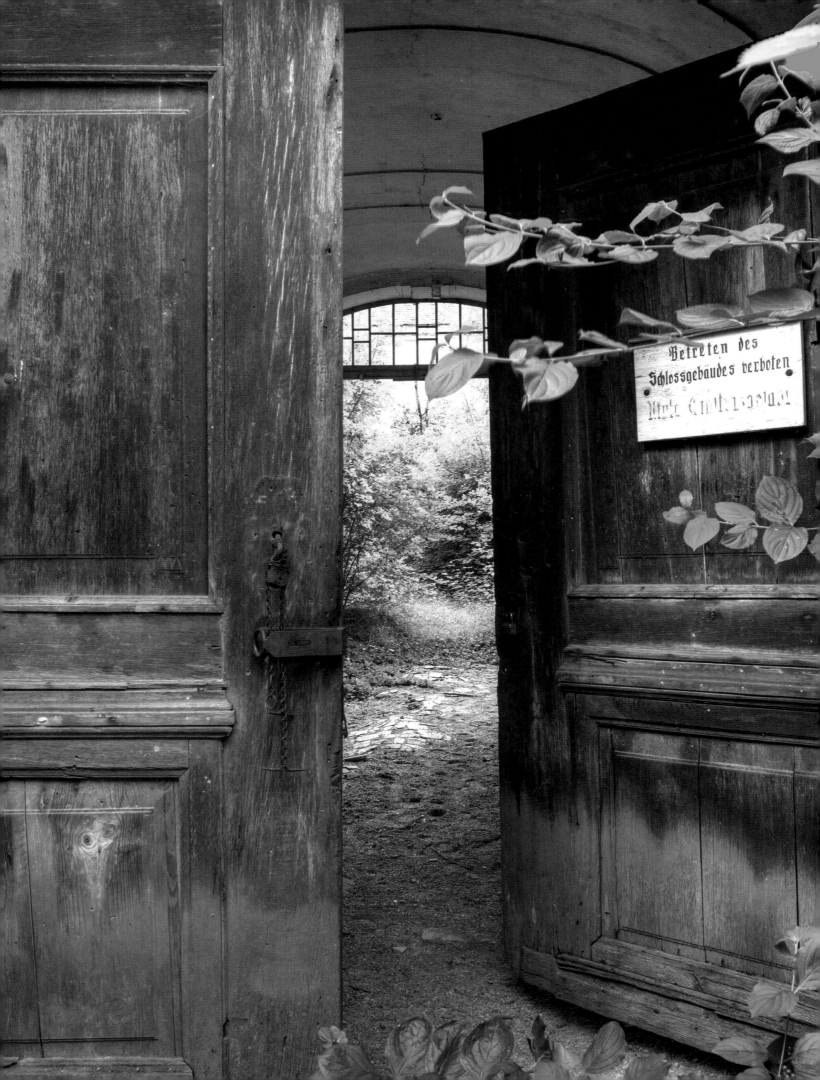

Betreten des
Schlossgebäudes verboten
Wird Einsturzgefahr!

Western Europe

Since antiquity, western Europe has considered itself the cradle of modernity: in the colonial era, it was to export its aesthetic assumptions and stylistic standards round the world. And, given the economic strength and political power of the region over recent centuries, those standards were inevitably embraced elsewhere.

Many archetypes originated here ended up seeming 'universal' – the classical temple; the medieval castle; the renaissance palace and many more. Western Europe was the civilization to which the rest of the world aspired – however exploitative and cruel it might have been. Not that Africa and Asia didn't have their own indigenous forms, but architects and patrons who wanted a paradigm of progress invariably found themselves looking to the West. That did, of course, include North America, which was coming to play an ever stronger leading role – though there, in a self-consciously 'young' country like the United States, European precedents were prized.

West European civilization is certainly old, and if that confers authority it hints at decrepitude too: there's no doubt that the region does decadence well. The US writer Edgar Allen Poe's celebrated story *The Fall of the House of Usher* (1850) seems, with its carved ceilings, 'sombre tapestries' and 'armorial trophies', to have a European aristocratic setting: the perfect place, then, for a dying 'fall'.

OPPOSITE:
Ladendorf Castle, Mistelbach, Austria
A door swings open at Schloss Ladendorf, inviting us to pass through and enter an interior so ungovernably overgrown it seems to reverse our usual sense of the solidly constructed castle as protective structure. In the homeland of Freud, perhaps, external dangers aren't as frightening as they might seem: the real wilderness is to be found within.

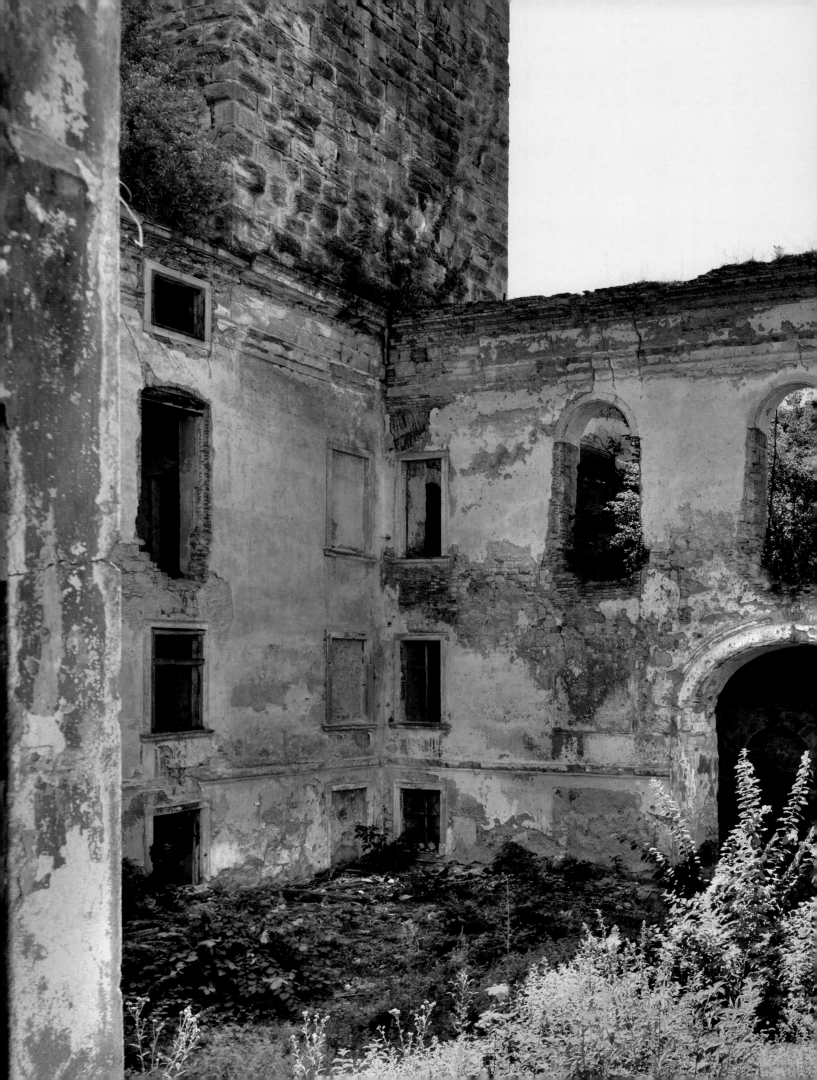

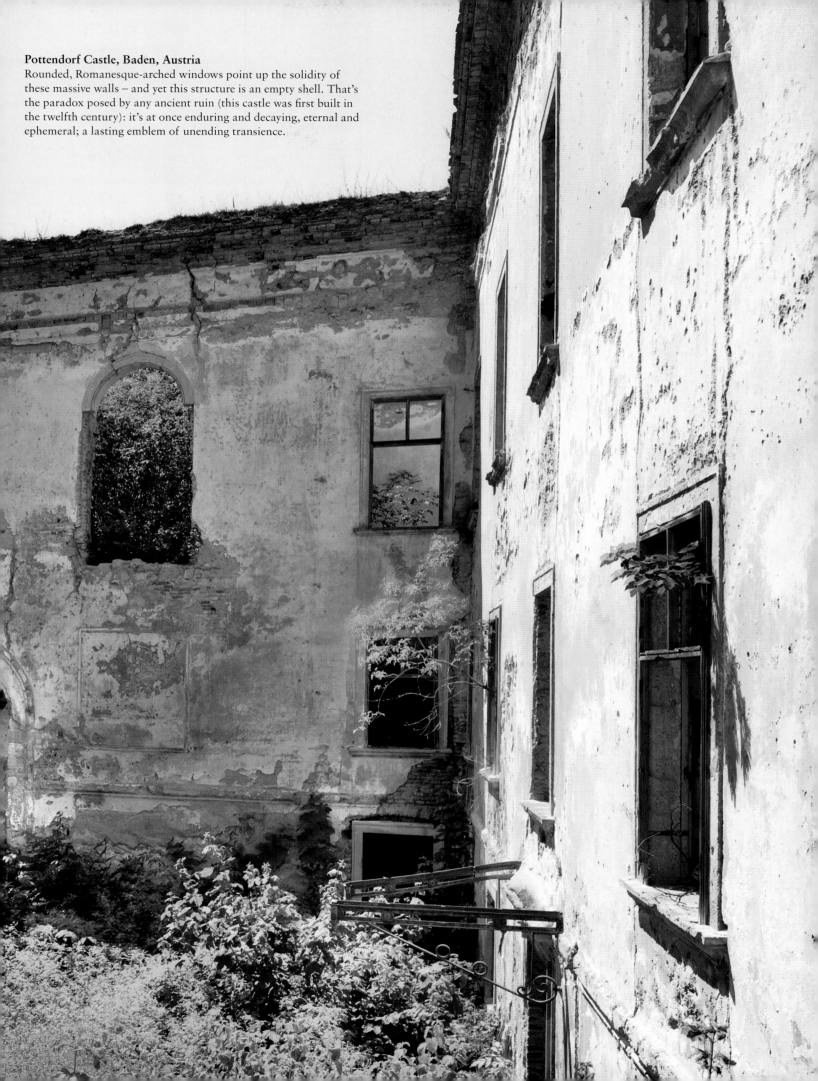

Pottendorf Castle, Baden, Austria
Rounded, Romanesque-arched windows point up the solidity of
these massive walls – and yet this structure is an empty shell. That's
the paradox posed by any ancient ruin (this castle was first built in
the twelfth century): it's at once enduring and decaying, eternal and
ephemeral; a lasting emblem of unending transience.

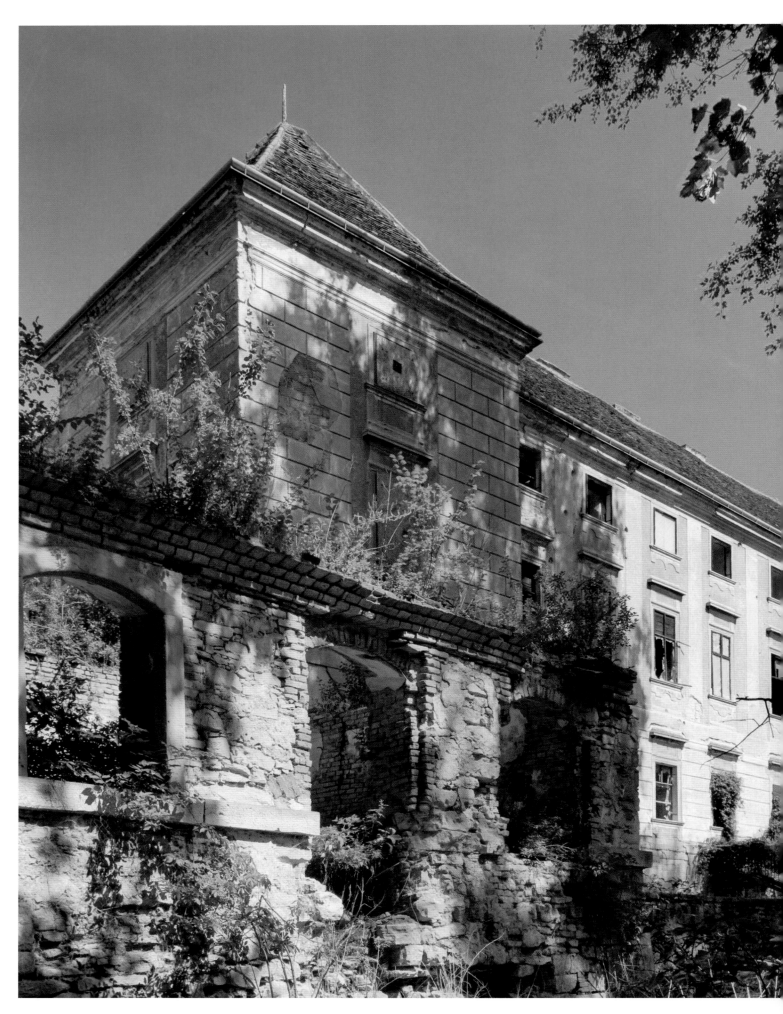

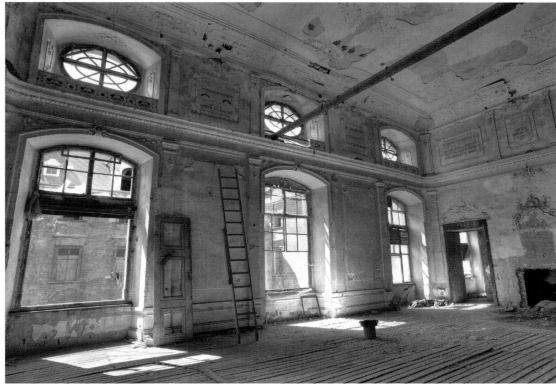

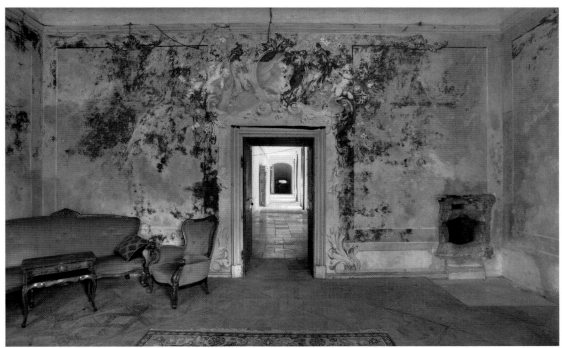

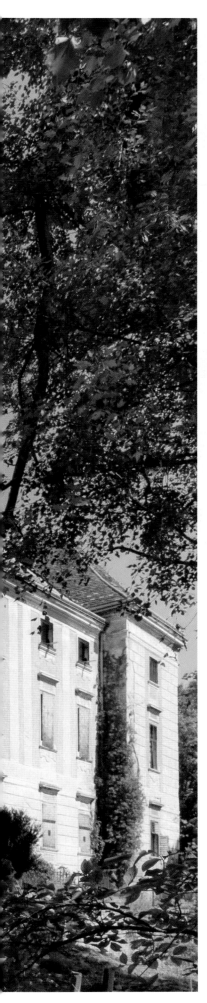

LEFT:

Ebenfurth Castle, Wiener-Neustadt-Land, Austria
The first, medieval castle here was substantially destroyed by the Ottoman armies that came this way en route to Vienna in 1529. It was later rebuilt in the baroque style and remained a home to the aristocratic Suttner family until the early decades of the twentieth century.

ABOVE (BOTH PHOTOGRAPHS):

Ebenfurth Castle (interior)
The Suttners didn't sell the castle till the early 1970s, but they hadn't actually lived there for many years. In the interim, Schloss Ebenfurth had largely lain vacant, and vulnerable to vandalism. Bare as this chamber (top) is, however, we still get a sense, in the stucco work, of how magnificent it must

have looked in its full splendour. Tentative efforts by recent owners to begin the restoration process at Ebenfurth Castle have already clearly paid real dividends. While this room (above) remains a mess, the luxurious extravagance of its decorative conception is unmistakeable and it is easy to imagine just how stunning it might one day look.

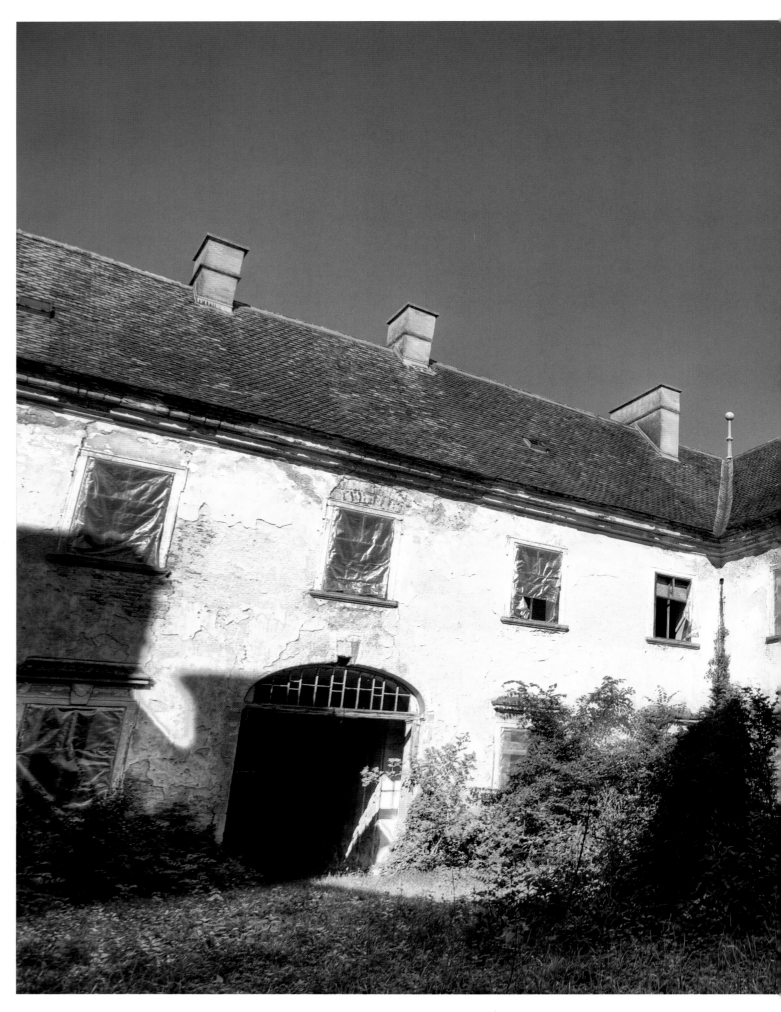

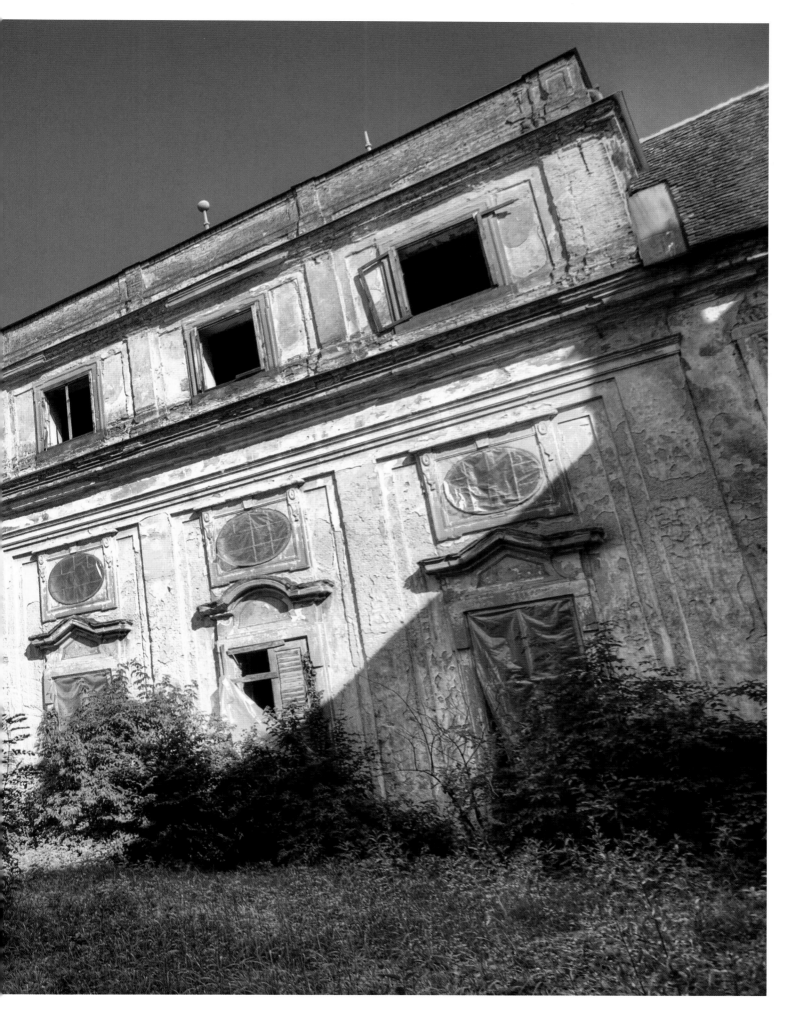

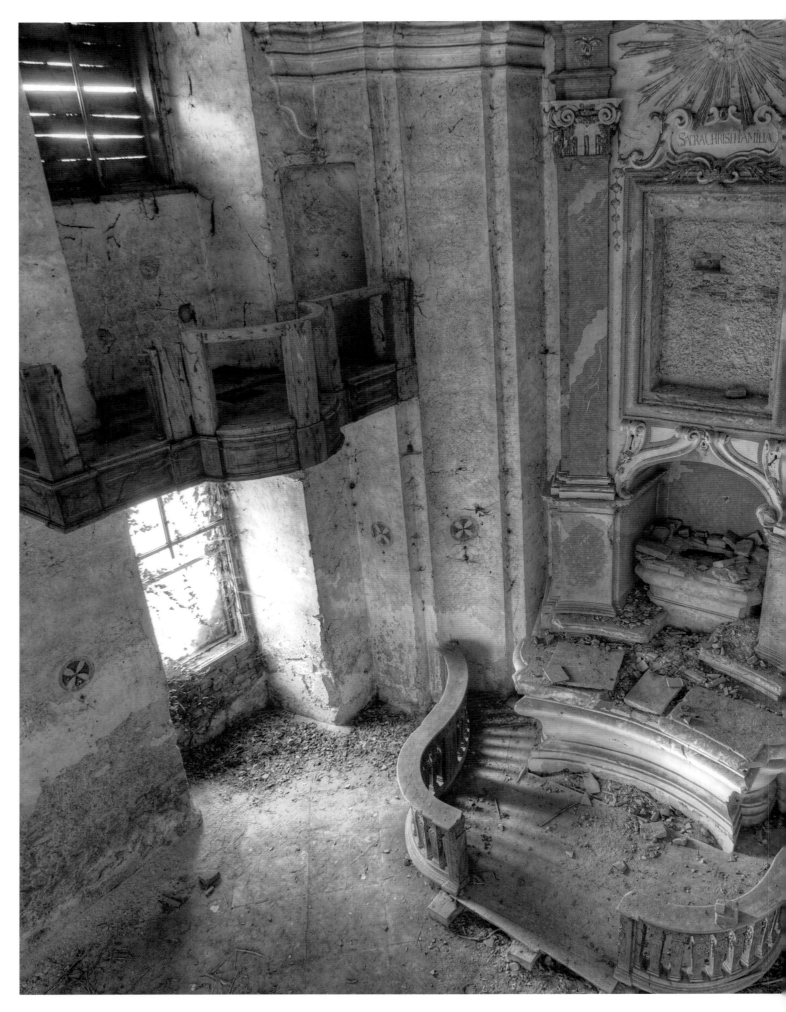

LEFT:

Chapel, Ladendorf Castle, Mistelbach, Austria

All that plaster-dust and dirt can't hide the fact: the chapel at Ladendorf Castle is still spectacular, three centuries after it was built. The baroque features are badly faded now: the grubby-looking communion rail with its looping curves; the terracotta tones of the imitation marble reredos; the ragged gap where presumably a painting was; the sunburst up above; the rough-and-ready choir stalls....

Even so, you can hardly miss the majesty of the place – or the melancholy of its passing, however necessary the transition to a more modern and more equitable social order. It's easy to imagine how sumptuous a spiritual environment this must have seemed in its heyday; how colourful the services held here must have been, between the robes of the priest and the clothes of the assembled lords and ladies.

PREVIOUS PAGES:

Courtyard, Ladendorf Castle

The window spaces in the walls are as blank and empty as eye-sockets in a bone-bleached skull: in contrast, the overgrown courtyard seems incongruously alive. Lovely, lively, fresh and green, this thicket strikes us much more positively in this view than it did when we glimpsed it through the Castle's great front door (see page 50). Nature's reclamation of this ruin is, if anything, redemptive.

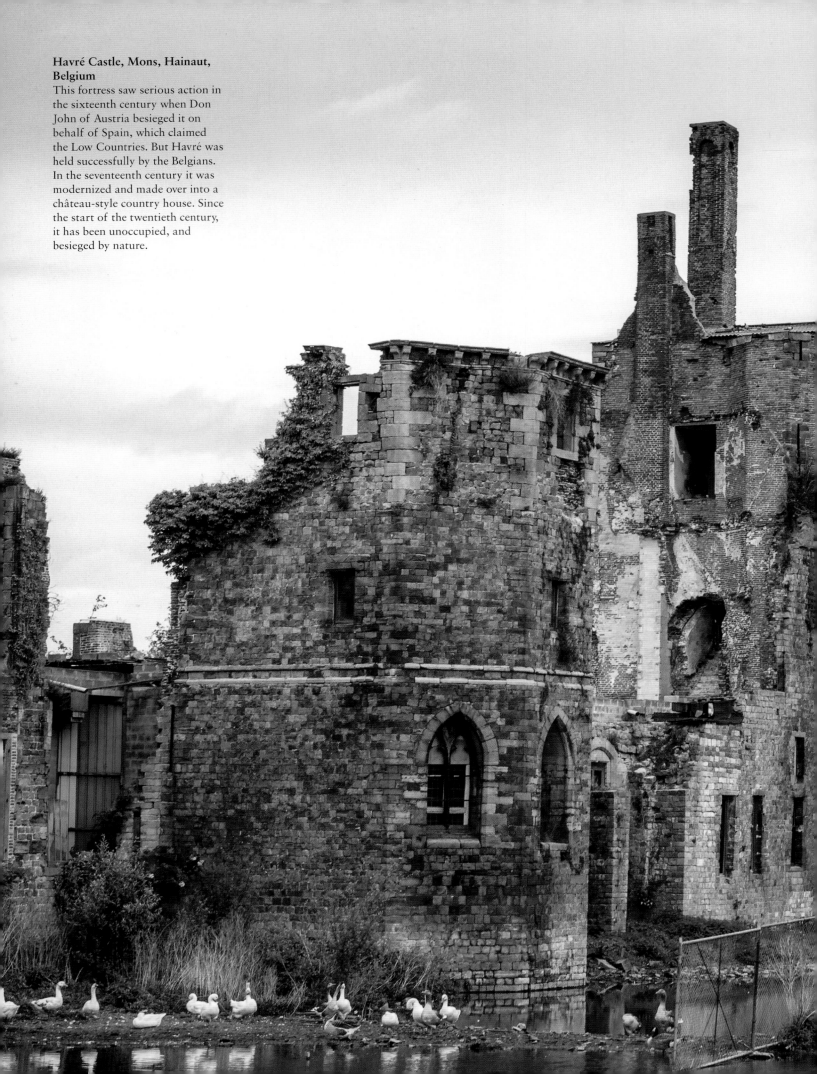

Havré Castle, Mons, Hainaut, Belgium
This fortress saw serious action in the sixteenth century when Don John of Austria besieged it on behalf of Spain, which claimed the Low Countries. But Havré was held successfully by the Belgians. In the seventeenth century it was modernized and made over into a château-style country house. Since the start of the twentieth century, it has been unoccupied, and besieged by nature.

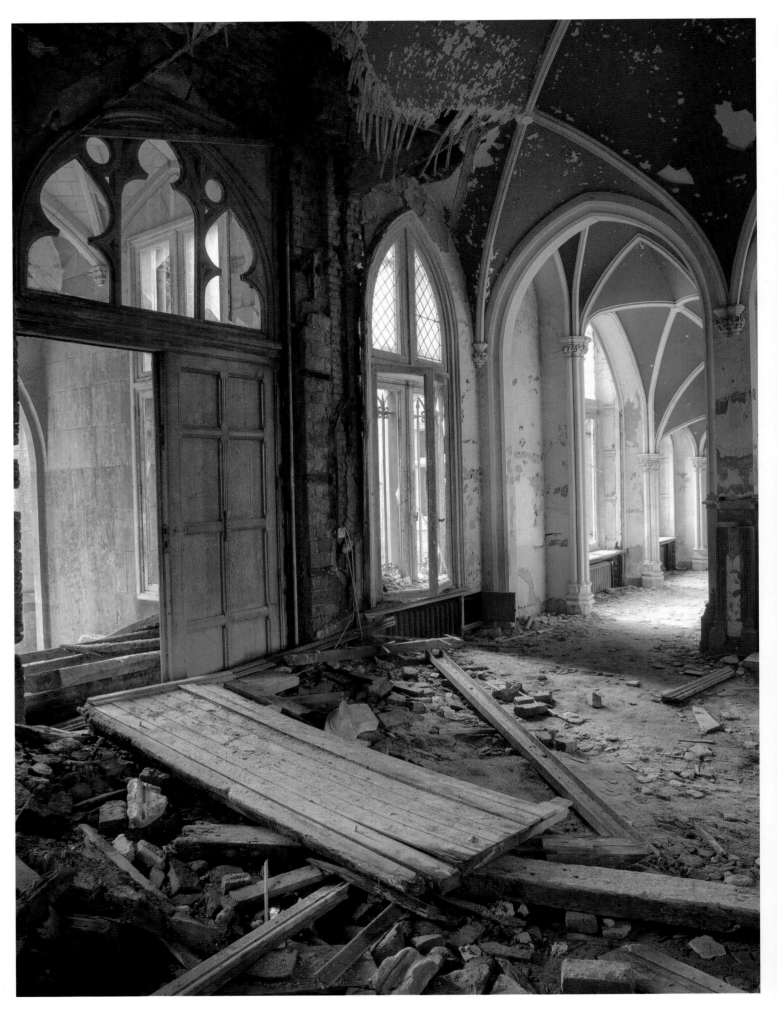

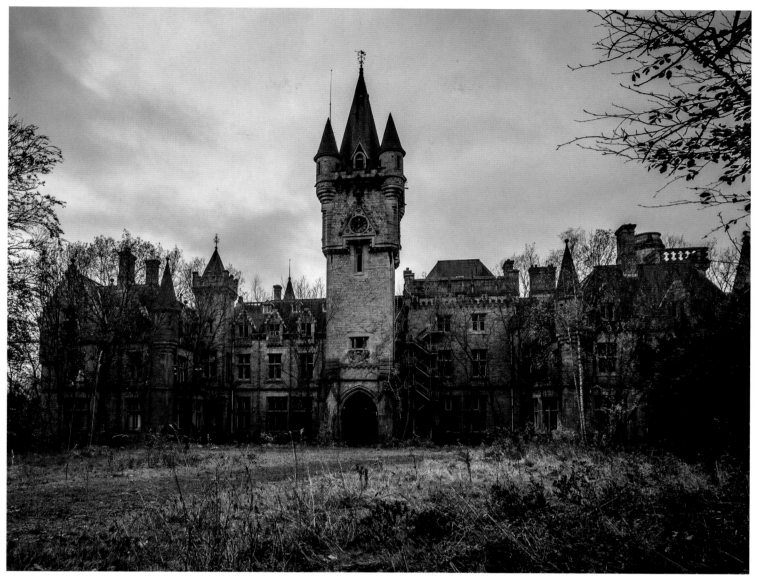

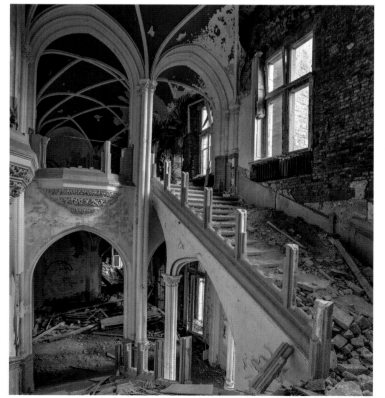

ALL PHOTOGRAPHS:

Château Miranda, Celles, Namur, Belgium

This neo-Gothic fantasy in stone was built between 1866 and 1907 for the Liedekerke de Beaufort family, formerly of Vêves Castle (still visitable, just a few kilometres from Château Miranda). But Vêves is very much a medieval castle, its rough-hewn walls in places up to 3m (10ft): it couldn't meet the standards of comfort and convenience nineteenth-century aristocratic life required. Hence the commissioning of the English landscape architect Edward Milner (1819–84) to design a more modern, yet still unmistakeably patrician, pile. Few would dispute that he succeeded in his task.

In the end, the family fled in the confusion of World War II, when Belgium was a battleground. The château was given to the National Railway Company, who used it as a vacation camp for children. From the 1970s it stood empty, and gradually decayed. During the 1990s, it became a favourite site for 'urban exploration' till finally being demolished in 2017.

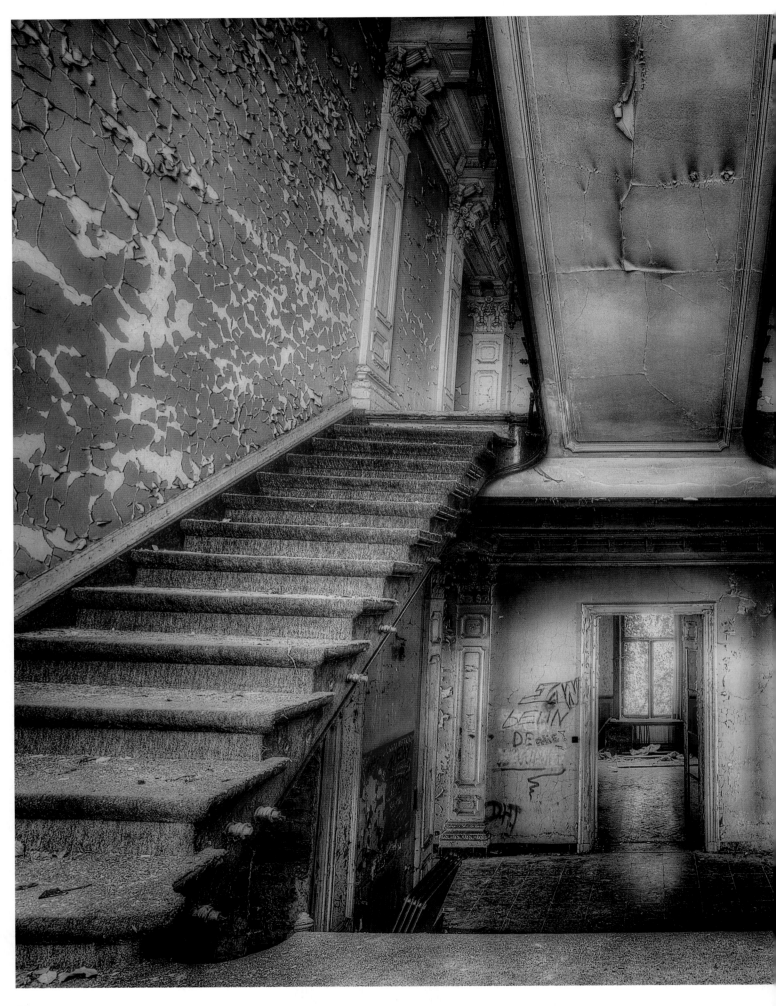

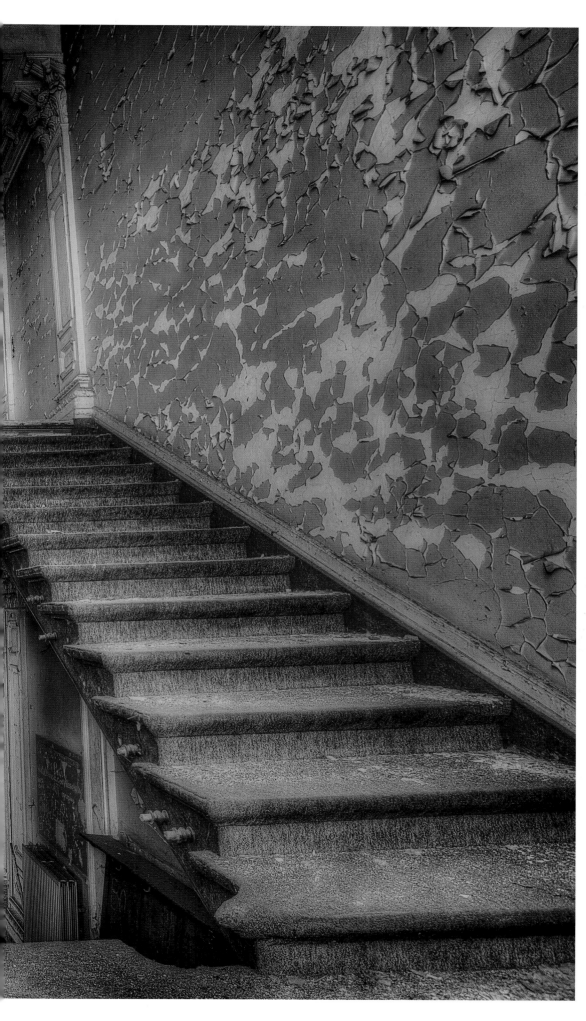

Château Rochendaal, Sint-Truiden, Limburg, Belgium
Local lawyer, and later Mayor of Sint-Truiden, Jean-Henri-Paul Ulens (1816–84) built this château for himself and his wife in 1881. A dream home, it had every convenience that could be thought of – even a sumptuously furnished and richly decorated chapel. So appealing was it that it was taken over by the Germans in World War II. They saw it as being suitably splendid for officer accommodation for the *Luftwaffe* and created an airfield in the parkland that lay around. Barracks buildings were thrown up for the other ranks. In 1945, the whole facility fell to the Belgian Air Force, who maintained it until the 1990s, after which it was abandoned and the château went to rack and ruin. Even so, it remains impressive: the paint may be peeling, the carpets choked with dust, but the overall impression is awe-inspiring. Some beautiful decorative details can still be seen.

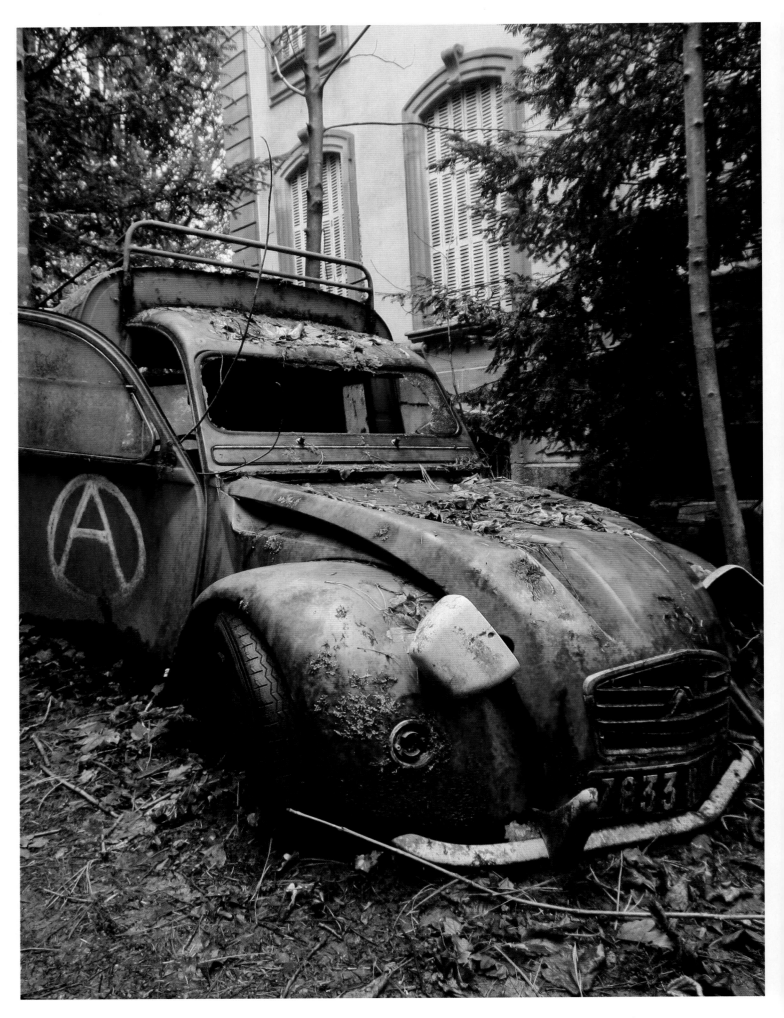

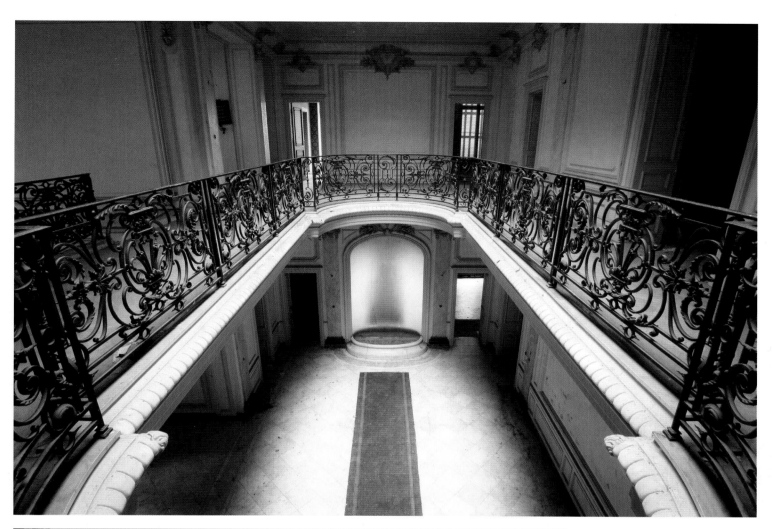

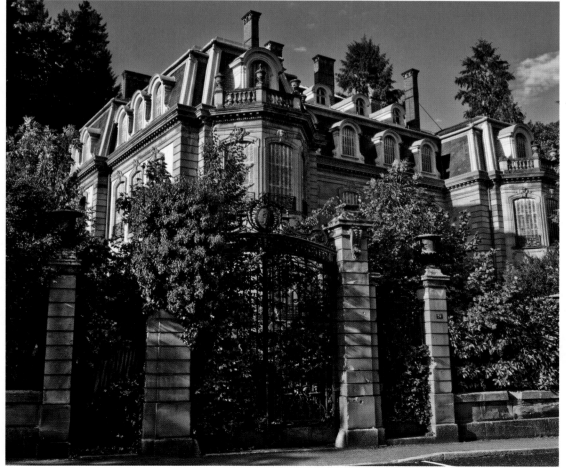

ALL PHOTOGRAPHS:

Château Lumière, Sainte-Croixe-aux-Mines, Haut-Rhin, France
The tobacco magnate Maurice Burrus (1882–1959) built this splendid neo-Baroque villa in the early 1900s. It was sold after his death and remained occupied for 50 years. Maintenance costs for so vast a house (it has over 30 rooms) proved increasingly prohibitive, however, and since 2010 it has stood empty. Except, of course, for the stream of 'urban explorers' who have come here from across Europe to experience what is admittedly something special and sublime in the way of ruination. For the most part, they have treated this gem of dereliction with respect – hence the slow and gentle pace of its degeneration down the years. From the street outside, you would hardly know the building was abandoned; and even inside there are areas which seem as though they might still – with a spot of dusting and a lick of paint – be as good as new.

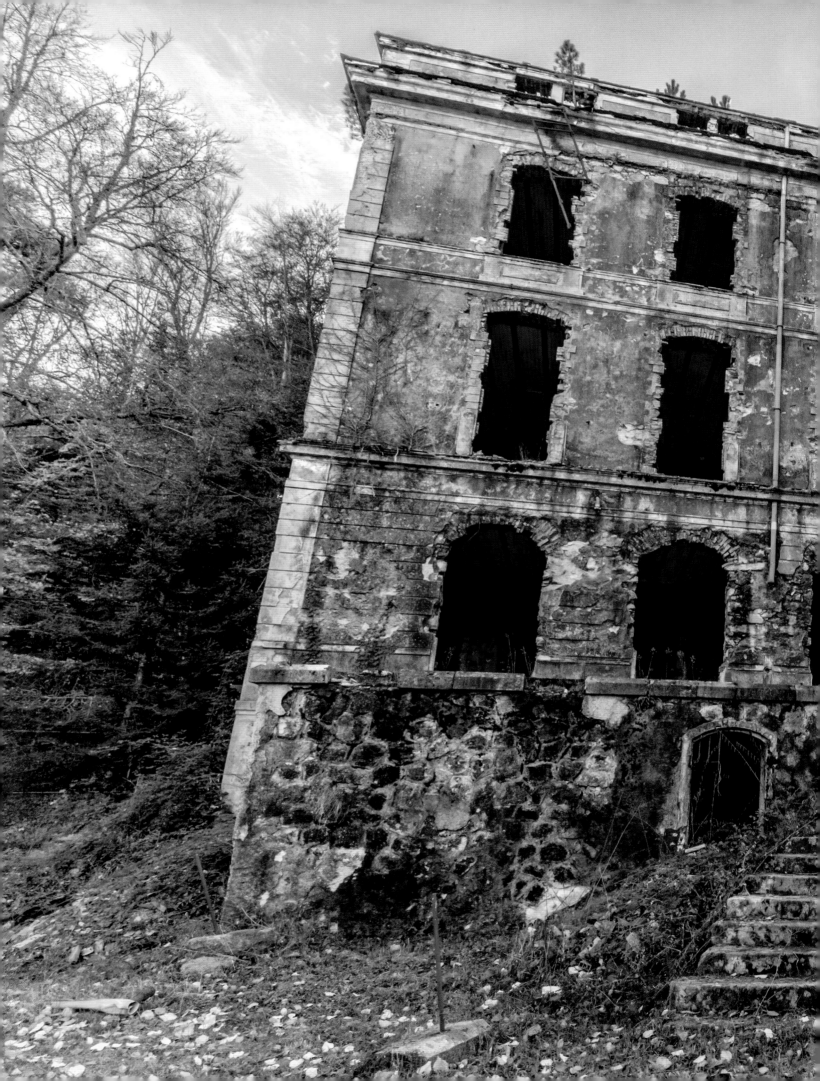

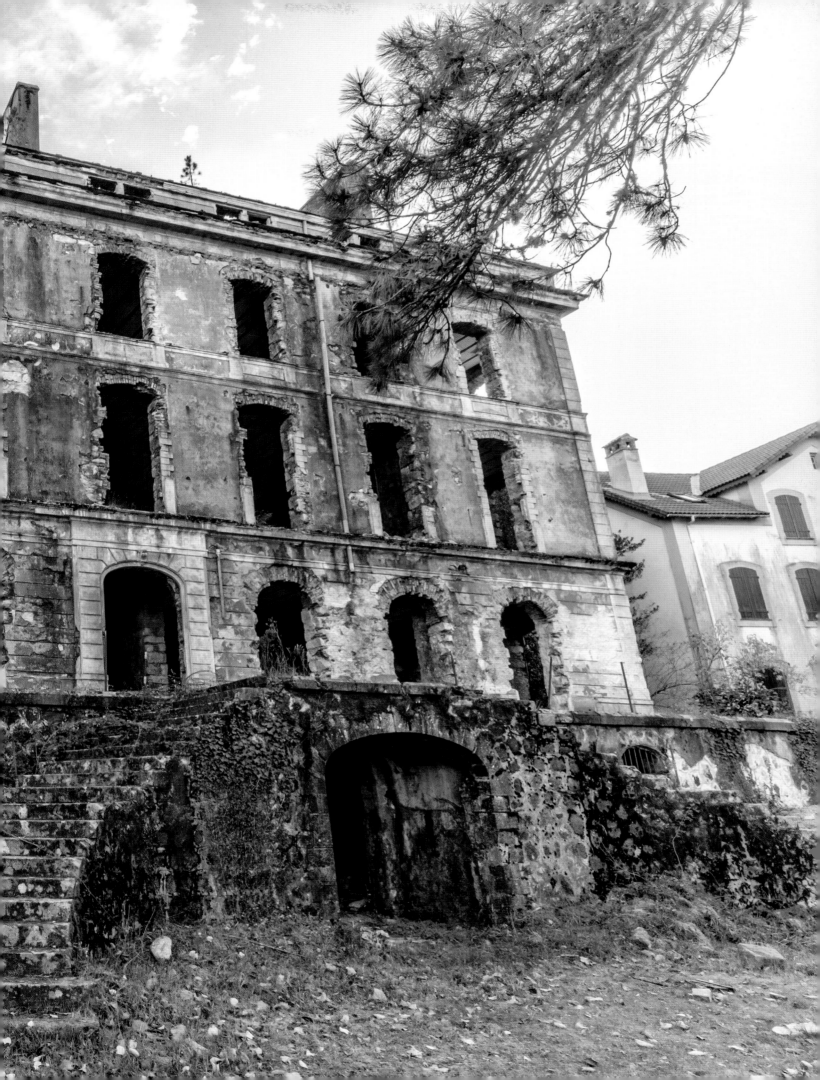

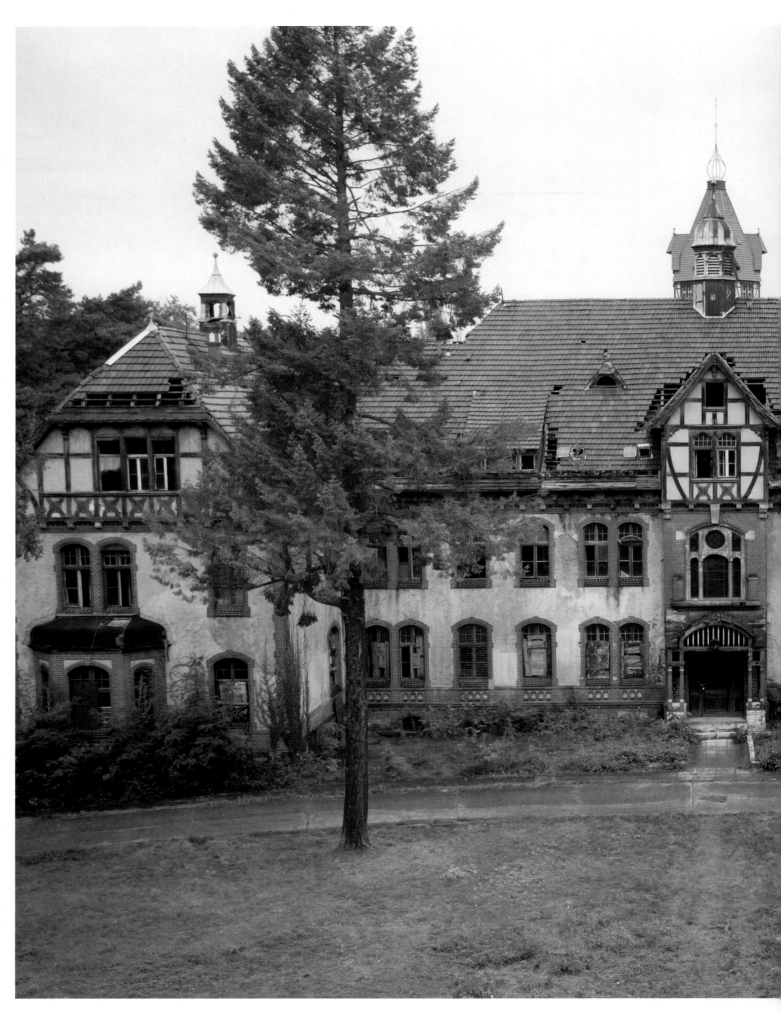

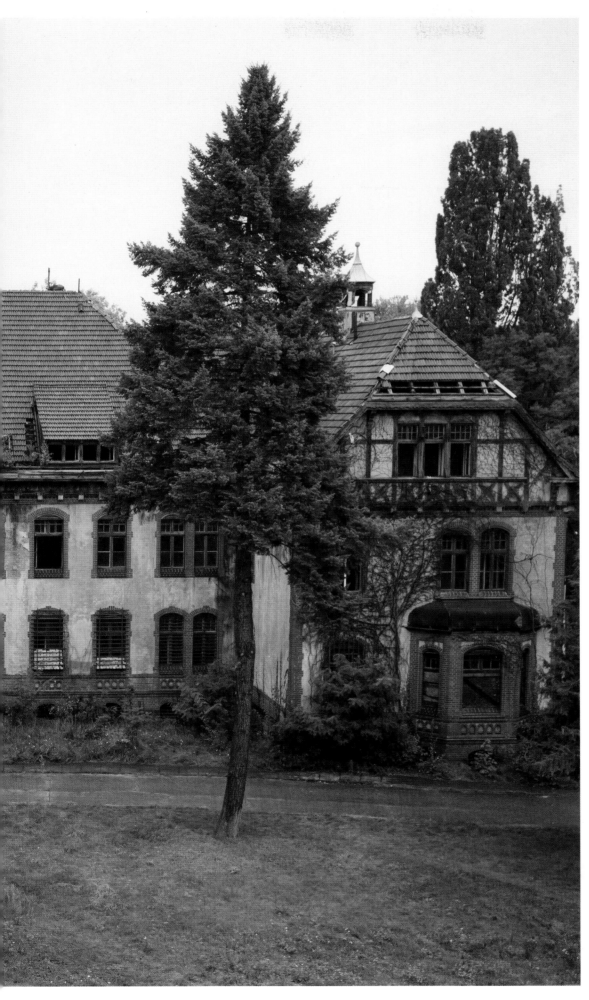

PREVIOUS PAGES:
Grand Hôtel de la Forêt Vizzavona, Corsica, France
The construction of a railway tunnel through an outcrop in the shadow of Monte d'Oro here at Vizzavona proved so long and arduous a task that accommodation had to be built to house the engineers and labourers. When the job was done, and the workers had packed up and left, the village that had been their dormitory remained, and – with the wooded hills of Vivario all around – it really was a very lovely spot. The perfect place for affluent foreigners to come and get away from it all in the Corsican interior. Hence the construction of this luxury hotel in 1893. In its heyday, the Grand Hôtel de la Forêt was a favourite destination for wealthy English holidaymakers, who loved to play on Vivario's first-known tennis courts. Now, of course, these are long overgrown: the tourist trade declined in the post-war years and the hotel was finally shut down in the 1960s.

LEFT:
Abandoned hospital, Beelitz-Heilstätten, Berlin, Germany
A sanatorium to begin with, and subsequently adapted to serve as a military and general hospital, Beelitz-Heilstätten has seen its share of history. It numbered among its patients not just Adolf Hitler (for several weeks invalided away from the fighting of World War I here), but Erich Honecker (1912–94). The leader of the German Democratic Republic was confined here with liver cancer in the months after the final collapse of communism in his country. Such associations add a sinister note to what was already a cheerless atmosphere in a haven for the sick that now seems well advanced in its own terminal decline.

Reinhardsbrunn Castle, Friedrichroda, Thuringia, Germany

What had first been an abbey, then an administrative complex, was in 1827 rebuilt by Duke Ernst I of Saxe-Coburg-Gotha (1784–1844). He intended it as a *lustschloss* (literally 'castle of pleasure' – an aristocratic holiday home). Queen Victoria came here a couple of times with her husband, Ernst's son Prince Albert, but for the most part Reinhardsbrunn remained outside the historical swim.

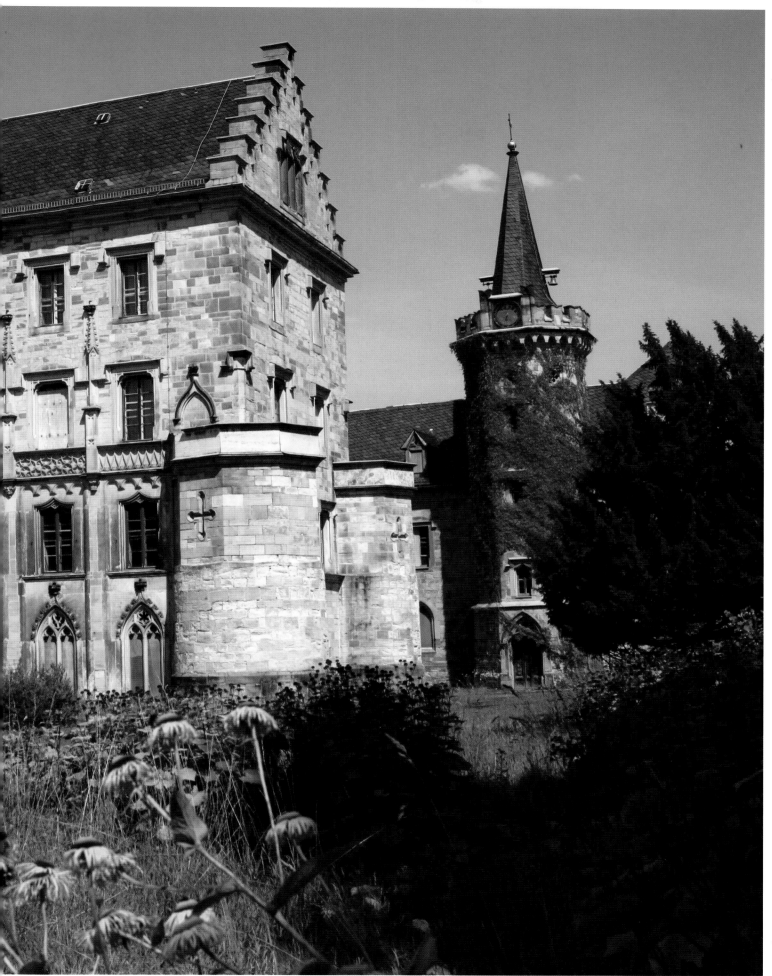

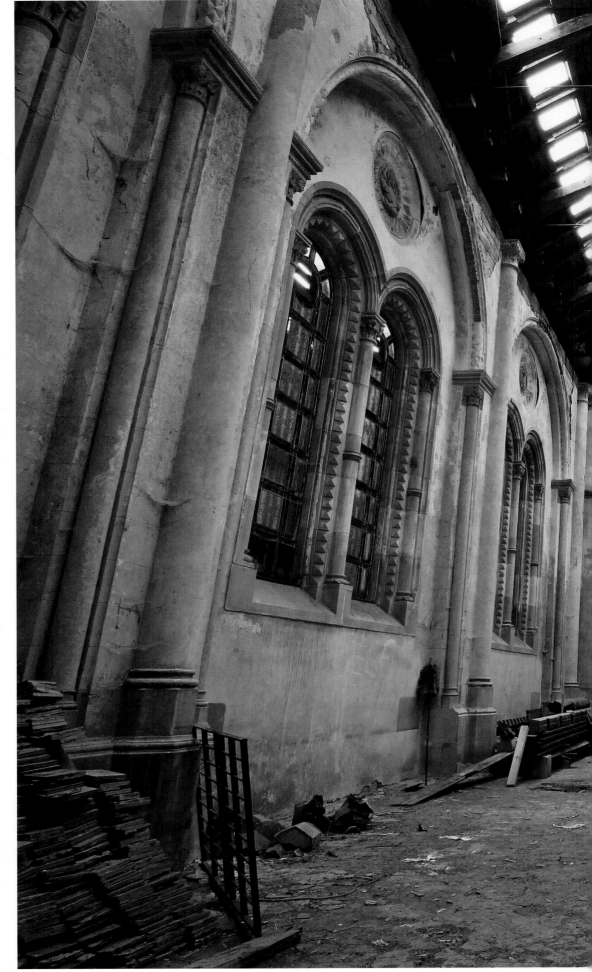

RIGHT:

Reinhardsbrunn Castle, Friedrichroda, Thuringia, Germany

Reinhardsbrunn is also known as 'Rapunzel Castle' – presumably for the picturesque neo-Gothic tower from which it's easy enough to imagine the maiden letting down her hair. (There is, it has to be said, though, another claimant to the title in Trendelburg, Kassel: the Brothers Grimm don't seem to have left a ruling.) There's any amount of fairytale frisson to be experienced at ground level, though, as we realize when we look into this atmospheric abandoned chapel.

OVERLEAF:

Prora, Rügen, Mecklenburg-Western Pomerania, Germany

Regimentation was the rule in Hitler's Germany – even for the beneficiaries of 'Strength Through Joy', the office that handed out holidays (for worthy workers) on the state. This unbroken line of beach apartments once went on for 4.5km (almost 3 miles); 3km (2 miles) remain. While part of the complex is currently used as a youth hostel and other sections are let out as retirees' maisonettes and holiday flats, much of the accommodation is unused.

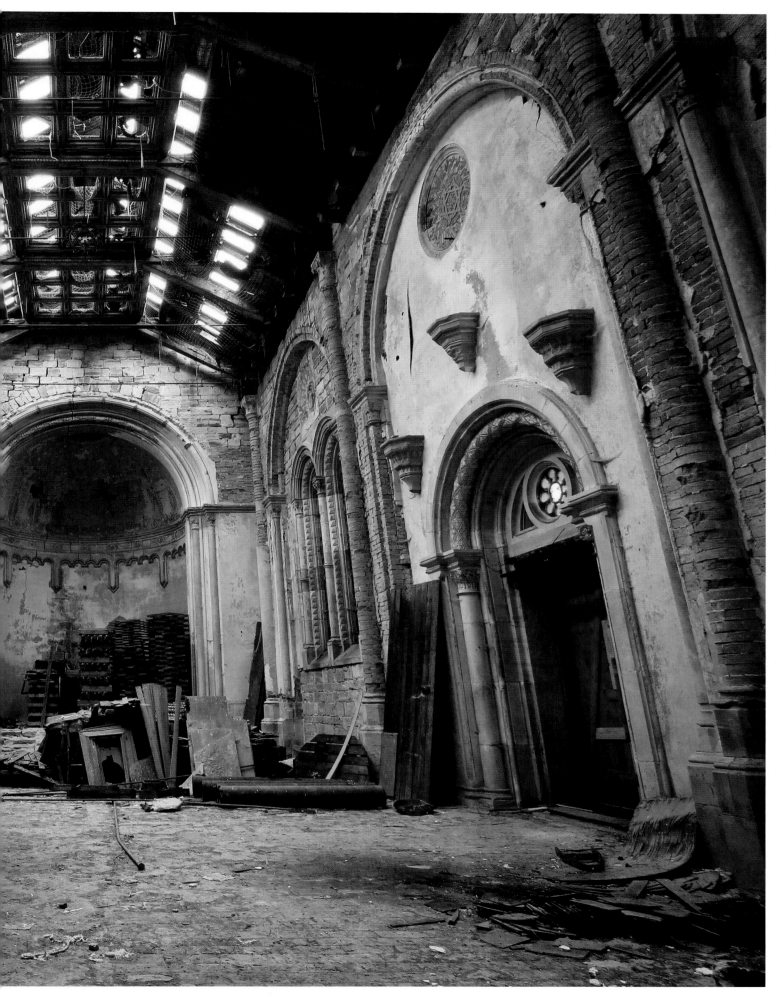

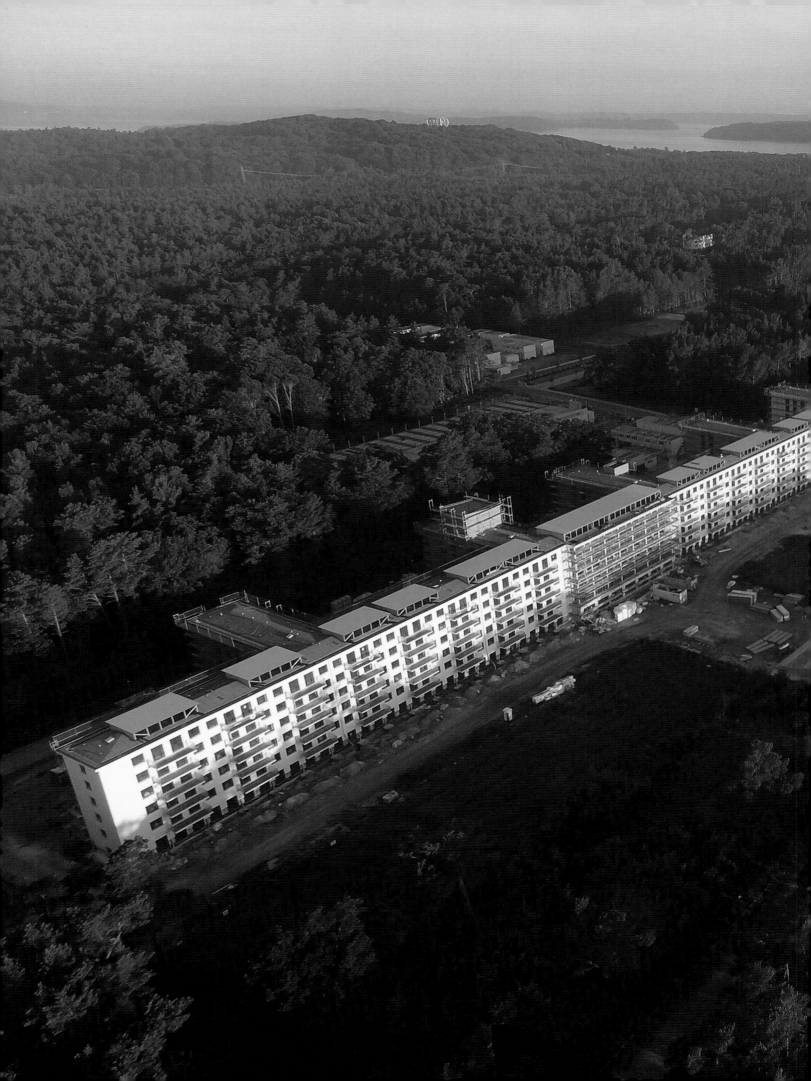

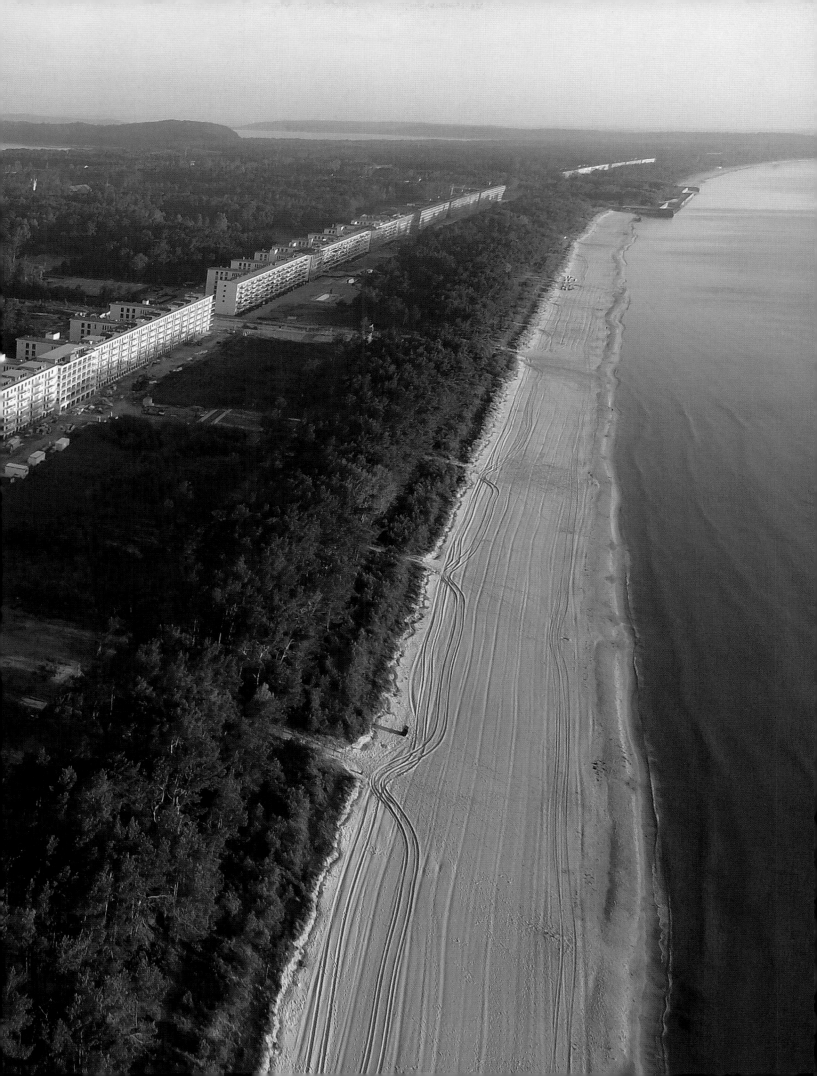

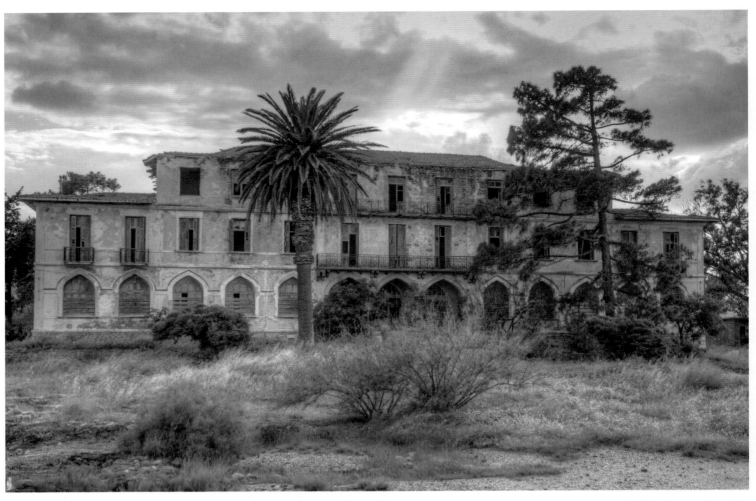

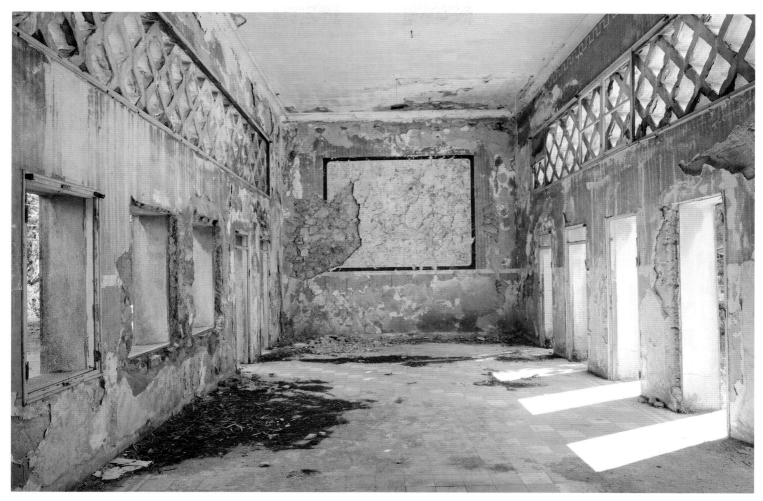

OPPOSITE TOP:

Sarlitsa Palace Hotel, Thermi, Lesbos, Greece

The Sarlitsa Palace was built in 1909 for all the monarchs, millionaires and other luminaries who came to take the waters at the hot springs from which the town of Thermi got its name. The flow of five-star visitors was interrupted by World War II and the political crises that followed, and the hotel never really recovered. The advent of the student backpacker could do nothing for a place like this.

OPPOSITE BOTTOM:

Castello Bibelli, Dassiá, Corfu, Greece

There's the slight suggestion of an Escher-esque spiralling round the rooftop, but turreted towers, top left and bottom right, balance out this neo-Gothic mansion in a bird's-eye-view. It was built in the 1900s by the Italian admiral whose name it bears, but who has otherwise historically slipped from view. This lovely retreat is situated in thick woodland only 700m (half a mile) from one of Corfu's most attractive beaches.

ABOVE:

Abandoned Governor's Palace, Eleoussa, Rhodes, Greece

The Italo–Turkish War of 1911–12 never did go down in the annals of heroic conflicts, but it did bring the Kingdom of Italy victory over the Ottomans in their all but final throes. Hence the acquisition of a tiny empire-ette in the Dodecanese – built on (quite literally, as here) by Mussolini's Fascist state in its eagerness to construct an all-conquering 'New Roman Empire'.

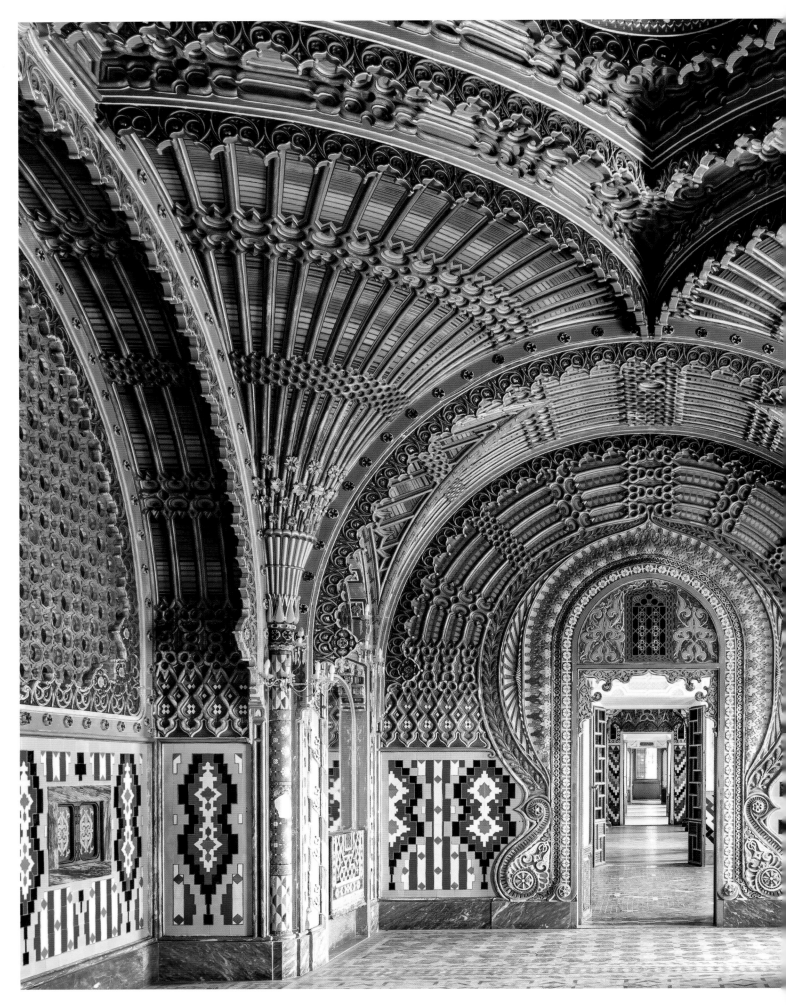

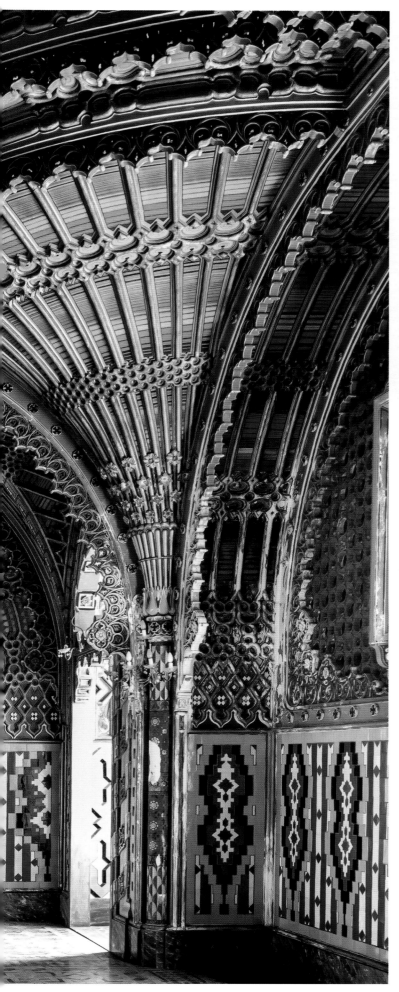

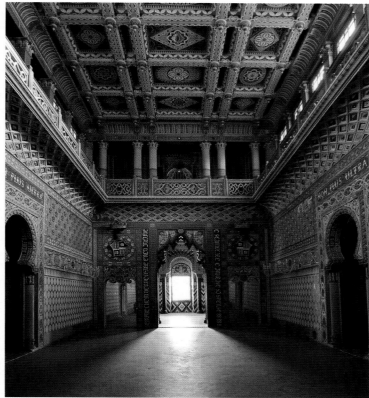

LEFT AND ABOVE:

Sammezzano Castle, Leccio, Tuscany, Italy

A Spanish ancestor having created his own 'castle' on this site in 1605, Ferdinando Panciatichi Ximenes (1813–97) seems to have been determined to build on that patrimony. And to indulge to the full his taste for that 'orientalism' that was then the rage among Europeans of culture (which he – politician, engineer, architect, botanist, publisher and thinker – undoubtedly was). Hence this extravaganza, as reminiscent of Andalucía as of the Maghreb – though the 'fan vaulting' of the Peacock Room (left) is a Gothic touch. You could hardly dispute the 'Moorish' look, though, from the horseshoe arches of the Entrance Hall (above) to the mosaiced multicoloured tiling on display throughout.

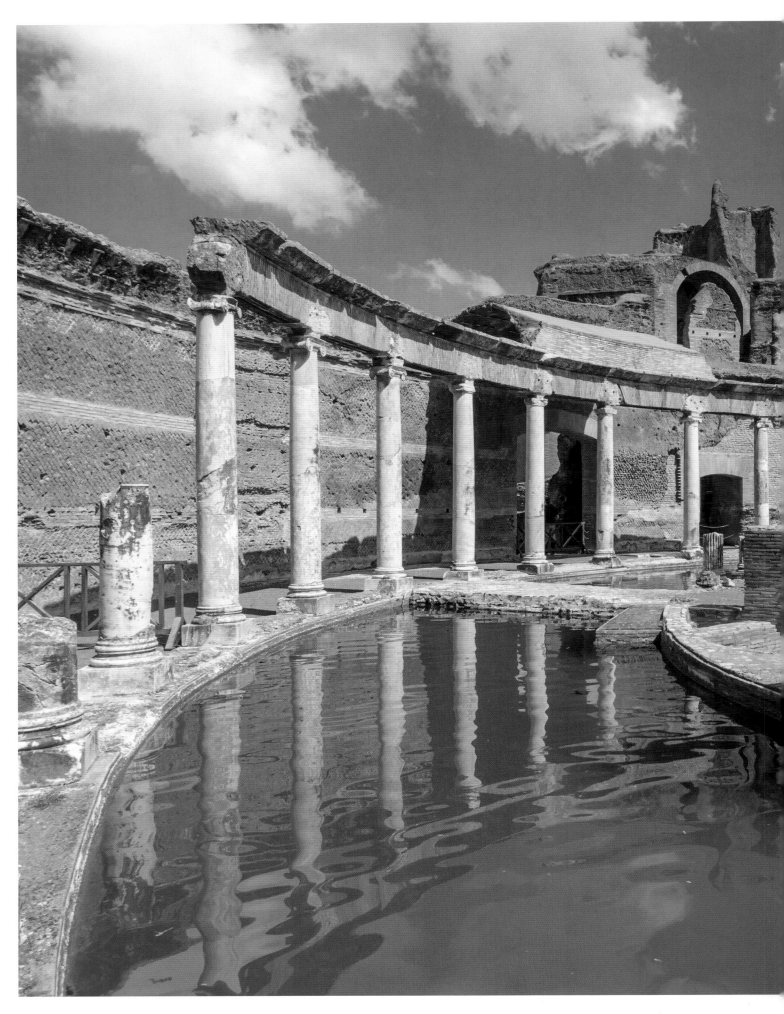

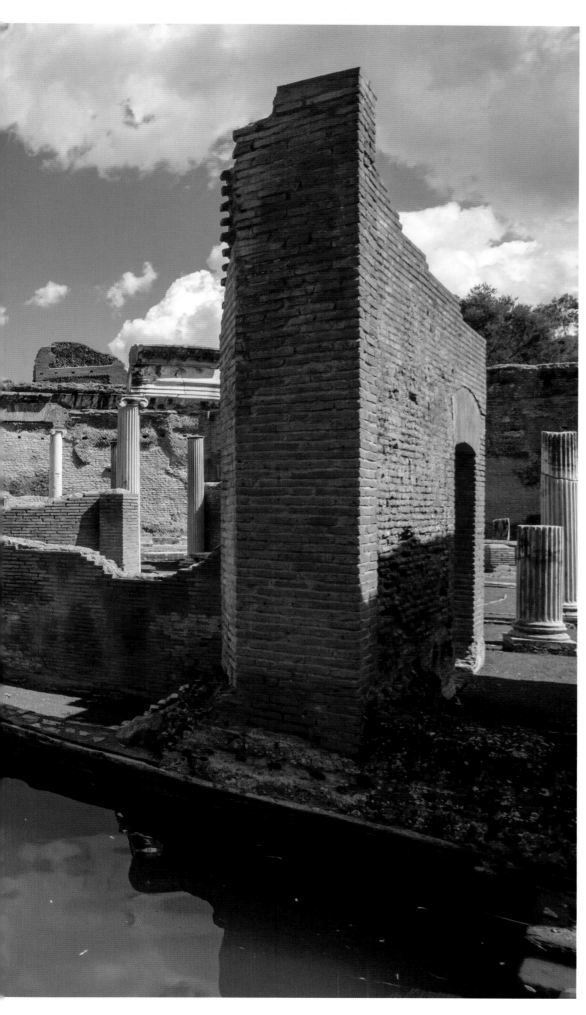

Hadrian's Villa, 'Maritime Theatre', Tivoli, Lazio, Italy
Hadrian (76–138 CE; reigned 117–38) came to Tivoli to get away from the bustle of his capital and the weight of his responsibilities. But he still seems to have liked to remind himself of his imperial reach. His estate here was laid out like a kind of stylized microcosm of the Roman world. The so-called 'Maritime Theatre' mocked up a little sea with its own island, where Hadrian had his own house to which he could retreat.

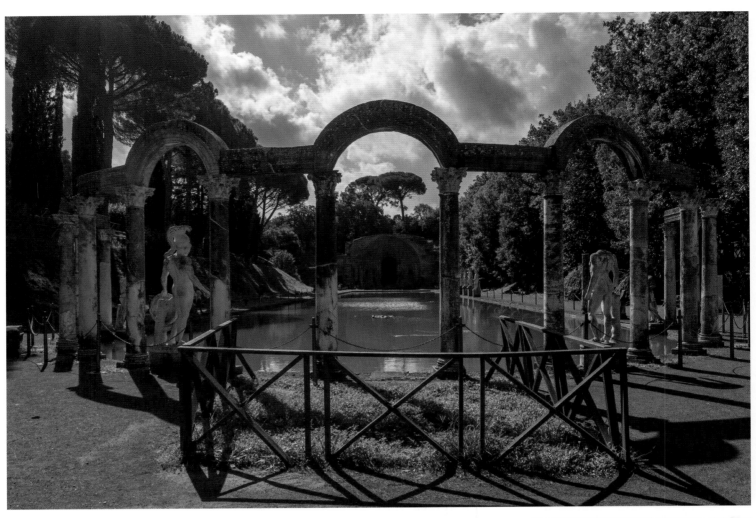

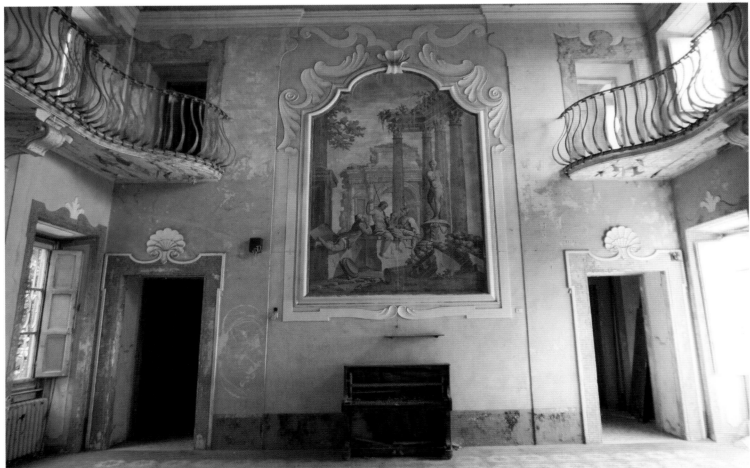

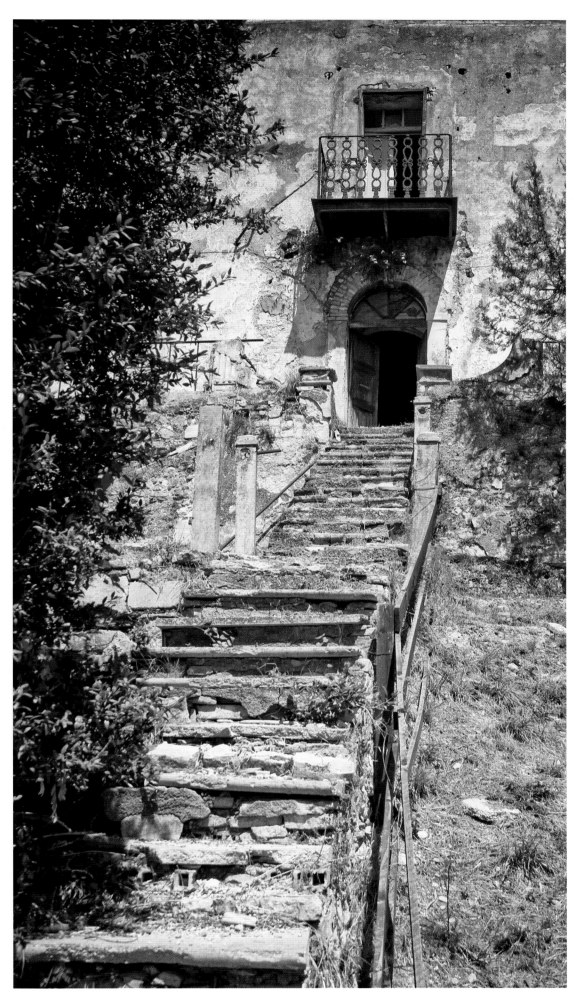

OPPOSITE TOP:
Hadrian's Villa, 'Canopus', Tivoli, Lazio, Italy

Despite the insistence of Hadrian himself that his gardens here were a sort of map of the Roman Empire, few specific places can be identified. One that can be is Canopus. This Egyptian city was famed for its temple to Serapis, a conflation of Osiris and several Greco-Roman gods. His cult was enjoying a vogue in Hadrian's Empire at this time. The water here represents the River Nile; the grotto at its far end is the Serapeum – a shrine to the deity.

OPPOSITE BOTTOM:
Villa Sbertoli, Pistoia, Tuscany, Italy

The pioneering psychiatrist Agostino Sbertoli (1827–98) opened his 'House of Health' in 1868. It's looking pretty poorly now, it must be said. And yet, it is still very much a place of beauty: Sbertoli was resolved that his 'house' should be first a home and then, as it grew in size (patients were soon flocking here from all over Europe and it had to be extended), a 'village'. He wanted it as un-'institutional' as he could contrive.

LEFT:
Staircase to abandoned palace, Spoleto, Umbria, Italy

The transience of all things human is acted out architecturally in this dusty, desiccated vision of glory gone. So too, though, is the special appeal of ruined splendour. Crumbling into the hillside on which they stand, these steps seem to beckon us back into a romantic past, when this palazzo shimmered with elegance and bustled with eager life.

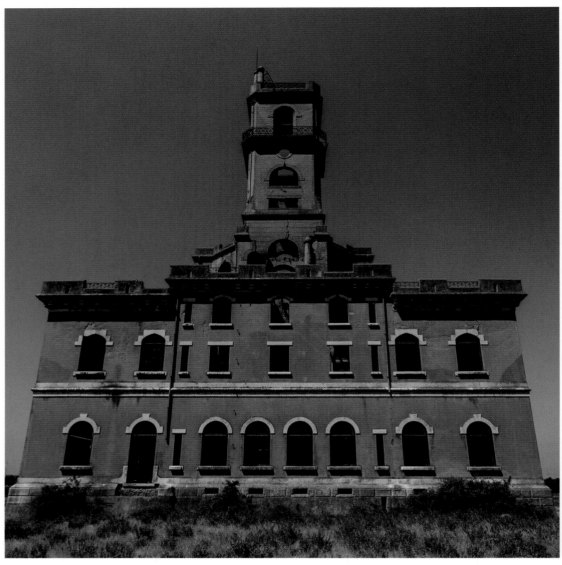

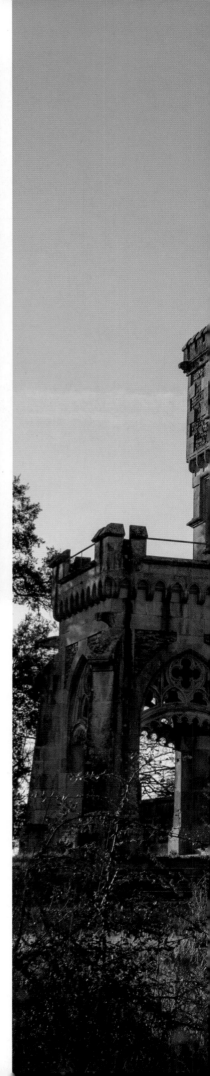

ABOVE:

**'Palace of the Rubbish King',
Coina, Barreiro, Portugal**

Facing Lisbon across the Tagus is another capital, Coina, historic centre of the realm of the 'Rubbish King'. It was here that, in the 1890s, Manuel Martins Gomes (1860–1943) established an enormous pig farm, feeding all his stock on Lisbon's slops, which he shipped across the strait in a little fleet of boats. A controversial and complex figure, Gomes had a gangsterish air and outspoken atheist views, but also endowed important public welfare projects. His whole estate, ironically, is now a wasteland.

RIGHT:

**Dona Chica's Castle,
Palmeira, Braga, Portugal**

'Dona Chica' was the title popularly given in Palmeira to the local landowner's Brazilian-born wife, Francisca Peixoto Rego (1895–1958). Swiss architect Ernst Korrodi (1870–1944) was commissioned to create a home appropriate to her prestige and beauty. This extravagantly romantic pile was the result. As the monument to a marriage, it proved melancholy: work was abandoned in 1919 when the couple parted. Though attempts were made to resume construction, this was invariably frustrated by financial or administrative problems, so Dona Chica's Castle still stands abandoned.

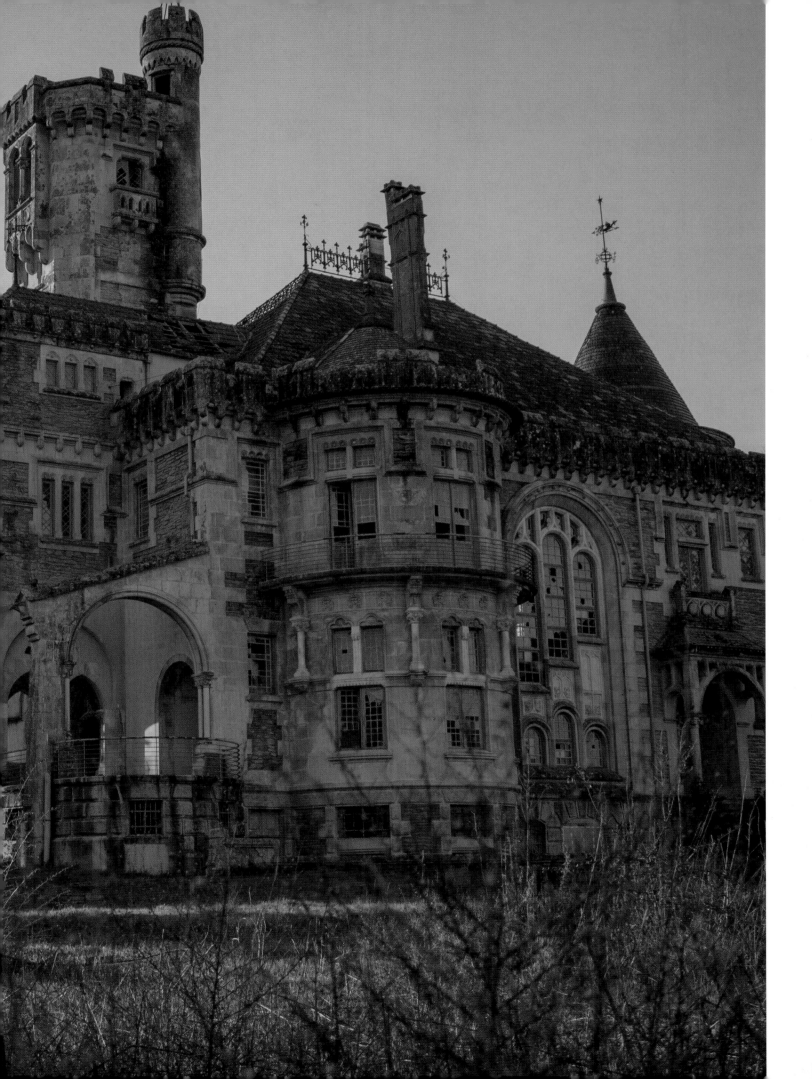

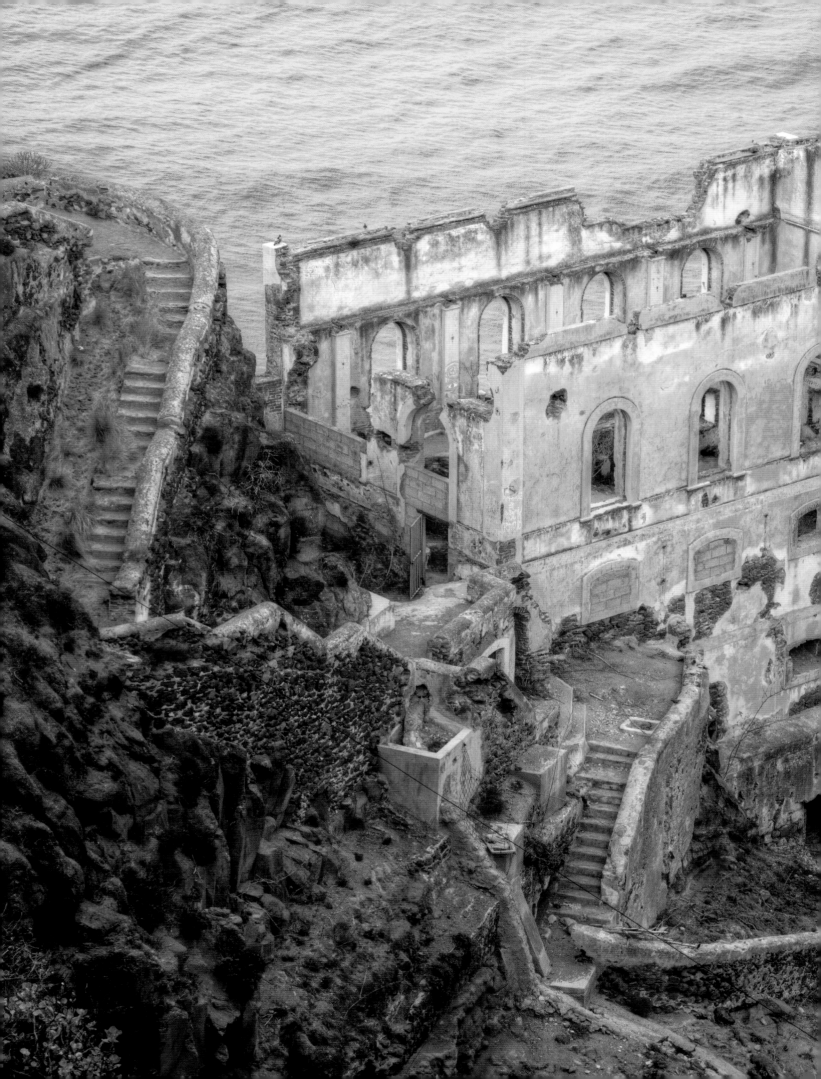

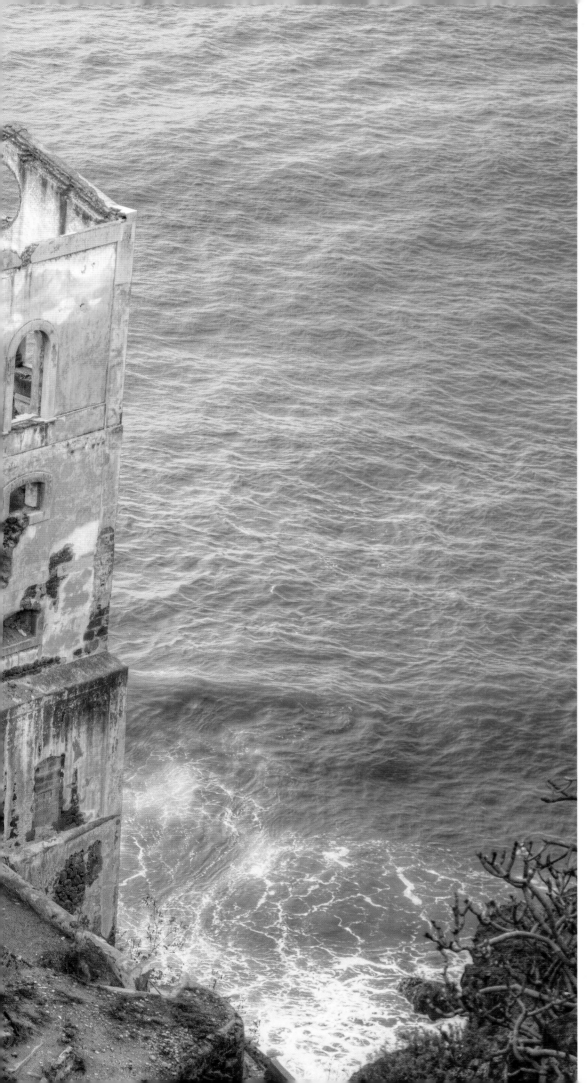

LEFT:

**Gordejuela Water Elevator,
Los Realejos, Tenerife,
Canary Islands, Spain**
Despite its situation perched
precipitously above the sea, this
water elevator pumped fresh water
from the Gordejuela Springs to
a reservoir on the hillside high
above. It was worked by Los
Realejos' first steam engine, which
forced the springwater along a
2-km (1.25-mile) pipeline, then
distributed it around the island's
banana plantations by aqueduct
and ditch. Opened in 1904, it
performed impeccably – but closed
just 15 years later as local fruit was
priced out by cheaper products
from the Caribbean.

OVERLEAF:

**Ruined castle, Córdoba,
Andalucía, Spain**
Sunset and stubble … suitably
melancholy conditions for viewing
a beautiful emblem of medieval
heroism – the values of an all
but mythic chivalric age long
past. The Spanish countryside
is littered with ruined castles, a
legacy of the Reconquista – the
Christian kingdoms' centuries-
long struggle to reconquer their
lost territories from the Muslim
Moors. Over 2500 such sites
have been identified, and many
thousands more are believed to
have existed. Even so, gothically
minded landowners in the
nineteenth century, in Spain as
elsewhere in Europe, believed that
what the country needed was even
more ruins. The cult of the 'folly'
never seemed more foolish than it
does here.

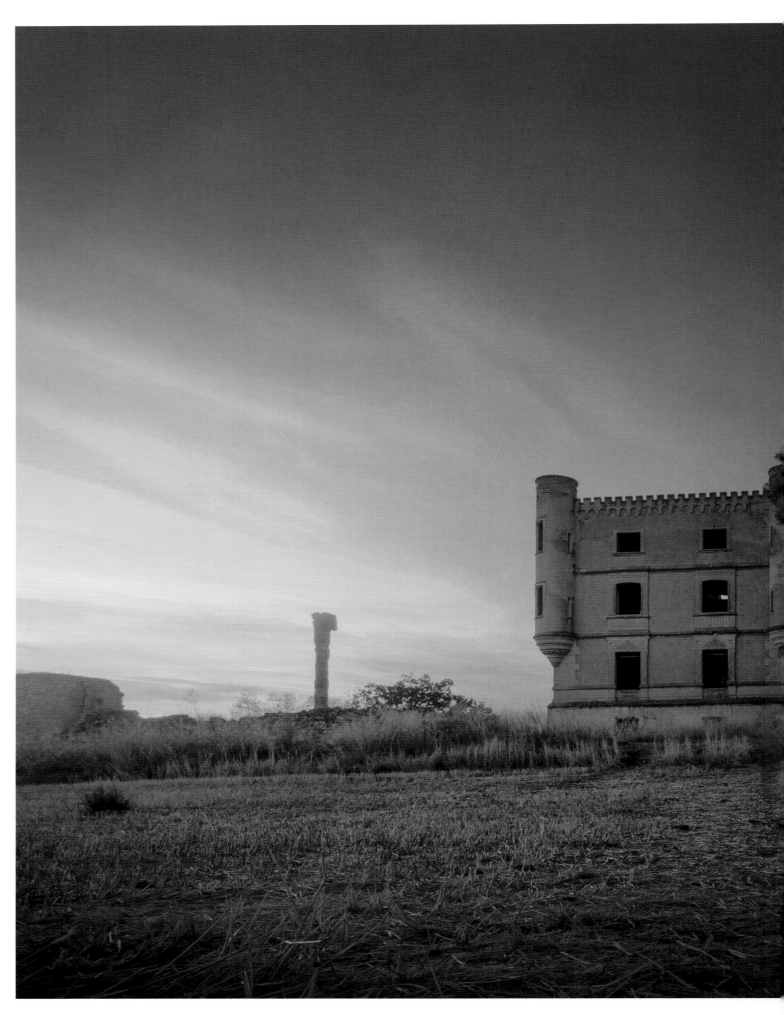

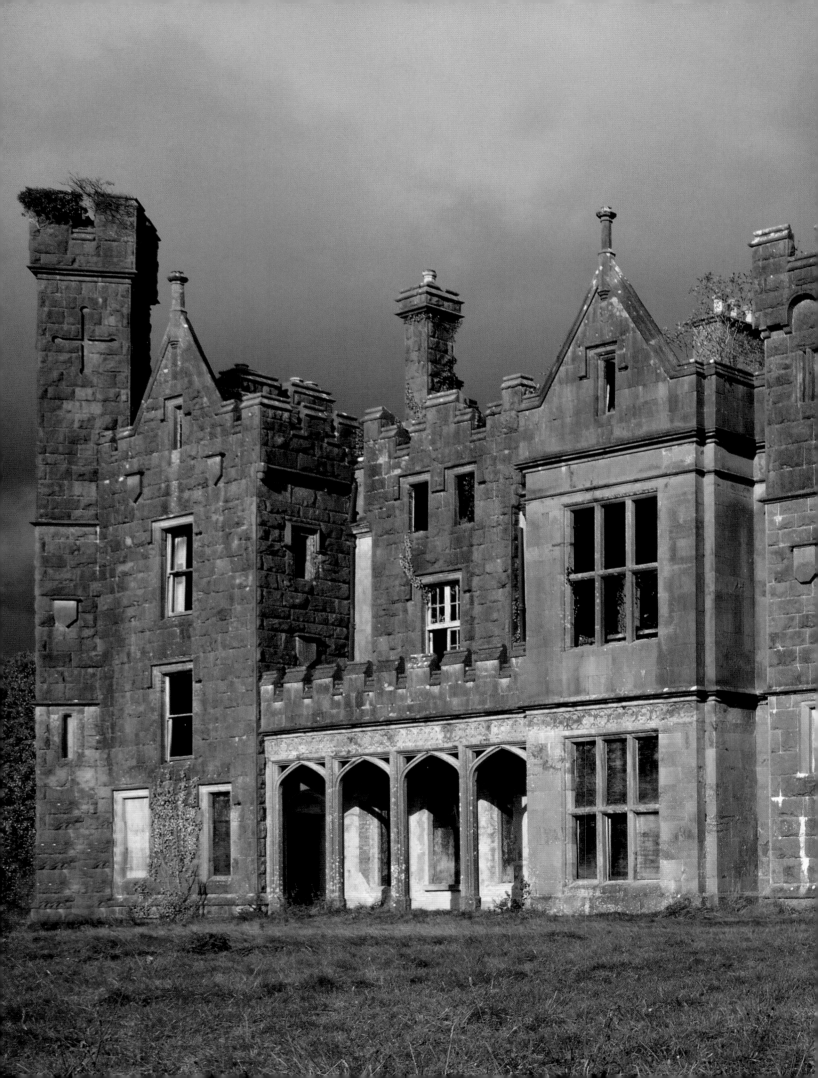

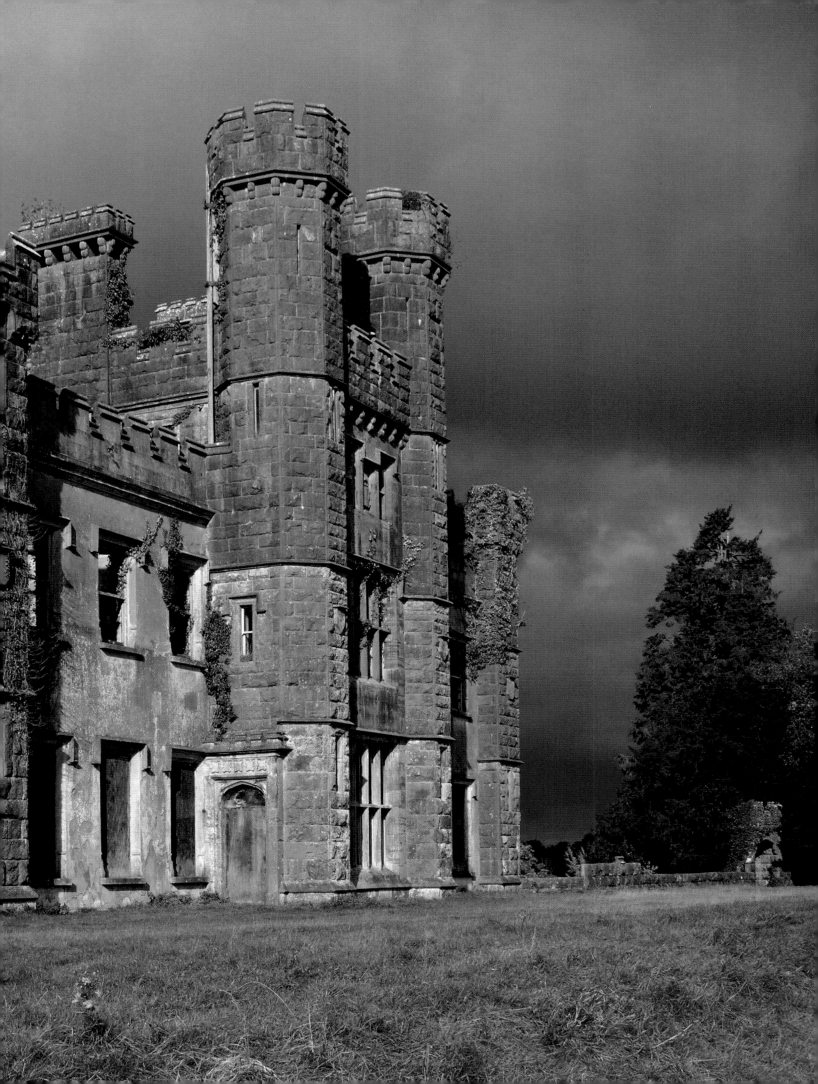

Castle Saunderson, Belturbet, Cavan, Ireland

Though the nearest town is in the Irish Republic, the Saunderson estate straddles the border with Northern Ireland. The castle itself in fact stands in County Fermanagh – fittingly enough for the family seat of the Saundersons, historically stalwarts of the Ulster Unionist cause. Built in 1840, Castle Saunderson was sold in the 1970s. Though it was supposed to be refurbished, a succession of fires left it gutted, but an international boy scouts centre has been established in its grounds.

TOP RIGHT:

Duckett's Grove, Carlow, Ireland

The 'big house' for an estate that by the middle of the nineteenth century extended across five counties, Duckett's Grove embodied the self-assurance (and the sheer affluence, of course) of the Anglo-Irish 'Ascendancy' in Ireland. Though the Ducketts had lived here since the seventeenth century, this house wasn't built till 1830. But the dynasty died out in the early twentieth century and in 1921 – a real sign of changing times – the empty premises were used as a base by the local unit of the IRA.

BOTTOM RIGHT:

Buchanan Castle, Drymen, Stirlingshire, Scotland

This impressive baronial mansion was built by the Grahams, Dukes of Montrose, in the mid-nineteenth century. It was supposed to become a new ancestral seat for a family that already had a long and distinguished dynastic history. The chronicle continues, but since the 1920s hasn't had a place for Buchanan Castle – too vast and expensive to maintain for a modern aristocracy. It's now stood empty for half a century, being slowly repossessed by nature.

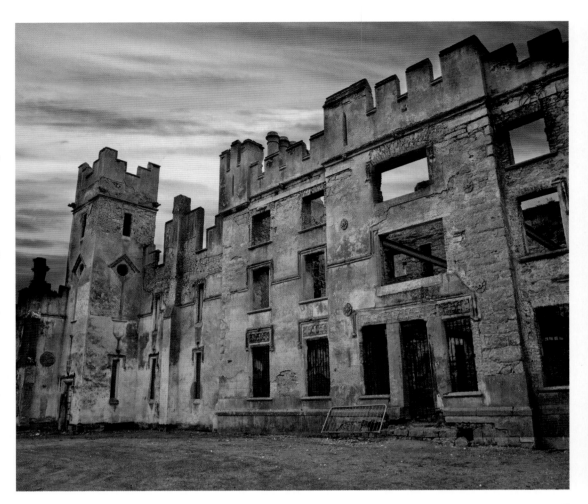

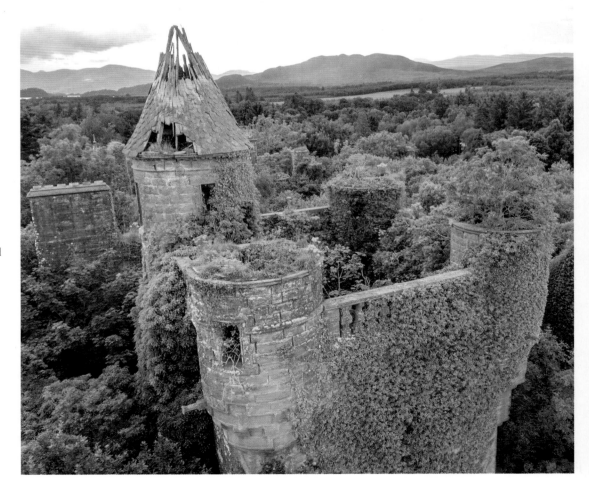

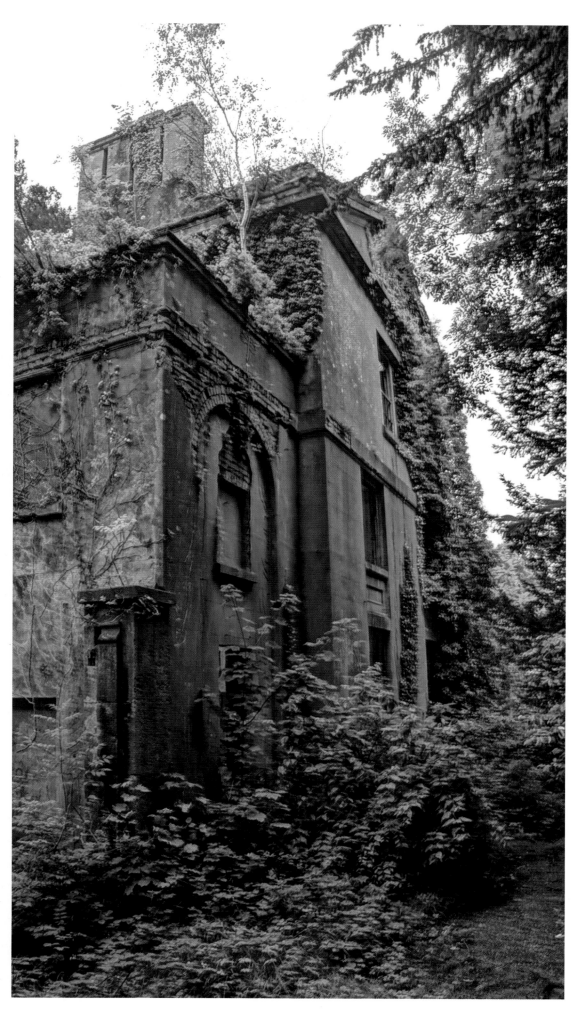

Baron Hill House, Beaumaris, Anglesey, Wales
Home of the Viscounts Bulkeley, Baron Hill originally dated from the 1600s, but was rebuilt in the 1770s in the neo-Palladian style. It was surrounded by extensive gardens and a landscaped park. Since the 1920s, however, it has been abandoned, and over the decades the grounds have become increasingly thickly wooded: the house itself has been substantially overgrown. Sealed off from the world throughout this time, the woods have flourished undisturbed and are now a site of special scientific interest.

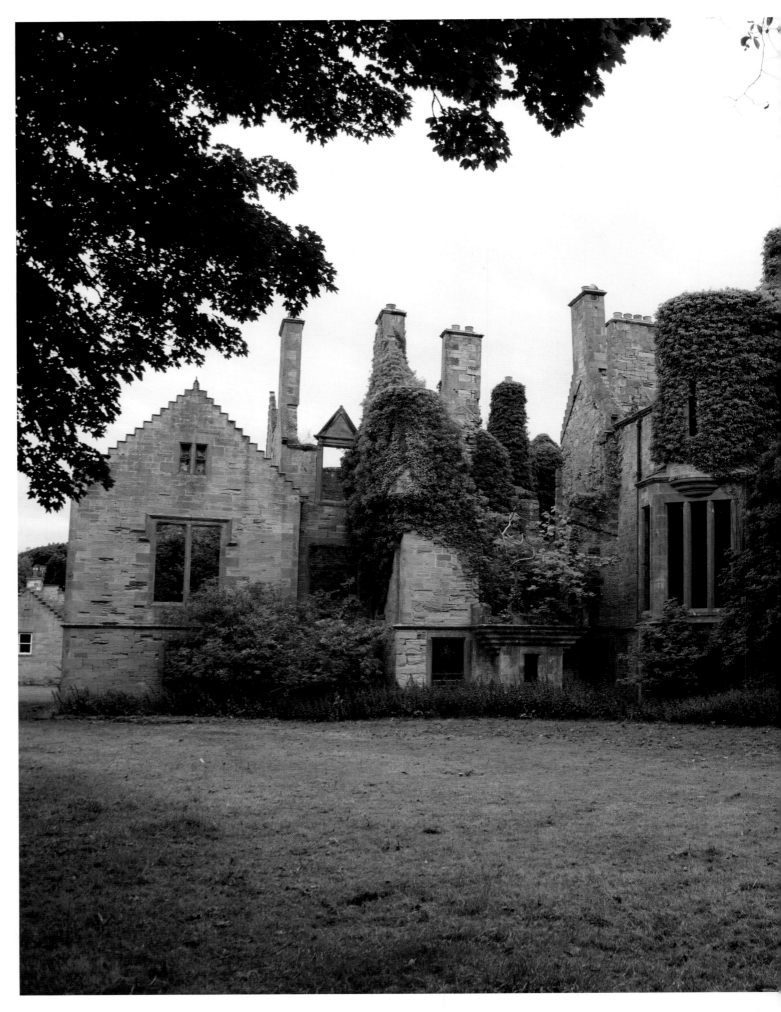

Seacliff House, North Berwick, East Lothian, Scotland

David Bryce (1803–76) designed this mansion in the 'Scottish baronial' style in 1841. John Watson Laidlay (1808–85) bought the place a few years later. Enriched materially by his family's plantations and manufactures in India, and intellectually by his own work and study in Bengal, he was now recognized as an important orientalist. His son inherited the house, but was tragically killed when, in 1907, it burned down. While the roof and fittings were all completely consumed and the structure left totally gutted, its stone walls, turrets and chimneys survived intact.

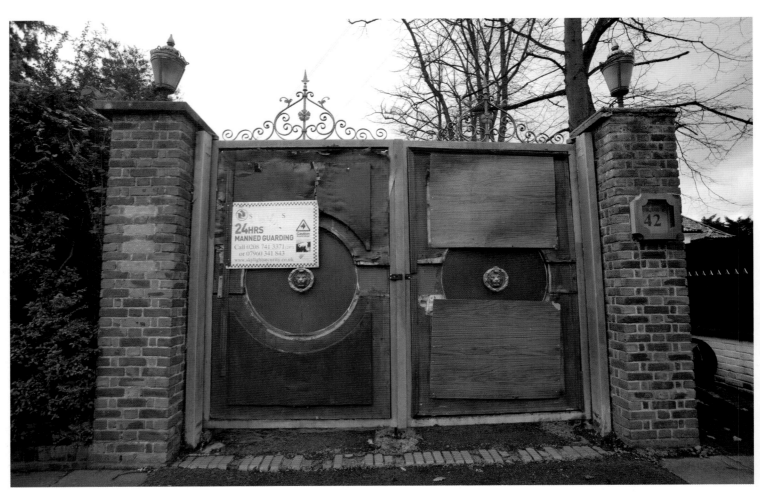

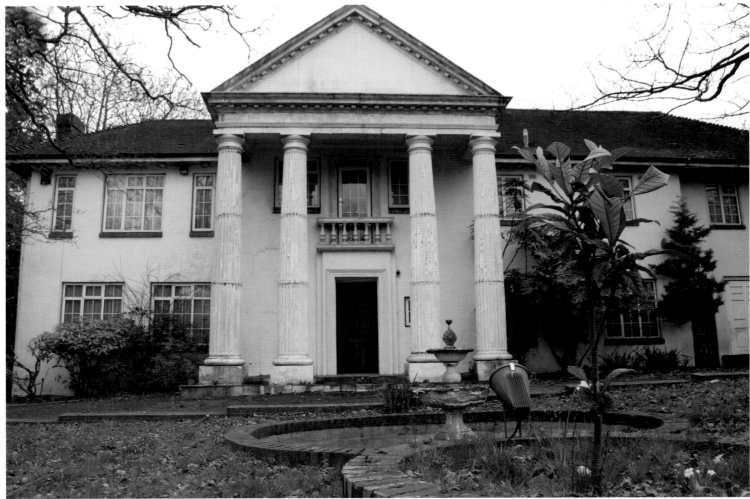

OPPOSITE TOP:

**Gateway to dereliction,
The Bishops Avenue,
Hampstead, London**

So lucrative has London's property
market proven over several decades
now that houses have become
an asset, their value essentially
unconnected with their real-world
use. Homes in Hampstead hotspot
The Bishops Avenue command
astronomical prices – among the
highest in Britain's capital – but
their purchasers seldom show
much interest in settling there.

OPPOSITE BOTTOM:

**Down-at-heel,
The Bishops Avenue,
Hampstead, London**

To buy a house in The Bishops
Avenue you have to be fabulously
rich – so fabulously rich, and
with so ludicrously privileged
a life, that you hardly have the
time or inclination actually to
live there. It's said that only a
very few properties on London's
'Billionaire's Row' are permanently
occupied; many have stood empty
– sliding into dereliction – over
several years.

ABOVE:

**'Longdrive', The Bishops
Avenue, Hampstead, London**

This £3 million 'des res' proved
so undesirable to its purchasers in
the event that they never actually
got as far as moving in. They left
the place instead to emptiness; and
ultimately, in 2009, to squatters
protesting the inequities of
modern Britain's economic and
social order.

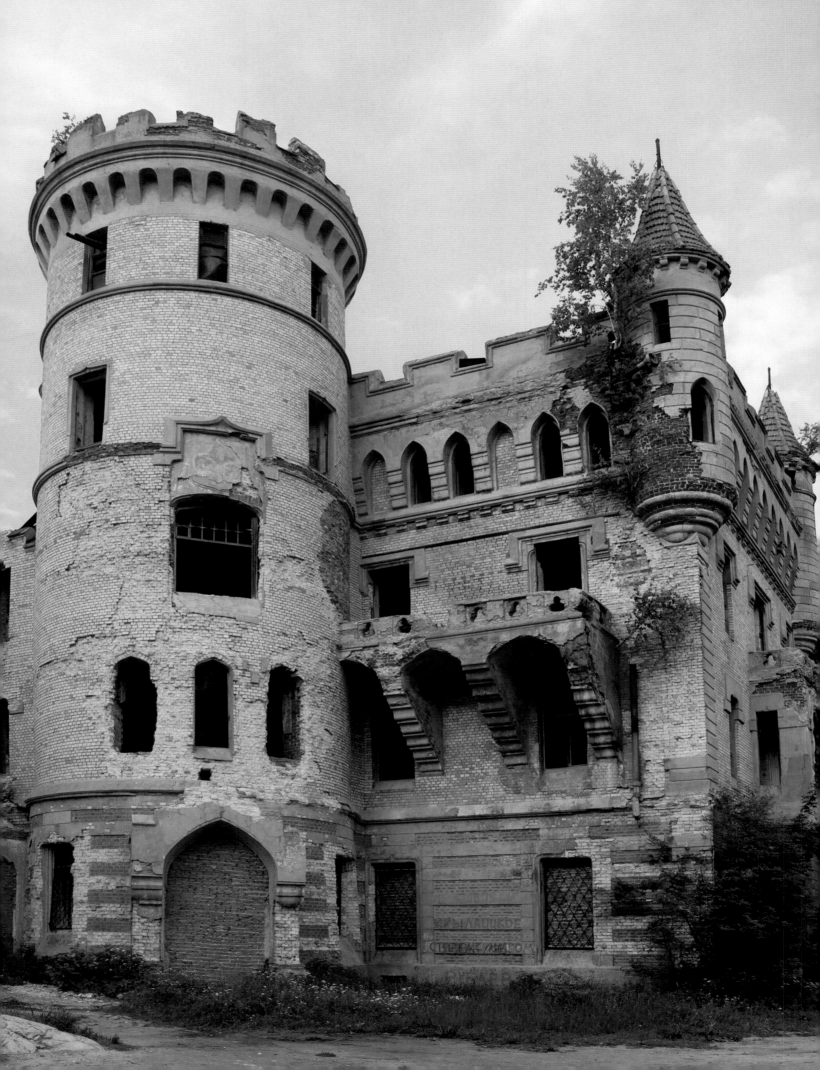

Eastern Europe

The writer and publisher Michael Korda (1933) has pointed out that 'In Eastern Europe the past is not only always hovering over the present, it is not even passed. It waits, like some malevolent caged beast, ready at any moment to escape and bring back all its horrors.' A pessimistic view, perhaps, but one that doesn't seem unwarranted in the light of the region's recent history of repression and of war.

One key feature has of course been the impact of those communist regimes that held sway in Russia from 1917 and in much of the rest of Eastern Europe in the decades after World War II. The position of the palace, even as an idea, was plainly problematic in the socialist scheme. These regimes were by definition antagonistic to ideas of wealth and rank. They were also wedded to a revolutionary rhetoric of violent, far-reaching change – of bringing down old institutions; of sweeping away the past.

They were unabashedly authoritarian, then, in pushing through what were often deeply brutalist building schemes. At the same time, though, strongly invested in a Marxist view of history, they sometimes proved more respectful of their architectural heritage than governments in the West. For the connoisseur of the palatial ruin, then, Eastern Europe presents a mixed picture – but one by no means lacking in visual splendour or in poetry.

OPPOSITE:

Muromtzevo Castle, Sudogda, Vladimir Oblast, Russia
This extraordinary mansion was built in the 1880s by a Francophile cavalry colonel who had (some said) bet some of his château-dwelling hosts that he could create a comparably palatial place at home. True or not, the story highlights the cultural 'cringe' experienced in an Eastern Europe overawed by the achievements of the West.

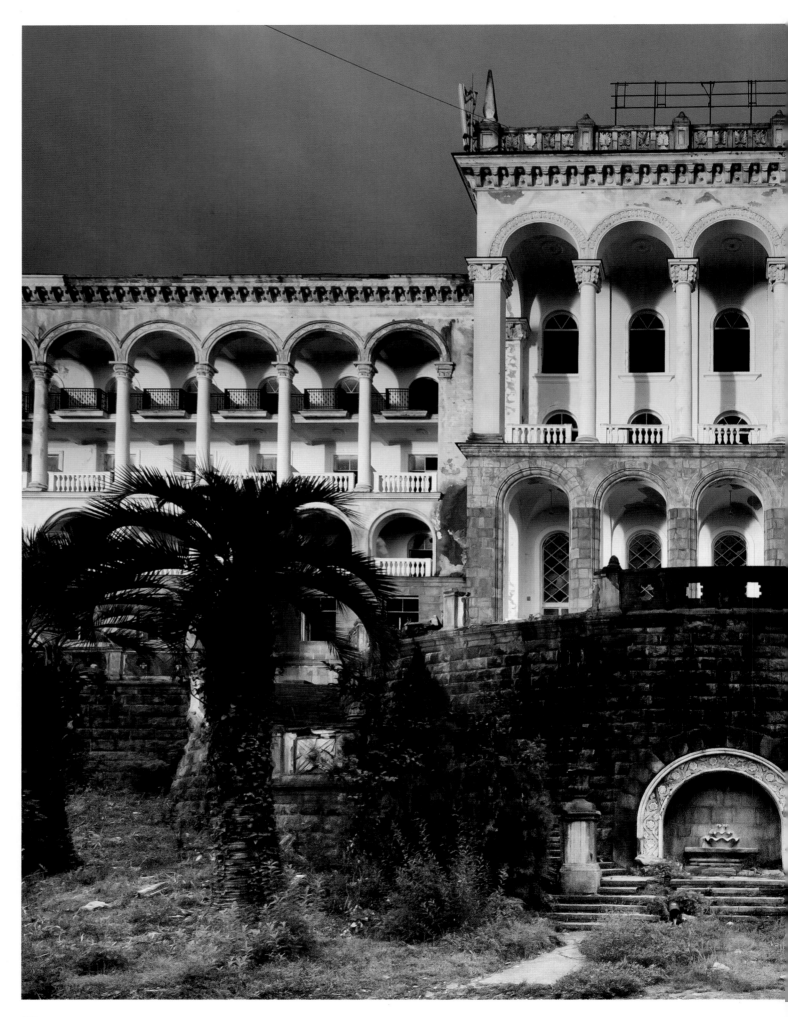

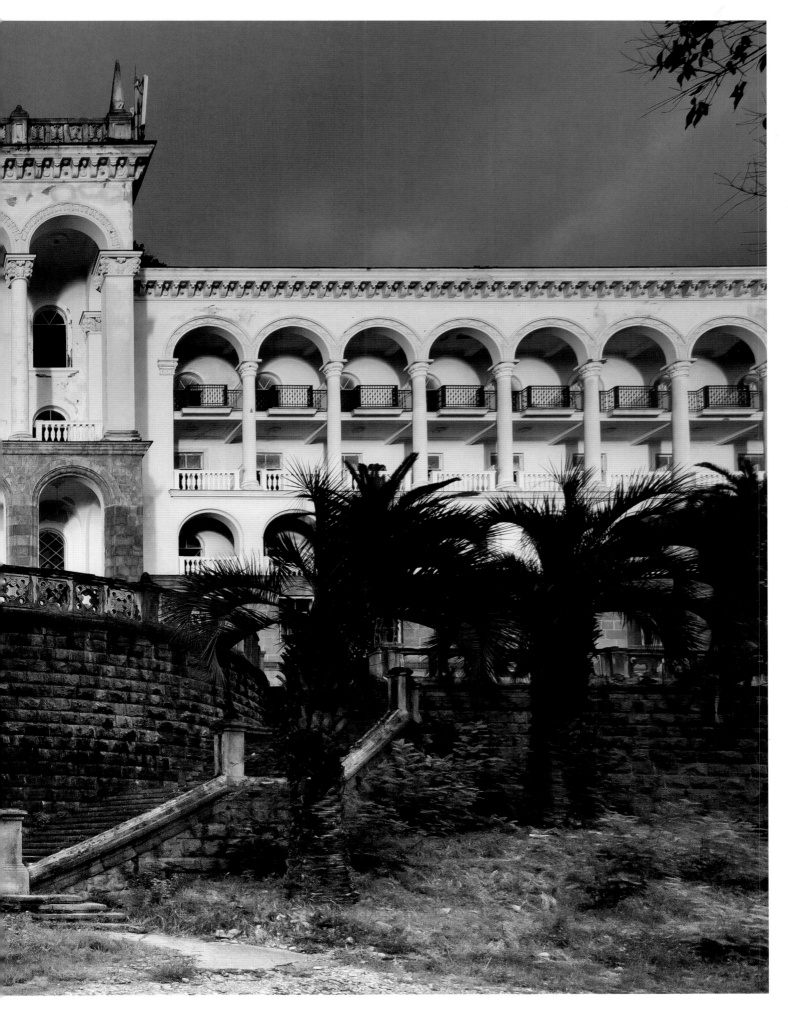

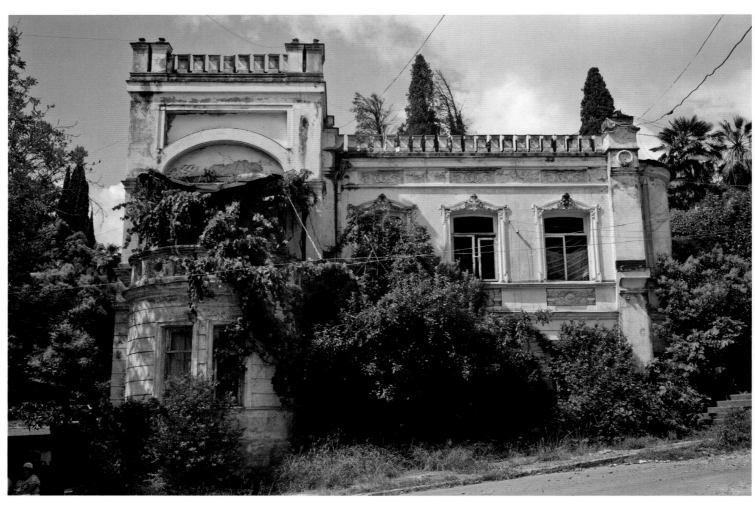

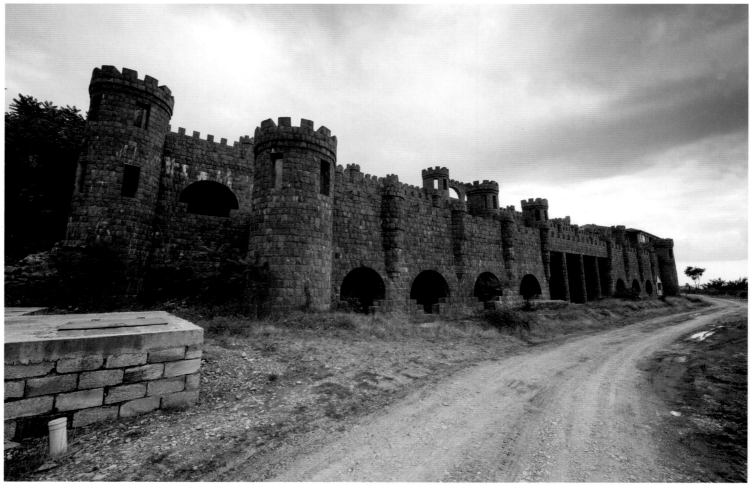

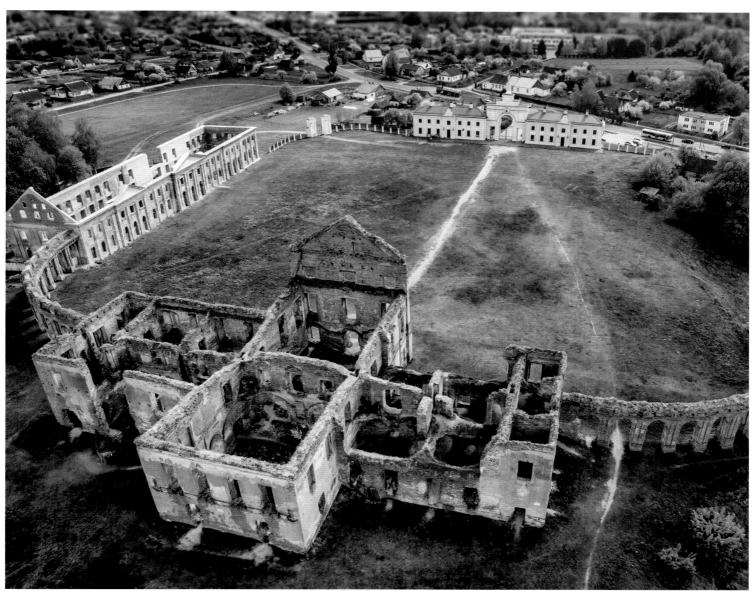

OPPOSITE TOP:
Derelict mansion, Sukhumi, Abkhazia
Abkhazia's identity and 'ownership' have been hotly contested over many years: Tbilisi maintains that it is Georgian through and through. But the nation (if that's what it is) has asserted its autonomy, with the support of a – proprietorially protective – Russia. What, geopolitically, may seem an abstract question is anything but in Abkhazia itself. Here the continuing ambiguity has left an uncertain society in some sense 'hollowed-out' – like this house, whose owners have vanished who knows where.

OPPOSITE BOTTOM:
Dili Qala, Sheki, Azerbaijan
This castle-like construction on a hill above Sheki, in northwestern Azerbaijan, was intended as a luxury hotel. In the end, however, it was never finished and was eventually abandoned, an expensive architectural white elephant. It does at least afford extensive views over the city spread out below its battlements, however, and as such has become a tourist attraction in its own right.

ABOVE:
Ruzhany Palace, Pruzhany District, Belarus
Local magnate Aleksander Michal Sapieha (1730–93) built this neo-classical palace in the 1780s, at a time when Belarus belonged to the Polish-Lithuanian Commonwealth. Sapieha was not just a nobleman but a significant statesman: the power, perhaps, went a little to his head. An ambitious – even overweening – project, this palace had its own theatre and glassed-in orangery and was surrounded by extensive parkland grounds. The palace burned down in 1914.

PREVIOUS PAGES:
Abandoned hotel, Gagra, Abkhazia
Decades of political uncertainty haven't done much for the tourist industry in what was once part of the 'Caucasian Riviera'. The coastal resort of Gagra is a lovely place, with a warm, subtropical climate and a scenic setting; an important resort since the days of Imperial Russia. But what is a hotel to do when its guests don't dare to come? This one stands empty, a memorial to better times.

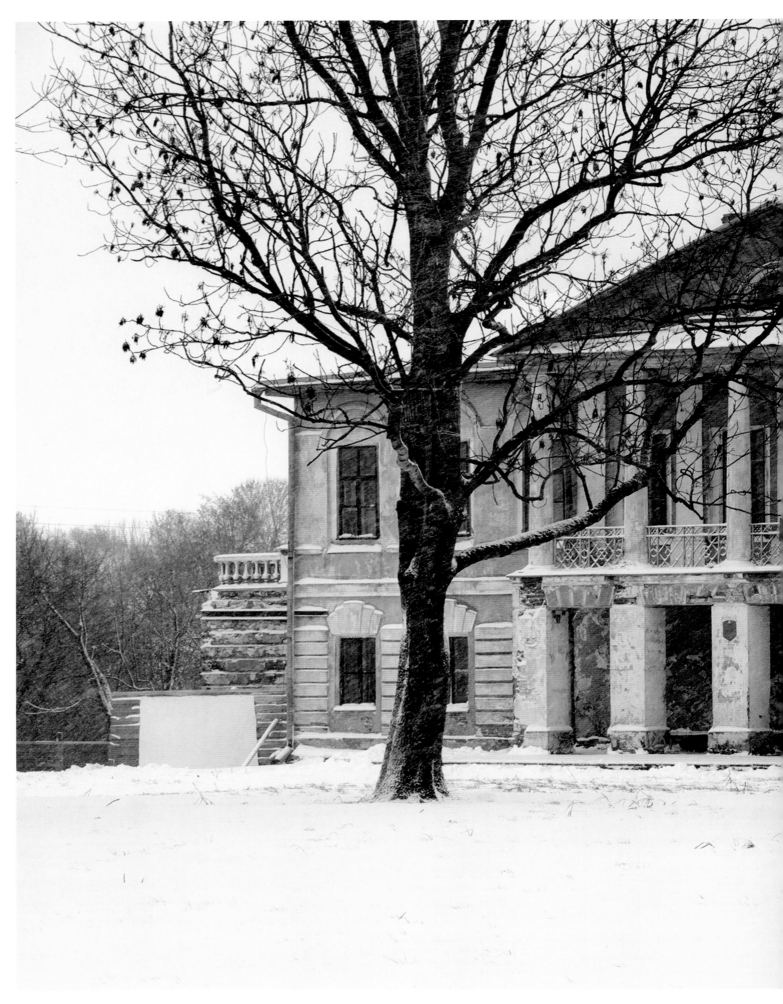

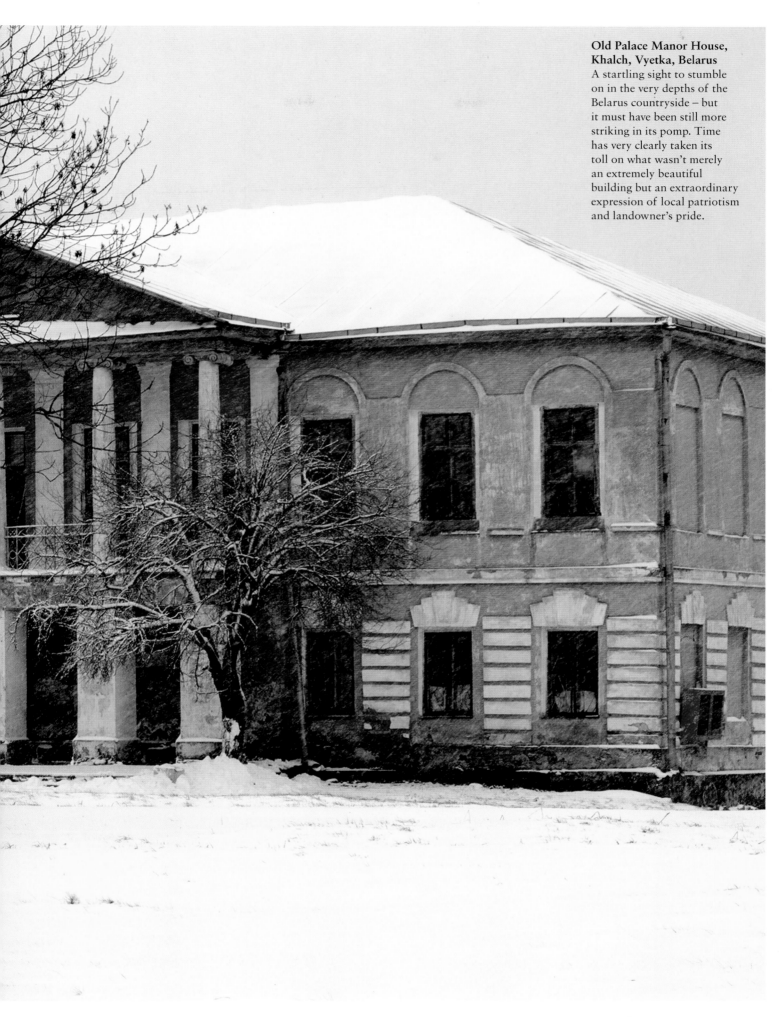

Old Palace Manor House, Khalch, Vyetka, Belarus
A startling sight to stumble on in the very depths of the Belarus countryside – but it must have been still more striking in its pomp. Time has very clearly taken its toll on what wasn't merely an extremely beautiful building but an extraordinary expression of local patriotism and landowner's pride.

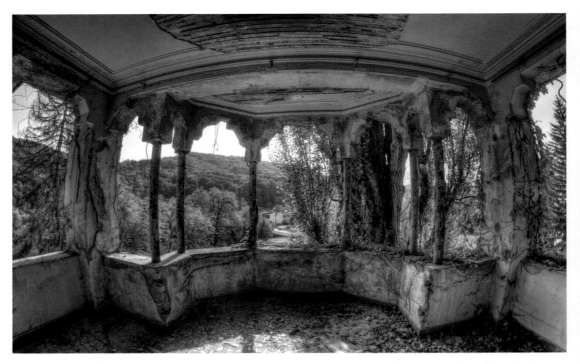

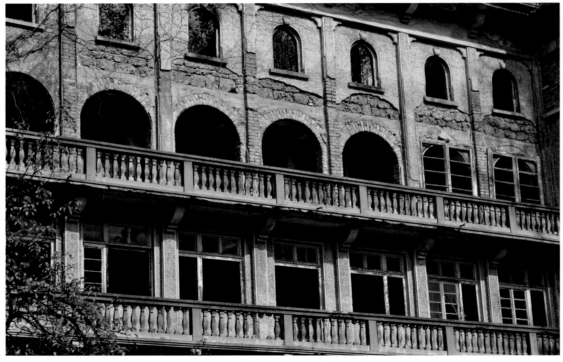

ABOVE (BOTH PHOTOGRAPHS):
Pencho Semov's House, Gabrovo, Bulgaria
Pencho Semov (1873–1945) was born into a poor Gabrovo family but went on to become the 'Bulgarian Rockefeller'. He made a fortune in the woollen textile trade, owned 18 factories, founded three banks and won renown as a philanthropist as well. His house in his home town is as beautiful as it is vast – it is crumbling steadily away, though, even so.

RIGHT:
Memorial House of the Bulgarian Communist Party, Mount Buzludzha, Stara Zagora, Bulgaria
This concrete mass was futuristic once. Buzludzha was already sacred to the national memory because heroic Bulgarians, massively outnumbered, had fought to the death against an Ottoman army here in 1868, while Communist partisans had seen off the Fascist threat in 1944. The Memorial House was not completed until 1981. Within another decade it would be obsolete.

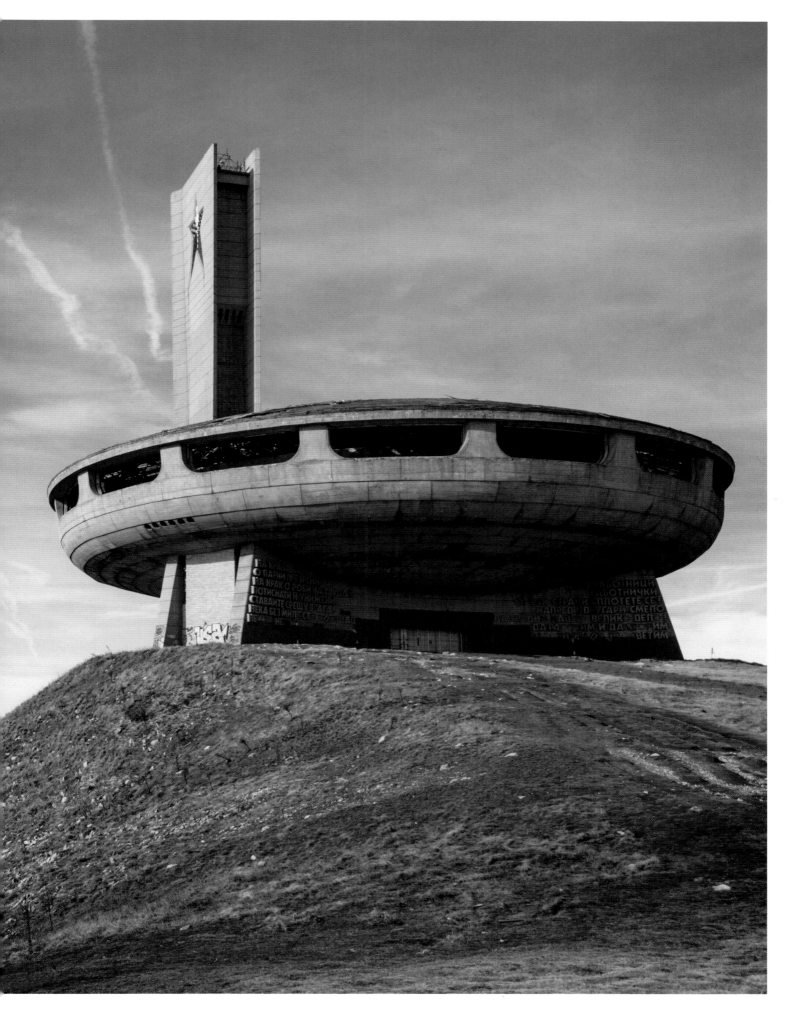

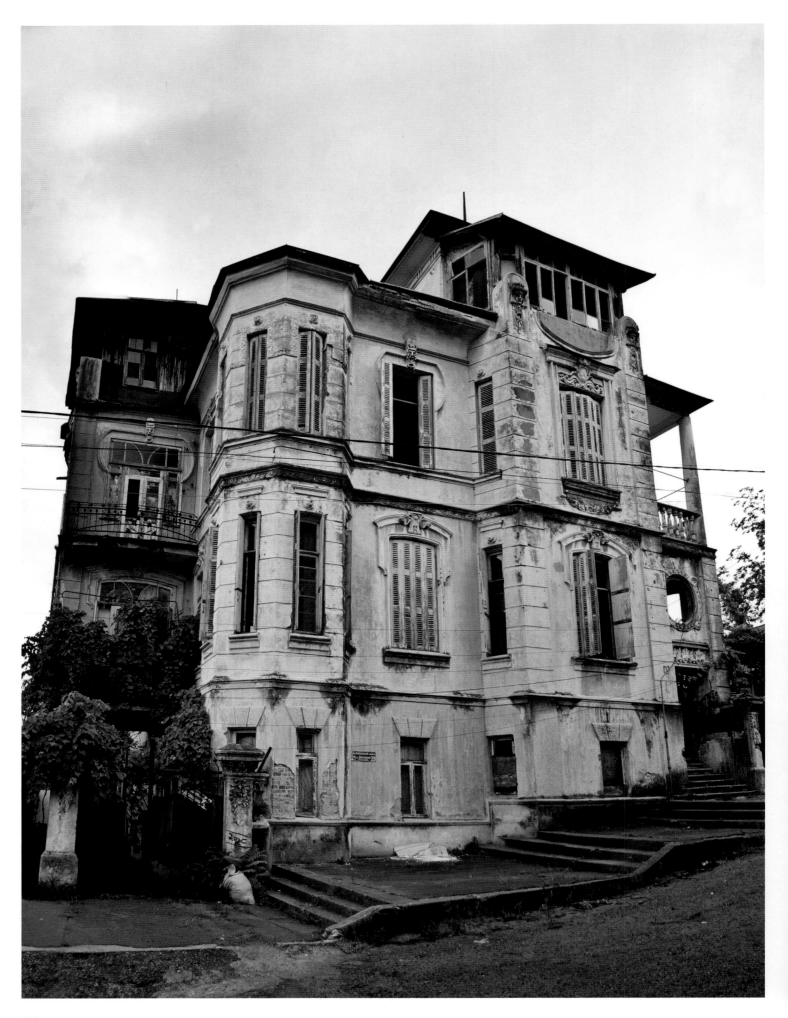

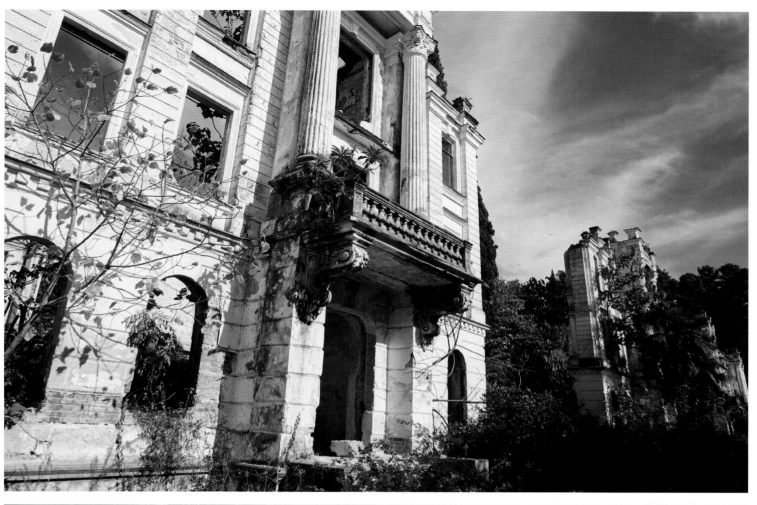

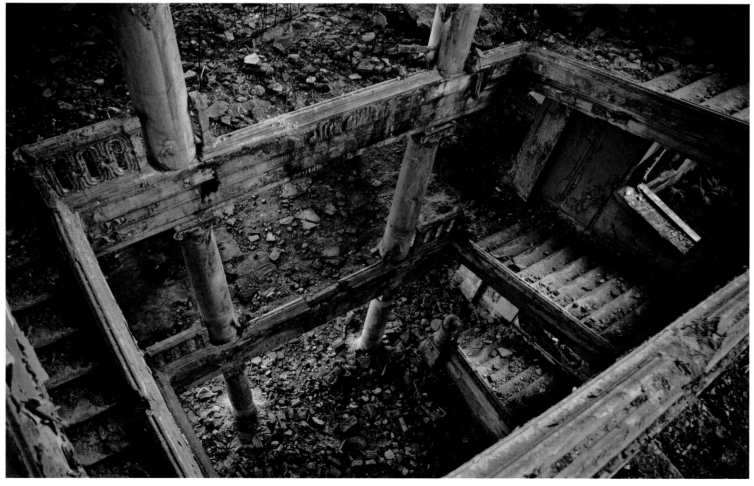

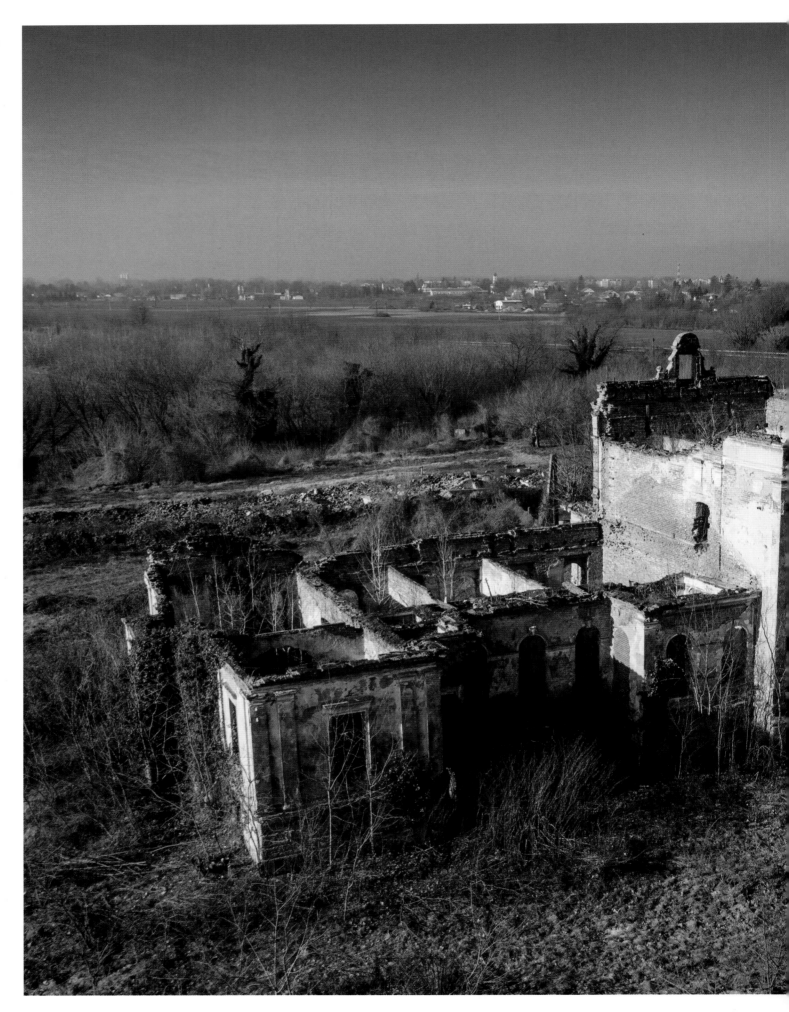

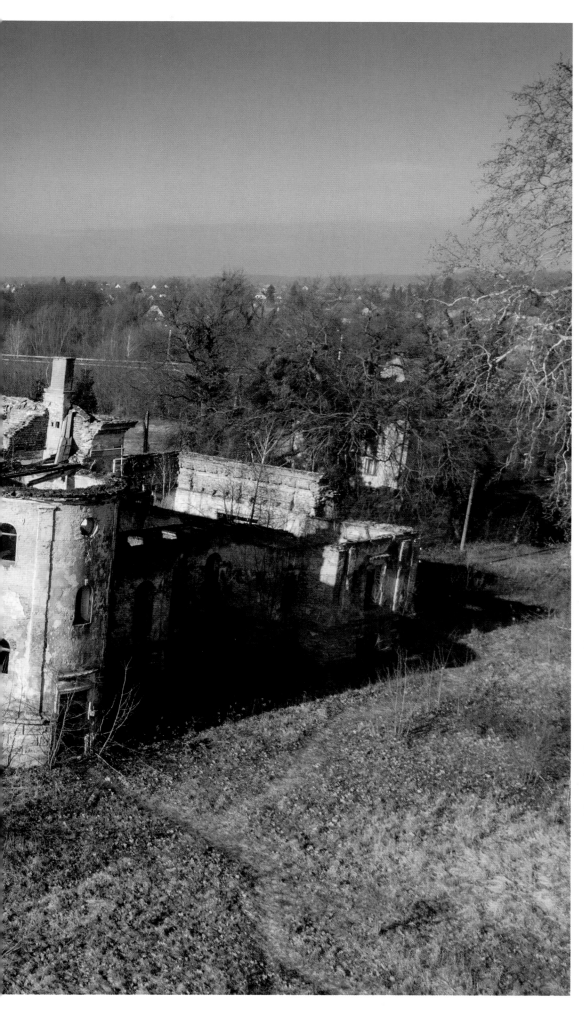

PAGE 110:

Abandoned townhouse, Sukhumi, Abkhazia

'War damage' doesn't just mean flying shells, falling bombs and machine-gun fire, though the Abkhaz capital was to experience its share of those during the 1990s. This once beautiful residence is one of many left to sink into dereliction after its wealthy owners opted to move away.

PAGE 111 TOP:

Prince Smetsky's Palace (exterior), Gulripshi, Abkhazia

Nikolai Smetsky (1852–1931) moved here from Moscow in the 1890s when his wife was diagnosed with tuberculosis. In the years that followed, he opened a series of superbly equipped and palatially constructed sanatoria, set in sumptuously landscaped grounds (Smetsky took a special interest in the subtropical region's many trees).

PAGE 111 BOTTOM:

Prince Smetsky's Palace (staircase)

After 1917, Prince Smetsky's sanatoria were taken over by the Soviet state, being set aside for the treatment of high officials. They passed to the care of the Georgian authorities after the break-up of the Soviet Union, but were badly damaged during the Georgia–Abkhazia War of the 1990s, since which time they have stood empty.

LEFT:

Kremsier Castle, Belcsapuszta, Barcs, Hungary

Local industrialist Mór Kremsier, the owner of a mill and a distillery in Belcsapuszta, built himself this neo-Renaissance palace in the 1880s. Awe-inspiring even in its dereliction, it suggests the elegance available to the successful nineteenth-century entrepreneur, even in so small and provincial a place (Barcs lies in Hungary's far southwest, close to the border with Croatia).

Abandoned house, Dobele, Latvia

Tourists come to Dobele to see the ruins of the castle, built in medieval times by members of the Livonian Order of Teutonic Knights. Just as atmospheric, though – and almost as awe-inspiring – is this dark and derelict wood-built villa outside the town. With its tidy lines, its appealing porch and its arts-and-crafts style windows – still surviving for the most part – this must have been a lovely dwelling in its day.

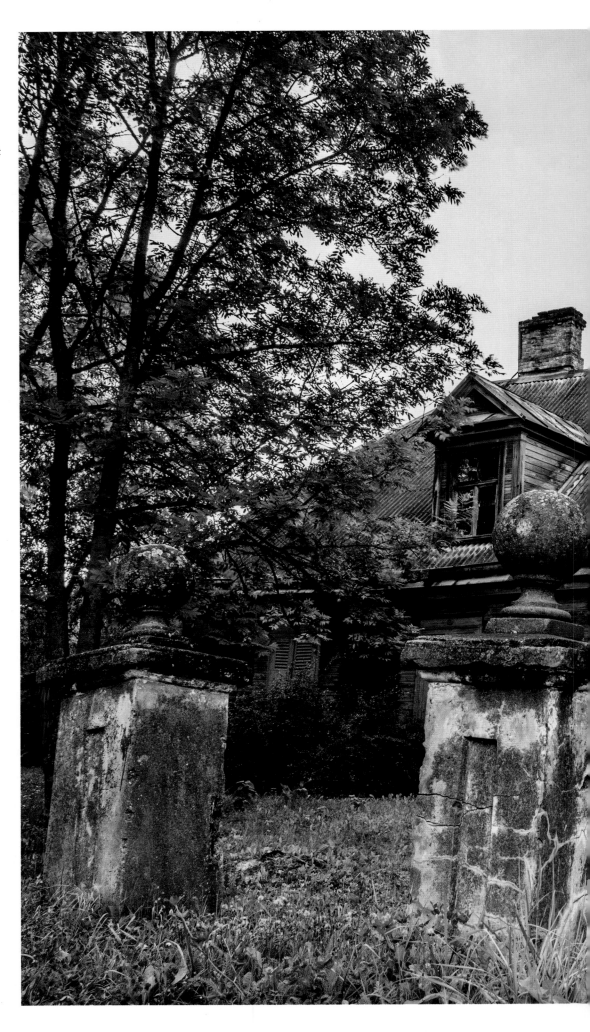

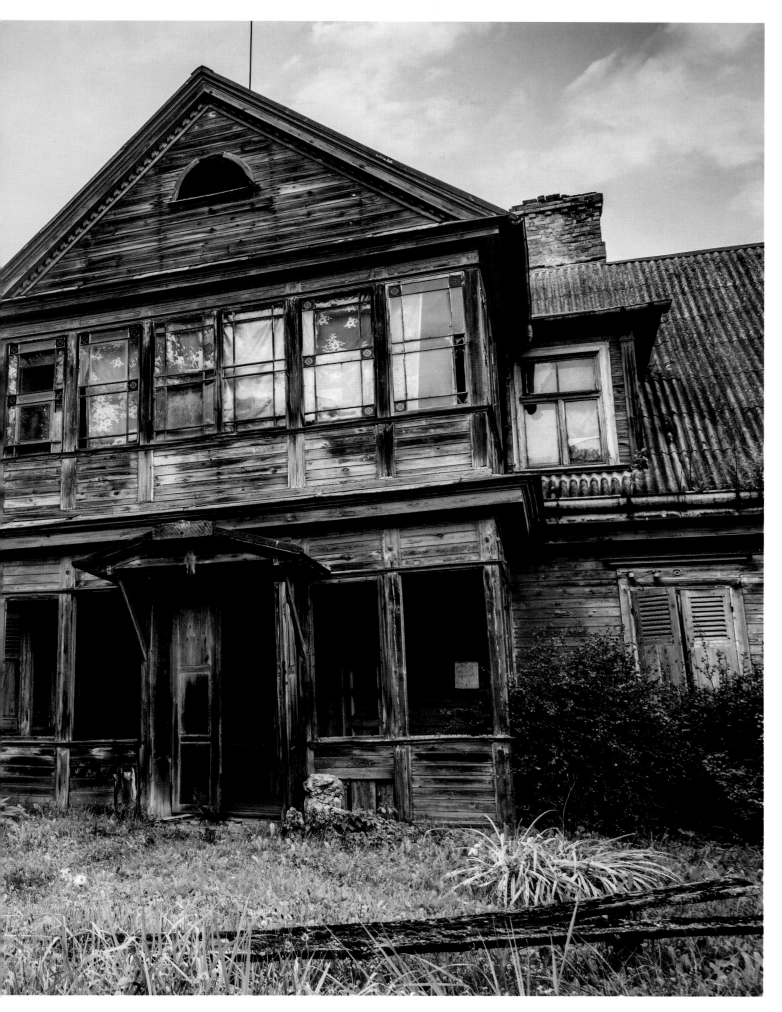

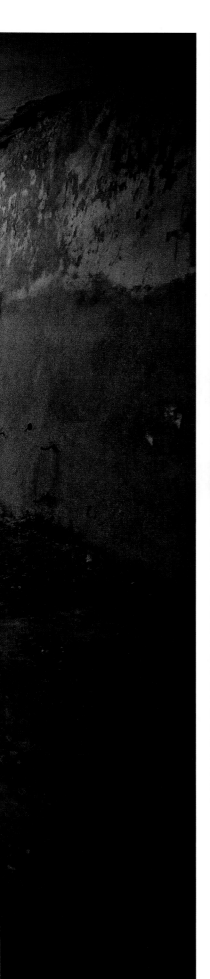

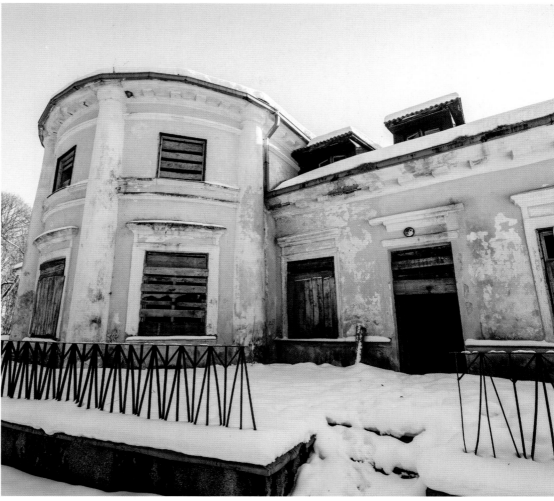

LEFT AND ABOVE:

**Sumskas Manor, Sumskas,
Vilnius, Lithuania**

The sunlight streaming in
through the slatted windows only
underlines the general gloom of
the interior (left) with its dirt floor
and its earth-toned décor – if you
can call it that. We might be in
a cave, not a nineteenth-century
mansion. This impression is only
underlined by the rounded bay,
though this must have made an
attractive feature when Sumskas
Manor was occupied. The
down-at-heel impression is only
reinforced by the outside view
(above), the white paint peeling
away like so much snow.

**Abandoned houses, 'Gypsy Hill',
Soroca, Moldova**
In Moldova, as elsewhere, the
Roma have suffered centuries
of discrimination and been
stereotyped as, essentially, a
community of criminals. Their
response in recent decades has
frequently been to meet crass
criticism with crude conspicuous
consumption. Most visibly, these
Roma-made-good have built
themselves ostentatious houses
in Soroca's so-called 'Gypsy
Hill' – a district otherwise very
poor in amenities. Often these
grandiose mansions have remained
unfinished, abandoned after dips
in fortune, or simply left empty
while work is pursued elsewhere.

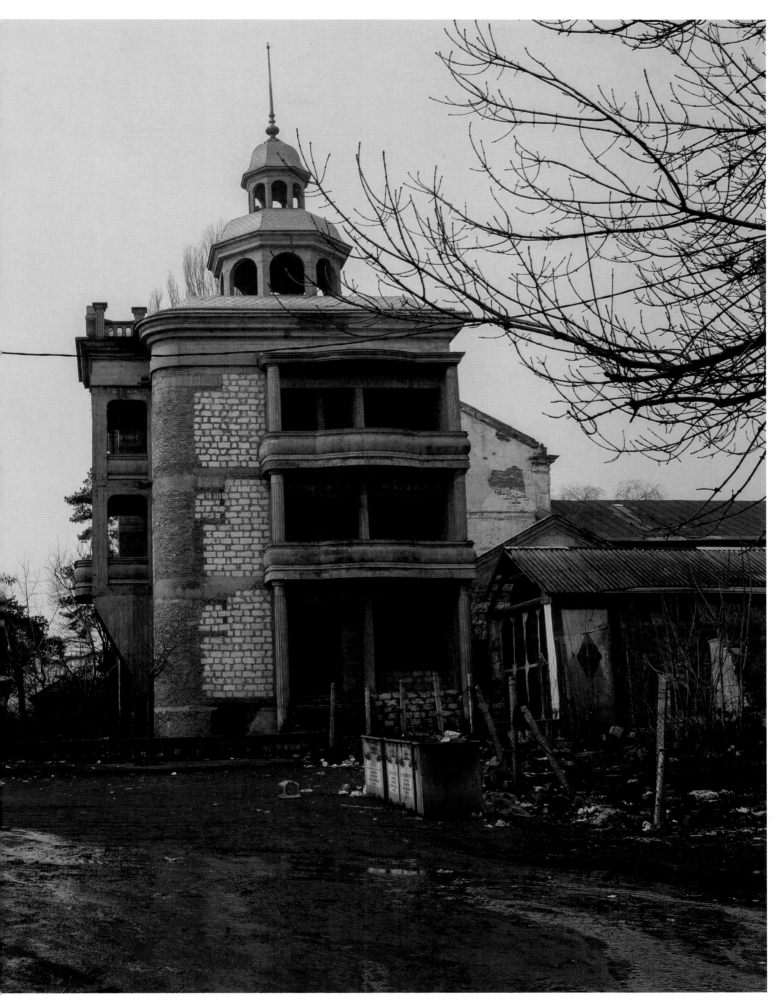

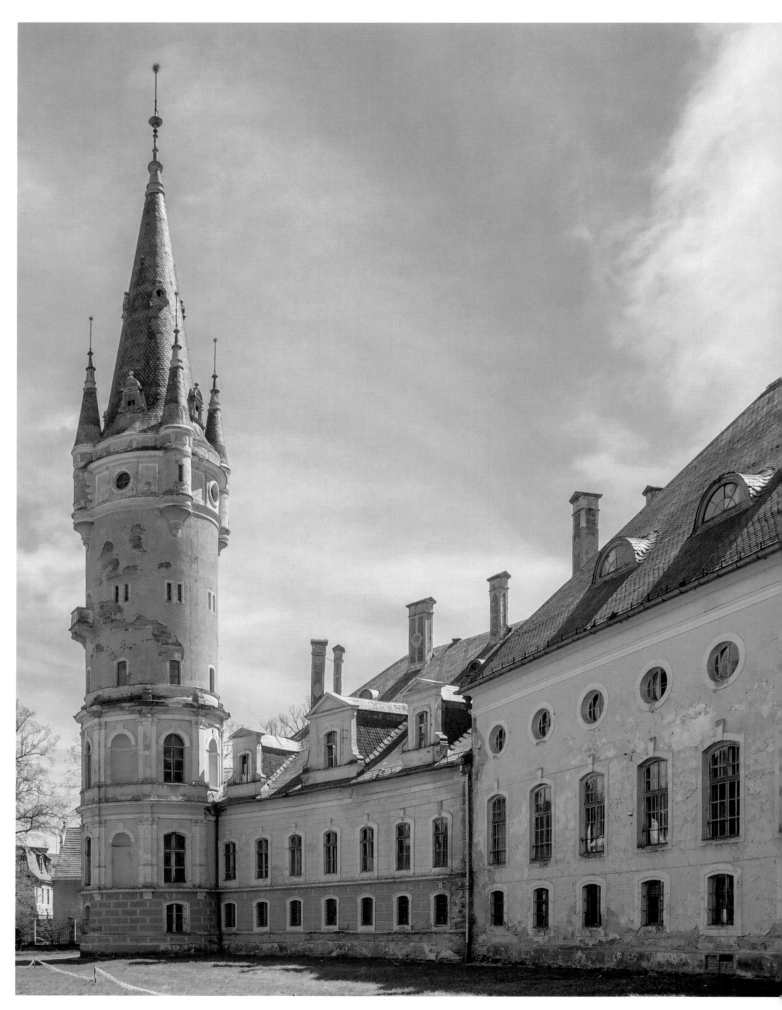

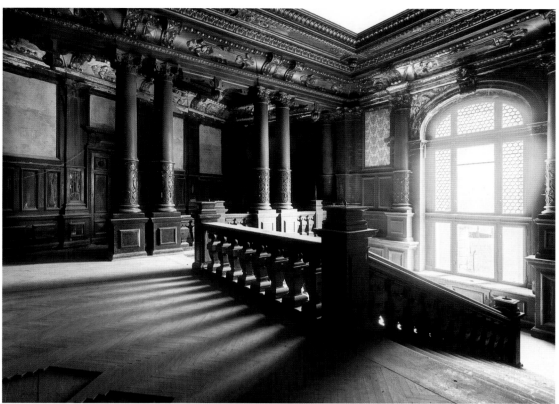

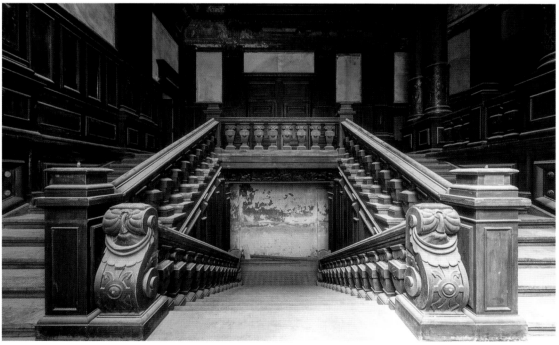

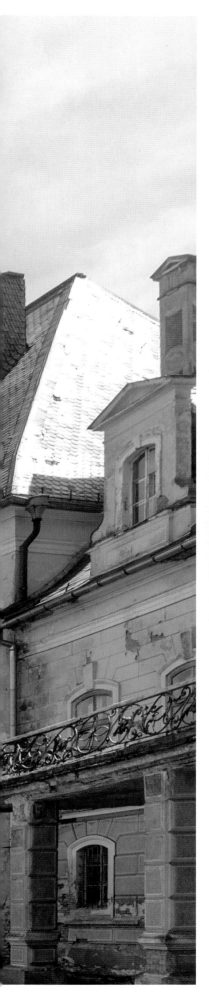

ALL PHOTOGRAPHS:
Bozkow Palace, Klodzko County, Lower Silesia, Poland
This magnificent palace was built in the 1780s, around a sixteenth-century core, by Count Anton Alexander von Magnis (1751–1817). Its château-style exterior (left), though indisputably imposing, is comparatively chaste. We owe the opulent interior, with its sweeping stairways with their massive banisters and their spectacular columns, to Anton's descendant Wilhelm (1828–88). He undertook major refurbishment works in the 1870s and didn't stint when it came to carved wooden fittings or stuccoed ceilings.

The post-war Polish government, slow to take charge, neglected the building for several years, but it was to some extent restored in the 1950s when it became a school. In recent years, however, it has once more been abandoned and has gradually been sliding into dereliction.

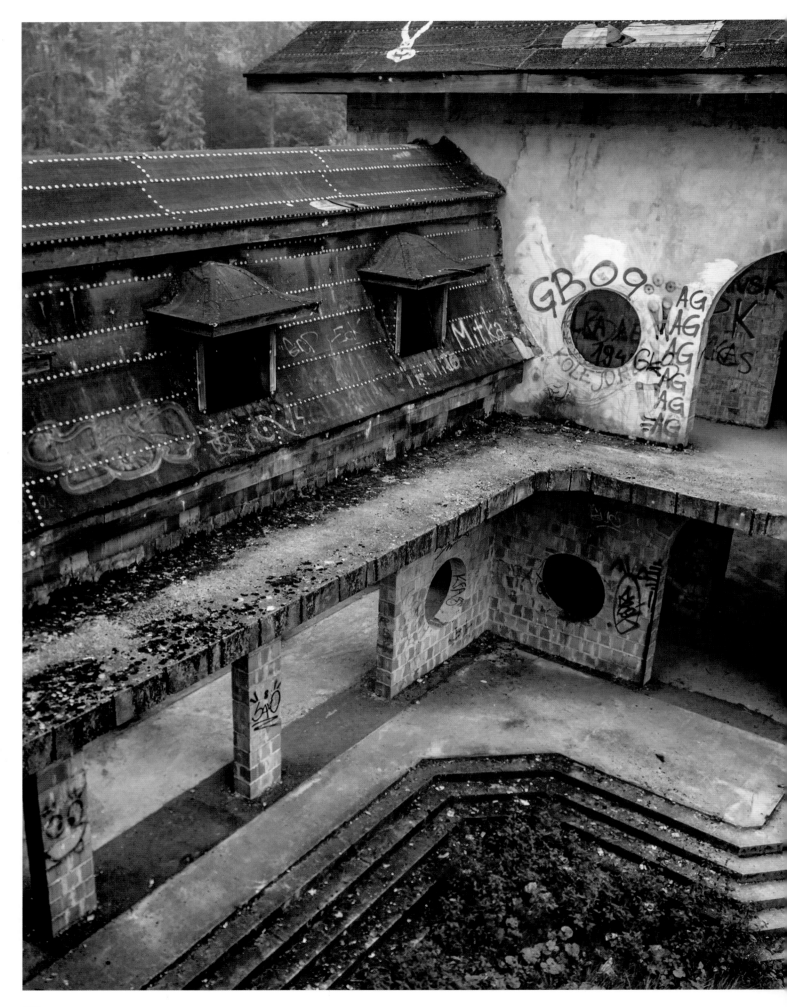

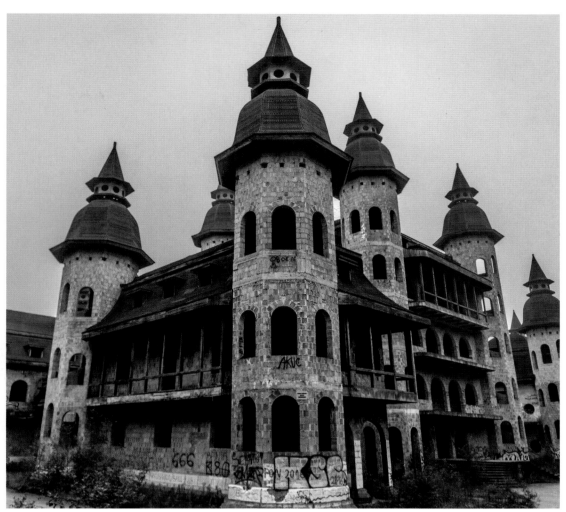

ALL PHOTOGRAPHS:

Lapalice Castle, Kartuzy, Pomerania, Poland

The most extraordinary thing about this medieval-style castle was that it wasn't built till 1979. A local artist intended it as a studio but, letting his ambition outrun all practicality, came up with this fairytale fortress instead. In hindsight, his romantic flight, though undoubtedly eccentric, doesn't seem quite so odd. This was, of course, a time when a new Polish Pope was reminding people of their long and often glorious pre-Communist past and shipyard workers were making democratic history – as the trade union movement 'Solidarity' – in nearby Gdansk. And, of course, it isn't strange at all that he fairly quickly ran out of money, leaving his creation to Lapalice's vandals – and to 'urban explorers' from far and wide.

OVERLEAF:

Sobanski Palace, Guzów, Mazovia, Poland

Feliks Sobanski (1833–1913) belonged to an old noble family, though its origins were in Podolia, southwest of here in what is now Ukraine. He acquired his Guzów estate at auction in the 1850s and commissioned architect Wladyslaw Hirzel (1831–89) to replace the old manor house with something grander and more up-to-date. The French-style château that resulted is undoubtedly impressive, though it found itself in the front line during World War I and didn't receive too much respect from the authorities in the Communist era. The Sobanski family has now got it back, and hopes one day to be back in residence: the complex is in the process of being restored, as the scaffolding here suggests.

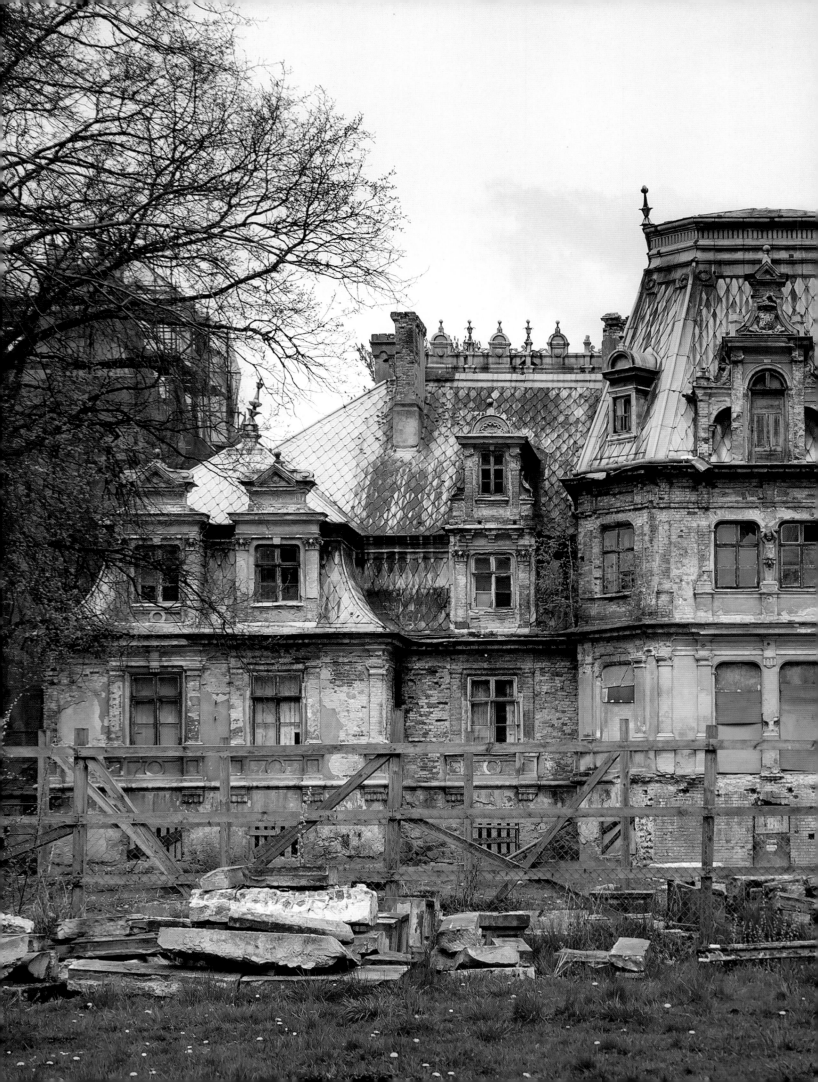

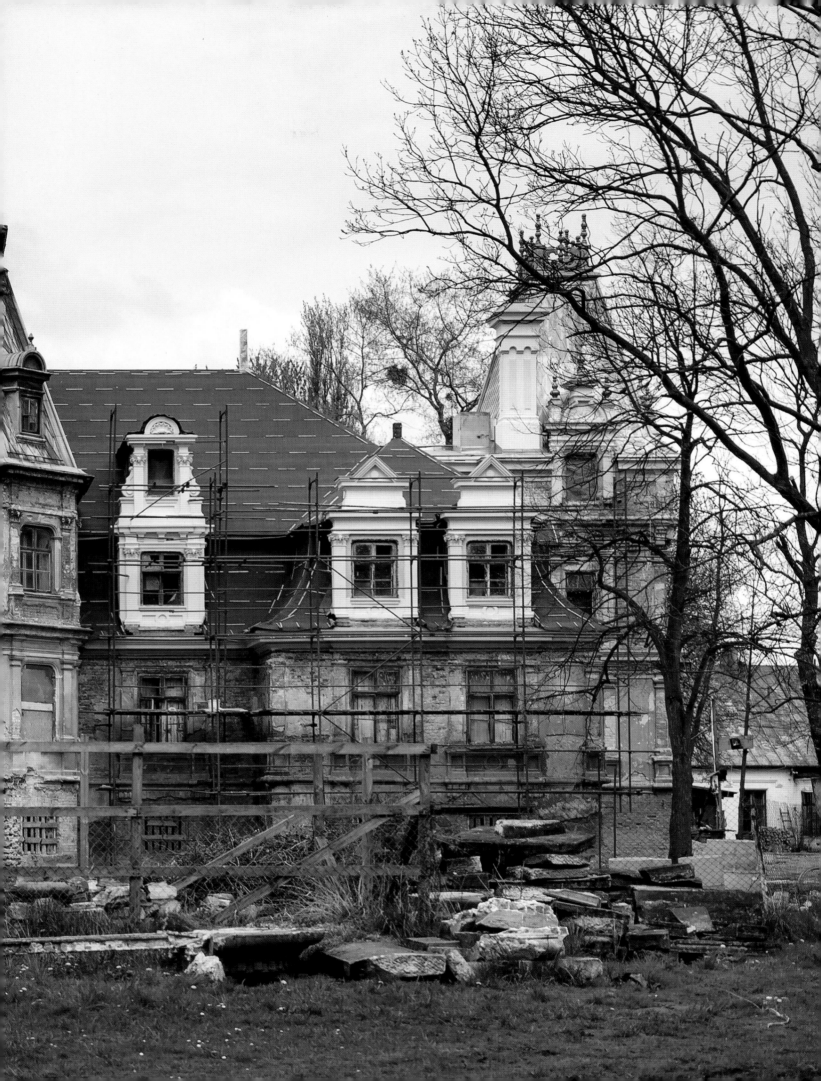

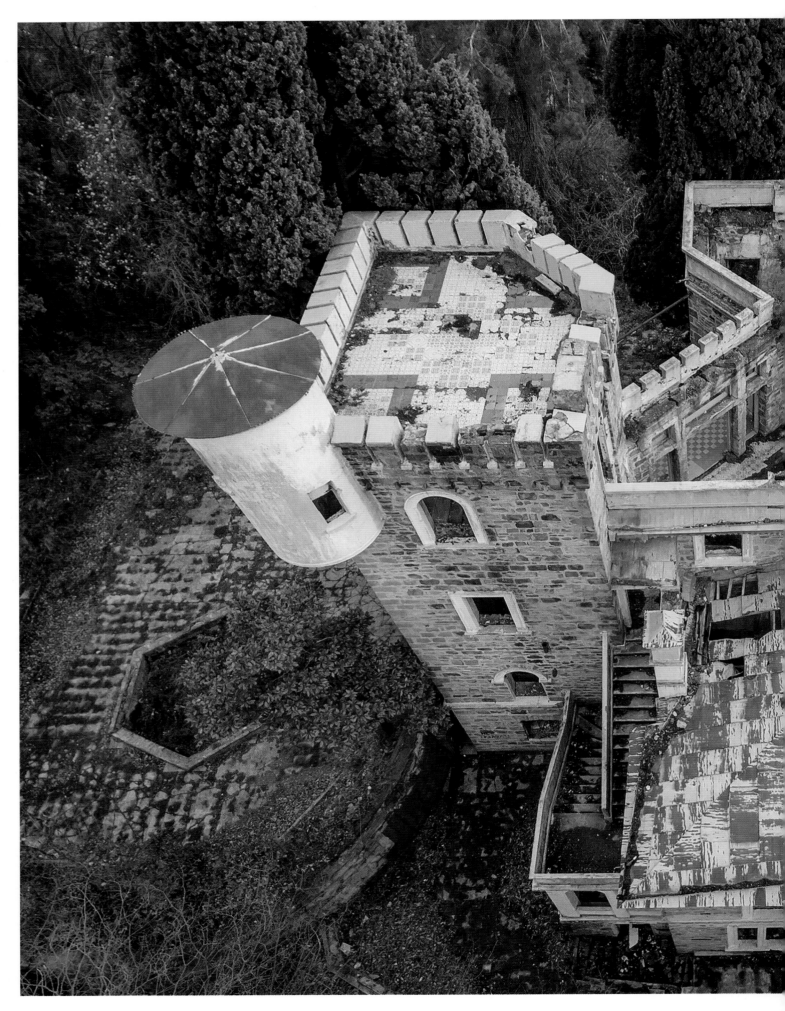

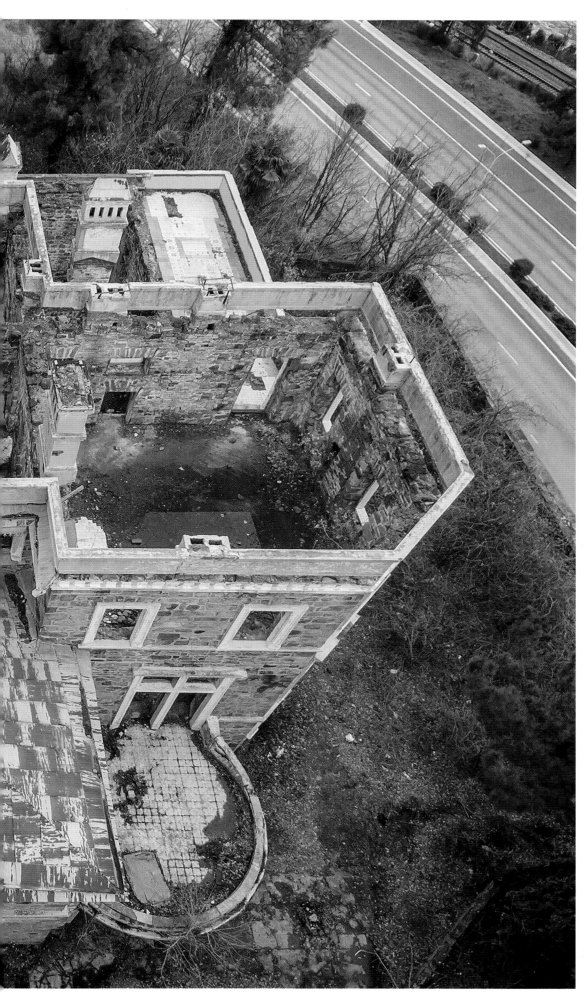

Dacha Kvitko, Sochi, Krasnodar Krai, Russia
This extravagant castle-like construction stands by the Black Sea shore, beside the coast road just a short way south of Sochi. It dates from the early days of the area's opening up as a subtropical seaside resort at the turn of the twentieth century. This continued unabated into the Soviet era, while acquiring a new aesthetic (modern, constructivist...) and social tone (official, workerist...). Big, barracks-like hotels sprang up in Stalin's time, arguably more reminiscent of Hitler's Prora than of what might be expected on any 'Riviera'. Dacha Kvitko's special charm is in reminding us of the romance, the exoticism of this coast, the escape it offered so many generations from the humdrum routines of Russian life.

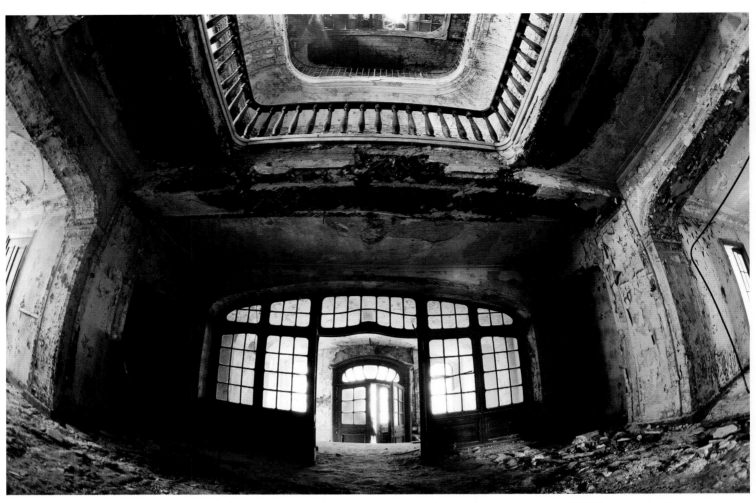

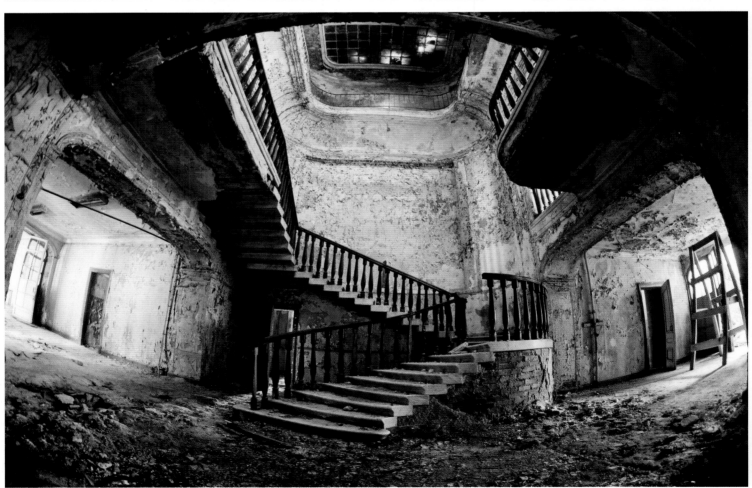

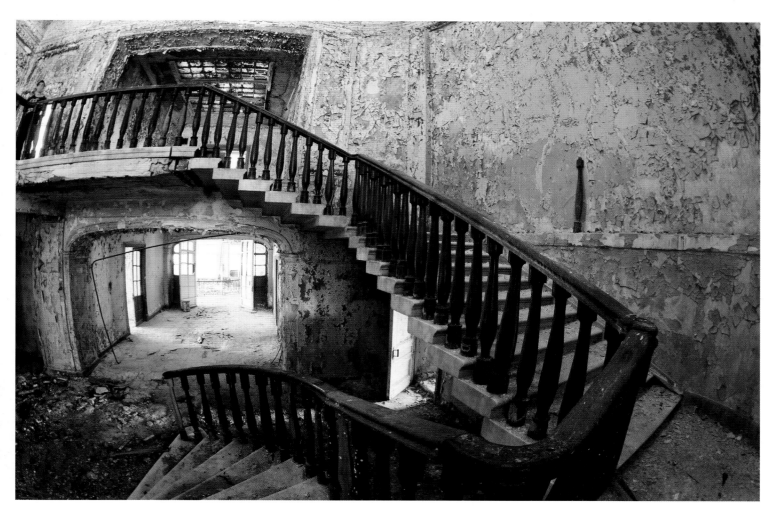

ALL PHOTOGRAPHS:

Fabergé Farmstead, Levashovo, St Petersburg, Russia

This gem of dereliction was the *dacha* (summer residence) of Peter Carl Fabergé (1846–1920), famous egg smith and celebrated jeweller to the Czars. He built this villa, some 20km (12.5 miles) north of St Petersburg, in 1900, but gave it to his son, Agathon (1876–1951), a few years later. The whole family fled the country after the Revolution of 1917. Not surprisingly, their *dacha* became a target for looters and (more official) 'liberators' alike, and it was systematically stripped of all its fittings. Despite the destruction, the structure as a whole was to survive in its essentials. Even in its ruined state, it retains a real mystique.

OVERLEAF:

Muromtzevo Castle, Sudogda, Vladimir Oblast, Russia

We're some 3500km (2200 miles) east of the Loire Valley here in a land of searing summers and snowbound winters, but this château still has the look of the real thing. Despite its disrepair, it looks the part. It is nevertheless utterly alien: Russia's notoriously violent history never included the sort of feudal phase the western countries experienced (serfdom under the Czars was a very different thing); nor, for all its wars, was there anything to be compared with the Spanish *reconquista*. So the castle as we know it – and its more refined, genteel successor, the château – has no place in the architectural traditions of the country.

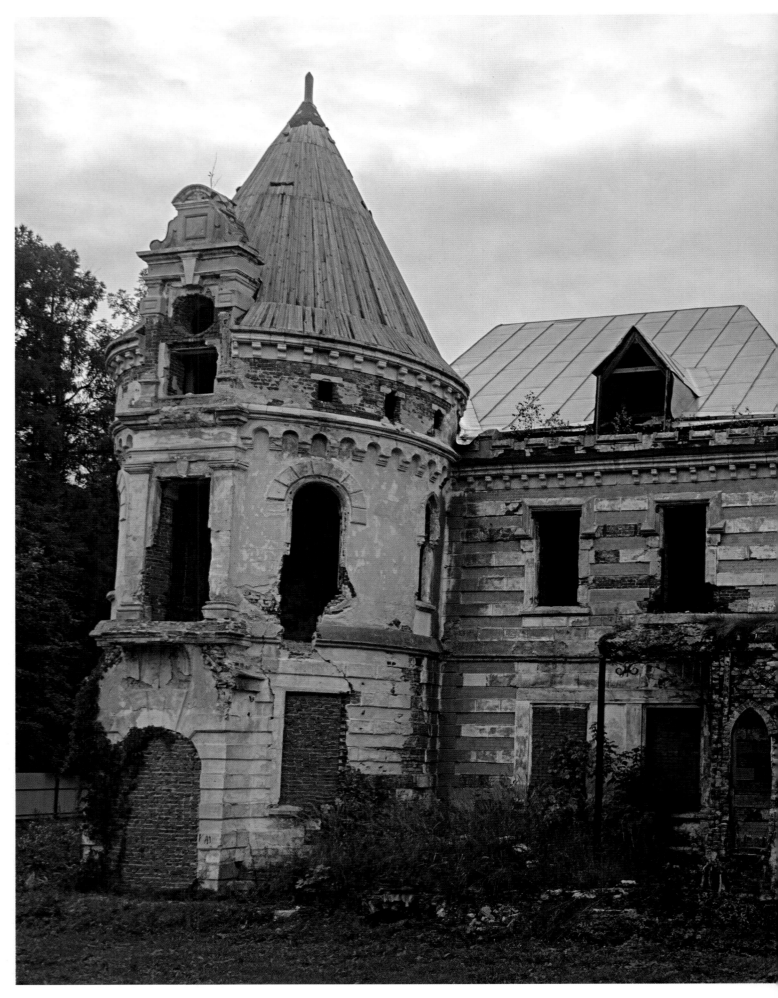

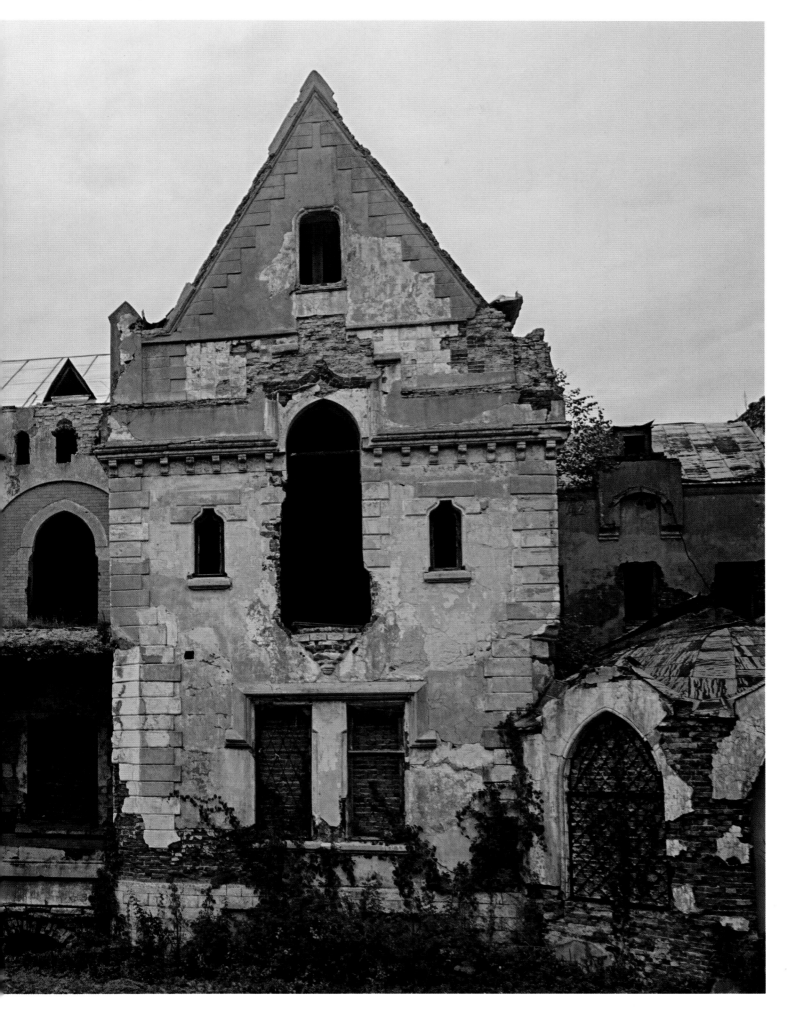

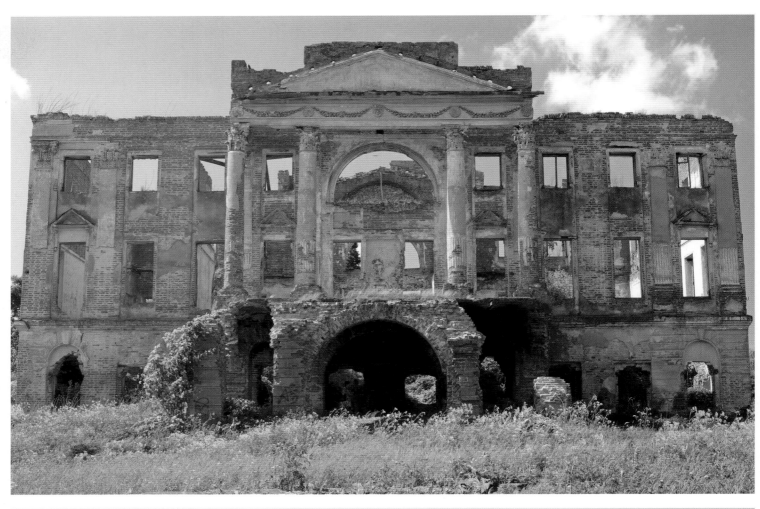

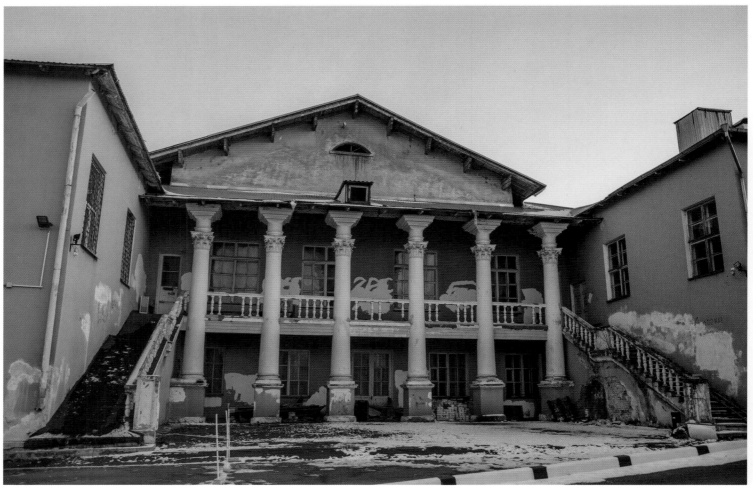

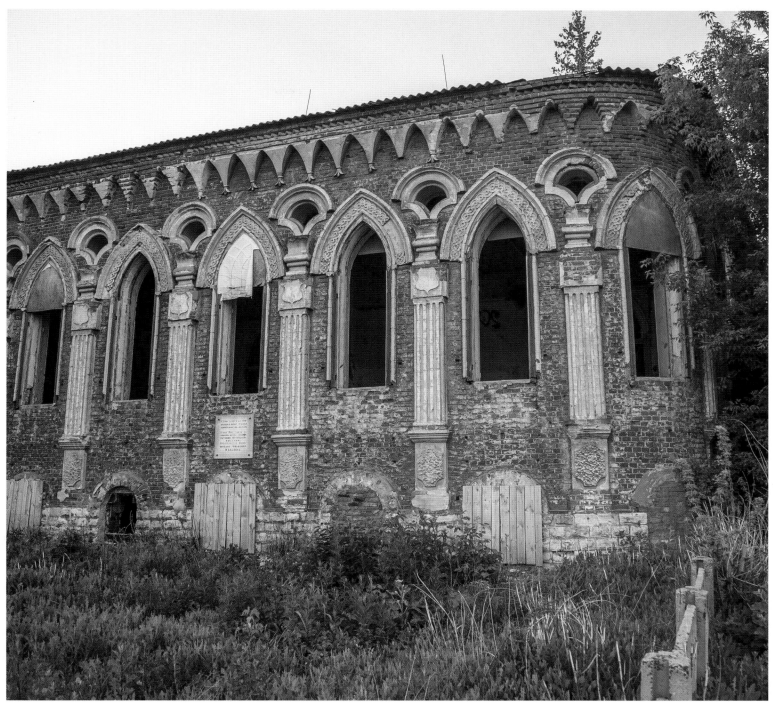

Pushchino Manor, Serpukhov, Moscow, Russia

An eighteenth-century mansion standing where the waters of the Nara flow into the Oka River was home to generations of the noble Vyazemsky family. In the early years of the twentieth century, it was sold to S.V. Perlov, whose tea house in Moscow's Myasnitskaya Street was famous across Russia. Perlov's Tea Room had an elaborately accoutred Chinese-style façade: the merchant went for something more conventionally neo-Classical – but still spectacular – for his country home.

Palace of Culture, Voronezh, Russia

There were, of course, no aristocrats in Soviet society (nor any acknowledgement that the *nomenklatura* – literally, the Party's 'named' or 'titled' officials – constituted an elite all of its own). It followed, then, that there was no place for the palace – except as a symbolically splendid place in which 'the people' could pursue the higher things in life. Movies; musical recitals; evening classes... all sorts of 'cultural' activities took place.

Abandoned mansion, Sasovo, Ryazan, Russia

A moment of architectural excitement interrupts the general monotony in what is otherwise one of western Russia's drabber towns (which is saying a great deal). Pointed, ogival windows give a Gothic look to this building in brick and stone, though altogether its ornamentation is as eclectic as it is ebullient.

Vlajkovac Castle, Vrsac, Vojvodina, Serbia

This beautiful, baroque château was built in the 1850s as a home for the Moconje family. It is also known as Bisingen Castle because, in 1888, it passed to the Austro-Hungarian Bisingen-Nippenburgh family as a dowry. After World War II, Yugoslavia's Communist government seized the property, but did very little by way of maintenance. So, indeed, it continues, though the house is back in private hands.

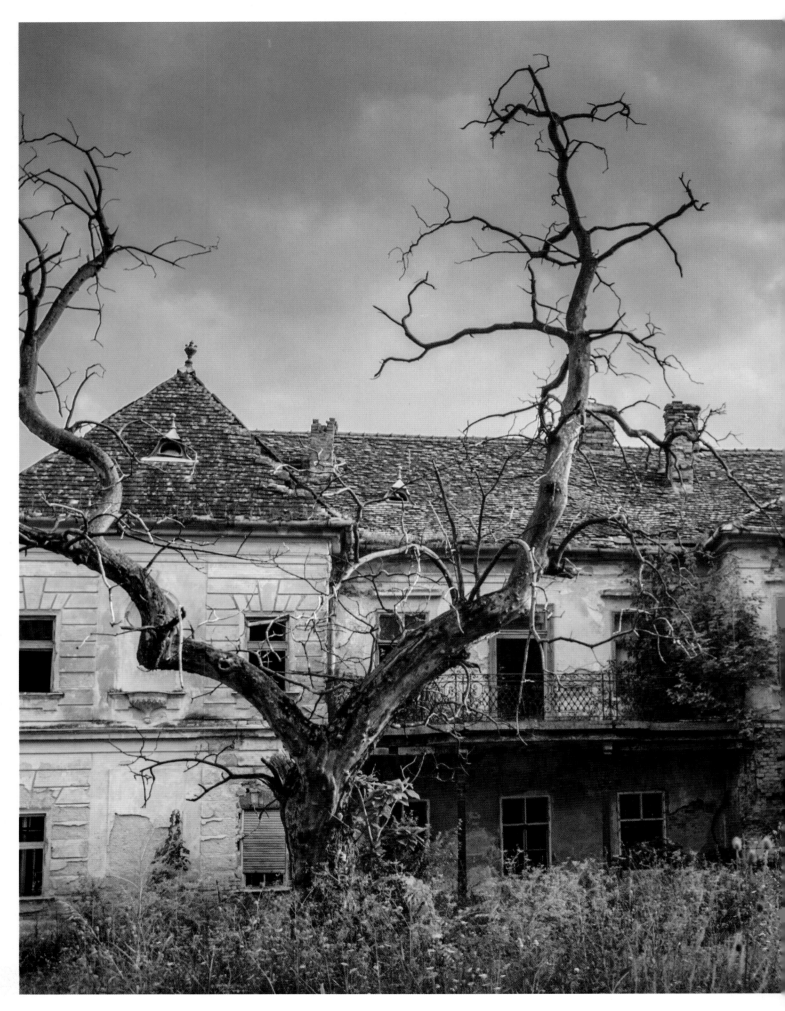

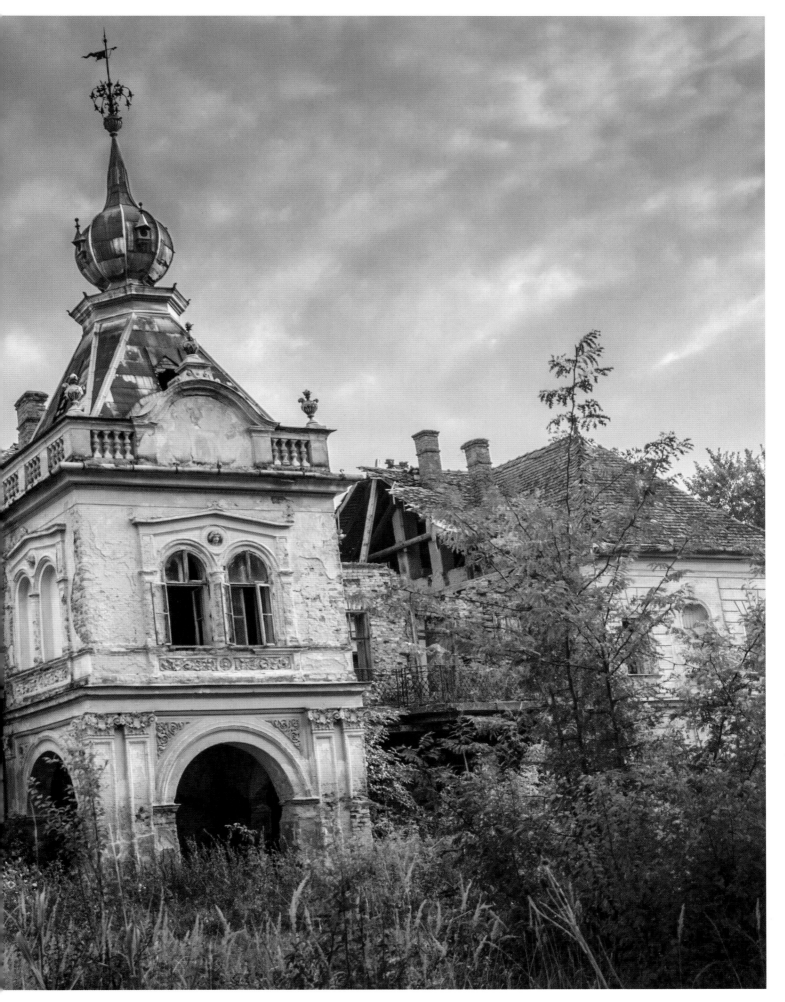

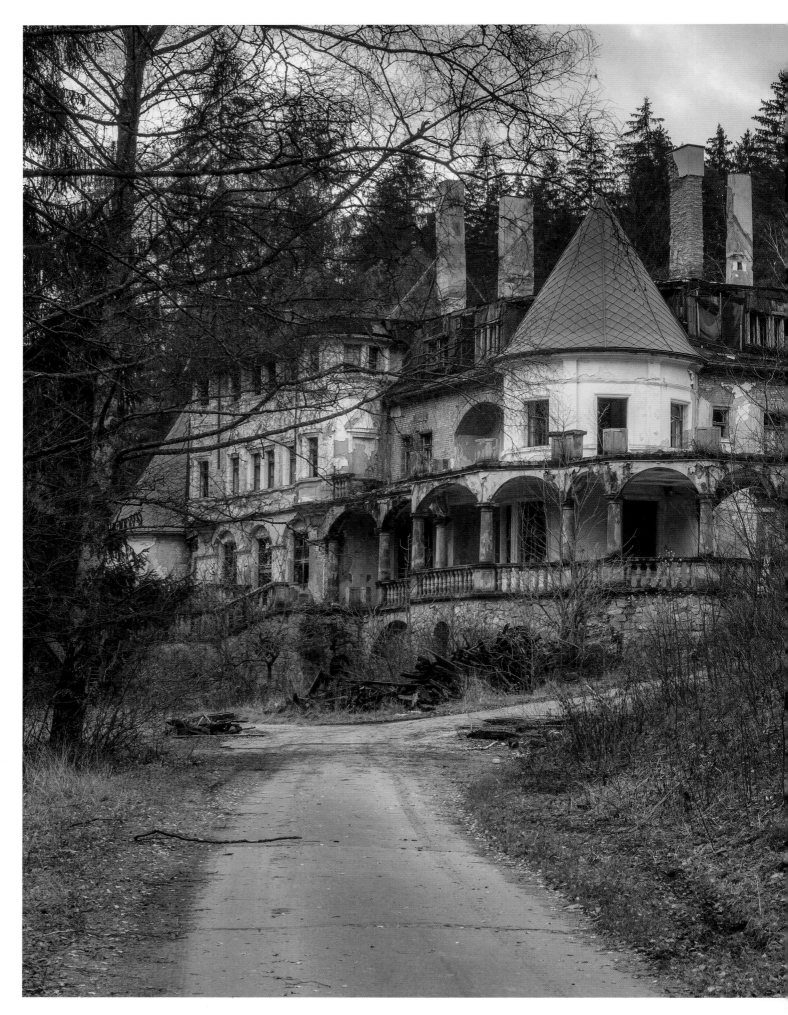

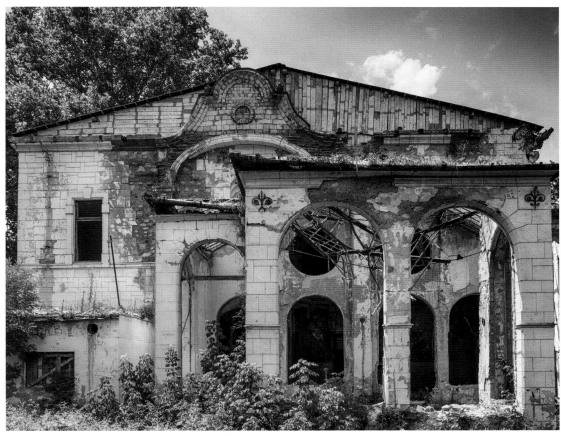

LEFT:

Abandoned health spa, Kunerad, Žilina, Slovakia

This centre of health and vigour cuts a fairly moribund figure now, its roof in tatters and its external paintwork largely gone. Slovakia boasts some 1300 officially registered mineral springs; more than 20 towns promote themselves as spas. The craze for 'taking the waters', at its height in the late nineteenth and early twentieth centuries, has held up much more strongly in Central Europe than elsewhere, but even so it has been in gradual decline.

ABOVE:

Castle Spicer, Beocin, South Backa, Serbia

A German family, in Beocin as owners of a cement works in the vicinity, the Spicers built this mansion in 1898. Standing in extensive grounds, it was designed by Imre Steindl (1839–1902), fresh from his triumph with the neo-Gothic Hungarian National Parliament Building in Budapest. 'Castle Spicer' is more eclectic. The Gothic Revival style certainly features, but so do Romanesque, Renaissance and Baroque elements.

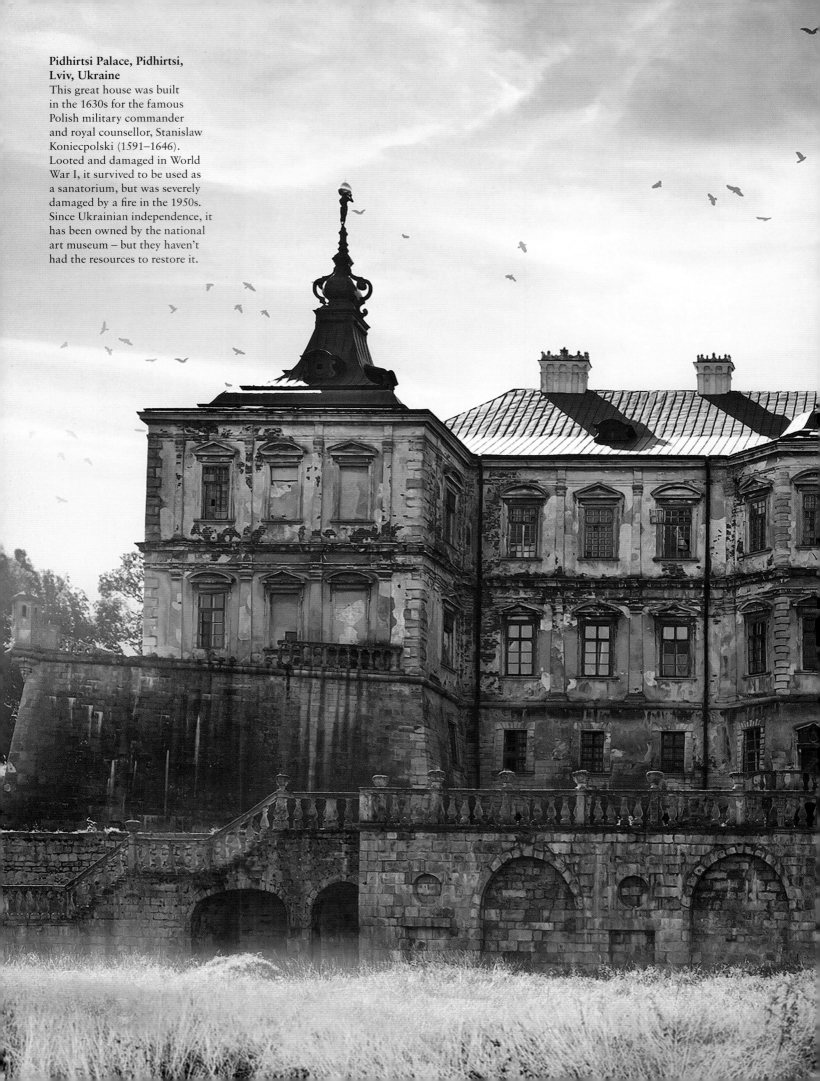

Pidhirtsi Palace, Pidhirtsi, Lviv, Ukraine
This great house was built in the 1630s for the famous Polish military commander and royal counsellor, Stanislaw Koniecpolski (1591–1646). Looted and damaged in World War I, it survived to be used as a sanatorium, but was severely damaged by a fire in the 1950s. Since Ukrainian independence, it has been owned by the national art museum – but they haven't had the resources to restore it.

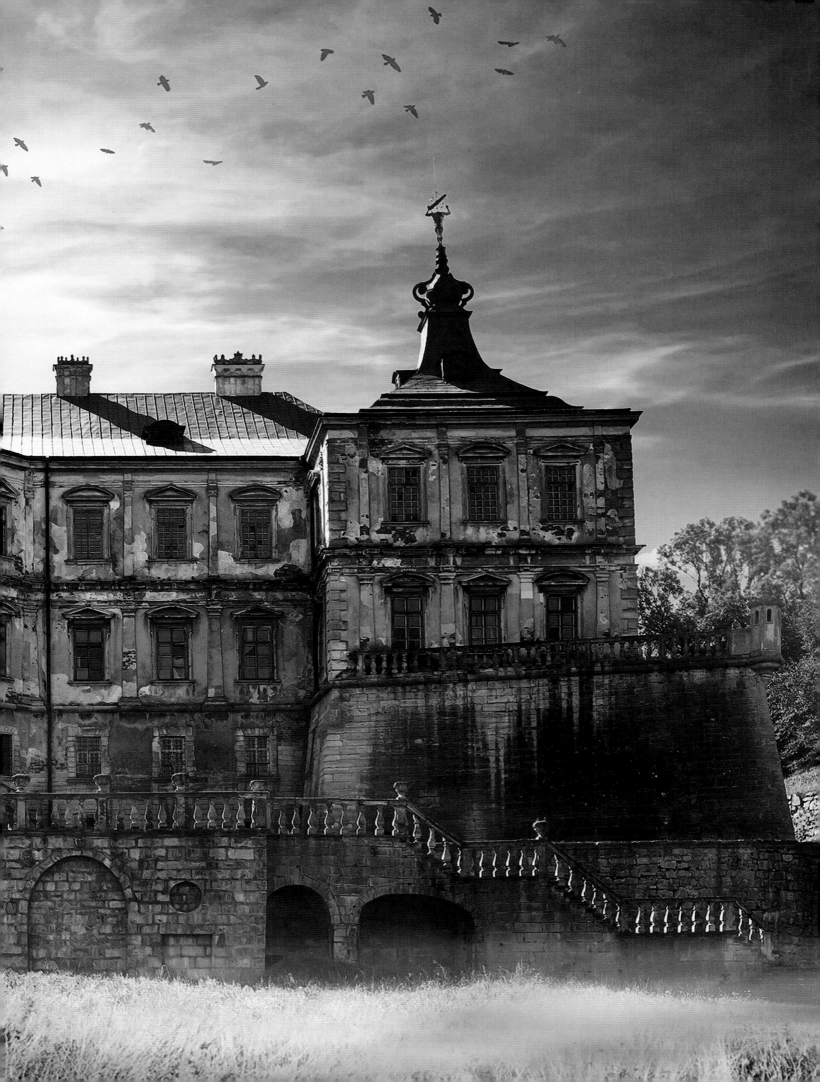

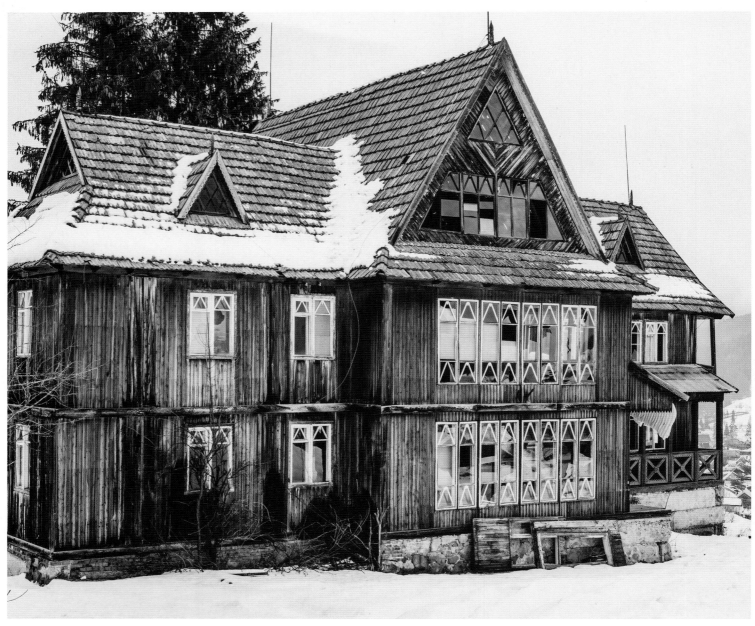

ABOVE:

Abandoned hotel, Yaremche, Ivano-Frankivsk, Ukraine
In the years between the two world wars, this area in the eastern Carpathian Mountains was part of Poland. It was an important centre for tourism at that time. It remained so in the Soviet era, but the industry's emphases were different under the state's direction, small private hotels like this giving way to larger-scale resorts.

OPPOSITE:

Ray's Mansion, Pryozerne, Ivano-Frankivsk, Ukraine
Local landowner Countess Wilhelmina Ray (1849–1907) built this extravagantly ambitious neo-Baroque mansion in the 1880s on the site of an earlier, eighteenth-century house. Her grandson took his family into exile at the start of World War II. Under the Soviets it was used as a mental hospital. After independence, it for a time became a convent, but has now stood empty and abandoned for several years.

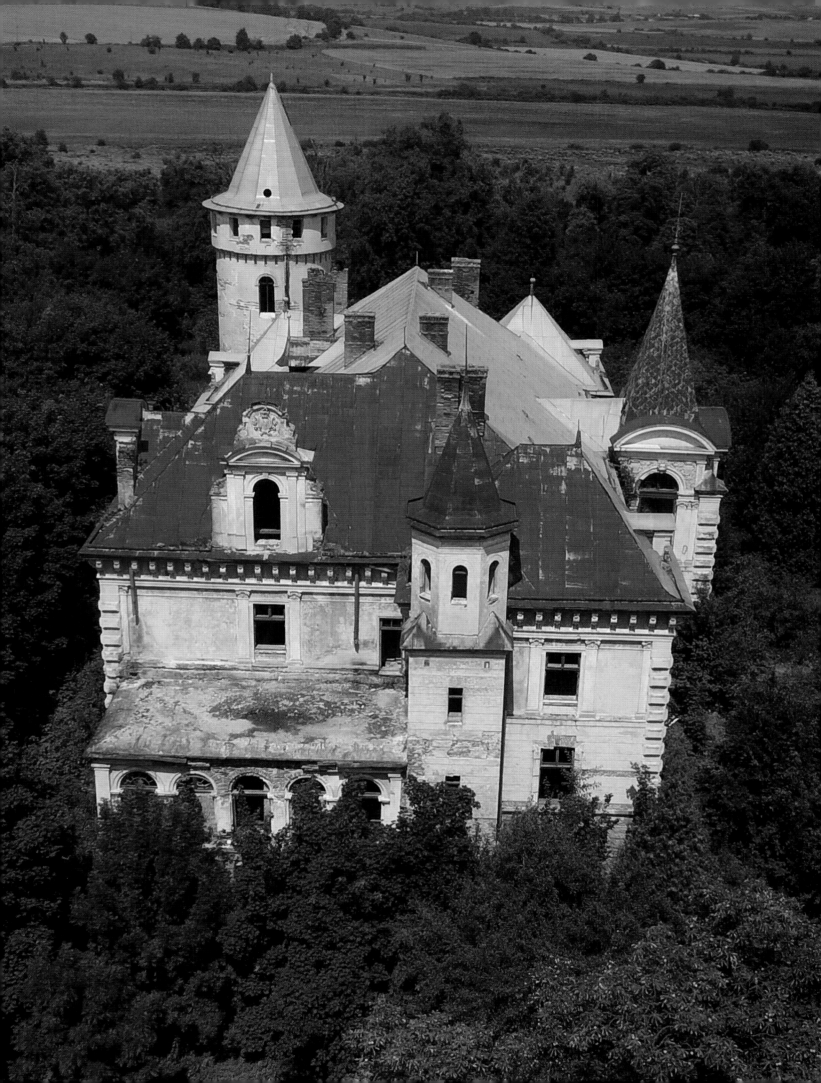

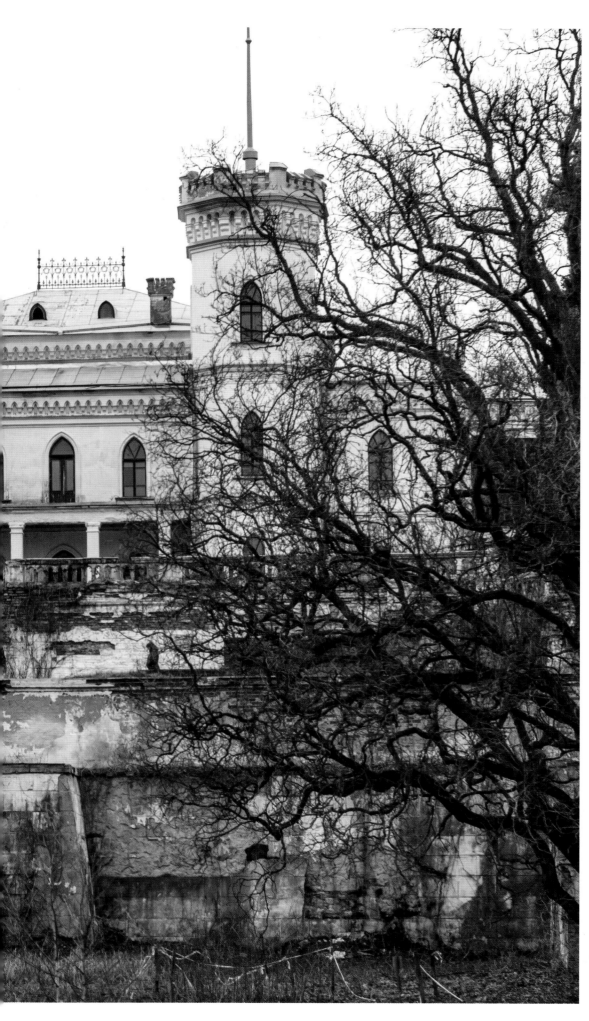

**Sharovsky Palace, Sharovka,
Kharkiv, Ukraine**
This stupendous palace was built
by Leopold Koenig (1821–1903) in
the 1870s. A self-made millionaire,
the son of poor German
immigrants, he had risen to be
Russia's 'Sugar King'. In doing so,
he had driven the industrialization
of the processing of sugar beet.
He had opened a vast refinery
complex at nearby Trostianetz.

Naryshkin Mansion, Bikovo, Ryazan, Russia

'There is nothing in the world more stubborn than a corpse,' said Russian writer Alexander Herzen (1812–70). 'You can hit it, you can knock it to pieces, but you cannot convince it.' Reports of Russia's nineteenth-century death may well have been exaggerated, but there was no disputing its deep torpor – economic, social and intellectual – or the Czarist regime's deadening obduracy in resisting change. So in considering a ruin like this one – sometime seat of a local branch of one of Russia's most famous families – it seems superfluous to look to such grand narratives as revolution and war, even if both were to have an enormous impact in this region. Like this crumbling, collapsing mansion, Russia had been rotting from within long before such tumults turned the country upside down.

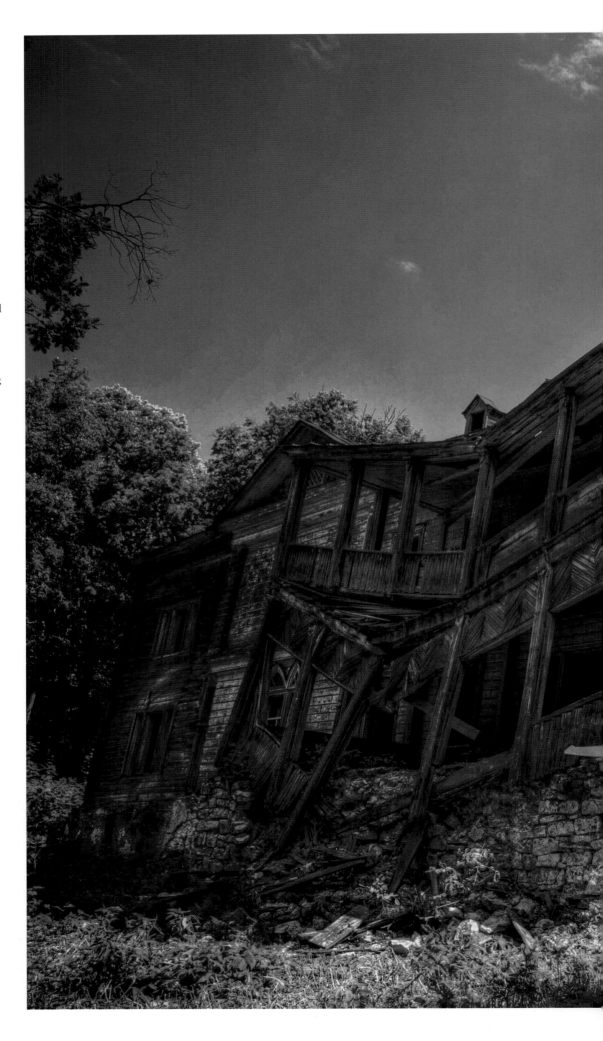

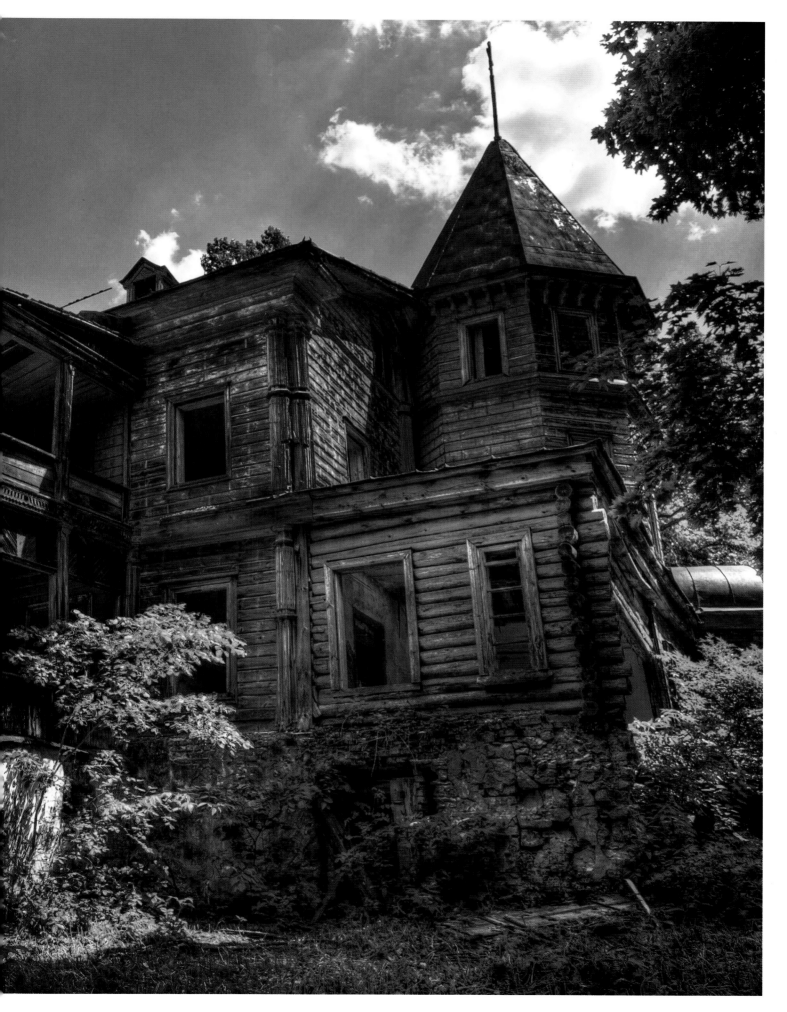

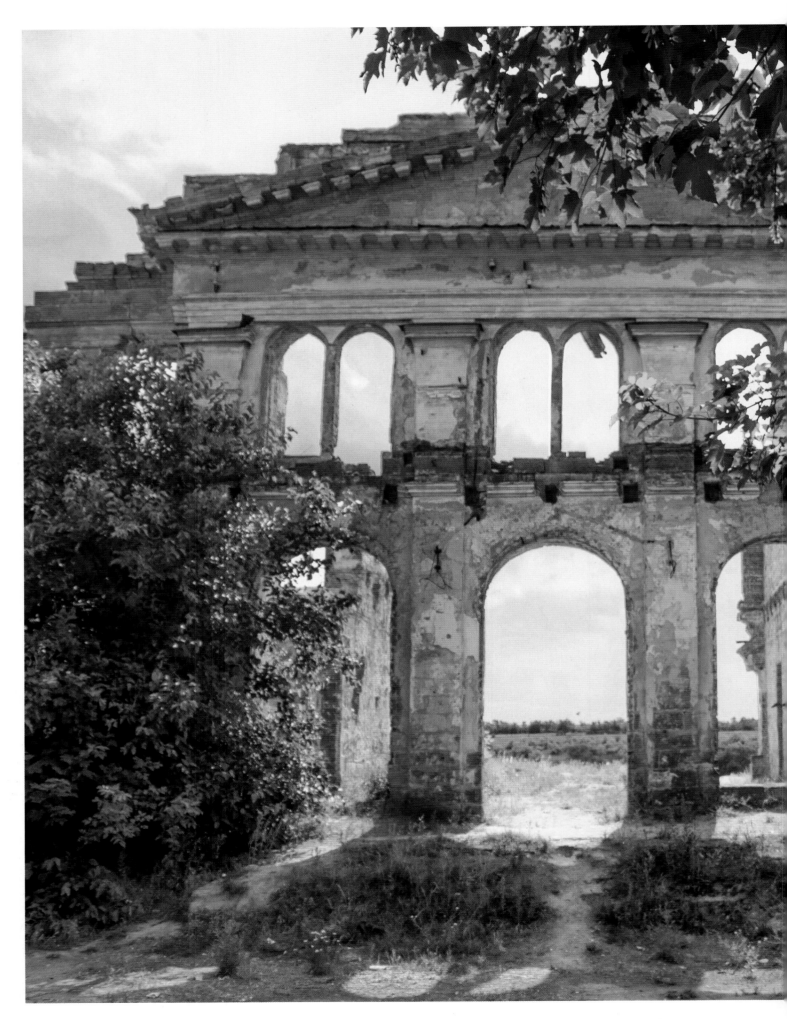

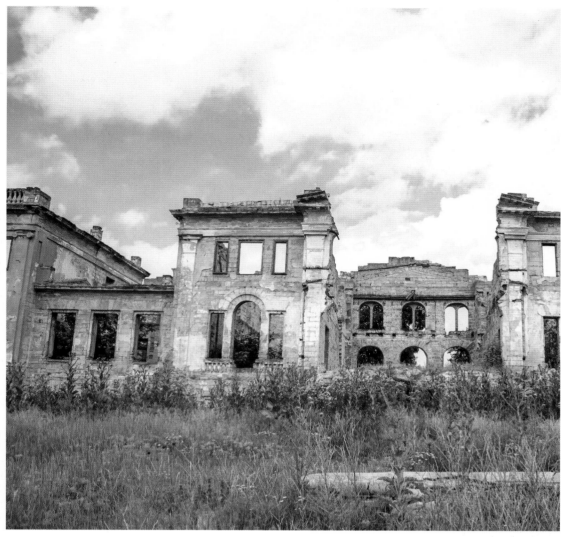

LEFT AND ABOVE:

Pankeyev Manor, Vasilyevka, Odessa, Ukraine

Built by the Dubieckis in the 1830s, this great house was bought by the Pankeyevs in 1885. Born the following year, that family's most famous son, Sergei (1886–1979) would become notorious as the 'Wolfman' – the most celebrated patient of Sigmund Freud. The name stemmed from a childhood dream in which the depressive Sergei remembered 'waking' from his sleep to see a line of wolves sitting in a tree outside his window. Freud's explanation – that this had been the boy's way of processing the trauma of witnessing his parents having sex – doesn't seem quite the clincher it once did. The father of psychoanalysis brushed aside Sergei's insistence that, in the generously apportioned sleeping quarters of an aristocratic Ukrainian household (we've seen the size of this one), such an event was inherently unlikely ever to have happened. Nor does Pankeyev's feeling that Freud was making too much psychological capital out of a single dream appear misplaced. Despite this, Vasilyevka's 'Wolfman' became iconic.

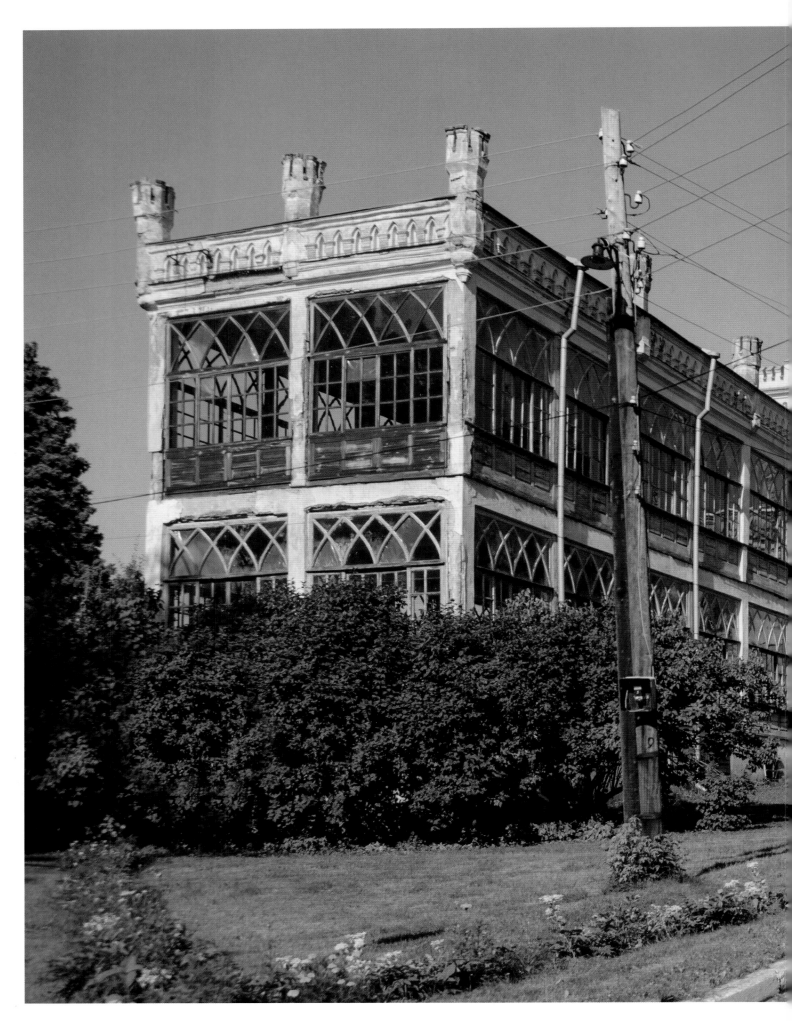

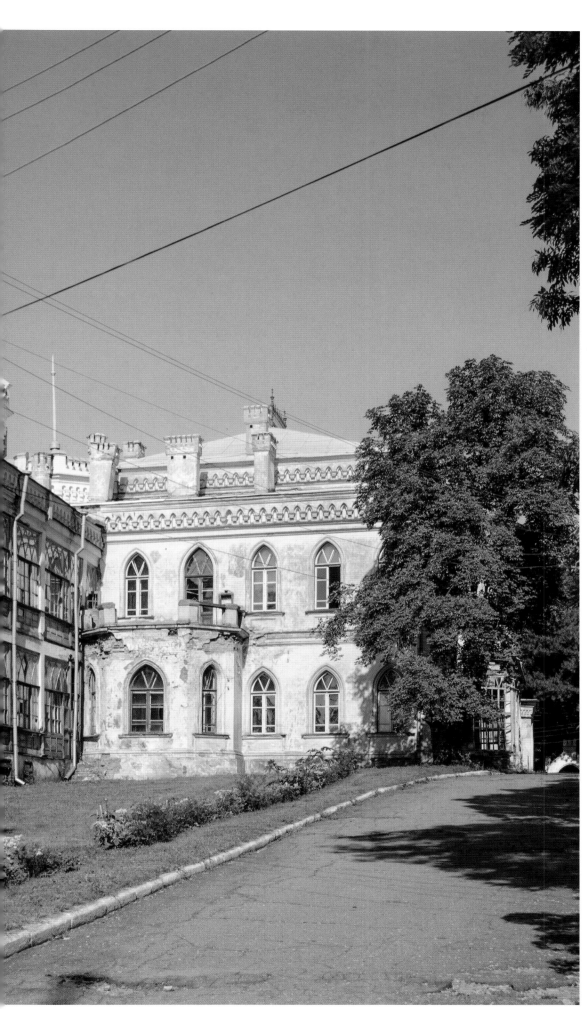

Ruined building, Kharkiv, Ukraine

Dereliction has done nothing to resolve this construction's contradictions: it can't make up its mind whether to be palace or industrial plant. The main building (in the background here) clearly leans towards the former – but the boxy wing is functional at best. This despite the fact that the architect has gamely tricked it out with an ornamental entablature, with a frieze of little Gothic arches and a row of tiny turrets up above. The folksy, traditional windows undoubtedly do show a certain flair, as shabby as their woodwork is: they might have been worthy of a better building. There's a real pathos about this ruin, a monument at once to architectural ambition and to real-world constraints.

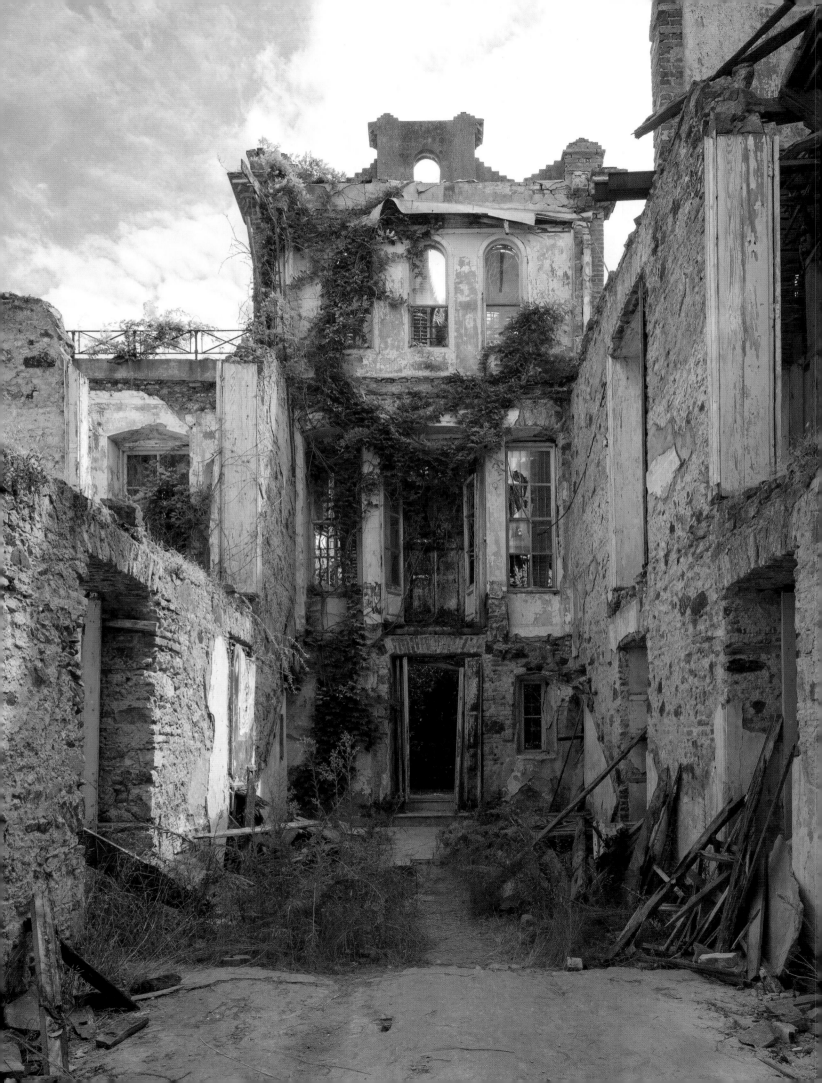

Africa and the Middle East

All humankind came out of Africa, the recent science has suggested; the so-called 'Cradle of Civilization' was in the Middle East. But both regions were to feel the impact of the Arab expansion of the seventh century onwards. They were also to bear the brunt of European colonialism in the nineteenth and early twentieth centuries – and of its agonizing aftermath in the decades since.

The focus of this book has not been yet again to revisit the grandeur that was Greece, the glory that was Rome, or the magnificence that was Medieval Europe. Its intellectual interest has been much more in those ruins that represent the places that were left in the historical slipstream; its aesthetic concern with the kind of 'accidental' sublimity achieved by inherently more mediocre, less significant buildings. Likewise now we pass by older African achievements like Great Zimbabwe, or the still more ancient civilizations of Nubia, Sumeria and Babylon, and the tomb and temple complexes of the Pharaohs, to consider less august, yet in some ways more intriguing, ruins. Generally speaking, they represent not the founding civilizations of Africa and the Middle East but the mongrel modernity to which they have been the heirs.

OPPOSITE:
**Leon Trotsky Mansion,
Büyükada, Turkey**
Exiled from Stalin's Soviet Union, Leon Trotsky (1879–1940) spent four years on this lovely island in the Sea of Marmara with his second wife, Natalia Sedova (1882–1962), before the Turks expelled them in their turn. They spent the last year of their sojourn in this house, first built in 1850.

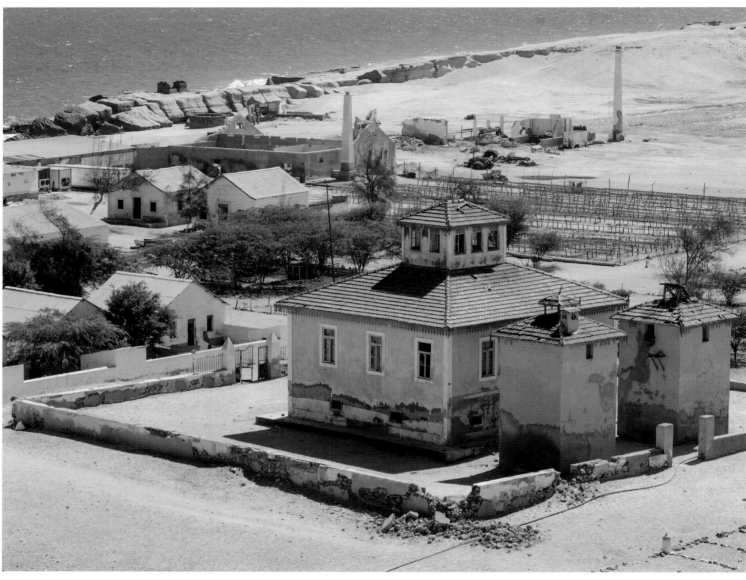

ABOVE:

Colonial mansion, Mucuio, Angola

Built by Portuguese colonists but now abandoned, this pink mansion dominates the desert scene, and the tiny fishing village it stands outside. From Diogo Cão's first visit (1484), the Portuguese had a presence in Angola that ended only with their withdrawal in the 1970s. For the most part, though, they did not generally penetrate too far into what was often an inhospitable interior.

RIGHT:

Berengo Palace, Bobangui, Central African Republic (CAR)

Bobangui is no more than a village, but it was the birthplace both of the CAR's founder, Barthélémy Boganda (1910–59) and Jean-Bedel Bokassa (1921–96) – kleptocratic president (and eventually self-styled emperor) of the CAR. Hence its designation as the administrative centre of the country and the siting of Bokassa's palace here.

OPPOSITE:

Berengo Palace

Bokassa, the people said, fed his enemies to crocodiles in his swimming pool. Claims of cannibalism were made against him, too. It is not known how many died during his reign of terror, though the figure is assumed to run into the thousands, including many children. He did his level best to bankrupt his mineral-rich country, too.

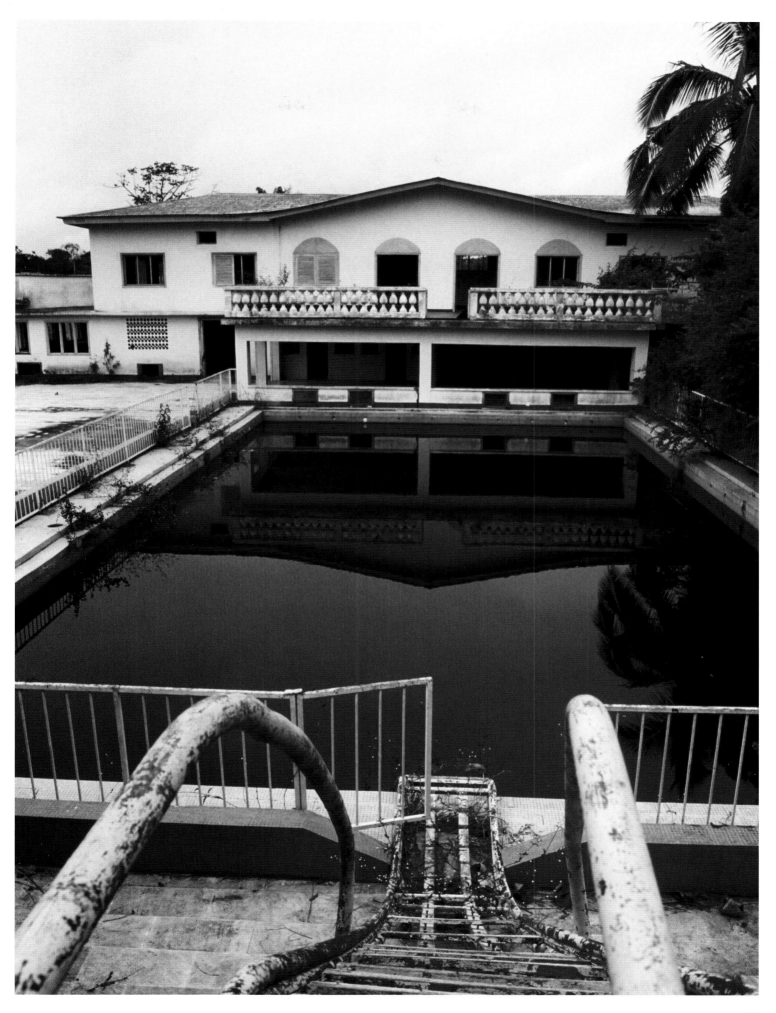

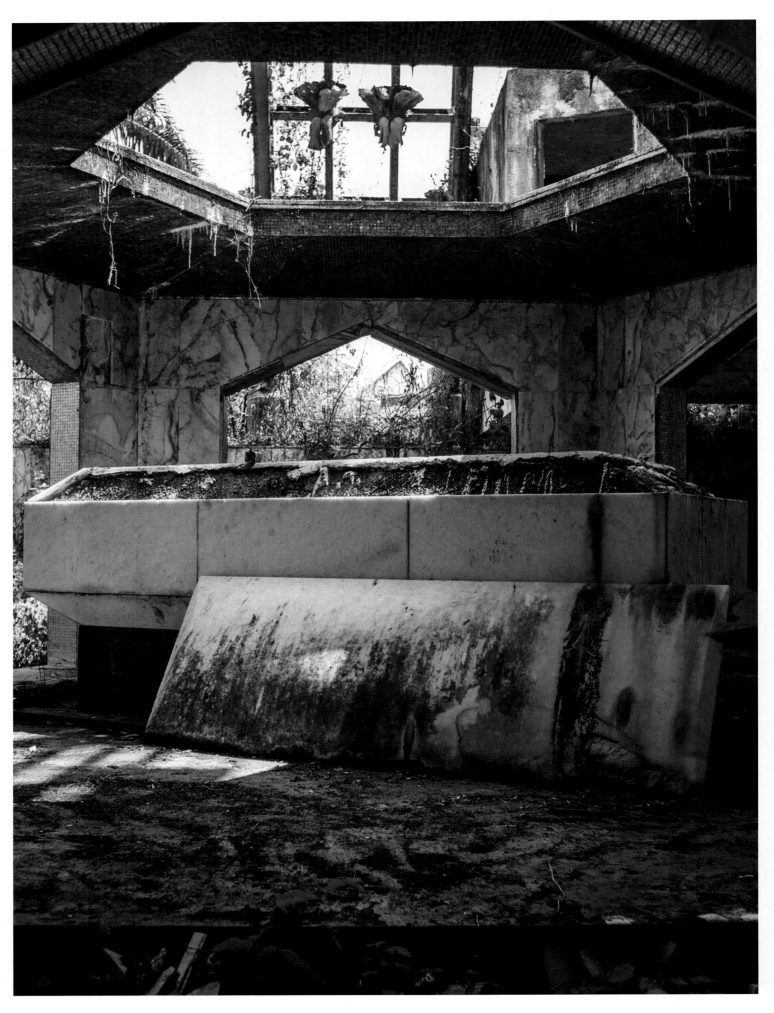

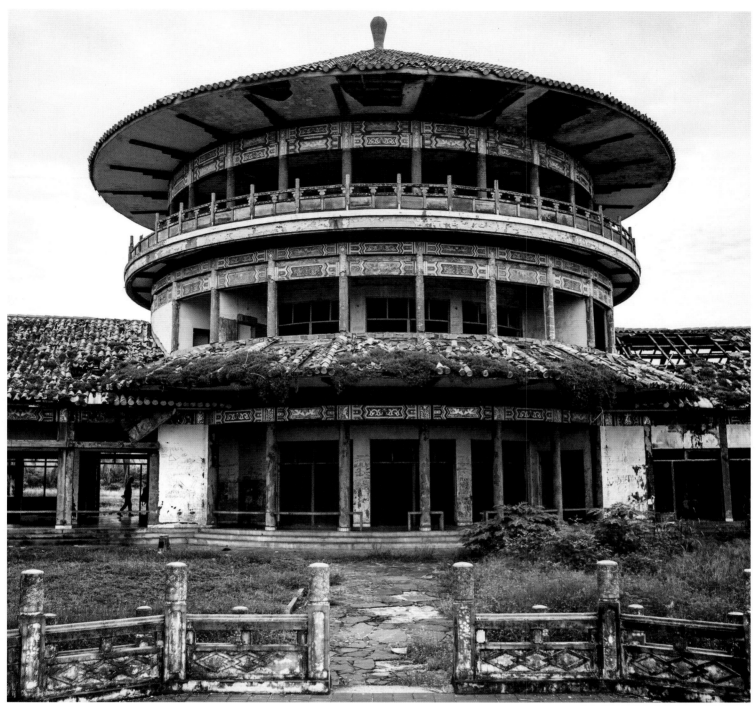

Tomb of Marie-Antoinette Mobutu, Motel Nzekele, Gbadolite, Democratic Republic of the Congo

Here lies the first lady of the late Mobutu Sese Seko (1930–97), President of the late Republic of Zaire. Marie-Antoinette died in 1977, aged just 36, after bearing the dictator nine of his 21 children. Marie-Antoinette's tomb is in a Mobutu-built motel which, though now abandoned, still seemingly belongs to his descendants.

Presidential Palace, Gbadolite, Democratic Republic of the Congo

Mobutu may have been a monster, but the United States and Belgium backed him as seeming preferable to Patrice Lumumba's leftist rebels. Believed to have helped himself to up to US$15 million from his country's coffers, he created a personality cult, key to which was the construction of once-prestigious palaces and public buildings.

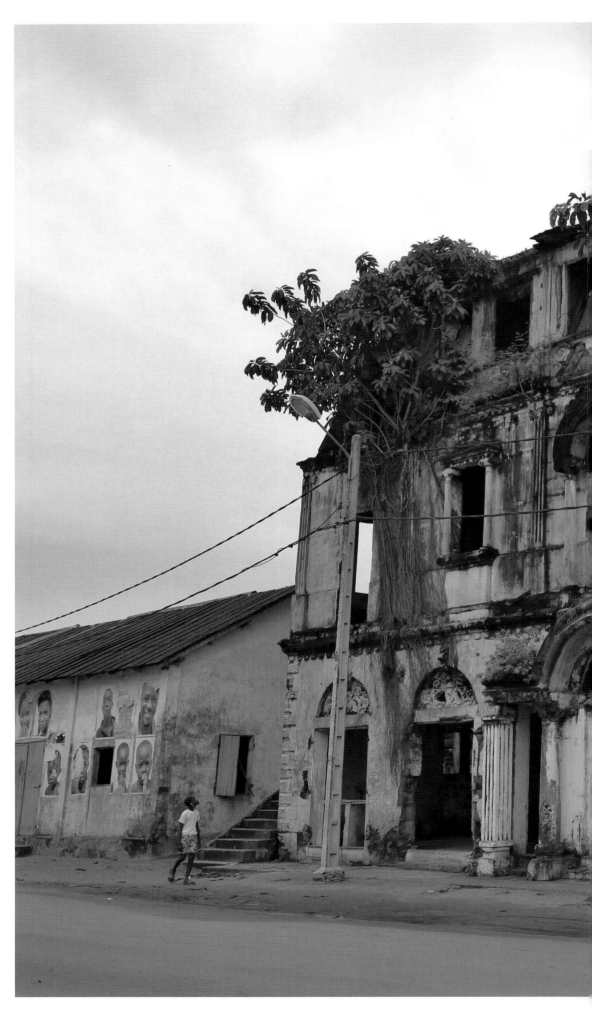

RIGHT:
**Abandoned building,
Grand-Bassam, Côte d'Ivoire**
A veritable shrubbery sprouts from among the masonry of what was once clearly a big and handsome building, which now lies open to the elements. The colonial capital for several decades, Grand-Bassam lost that status to Bingerville (now a suburb of Abidjan) after a yellow fever outbreak in the 1890s. The port city limped on through the twentieth century but was soon evidently in inexorable decline, and by the 1960s had been more or less abandoned.

OVERLEAF:
**Baron Empain's Palace,
Cairo, Egypt**
'Orientalism' flourished in France's *Belle Époque*, but Alexandre Marcel (1860–1928) really doubled down on the craze when the Belgian banker and industrialist (and amateur Egyptologist) Baron Édouard Empain (1852–1929) commissioned him to design his Cairo mansion. Not content with the obvious pseudo-Pharaonic or Arabesque options, Marcel drew his inspiration from further east – from Cambodia's famous Hindu temple complex Angkor Wat. As impressive as it seems, the baron's palace did involve some architectural sleight of hand: it was built in reinforced concrete, not in stone.

156

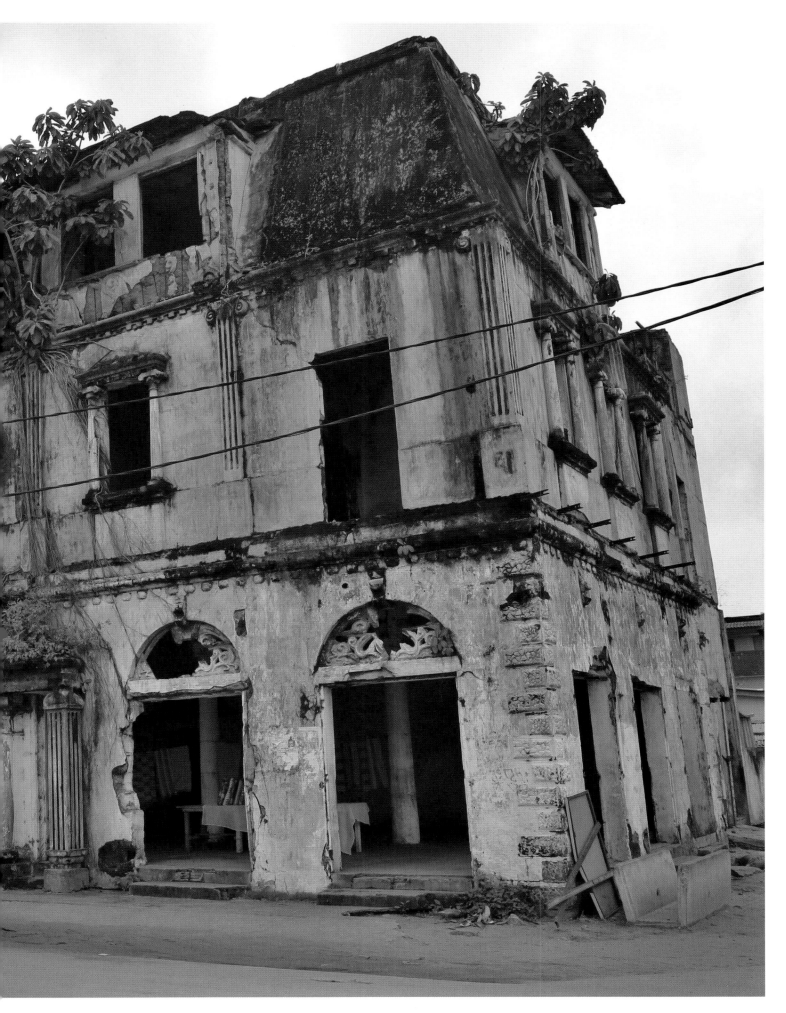

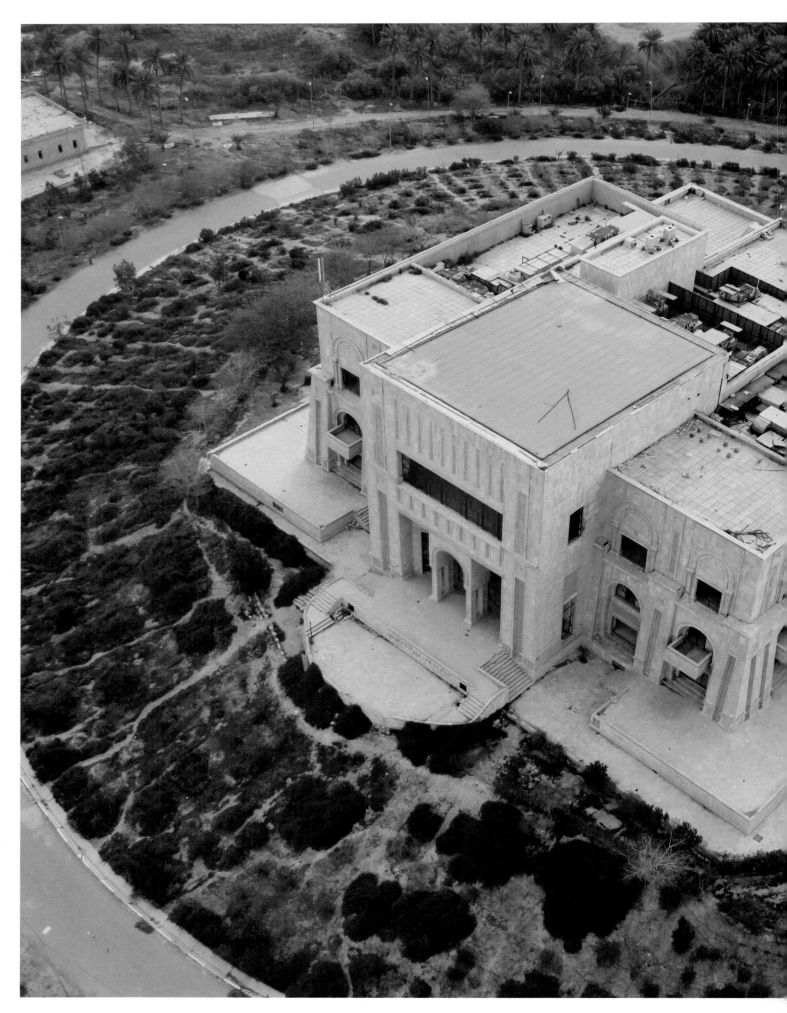

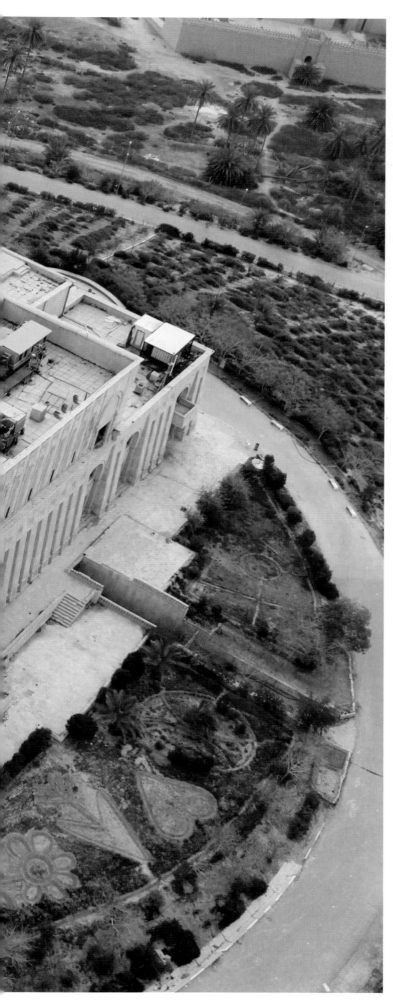

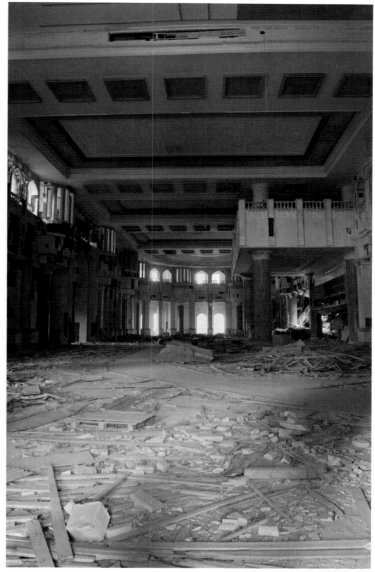

LEFT:

Saddam Hussein's Palace, Hilla, Babil Governorate, Iraq

Saddam Hussein's (1937–2006; president 1979–2003) homage to Babylon is now as much a ruin as the real thing, on whose foundations this residence was built. Allegedly, it is a replica of the palace of Saddam's (equally despotic) predecessor Nebuchadnezzar II (c. 605 BCE). In practice, as magnificent as it no doubt was, that building was – like all Mesopotamian monuments – of mud-brick construction. Its structures, and their design details, hav been long since lost.

ABOVE:

Victory Over America Palace, Baghdad, Iraq

A palace fit for a fallen despot. Saddam Hussein had this complex built to commemorate his supposed triumph in the Gulf War of 1990–1. It was still under construction in 2003 when work was interrupted by US 'shock and awe' tactics. It remains incomplete and empty, a monument to unchecked tyranny and overweening pride.

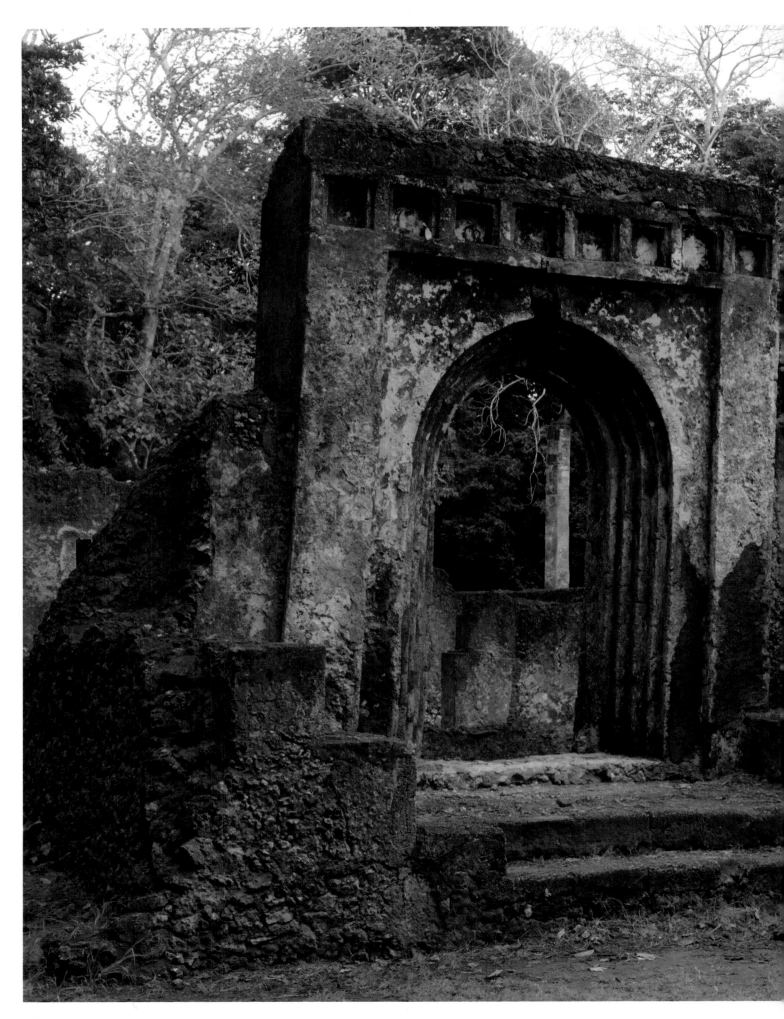

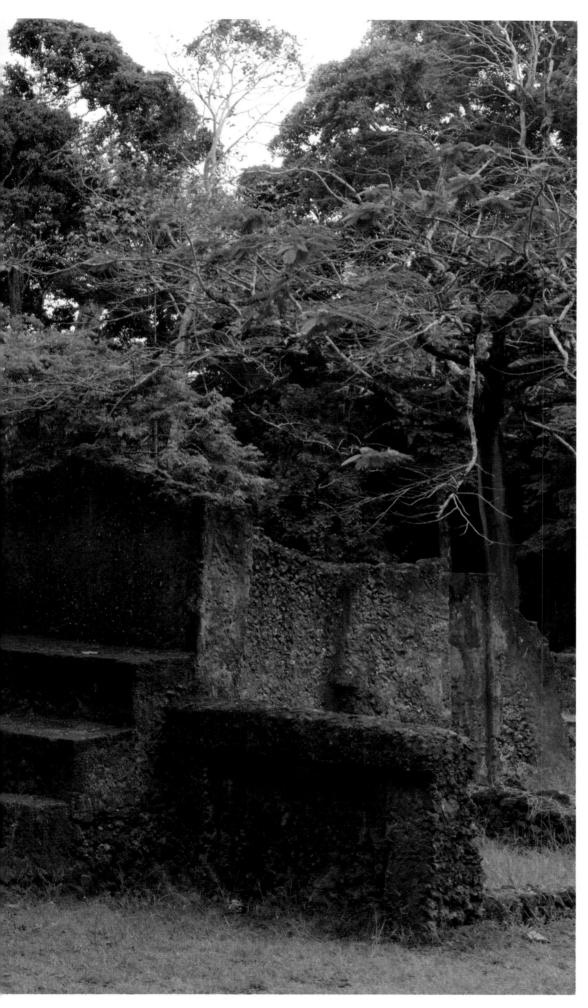

LEFT:
Swahili Palace, Gedi, Kilifi, Kenya
Arab merchants had already been plying East Africa's coast for many generations when the Gedi sultanate was founded – perhaps as early as the eleventh century. A new trading language had evolved: Swahili – a blend of Arabic and Bantu – and with it an associated hybrid culture. By the seventeenth century, however, Gedi had been abandoned.

OVERLEAF:
Bechara el-Khoury Palace, Zuqaq al-Blat, Beirut, Lebanon
Lebanon was long celebrated for the liveliness of its culture, a fusion of all that was most sophisticated in the Arab East and the French West. A monument to that vanished but still valued past, this nineteenth-century mansion was left gutted by artillery fire – one more casualty of the civil war that, in the 1970s and 1980s, made Beirut a byword for destruction all around the world. Despite its dereliction, its earlier magnificence is unmistakable; its elegant arches on their shapely columns; its beautiful proportions; its light and airy atmosphere.

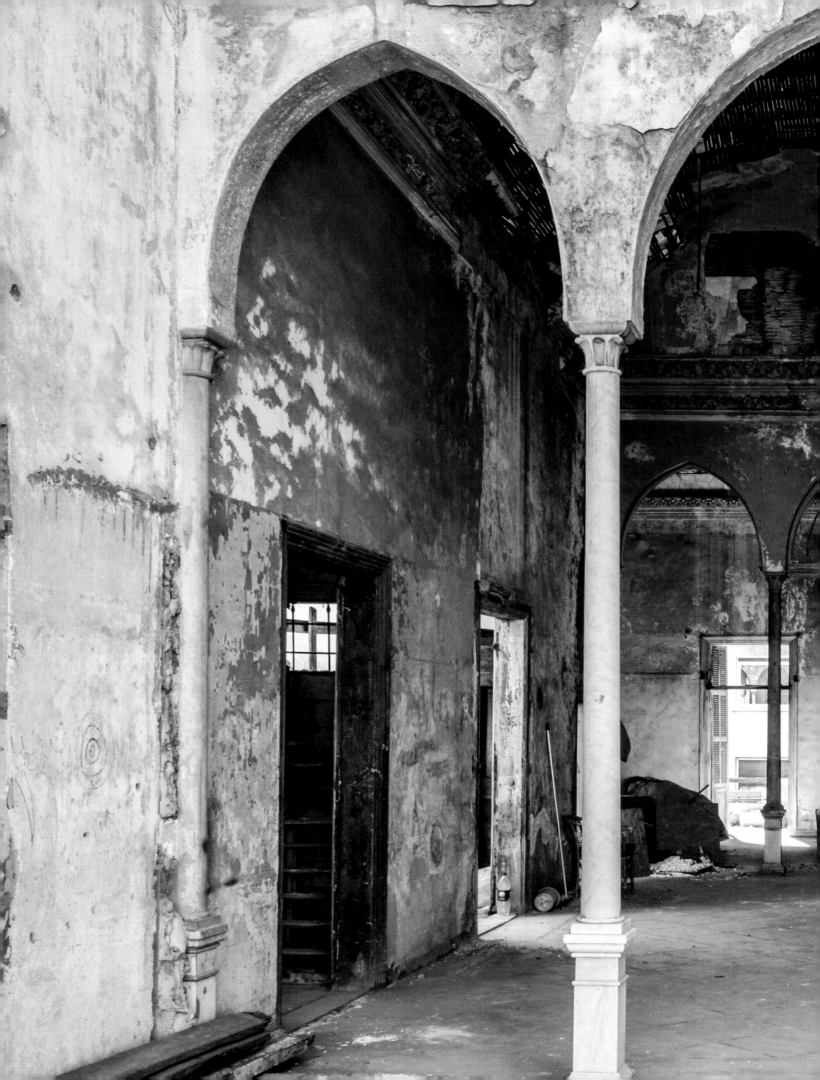

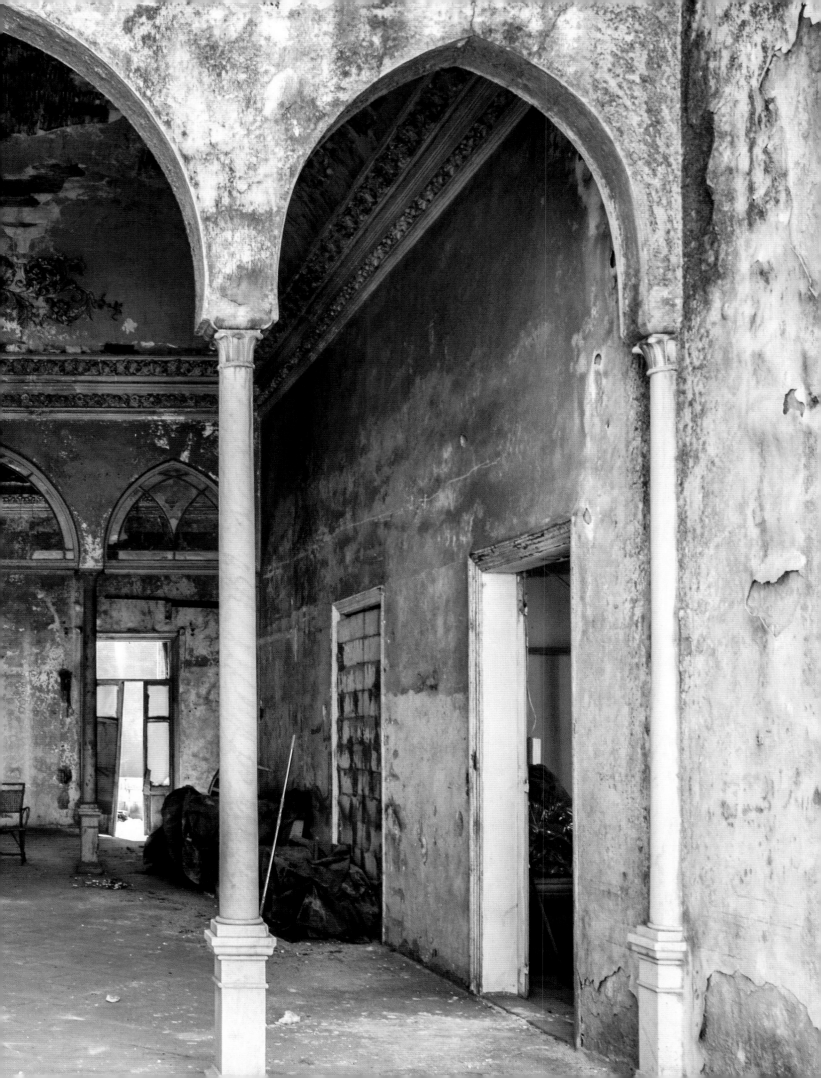

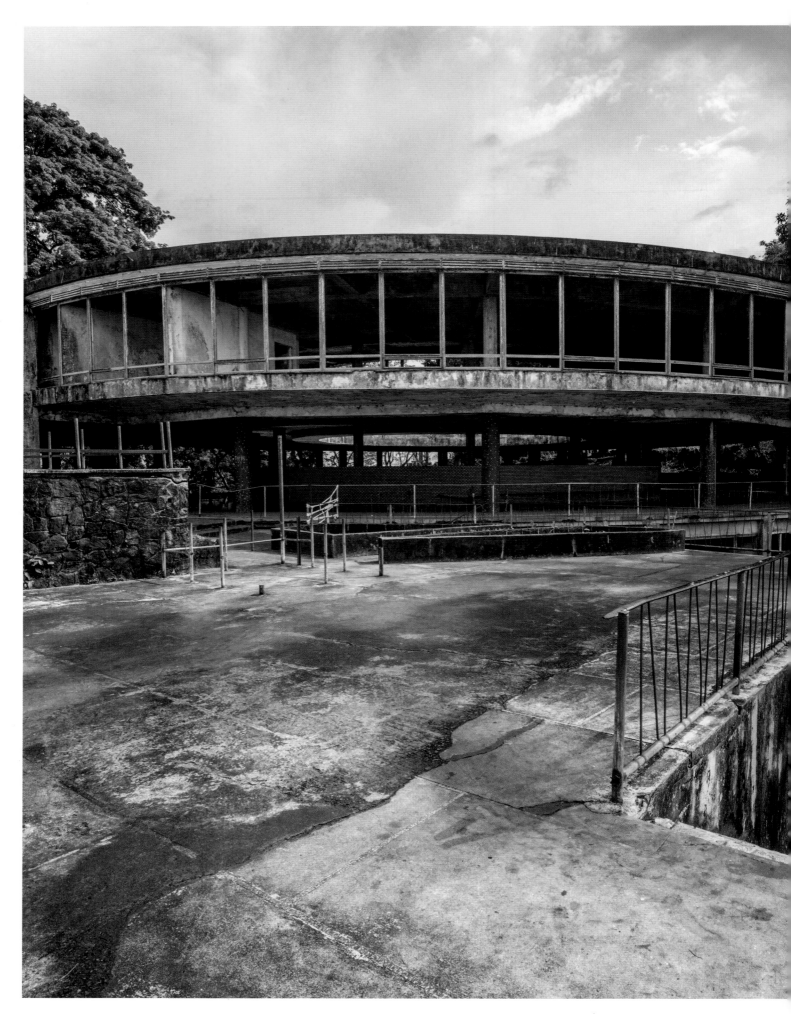

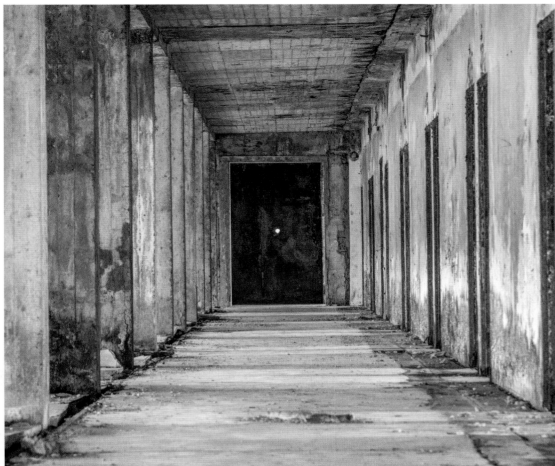

LEFT AND ABOVE:

Ducor Hotel, Monrovia, Liberia
Till 1989, when Liberia was
plunged into the best part of a
decade of civil war, the Ducor
Hotel was the glory of Monrovia,
something of a jewel in the
country's crown. In the years that
followed, however, its precincts
first became a free-fire zone and
subsequently a home to families of
squatters. The attempt to clean the
complex up after those hostilities
had ended was interrupted by
a second civil war (1999–2003).
Today, while the views out over the
Atlantic are as stunning as they
ever were, Ducor Hotel has been
left a five-star eyesore.

OVERLEAF:

**Abandoned house,
Robertsport, Liberia**
Liberia's nineteenth-century
colonists were of course freed
slaves from America: the culture
they brought with them smacked
of the American South. This
deserted house would not be
out of place in the back country
of Georgia or Alabama. Here,
though, the dereliction has been
caused not just by economic
stagnation and abject poverty but
by several decades of one of the
world's most savage civil conflicts.

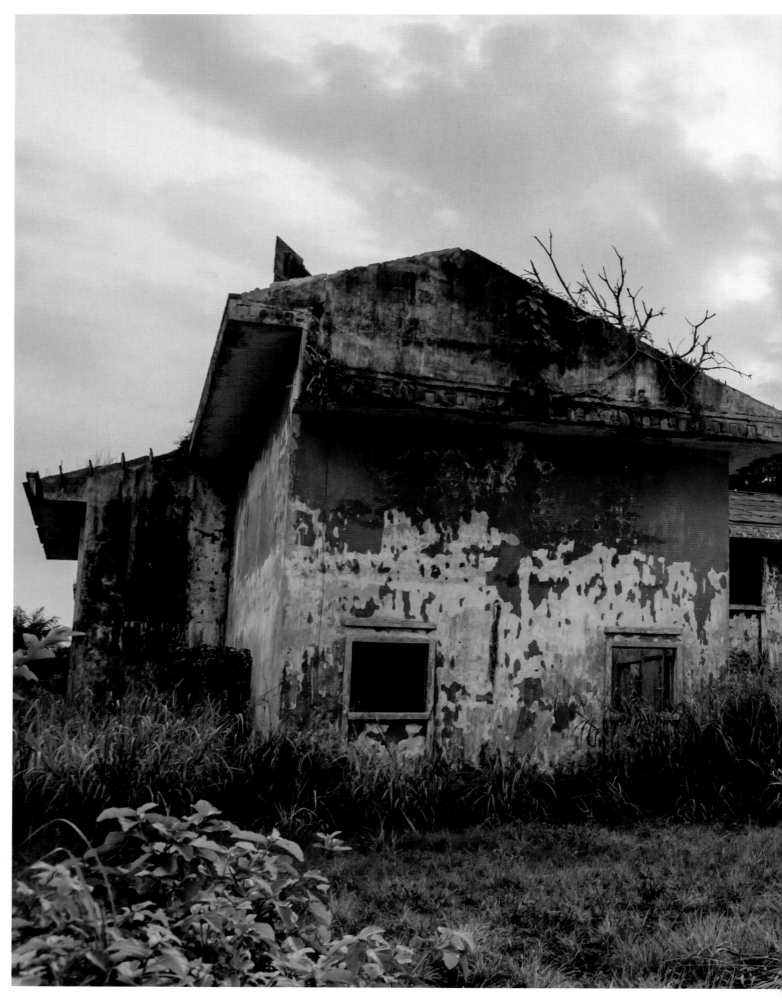

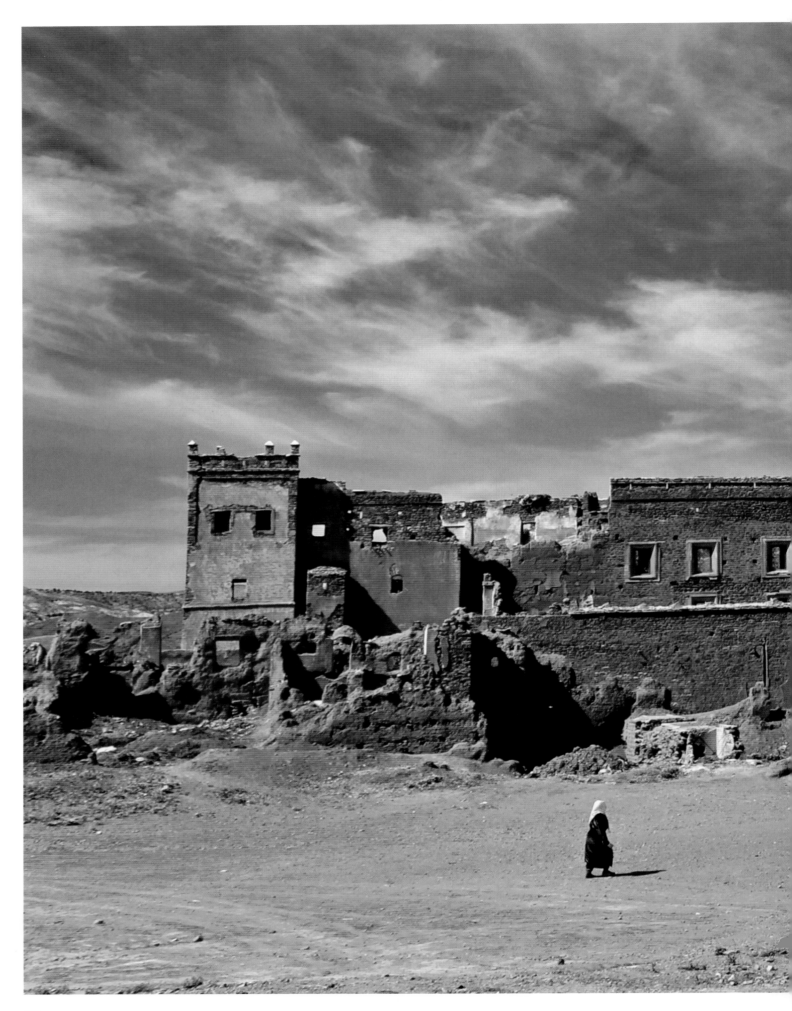

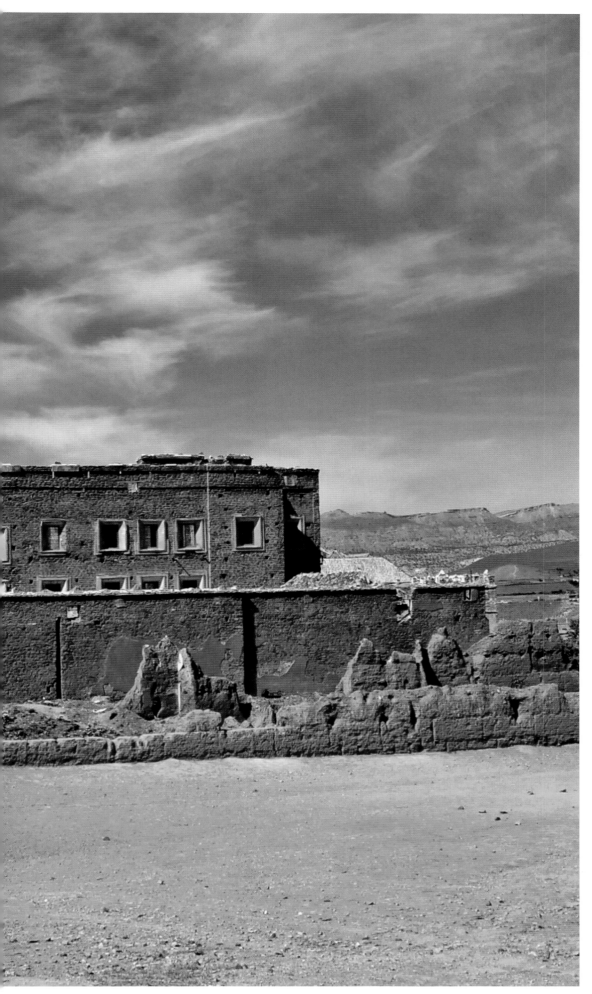

Kasbah, Télouet, Morocco
By the standards of a modern
geography of airports and paved
highways, Télouet feels impossibly
remote, the dereliction of this
kasbah (citadel-cum-palace)
unsurprising. In its day, though –
and that was really not more than
a century ago – it was something
of a centre. Not only were there
salt mines, but the town was
important as a way station on the
caravan route from the Sahara
over the mountains to Marrakesh.
The chiefs of the Glaoua Berber
clan had their headquarters here,
this mud-brick citadel offering
luxurious living quarters while
providing them with protection in
a wild and often lawless country.

OVERLEAF:
**Grande Hotel Beira, Beira,
Sofala, Mozambique**
When is an abandoned building
not an abandoned building? When
it has become a home for hundreds
of families of squatters. Beira had
flourished during the final decades
of Portuguese rule in Mozambique
(at least its wealthy had); and
a steady stream of business
travellers had passed through
the port – hence the popularity
of the Grande Hotel. From the
1960s, though, this traffic was
very obviously declining and in
1974, the 'Carnation Revolution'
in Portugal spelled the end for the
country's colonial reign in Africa.
In the civil war that followed
independence, the hotel became
a base for the troops of the
governing Mozambique Liberation
Front (FRELIMO).

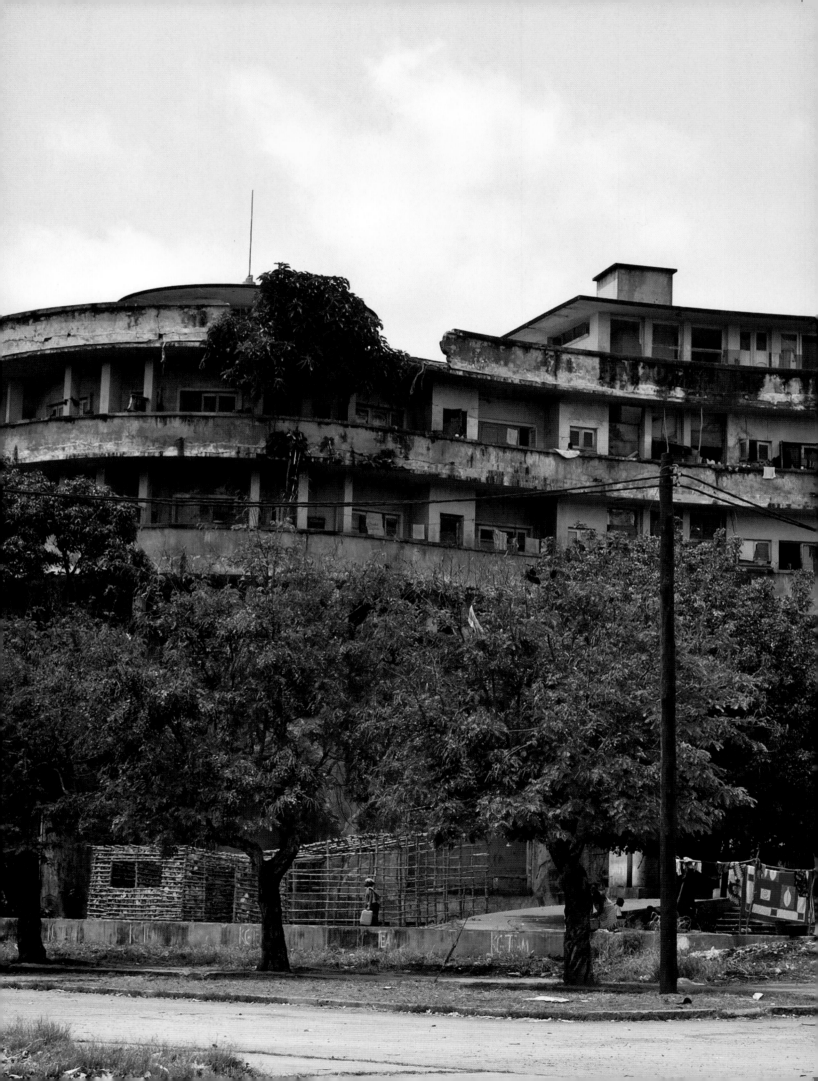

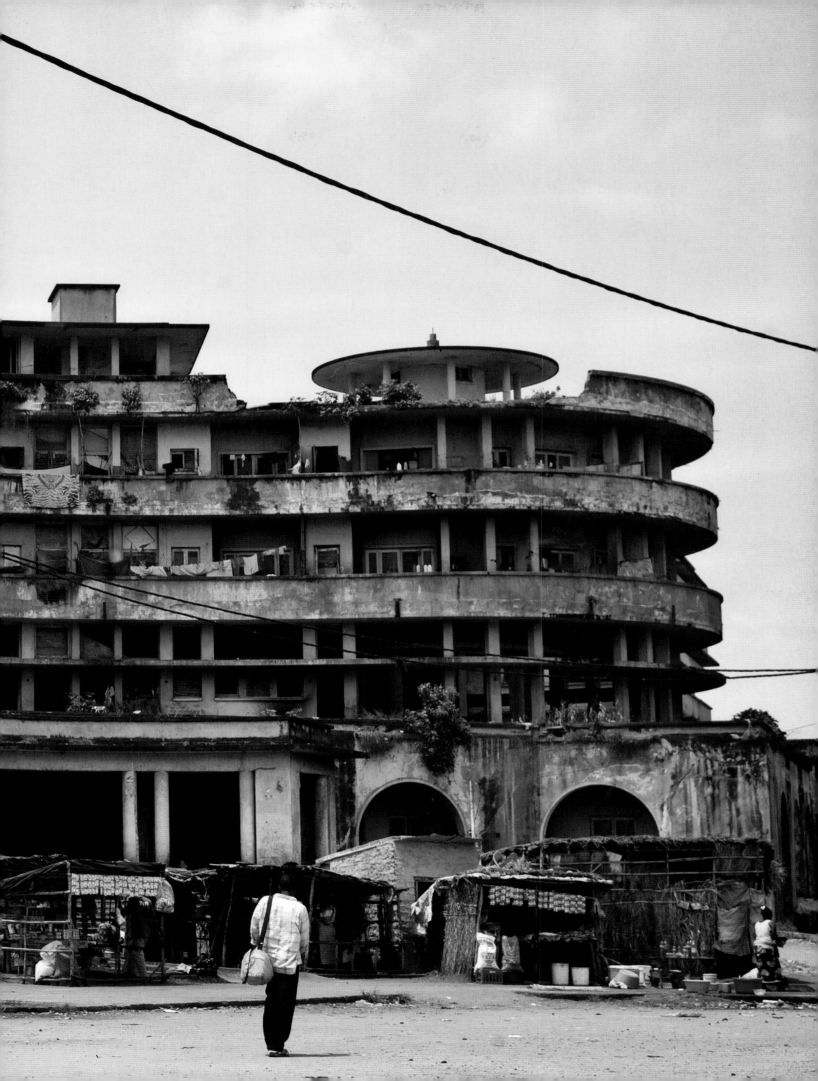

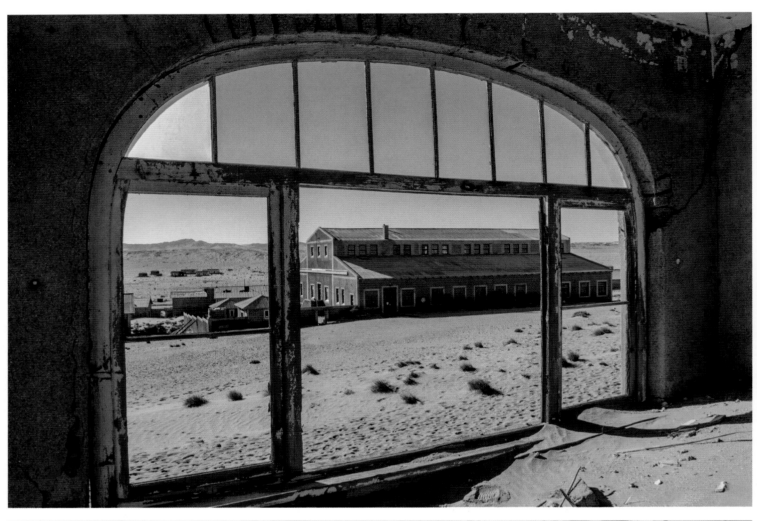

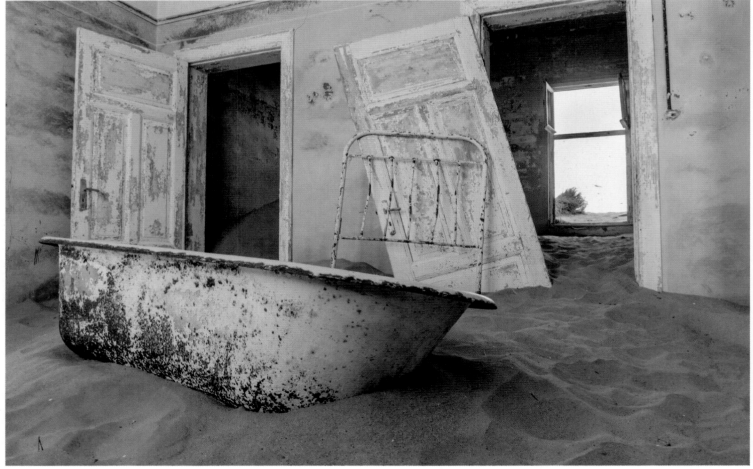

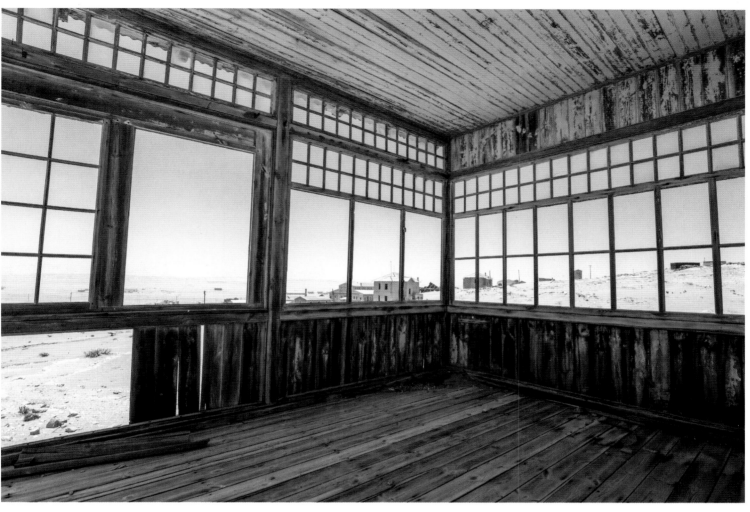

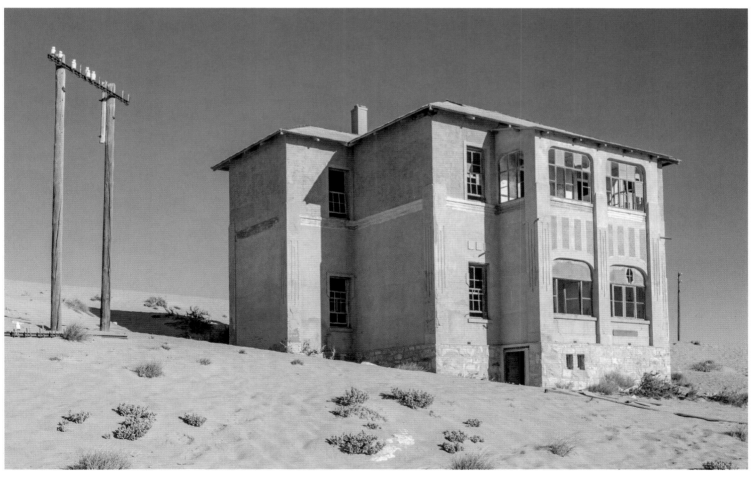

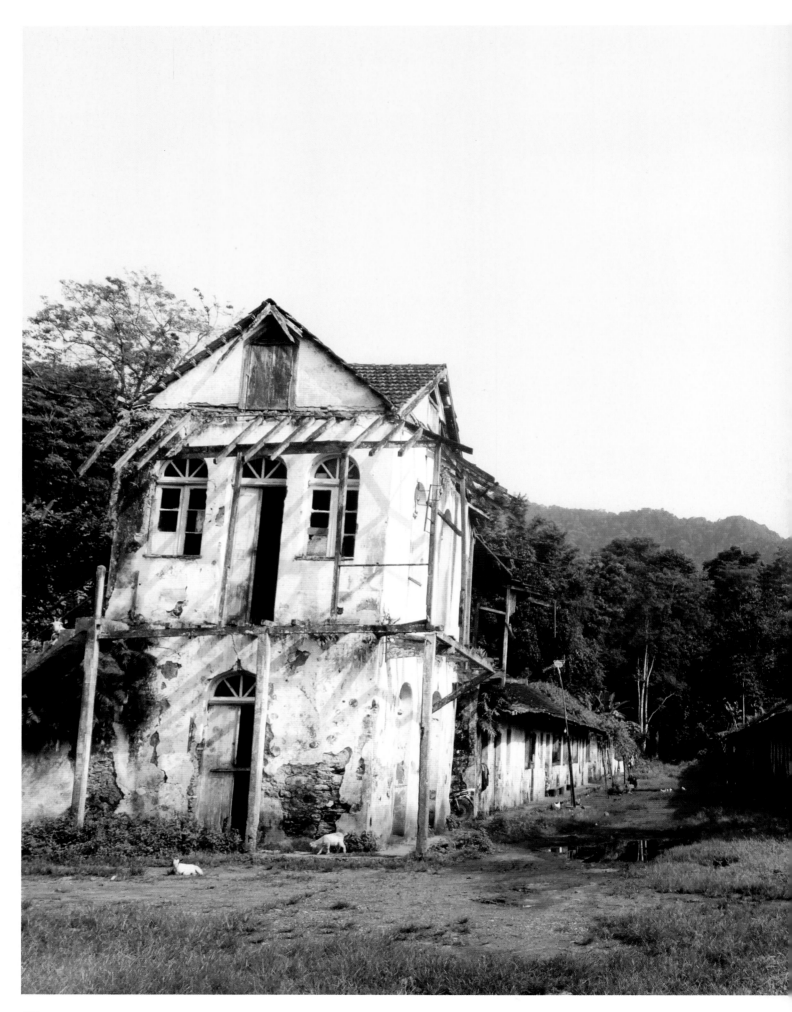

PREVIOUS PAGES:
Ghost Town, Kolmanskop, Lüderitz, Namibia
This boomtown went bust in the 1950s, but it still has an oddly well-preserved air. Chiefly because, even if the desert sand has encroached in many places, its dry and searing sun has helped preserve its structures. Kolmanskop's half-century of history began with the discovery of diamonds in 1908: within weeks, German prospectors were flocking to what was then their country's colony of South West Africa. Though its population never topped 1300, so wealthy was the town that it could afford a power station, school, hospital, theatre, ballroom and bowling alley. It even had a tramway of its own.

LEFT:
Plantation houses, Roça Bombaim, São Tomé, São Tomé and Príncipe
Beyond the bigger structures we see an alley of terraced cottages – picturesque, perhaps, but the lives led here were unimaginably harsh. Slavery wasn't abolished in the Portuguese empire until 1876 – and even then it continued on the quiet for several decades. It isn't known exactly when the practice ended at Bombaim, but so secluded was the *roça* (or 'plantation') here that it's hard to imagine any great pressure being felt.

OVERLEAF:
Ishak Pasha's Palace, Dogubeyazit, Agri, Turkey
Arrestingly situated atop a rocky outcrop in the foothills of Mount Ararat, this magnificent palace doubles as an administrative centre. Though undertaken in 1685 by the Ottoman provincial governor Colak Abdi Pasha, it had in large part to be constructed by his son – and was only completed by his grandson, the Ishak Pasha of its common title, in 1784.

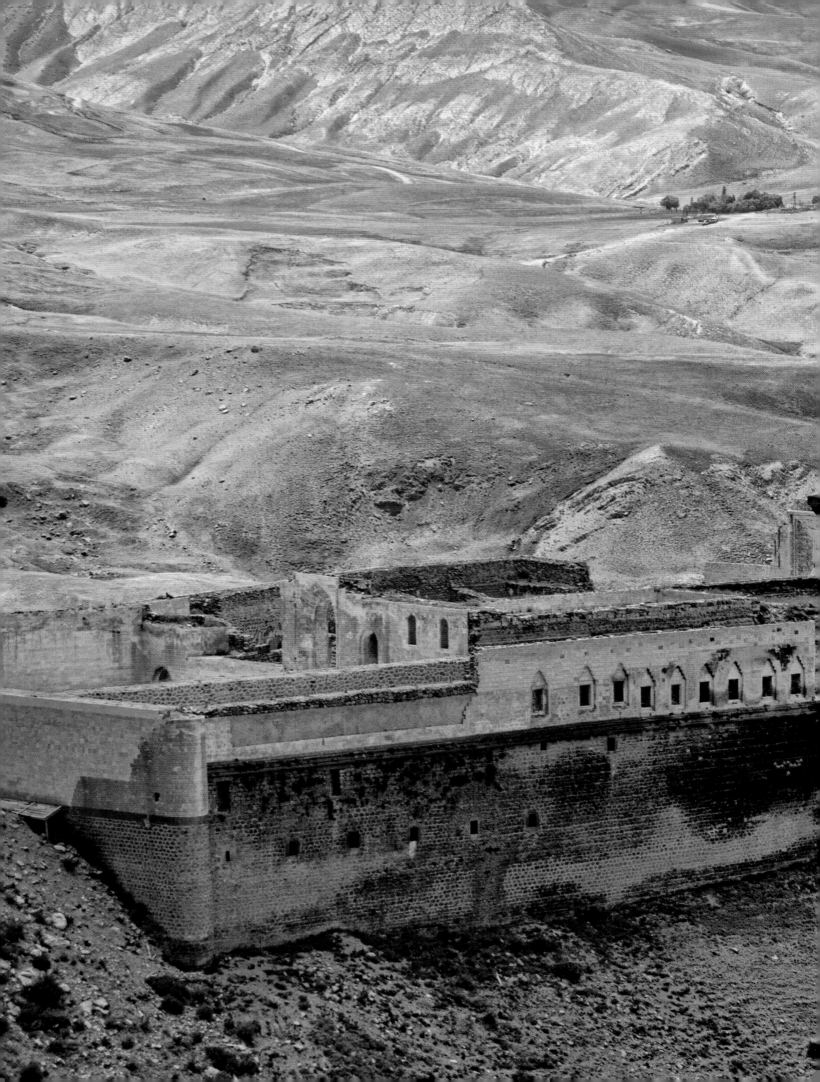

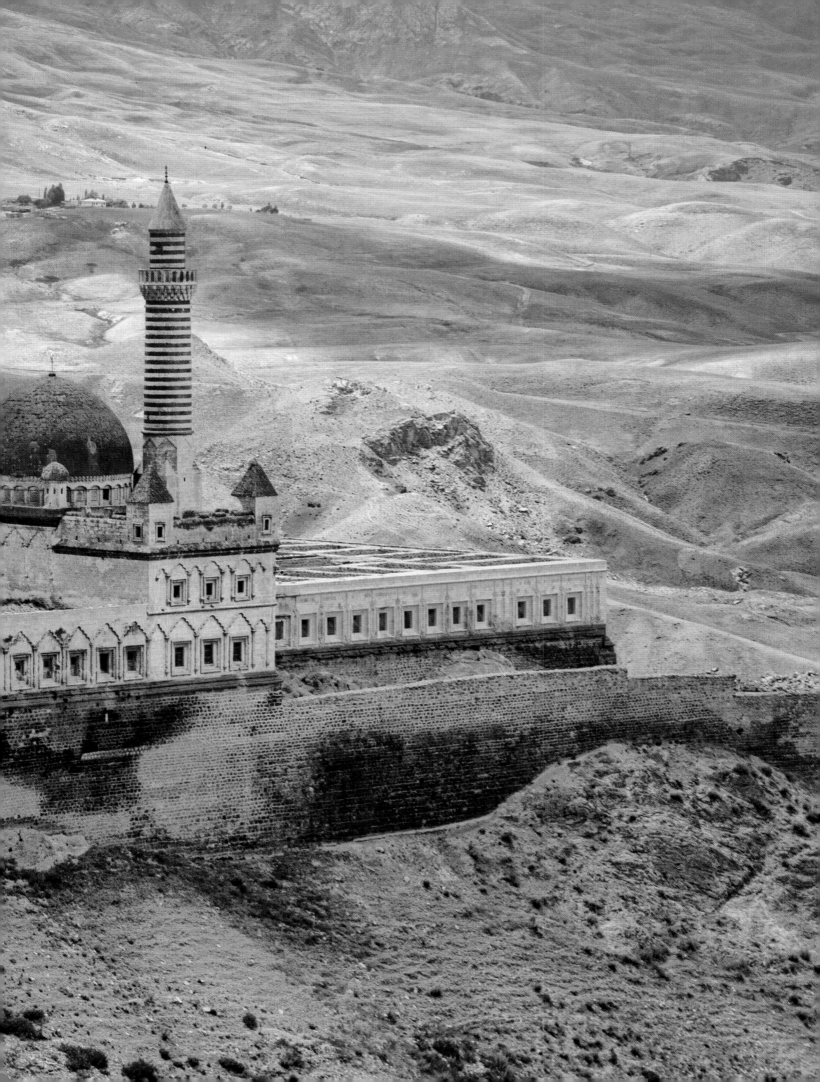

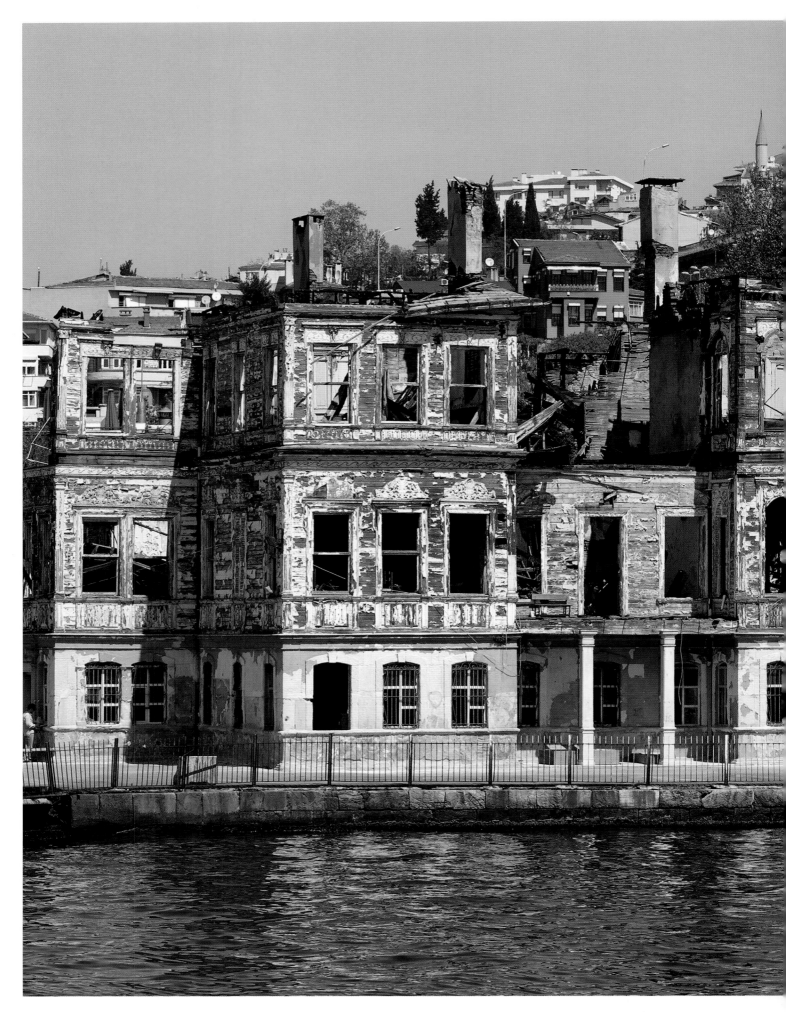

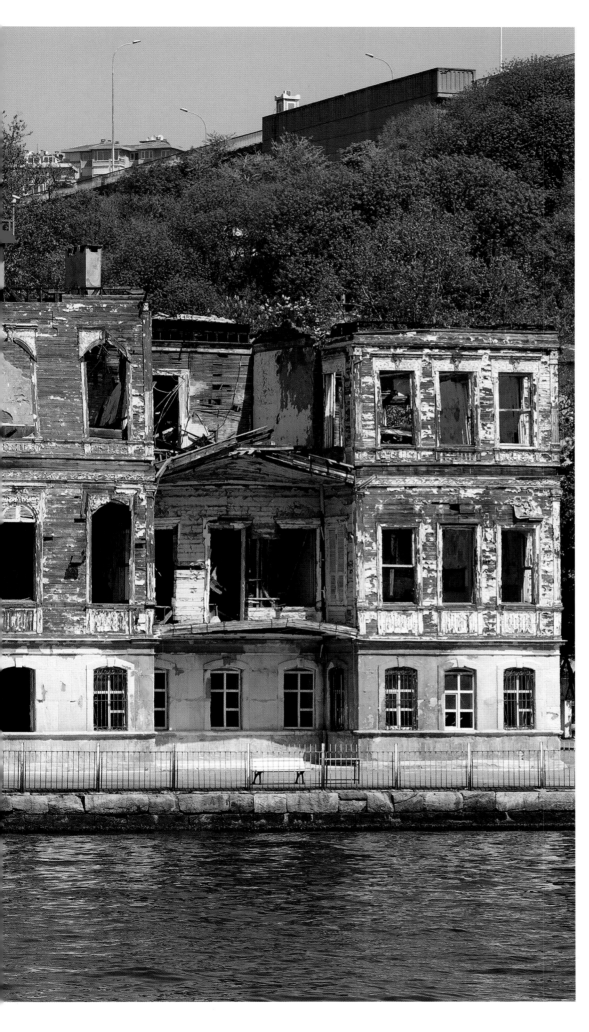

Broken-down villa, Yaliler, Ortaköy, Istanbul, Turkey
This suburb lies on the banks of the Bosphorus, on the European side. It has some stunning villas, as might be imagined. This one has very obviously seen better days. We look clear through one third-storey section to the hillside and houses behind. Yet this house has its dignity, its dilapidation notwithstanding.

Asia and the Pacific

'Your idol is shattered in the dust,' wrote Rabindranath Tagore (1861–1941), 'to prove that God is greater than your idol.' Asia and the Pacific are positively littered with such shards. The Bengali poet was spiritual first and foremost, but was by no means unworldly or apolitical, and it's hard to avoid the feeling that among the more metaphorical idolatries he had in mind were those of modernity and progress. That Western worldview that, he complained, set out to persuade Indians like himself that 'our only good is in rooting out the three fourths of our society along with their very foundation, and in replacing them with the English brick and mortar as planned by English engineers.'

But these earlier social structures had themselves been fabricated from the fragments of previous civilizations, broken up by earlier conquests and coercions. While the Spanish, the Portuguese and the Dutch had been busily acquiring outposts in the East as long ago as the sixteenth century, home-grown empire builders had been building empires long before.

Those ruins – ancient and modern – in which Asia and the Pacific are so rich aren't just 'bricks and mortar' but the visual representation of a region's history.

OPPOSITE:
Dominican Hill Retreat House, Baguio, Luzon, Philippines
This house, high on a hilltop, is as much a haven of calm today as it was a century ago when it received friars on retreat. Less peaceful times have intervened, though: during World War II, this was a base for the Japanese secret police. From 1973 the Diplomat Hotel, it was abandoned in the 1980s.

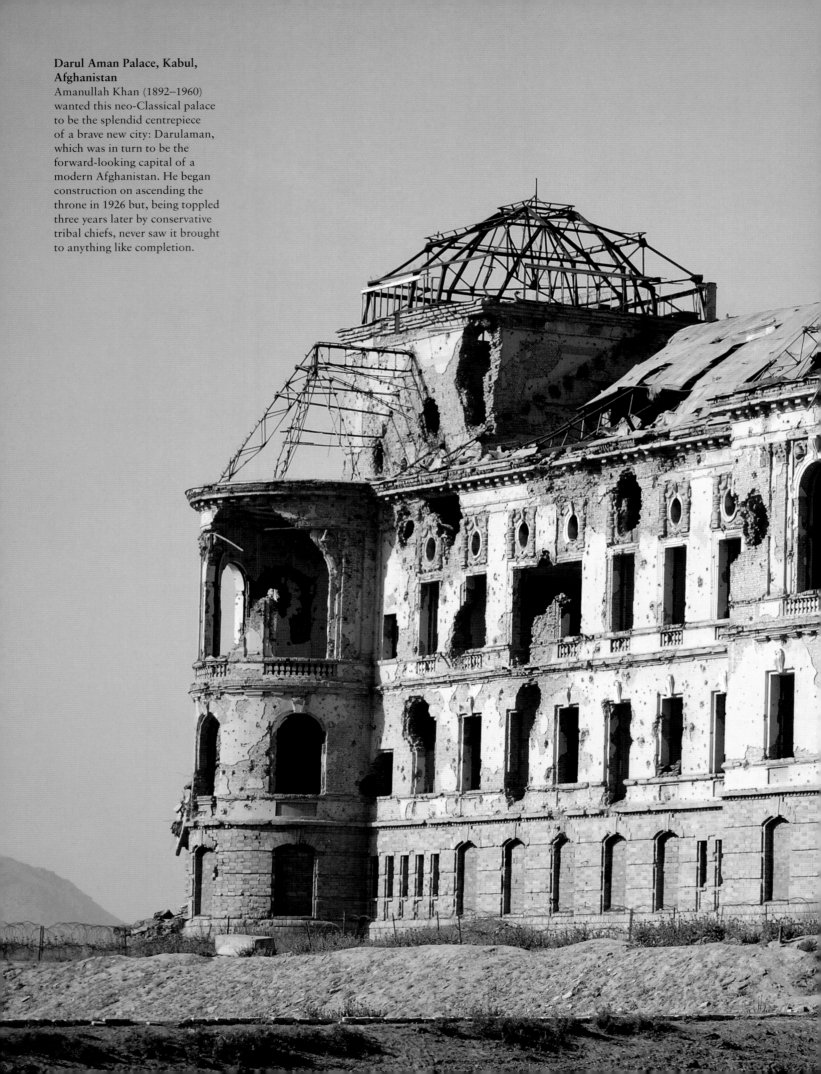

Darul Aman Palace, Kabul, Afghanistan
Amanullah Khan (1892–1960) wanted this neo-Classical palace to be the splendid centrepiece of a brave new city: Darulaman, which was in turn to be the forward-looking capital of a modern Afghanistan. He began construction on ascending the throne in 1926 but, being toppled three years later by conservative tribal chiefs, never saw it brought to anything like completion.

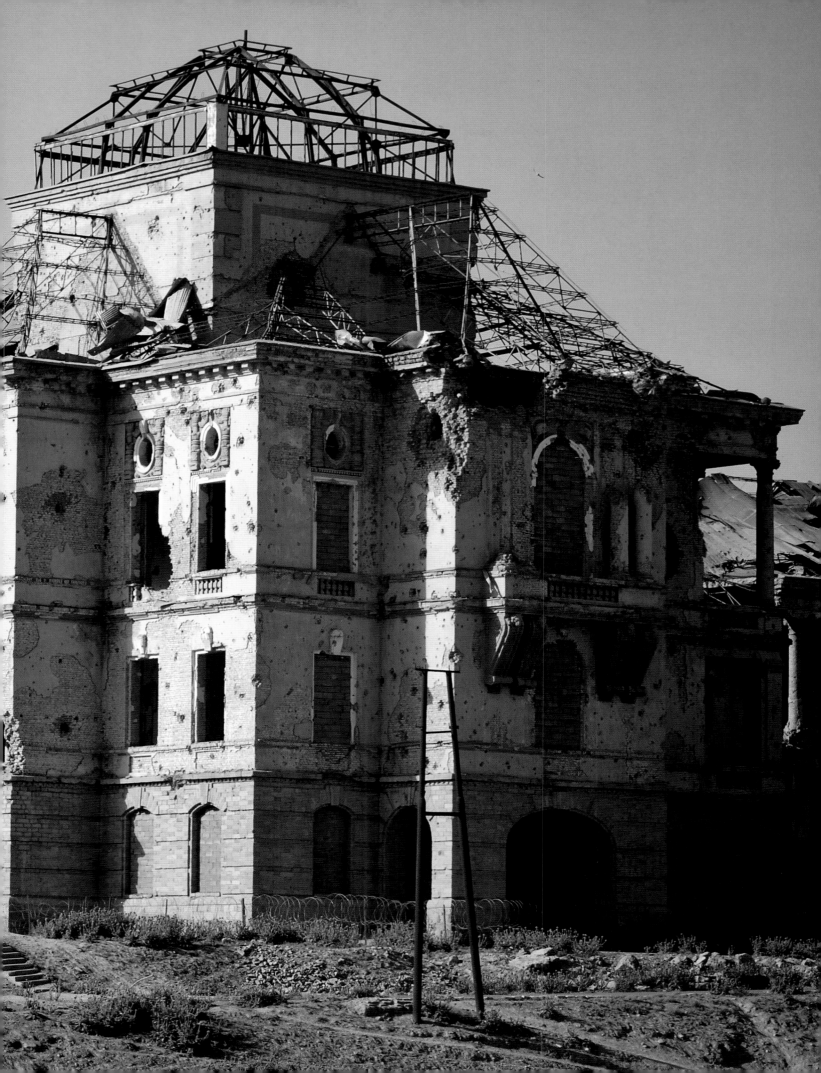

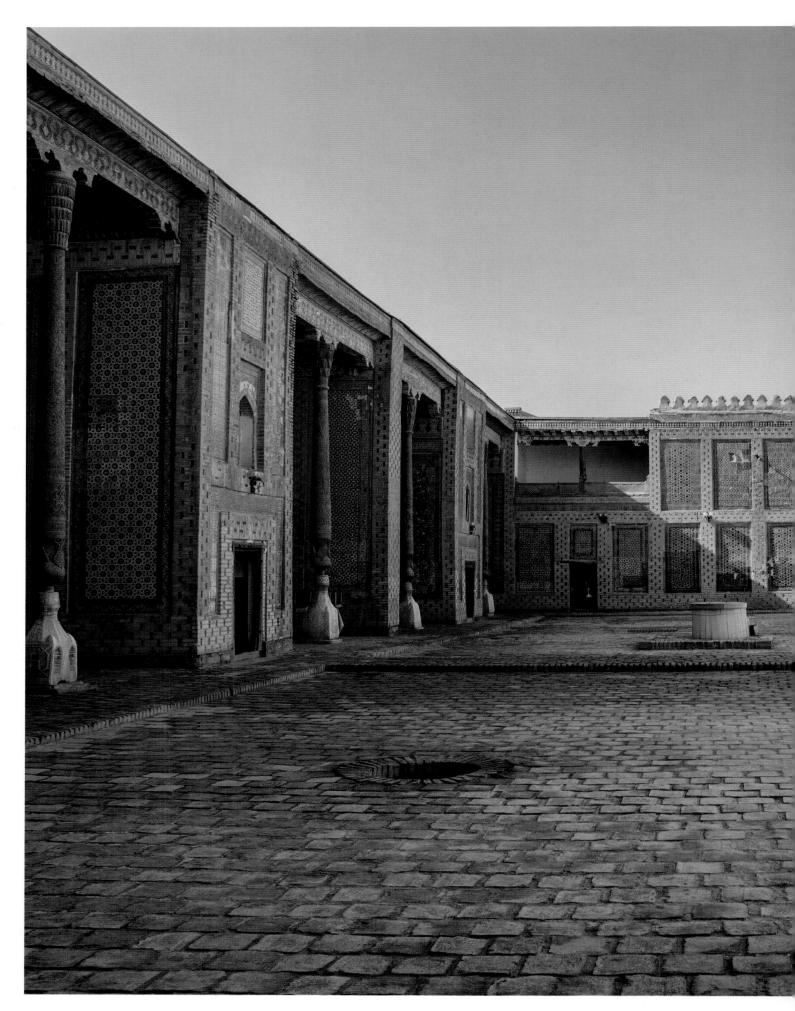

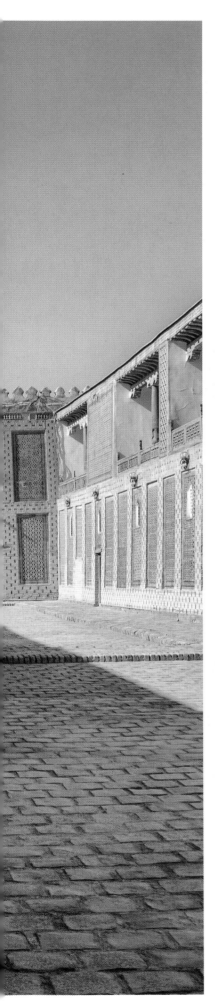

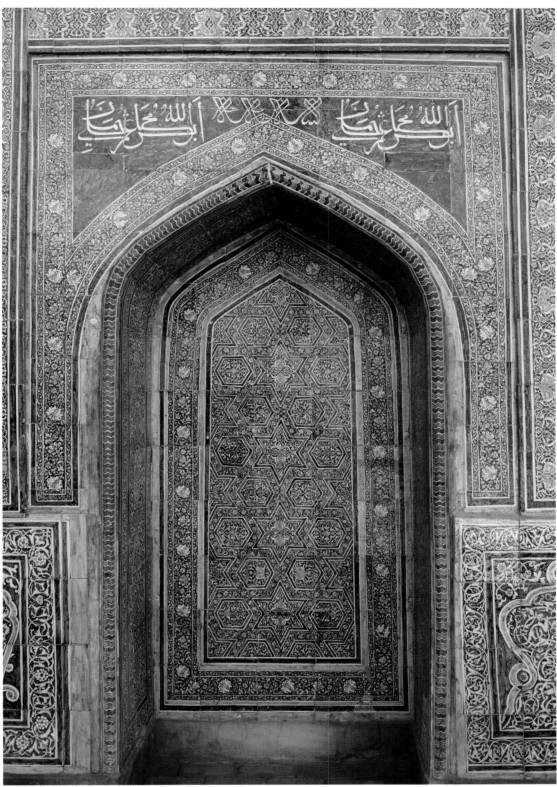

LEFT AND ABOVE:

Tash-Hauli Palace, Khiva, Xorazm, Uzbekistan
Tash-Hauli means 'stone house' – a real distinction in a city with a mud-brick vernacular. This stupendous palace was built by Allah Kuli Khan (1794–1842; reigned 1826–42). The royal harem (left) – the women's quarters – was tucked away, beyond reach of prying eyes, but still has a light and spacious feel.

This recess (above) wasn't just ornamental. It served a highly sacred purpose, indicating the *qibla* – the direction of Mecca – for those who prayed in Allah Kuli Khan's mosque. It certainly is ornamental, though: it goes without saying that it is mesmerizingly decorated. Even by Khiva's stunning standards, the tiling is a tour-de-force.

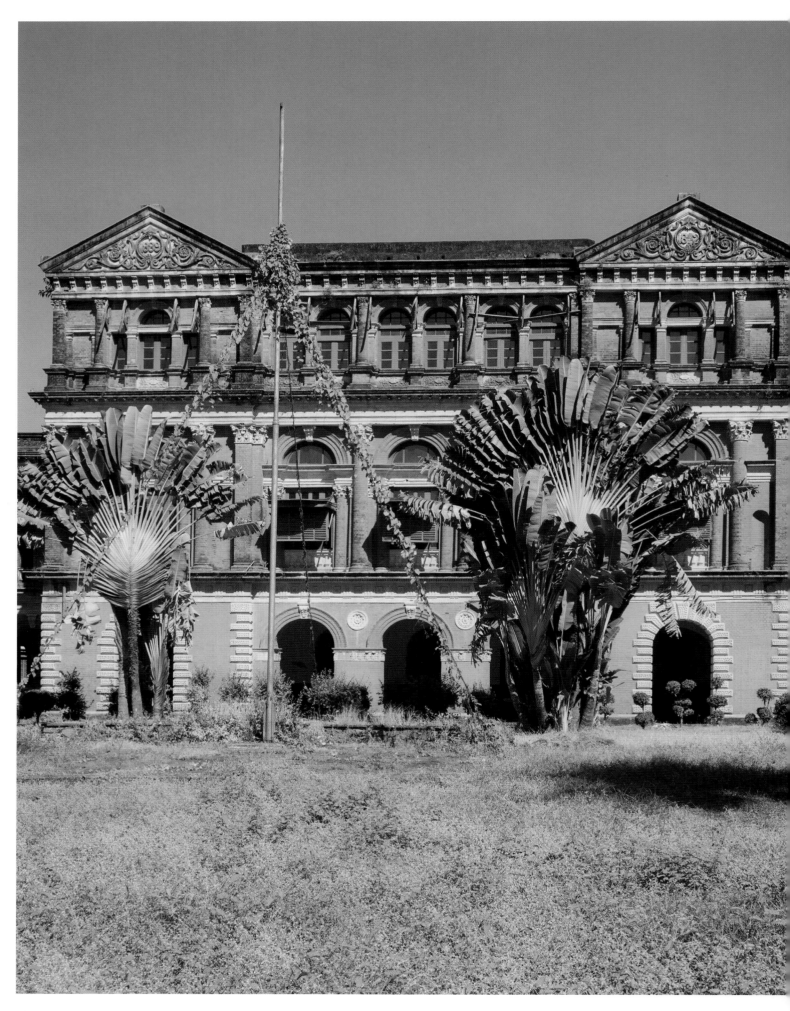

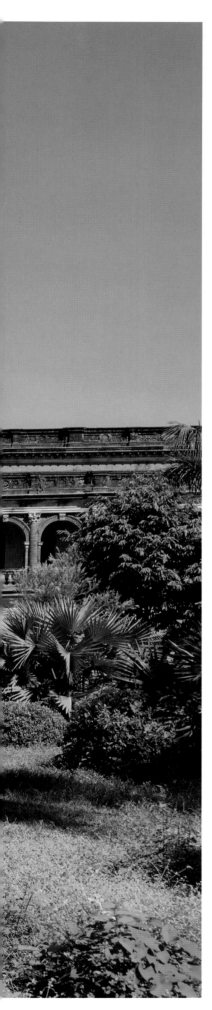

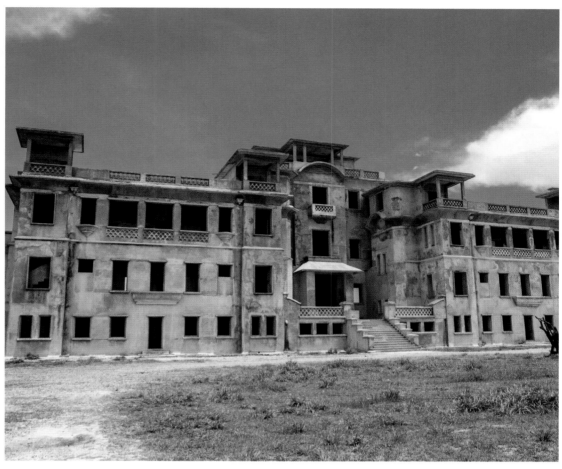

LEFT:

Minister's Building, Yangon, Myanmar

For more than a century, the so-called Secretariat was the centre of the colonial administration of British Burma. After 1948, as the 'Minister's Building', it served the same function for the independent state. The man who had led the drive for freedom, Aung San (1915–47), was assassinated here (in what remain mysterious circumstances) just six months before his dream was realized. Extending over 6.5 ha (16 acres), the complex is not only bigger than it looks here but more ruinous: its central dome was brought down by an earthquake in the 1930s.

ABOVE:

Bokor Palace Hotel, Bokor, Kampot, Cambodia

Bokor was a 'hill station' – a resort to which colonial administrators came with their families to escape the intense heat of the big cities. This luxurious hotel opened its doors in 1925. Cambodia was a French possession: resentment of their rule flaring up into outright resistance in the years after World War II, French officials soon ceased to feel comfortable here. A degree of peace was restored in the 1960s, and the resort reopened – with the addition of a new casino – but with the advent of the Khmer Rouge in 1972, it closed for good.

OVERLEAF:

Abandoned mansion house, Fanling, New Territories East, Hong Kong

Though quite some way out from Hong Kong, Fanling's closeness to the colony's border with China proper made it an important base for customs and other administrative officials. Hence the presence of prestigious houses like this one. The suburb's outlying situation has, however, helped to spare it the rampant redevelopment seen in central areas. It has consequently become a favourite destination for 'heritage' tourists – especially those in search of a taste of imperial nostalgia. And there's no denying its allure. Even in its dilapidation, this house exudes style and elegance: it's easy enough to imagine the gracious living that went on here.

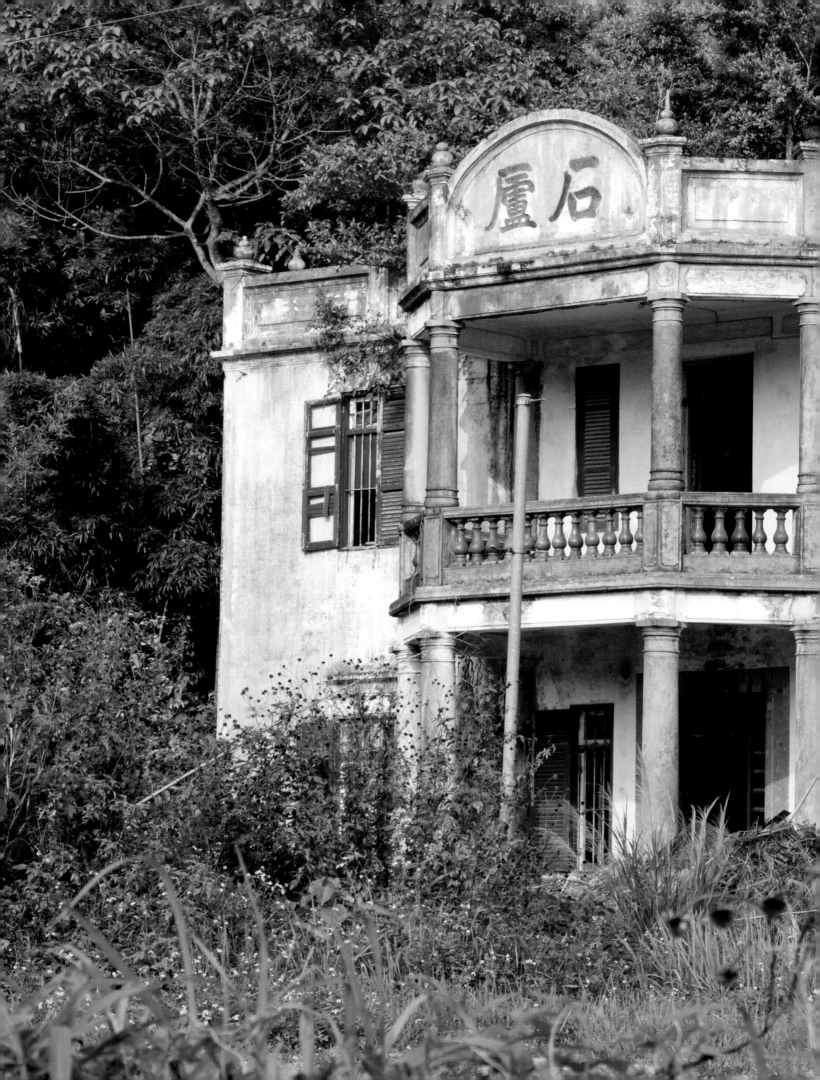

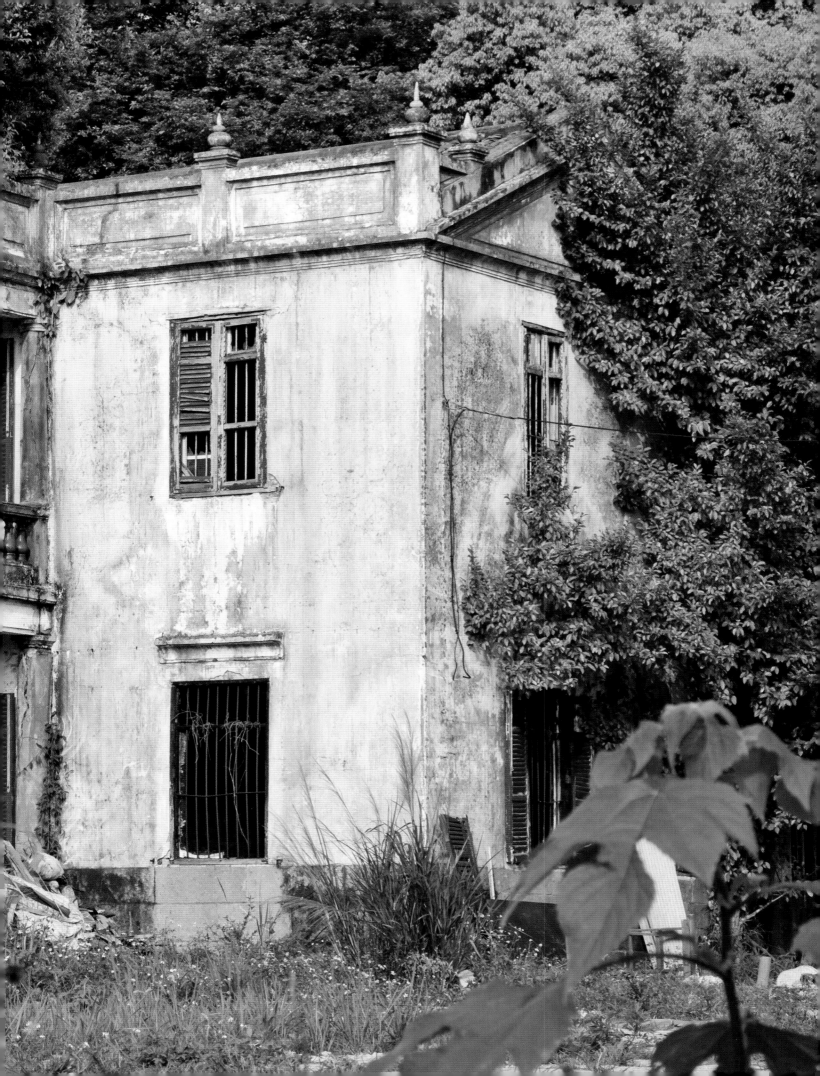

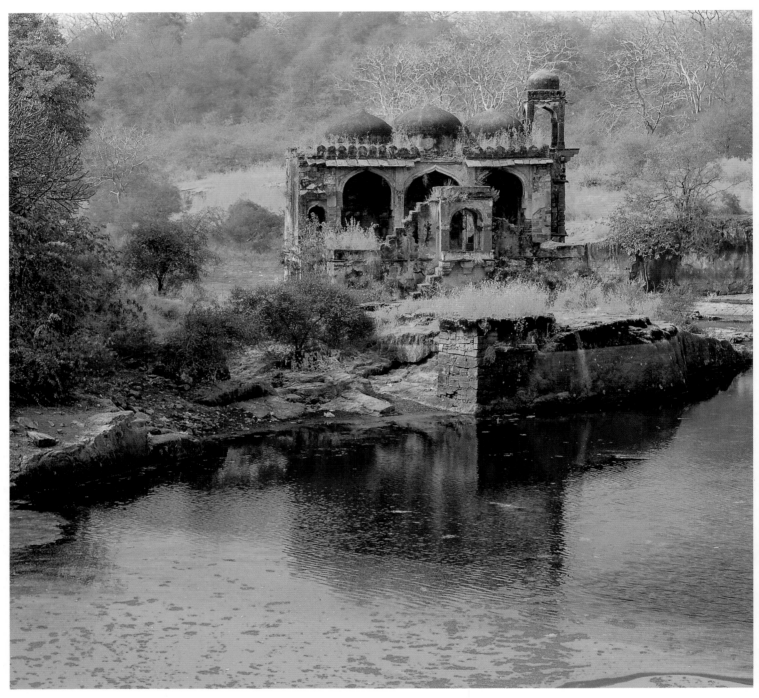

ABOVE:

Badal Mahal, Sawai Madhopur, Rajasthan, India

Ranthambore Fort, high up in the Rajasthan Mountains, forms a link in the wider defensive complex of Kumbhalgarh, built the best part of a millennium ago, and fought over as late as the sixteenth century. Here, however, all is peace. Indeed, looking across the sacred waters of Rani Kund to Badal Mahal, the so-called 'Palace in the Skies', it's hard to imagine a time when it was otherwise.

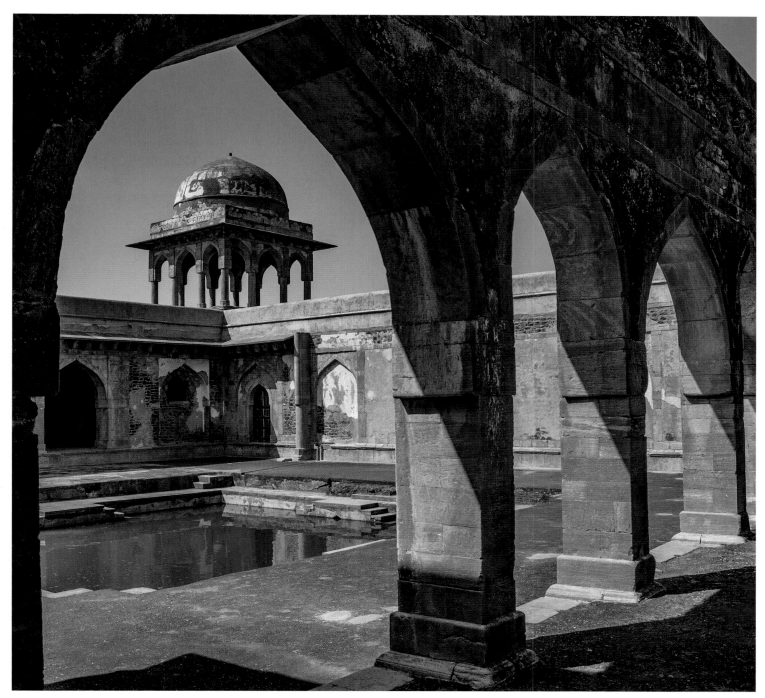

ABOVE:

Baz Bahadur's Palace, Mandav, Mandhya Pradesh, India

The story of Baz Bahadur and his love for the beautiful Hindu singer Rani Rupmati has passed into legend, a sort of Indian *Romeo and Juliet*. But, the mythology notwithstanding, they did exist, even if the Sultan's reign (1555–62) was otherwise inglorious and he ended up losing his realms (and, indeed, his life) to Mughal invaders. He did, however, build this beautiful love nest for himself and his queen before he died.

Bundi Palace, Rajasthan, India
Spectacularly situated, hugging a hillside above a town in the Aravalli Mountains, this palace was built in 1602–31 by Rao Raja Ratan Singh Hada. Challenging topography dictated unusual design, the impression of unconventionality only compounded inside the palace itself by the phantasmagorical range of fresco art covering just about every ceiling and wall. 'It is', wrote Rudyard Kipling (1865–1936), 'such a palace as men build for themselves in uneasy dreams – the work of goblins rather than of men.' A more recent visitor shared the feeling of having passed into another and an eerier world: 'It was like being Alice in India,' said the artist Natasha Kumar (1976–).

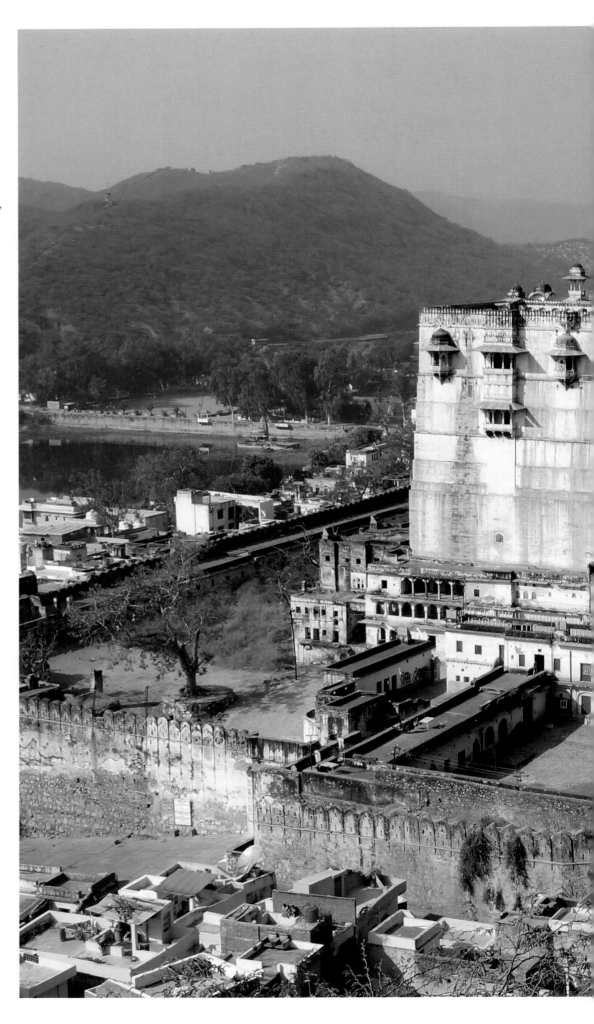

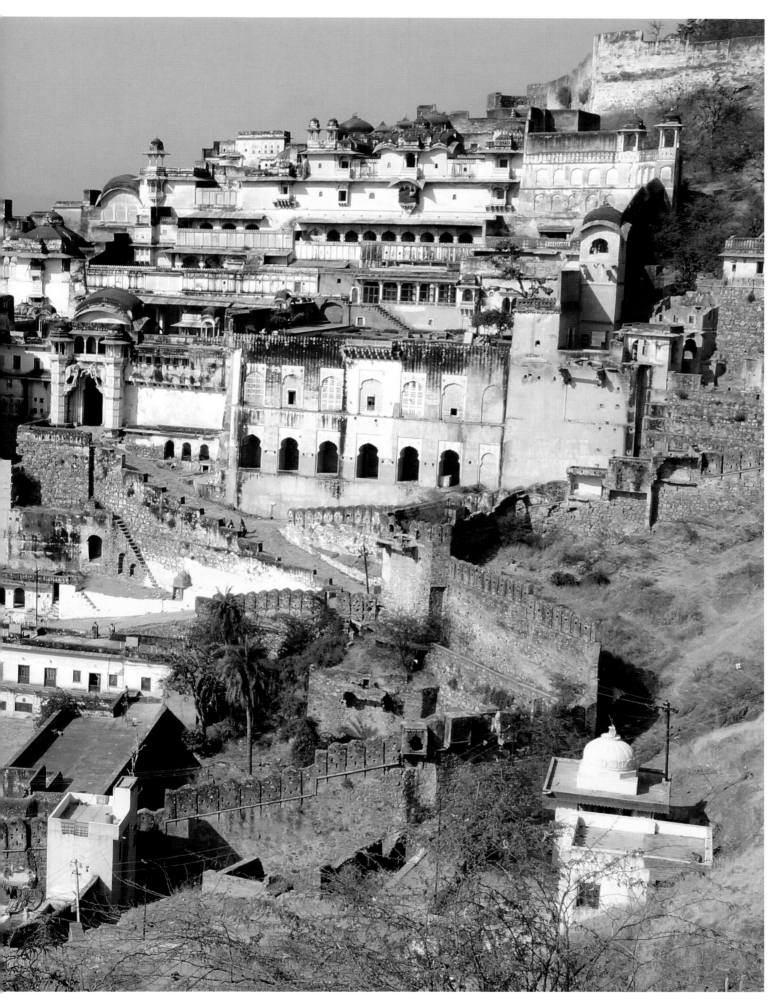

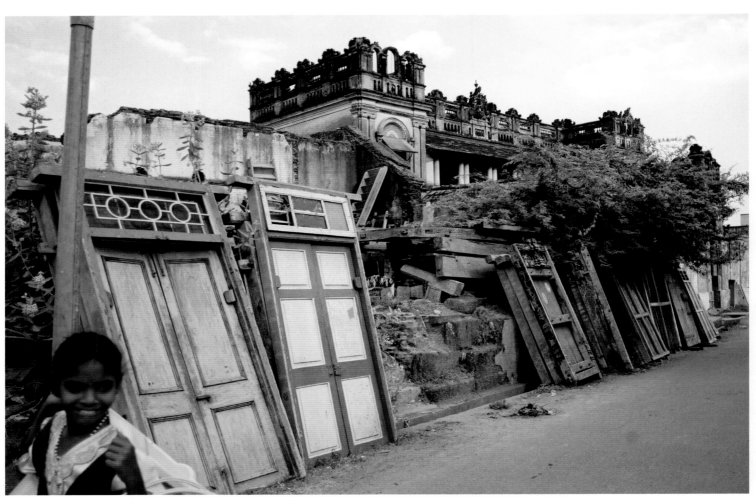

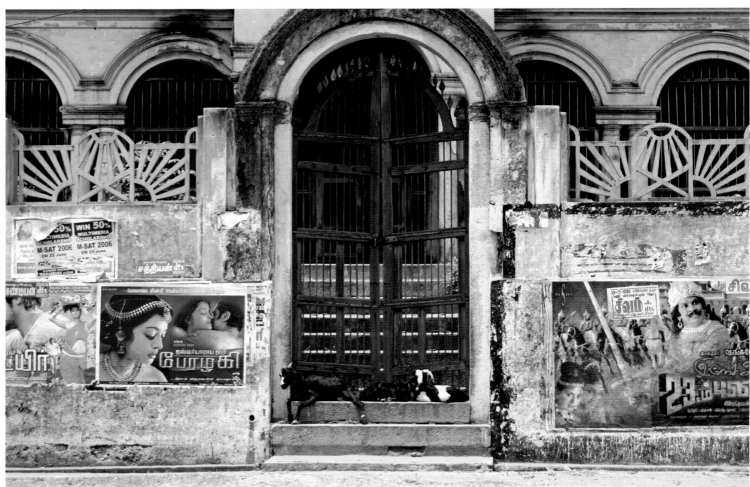

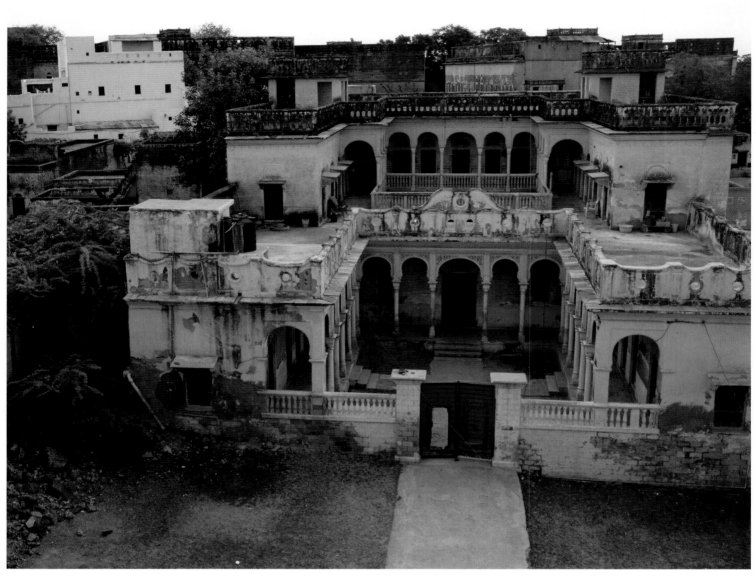

OPPOSITE TOP AND BOTTOM:

Nagarathar Mansions, Chettinad, Pandya Nadu, India
A community of Tamil traders, the Nagarathar historically made their fortunes as bankers or as merchants dealing in marble, teak and other prestigious commodities, travelling the length and breadth of India and beyond. Their wealth – and their geographical reach – was reflected in their lavishly appointed homes, built of local limestone, but decorated with furnishings in the finest materials and with fittings from as far afield as Europe. These mansions had, however, to be abandoned when they were requisitioned in the course of World War II.

ABOVE:

Abandoned *haveli*, Mandawa, Shekhawati, Rajasthan, India
That Mandawa's *haveli* or townhouses are just about all in a state of semi-dereliction seems unremarkable. The only surprise is that they were built here to begin with. Until the nineteenth century, though, what is now a poor, provincial city stood on a major trading route, and became famous for its wealth. Mandawa's merchants advertised their success by building themselves these stunning mansions – so richly decorated that the town has been described as 'the world's greatest open art gallery'.

OVERLEAF:

Jahangir Mahal, Orchha, Tikamgarh, Madhya Pradesh, India
The local ruler Vir Singh Deo built this impressive complex some time around 1610 to welcome the Mughal Emperor Jahangir (1569–1627; reigned 1605–27), who was making a visit to his city. Windowless walls at ground-floor level underline the uncompromising solidity of a palace that was intended to be a serious fortress, too. The upper storeys make up for it – not just with their eight large crowning domes and smaller minarets, but with their arcaded, elegantly balconied rooms with latticed windows. There are delicate carvings and beautiful wall paintings throughout.

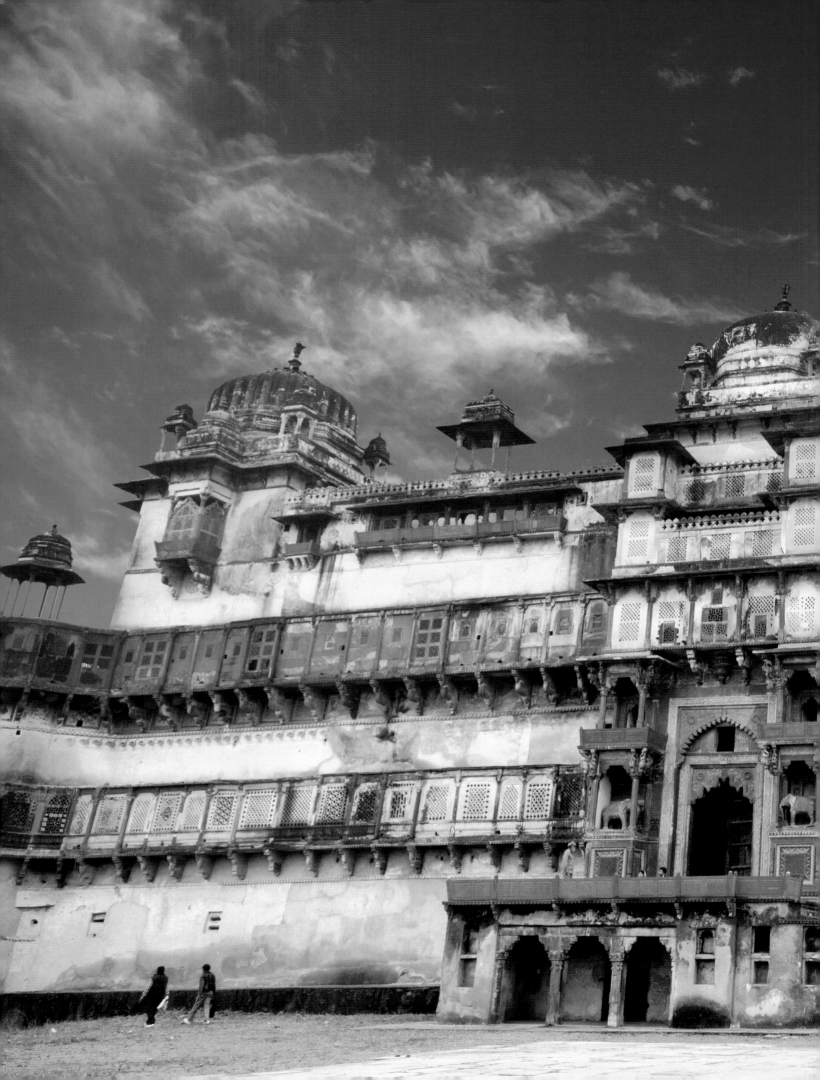

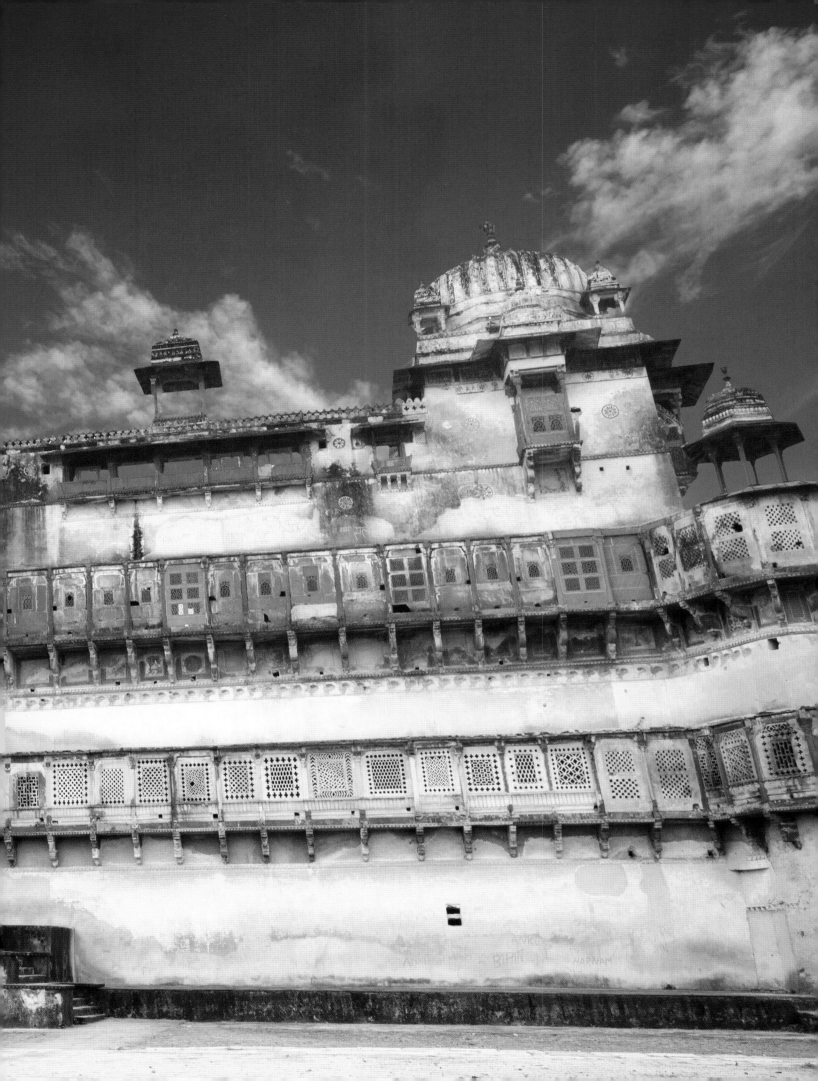

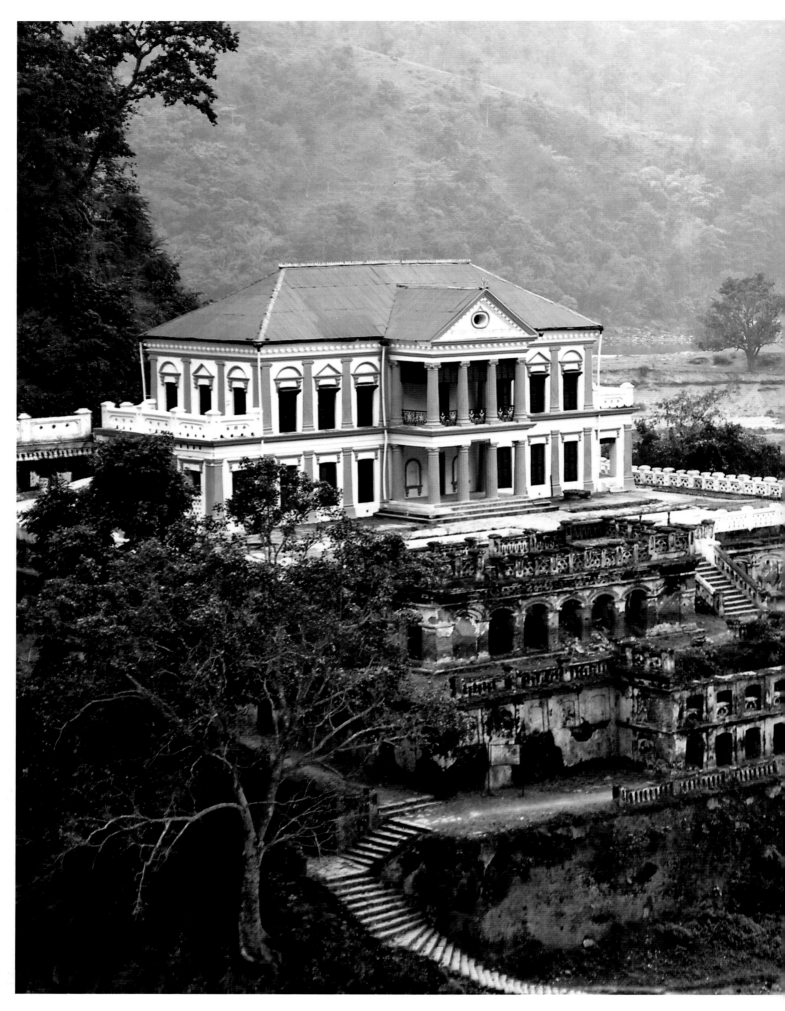

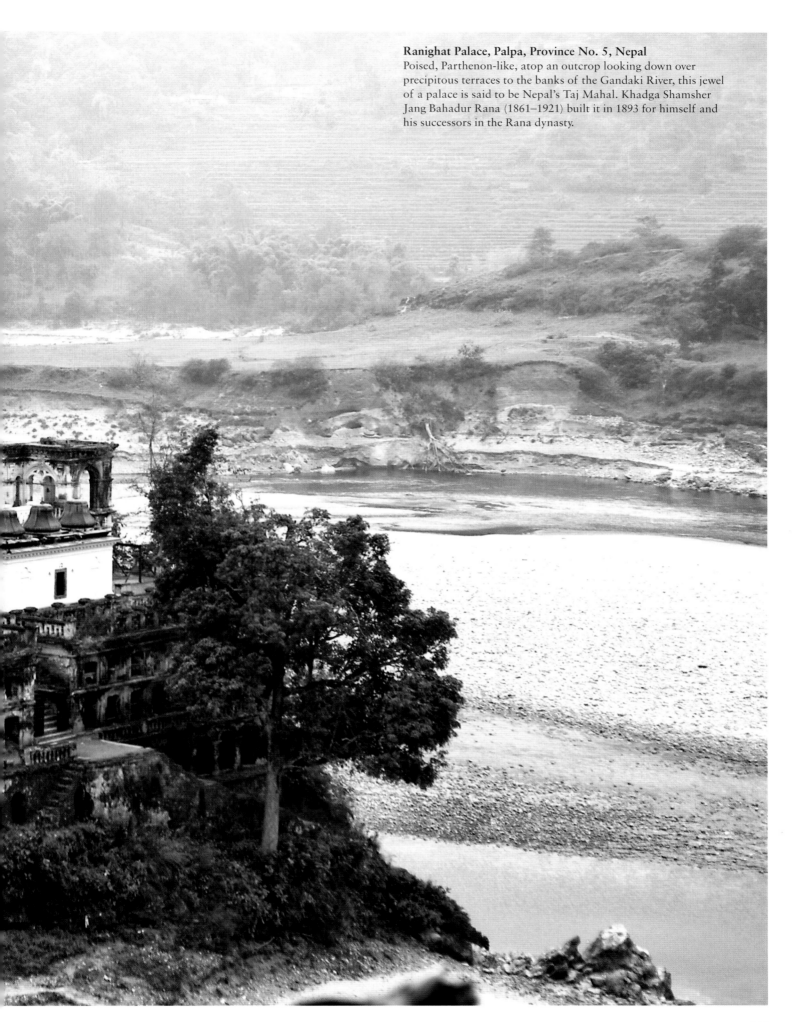

Ranighat Palace, Palpa, Province No. 5, Nepal
Poised, Parthenon-like, atop an outcrop looking down over precipitous terraces to the banks of the Gandaki River, this jewel of a palace is said to be Nepal's Taj Mahal. Khadga Shamsher Jang Bahadur Rana (1861–1921) built it in 1893 for himself and his successors in the Rana dynasty.

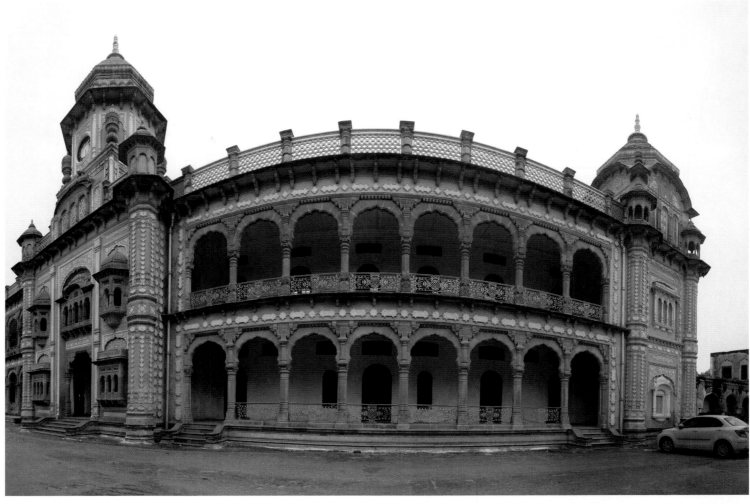

ABOVE:

Mubarak Mandi Palace, Jammu, Jammu and Kashmir, India
The maharajas of the Dogra dynasty built this vast and beautiful palace complex in stages through the nineteenth century, beautifying its halls and galleries with stunning artworks as they went. In 1925, however, they left Mubarak Mandi for more comfortable, modern accommodation.

RIGHT:

Raj Mahal Palace, Orchha, Tikamgarh, Madhya Pradesh, India
Part of that same great Orchha Fort complex to which the Jahangir Mahal also belongs, this 'King's Palace' is slightly older, dating back to the sixteenth century. Breathtakingly beautiful, with its arcaded courts and sumptuously sculpted stonework, it would make a fitting residence for any king.

OPPOSITE TOP:

Memorial Palace, Orchha, Tikamgarh, Madhya Pradesh, India
Standing beside the Betwa River, this is one of 15 structures, of differing sizes, and variously described as 'palaces' and 'cenotaphs'. The truth lies in between, since they commemorate successive rulers, their size representing the relative durations of their reign. This one was built for Vir Singh Deo.

OPPOSITE BOTTOM:

Rana Kumbha Palace, Chittorgarh, Rajasthan, India
Though dating back to the sixth century, the state of Mewar didn't really come to prominence in Rajasthan till the reign of Rana Kumbha (1433–68). He made Chittor his capital and built himself this splendid residence with projecting balconies and walls of plastered stone. The mystic poetess Rani Meera (1498–1546) would later live here.

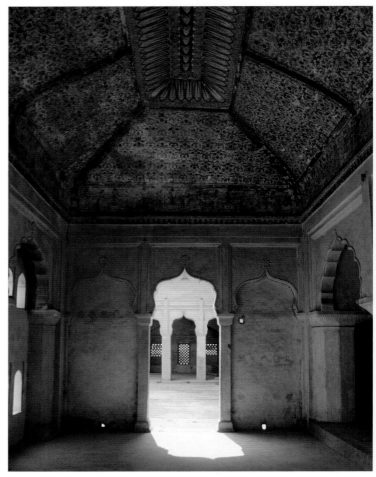

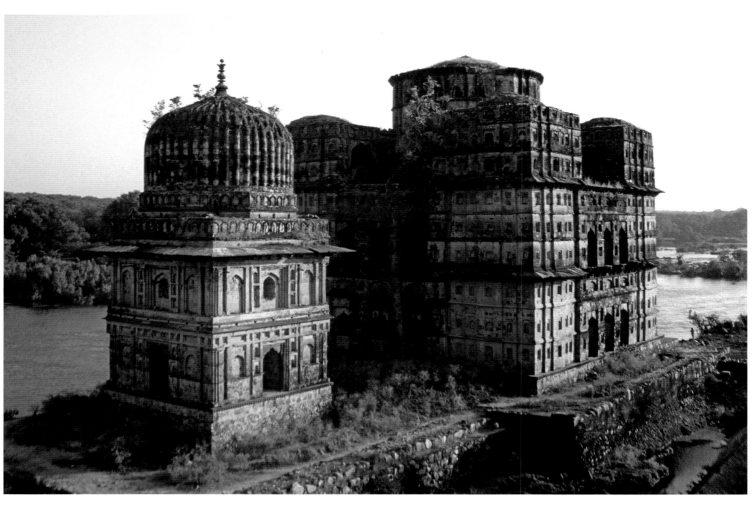

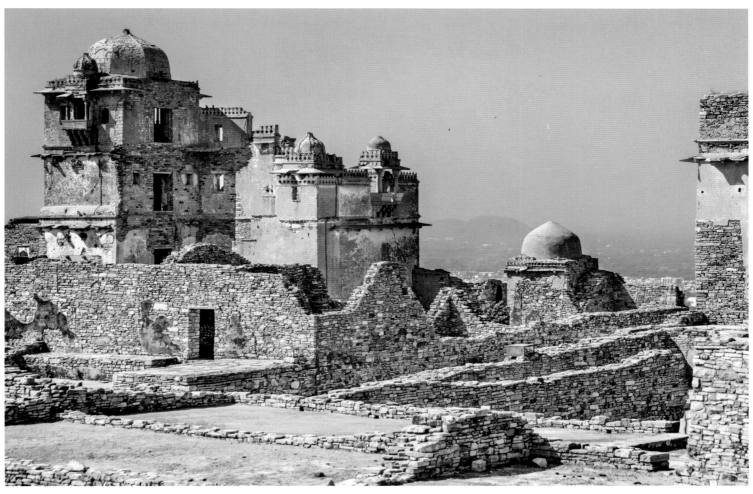

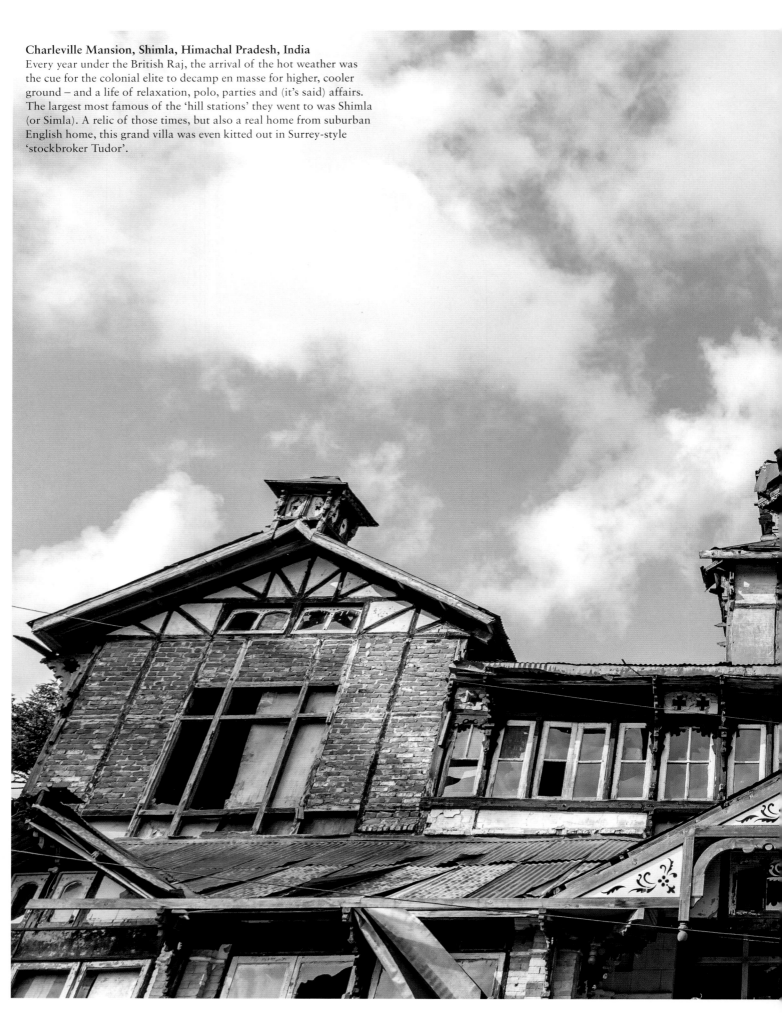

Charleville Mansion, Shimla, Himachal Pradesh, India
Every year under the British Raj, the arrival of the hot weather was
the cue for the colonial elite to decamp en masse for higher, cooler
ground – and a life of relaxation, polo, parties and (it's said) affairs.
The largest most famous of the 'hill stations' they went to was Shimla
(or Simla). A relic of those times, but also a real home from suburban
English home, this grand villa was even kitted out in Surrey-style
'stockbroker Tudor'.

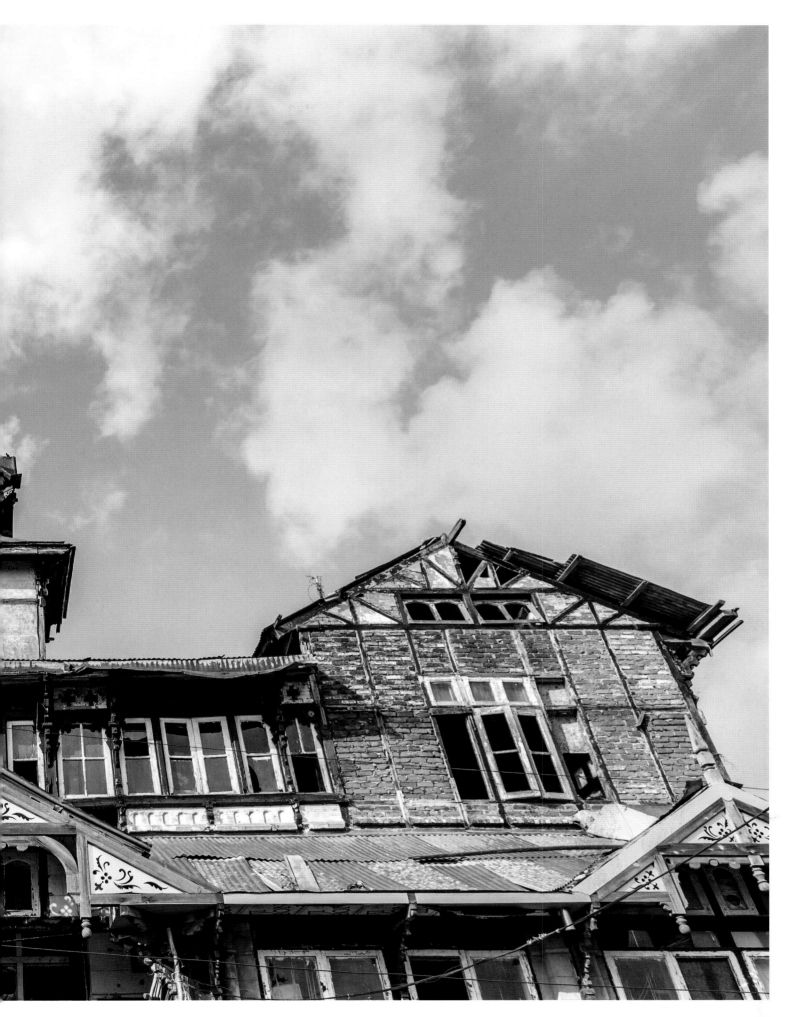

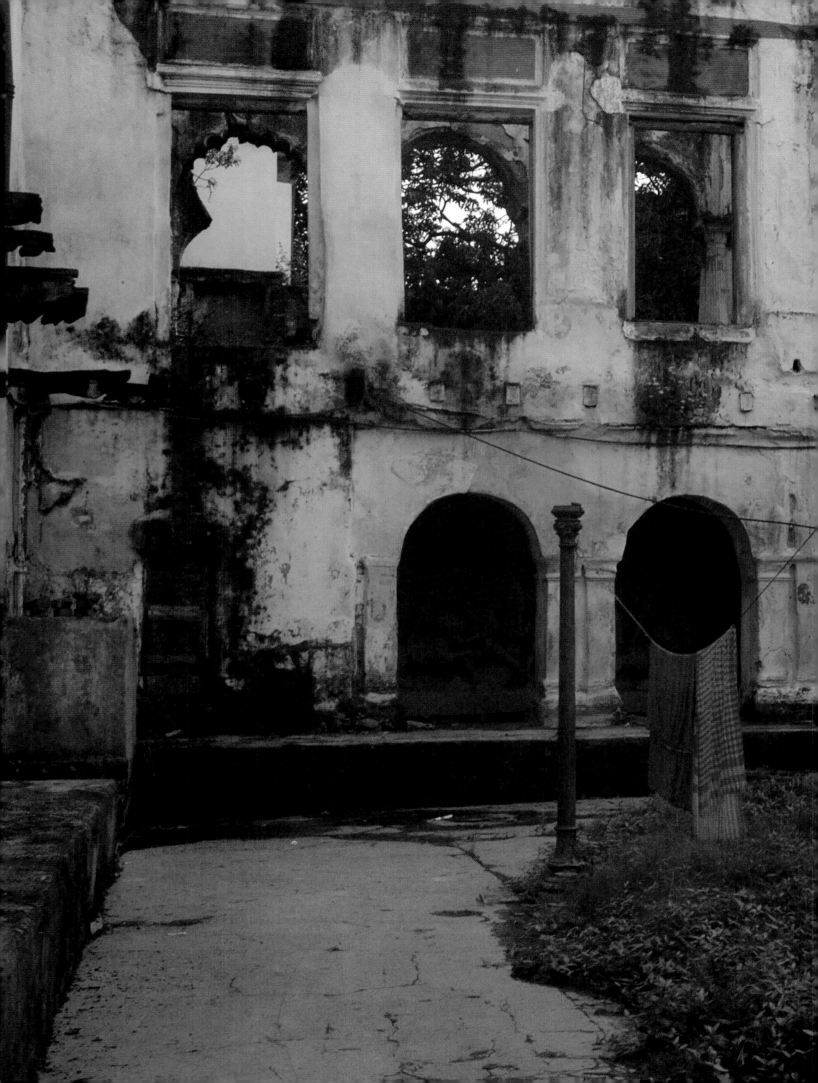

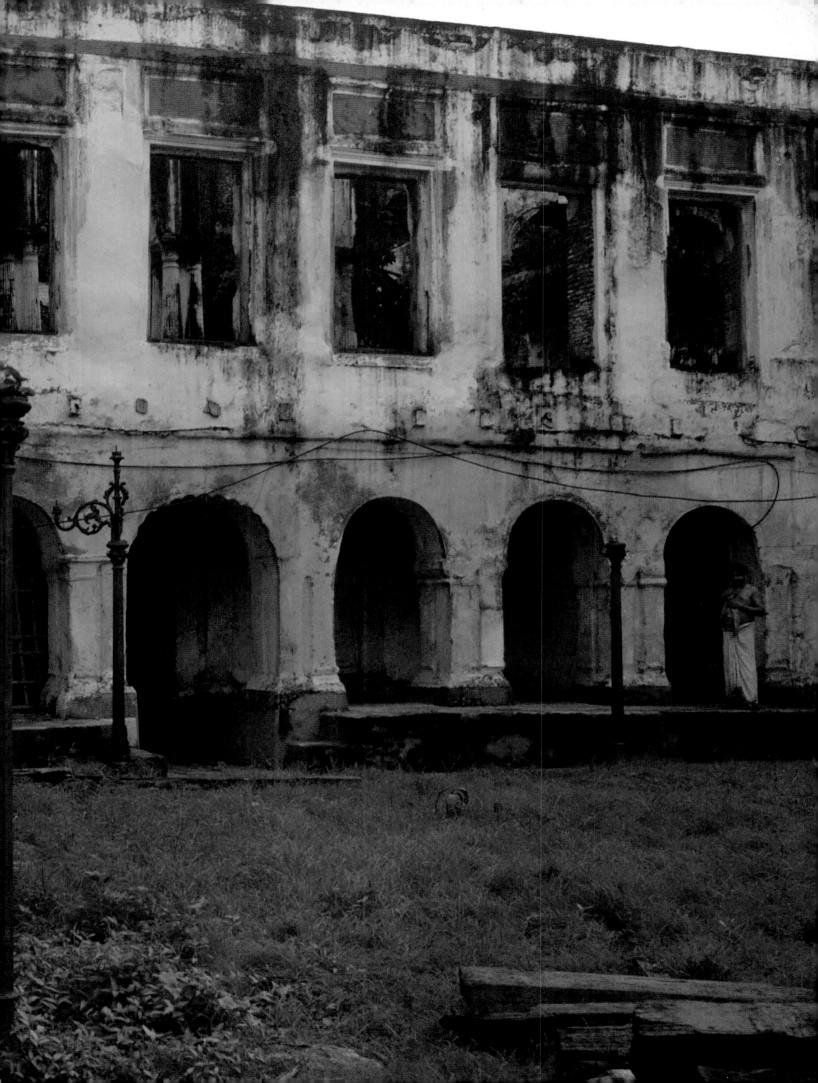

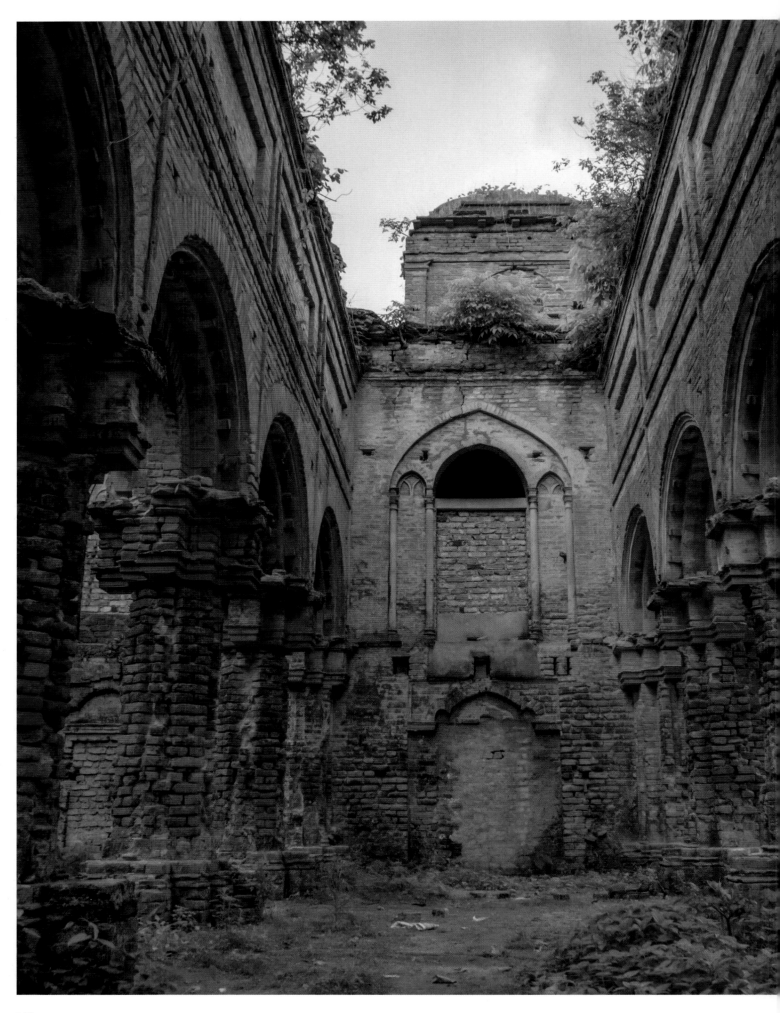

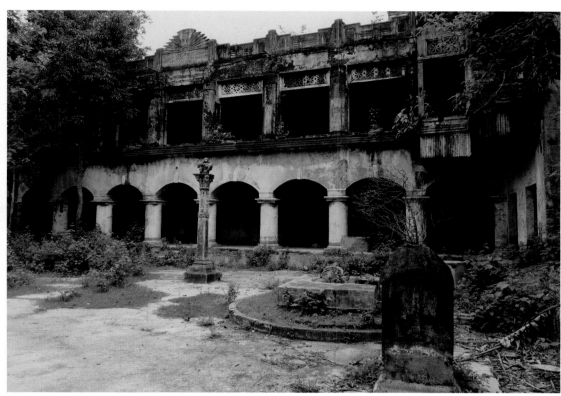

LEFT:

Tamluk Rajbari, Tamluk, Purba Medinipur, West Bengal, India

Krishna comes here in the *Mahabharata* to free the sacred horse of Aswamedjha Yajna from King Tamradhwaj of the Mayura-dwhaja ('Peacock Dynasty'). The epic poem is many centuries old, of course; this building far too recent to have been Tamradhwaj's Rajbari ('King House'). Even so, it has clearly been here quite some time. Either way, it's atmospheric: a sense of ancient poetry and legend seem to resonate in this ruin; in its eroded columns; its sweeping, brick-built arches and its grassy aisles.

ABOVE:

Abandoned palace, West Bengal, India

So vast is India, so long its history and so complex its cultural formation, it's all but impossible to get a comprehensive picture. Rajahdoms rose and fell here; dynasties came and went – though many, making their own peace with the British occupiers, maintained a modest presence into modern times. Hence the ever-present possibility of stumbling on some long-forgotten palace like this one, deep in rural West Bengal – a prestigious capital and a provincial backwater at the same time!

PREVIOUS PAGES:

Shobhabazar Rajbari, Kolkata, West Bengal, India

Brought to prominence by Nabakrishna Deb (1733–97), the Shobhabazar dynasty found favour as backers of British rule and power as client rulers under the Raj. It was Deb who built this palace and inaugurated the tradition of celebrating the Durga Puja festival here to commemorate the mother goddess Durga's victory over the monstrous demon Mahishasura – and the abundance that her triumph assured for all. The palace precincts seem sad and dismal now, but come alive each year at Durga Puja when the festival is celebrated here anew.

ABOVE AND RIGHT:

'Ghost Palace' Hotel, Baturiti, Bali, Indonesia

Spread out across a ridge in Bali's upland interior, a little way south of Lake Beratan, stands a state-of-the-art resort – without guests or staff, or seeming purpose. Though badly overgrown and damp-damaged, the Ghost Palace (or, to give it its full name, the PI Bedugul Taman Rekreasi Hotel and Resort) was only built towards the end of the 1990s. Its developer – said to have been Hutomo ('Tommy') Suharto, the son of Indonesia's late dictator President Suharto (1921–2008) – is believed to have been imprisoned for corruption before the complex could be opened.

OVERLEAF:

Derelict Hotel, Hachijojima, Izu Islands, Japan

In the early 1960s, Japan was economically on the rise but a cautious government discouraged foreign travel. Instead, the newly affluent were encouraged to find their jet-set luxury nearer home: Hachijojima was being billed as the 'Hawaii of Japan'. The Royal Hotel was its five-star centrepiece: French Baroque met modern brutalism in its design. In fairness, its guests were happy here and the hotel was a huge success – till restrictions were relaxed and alternative destinations brought within their reach. In the 1990s, the hotel closed, since which time it has stood empty, gradually decaying.

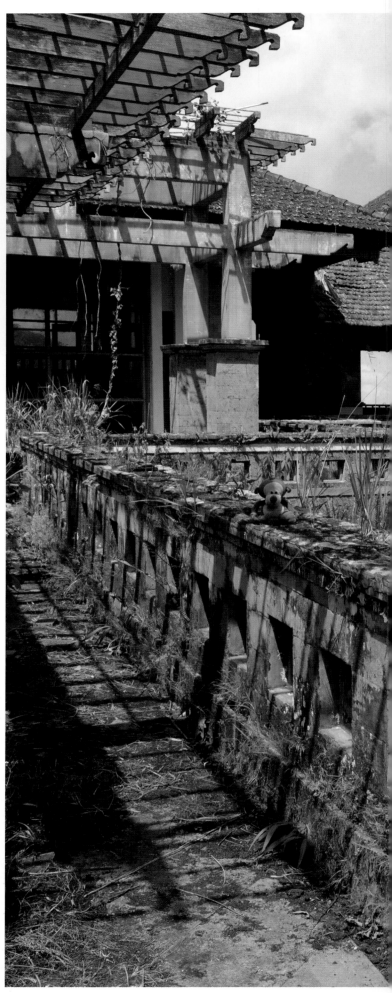

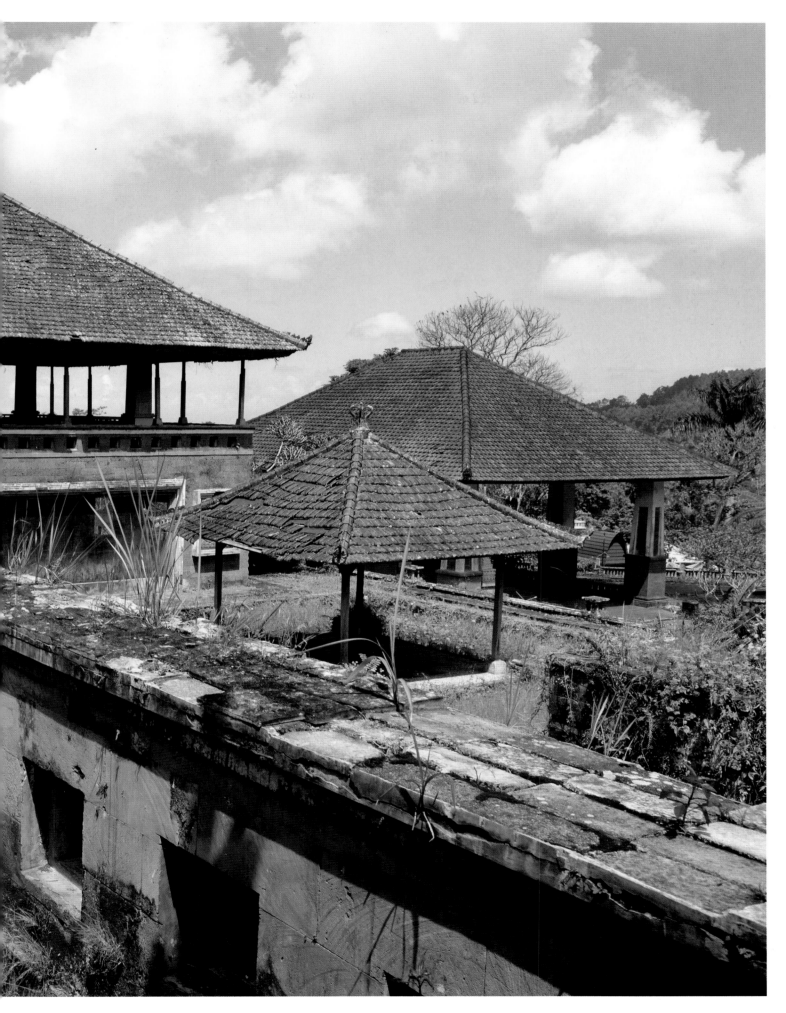

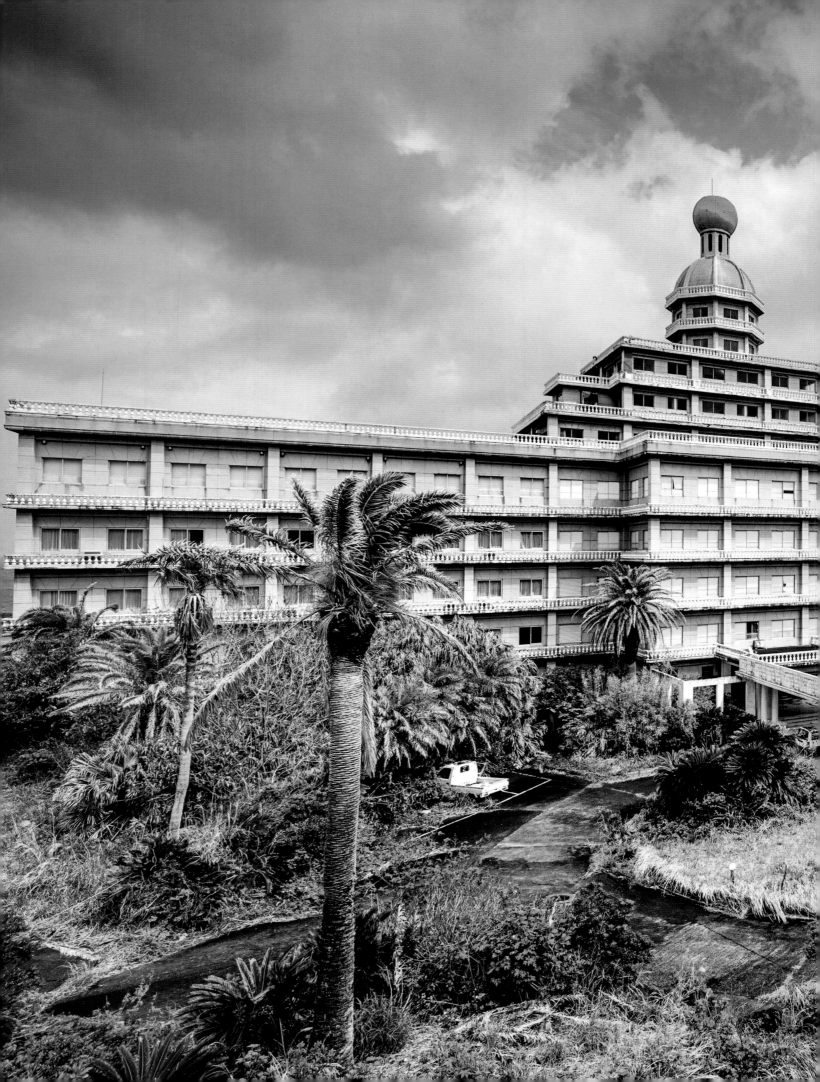

Kellie's Castle, Batu Gajah, Kinta, Perak, Malaysia

Scottish Baronial, Moorish and Indian styles come together (or, rather, have a head-on collision?) in William Kellie-Smith's nostalgic folly – now known affectionately as 'Kellie's Castle'. The wealthy rubber planter may have been missing his birthplace by the Moray Firth, but he also clearly felt (even after living and working in Malaysia for a quarter of a century) a wider romantic connection with an exotic East. The migrant labourers from Chennai, Tamil Nadu, introduced touches from their own tradition, with his encouragement. Materials were shipped from India as well. Begun in 1915, the house remained uncompleted on Kellie's death in 1926, after which his widow returned to Britain, abandoning the project.

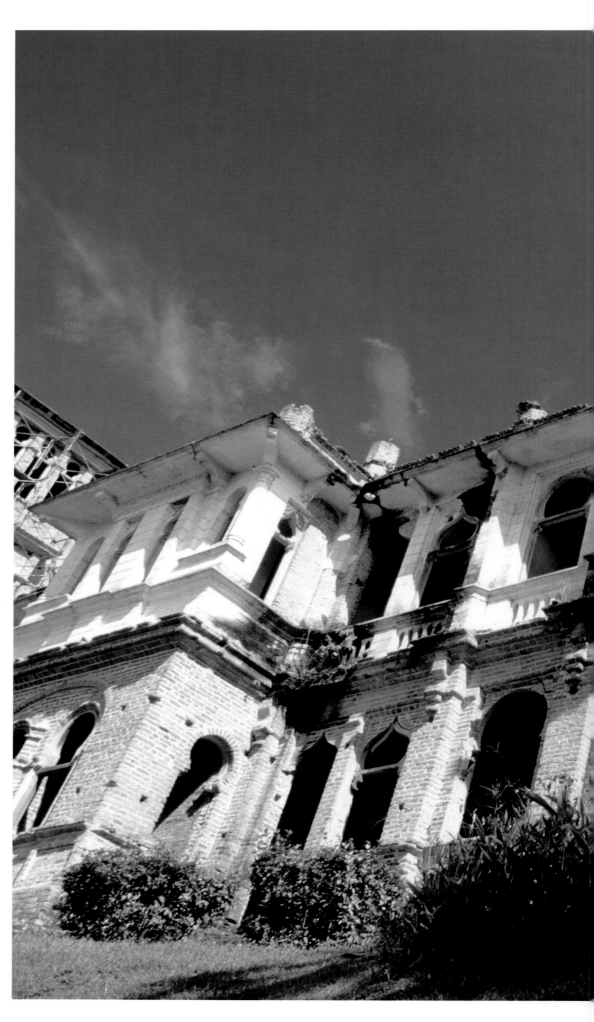

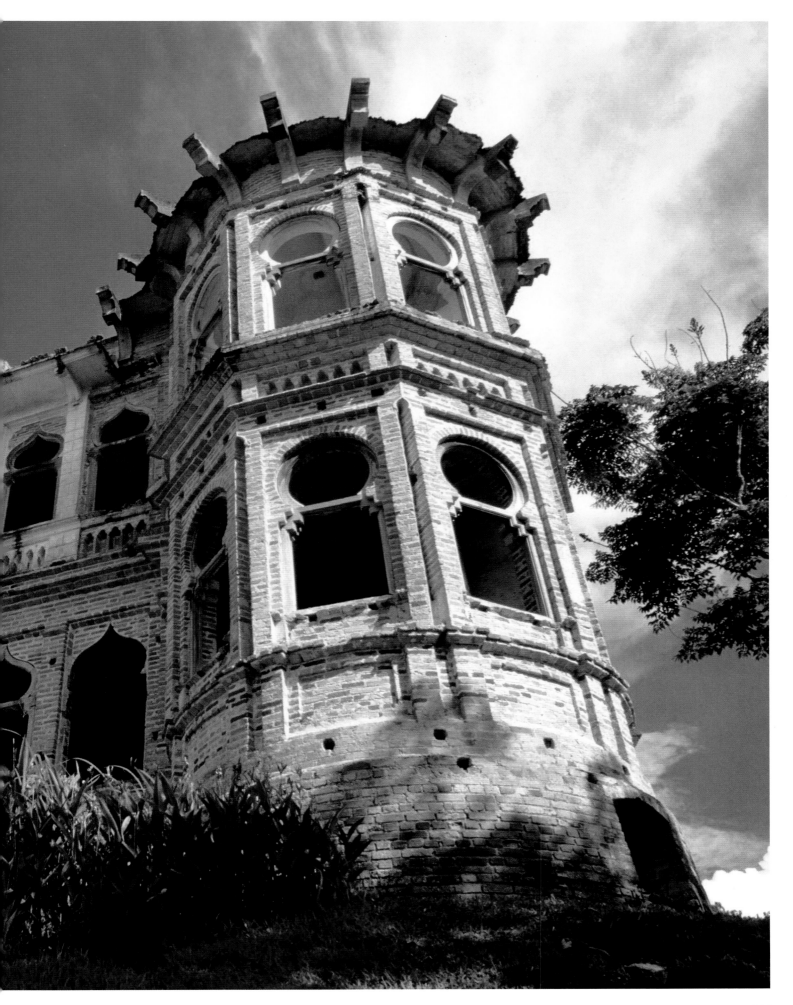

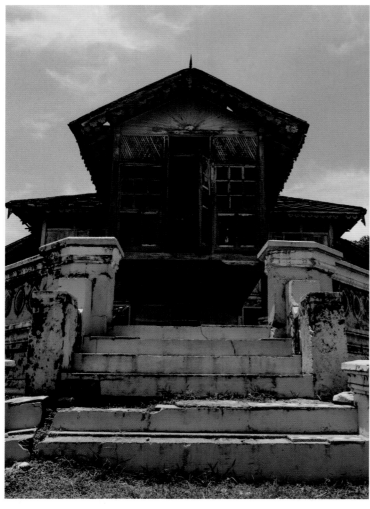

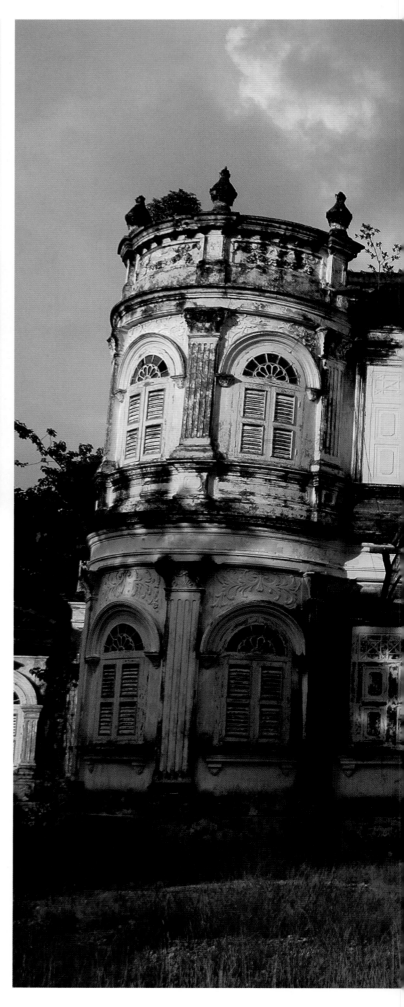

ABOVE:

Abandoned wooden house, Kuala Kangsar, Perak, Malaysia

The steps are shabby and overgrown; the timbers are tired and grubby, with gaps and gaping holes, but this house in traditional Malay style still looks inviting. Raised up to catch the cooler breezes, it has slatted windows which (even when they were intact) would have helped to maximize ventilation in the tropical heat. The covered porch and the 'hanging verandah' hark back to the days when Malaysian jungle longhouses literally stood on stilts.

RIGHT:

Derelict mansion, George Town, Penang, Malaysia

Northam Road has been George Town's 'Millionaire's Row' since the close of the nineteenth century, when British planters first settled here. When the sun set on their empire, an international Chinese elite moved in. Now they in their turn have been moving on. As the business district has expanded, the city end has sprouted skyscrapers – further out, though, it's a picture of decline and dereliction.

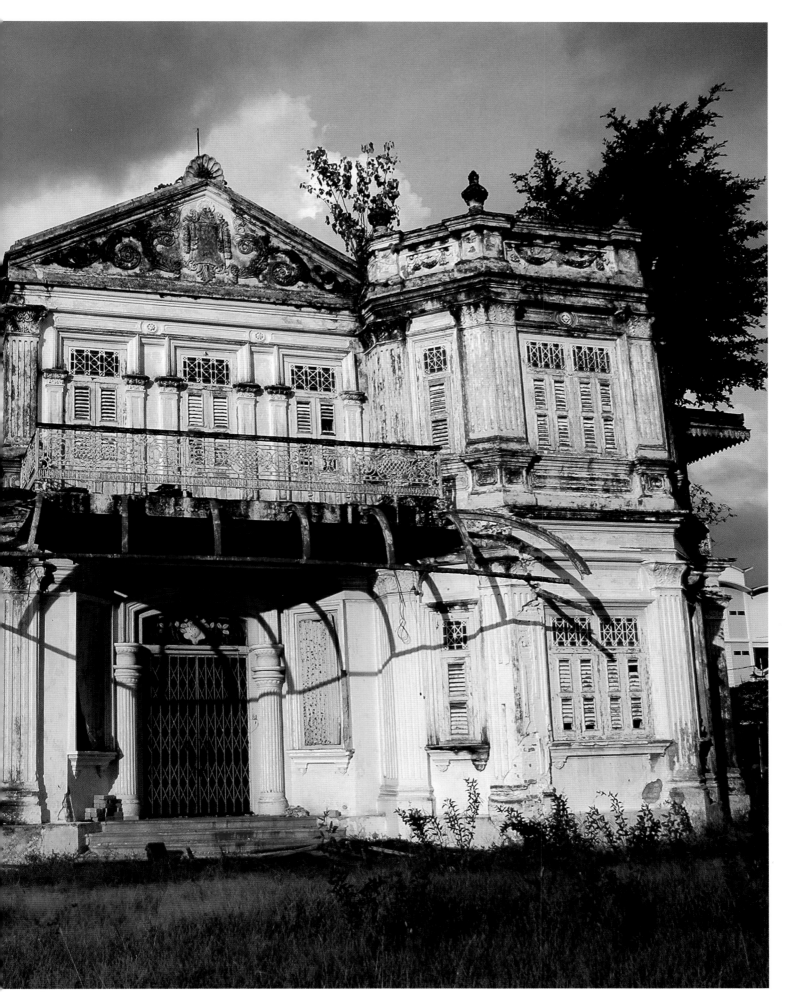

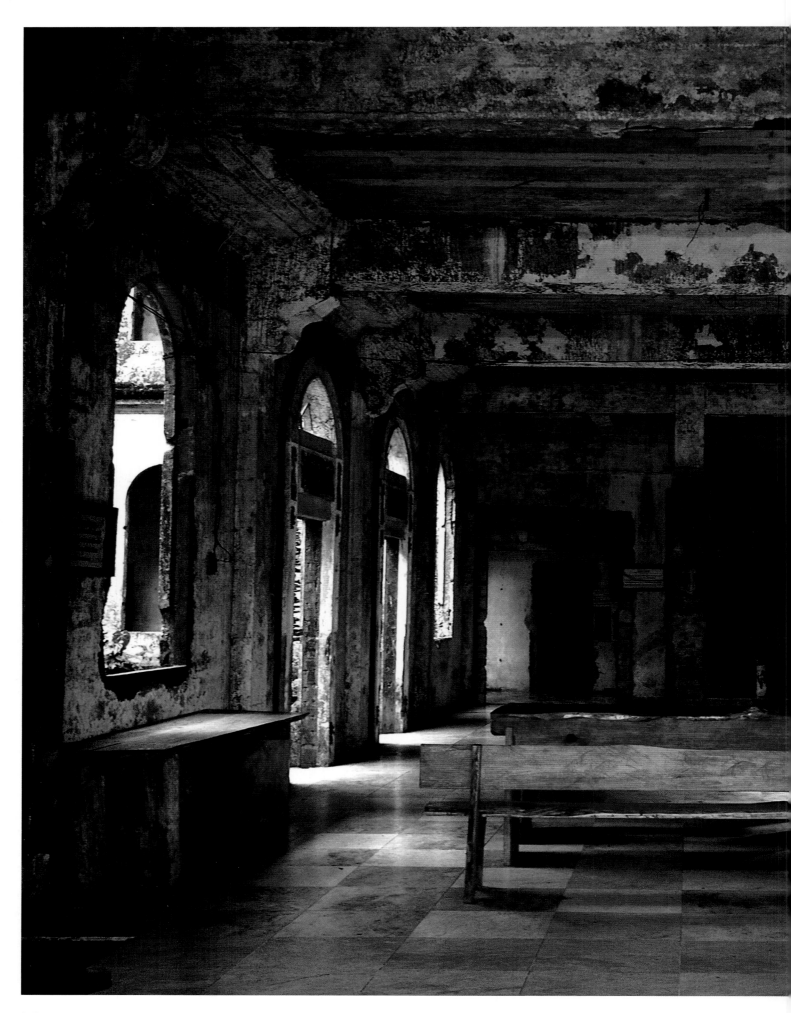

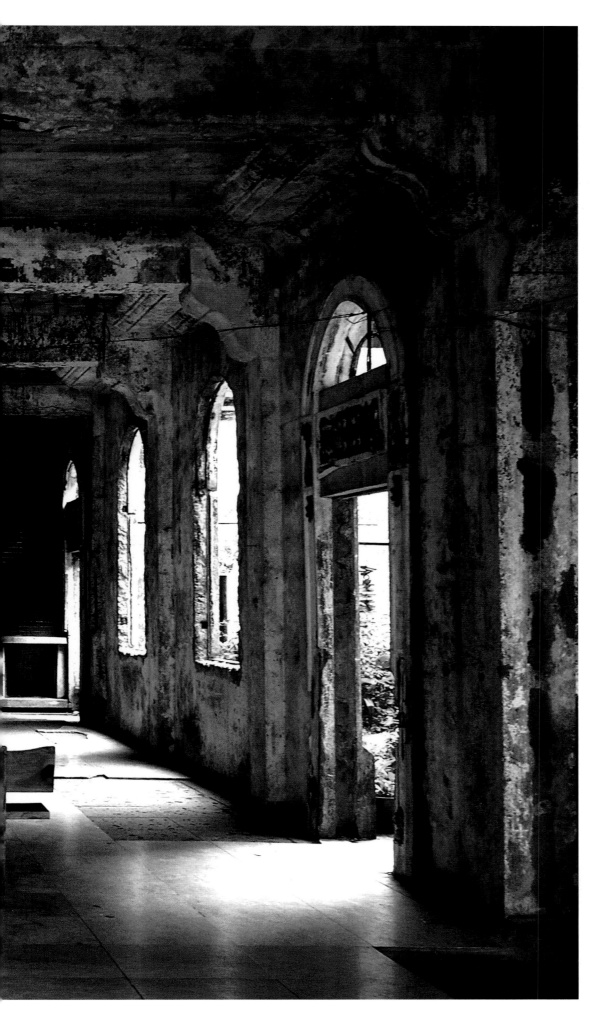

LEFT:

Dominican Hill Retreat House, Baguio, Luzon, Philippines
This empty, echoing space was (until 1982) the lobby of the Diplomat Hotel. Even now it has an agreeably light and airy atmosphere. At night, though, not so much – even if we discount the reports of ghostly shrieks and wails and the rattling of chains by the spectres of prisoners (or perhaps priests and nuns: this was once a sort of seminary) tortured and killed here by the Japanese during World War II.

OVERLEAF:

The Ruins, Talisay, Negros Occidental, Philippines
Sugar planter Don Mariano Ledesma (1863–1948) built this Palazzo-style house in memory of his wife, Maria Braga Lacson (1870–1910), who had died in childbirth. It was lavishly conceived and painstakingly constructed. Little moulded portraits of Maria punctuated the exterior, along with seashells (to commemorate her sea captain father). The couple's initials, M & M, faced each other on every upright post. During World War II, local guerrillas burned it down to put it beyond use for the arriving Japanese. Though the house burned for three days, its reinforced concrete shell survived – arguably making it more fitting as a monument.

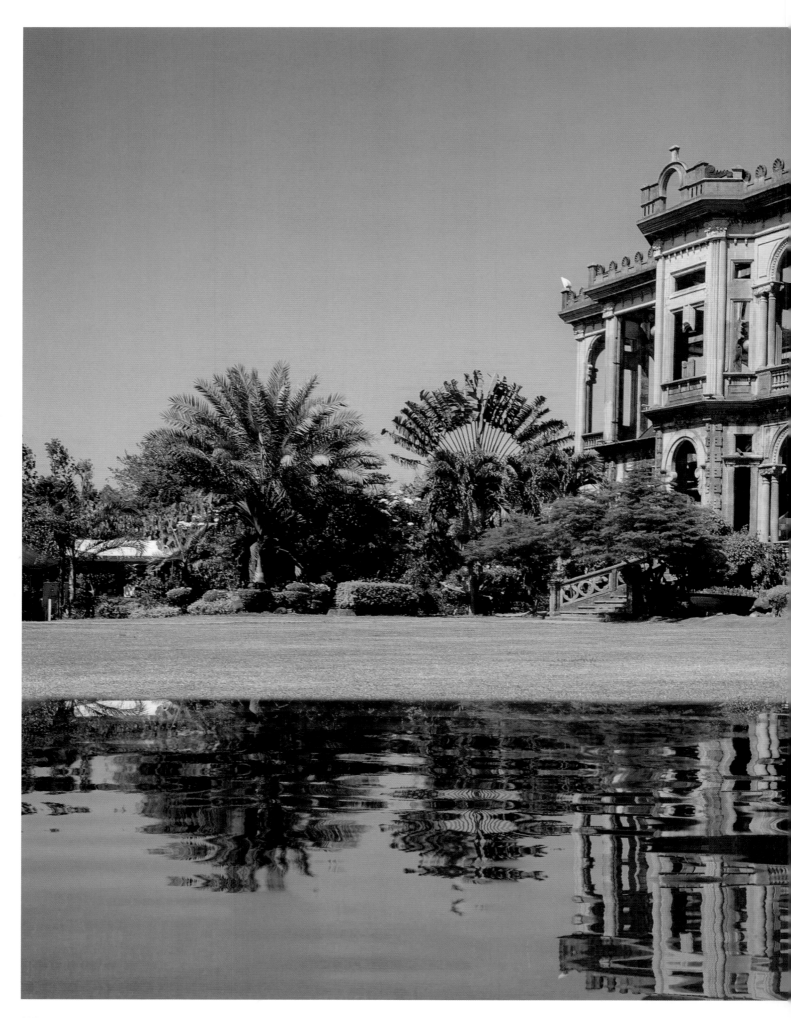

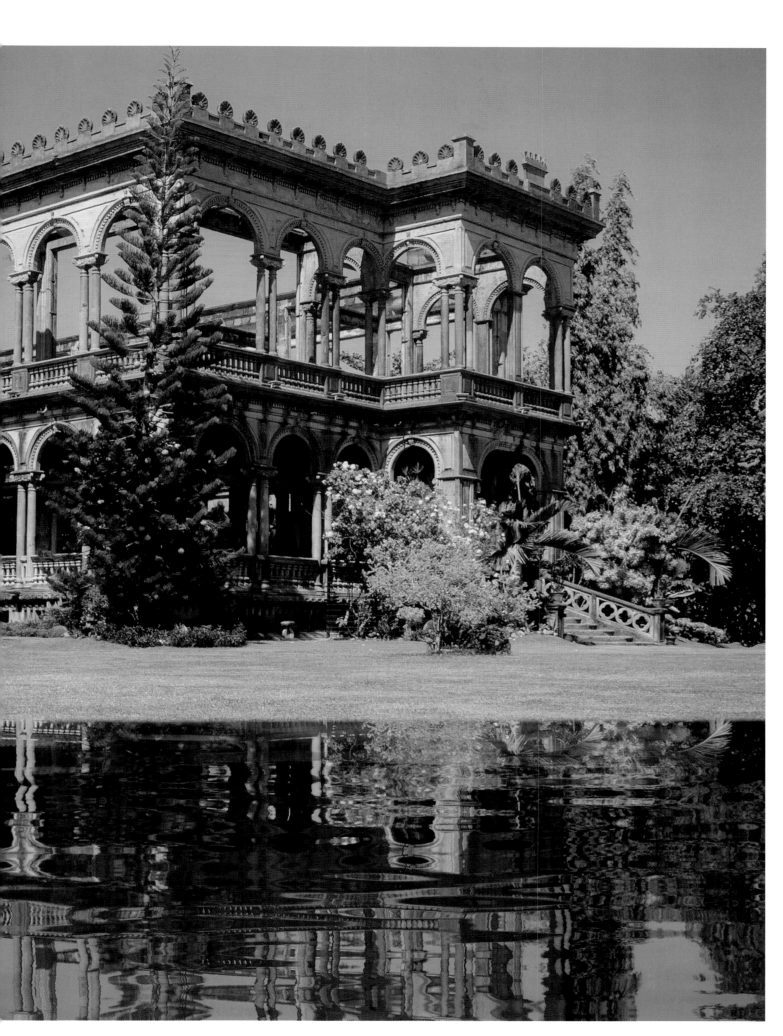

King Narai's Palace, Lopburi, Thailand

A predecessor of the kingdom that became Siam, and subsequently Thailand, Ayutthaya existed from the fourteenth century. Only towards its end, in the reign of King Narai (1656–88), however, did it really become a power in Southeast Asia. Narai built up his country's wealth by promoting trade with Europe and its influence by diplomatic partnership with France. These Westernizing tendencies were reflected in the design of his palace, whose great throne room – bleak but still impressive – we see here.

Picture Credits

123RF: 30/31 (Ivan Kokoulin), 170/171 (Karel Kryl)

Alamy: 12 (Arduo Press/Andre M Chang), 13 (Pulsar Imagens), 24/25 (BE & W Agenja Fotograficzna), 32 (Bert Hoferichter), 33 (National Geographic), 35 (James Cheadle), 48/49 (National Geographic), 50-59 all (Viennaslide), 62 & 63 bottom (Media Drum World), 63 top (Mauritius Images), 67 bottom (Simon Webster), 72/73 (Panther Media/ETfotos), 79 (Image Broker/Christian Handl), 90/91 (Alvaro Tejero), 98 top (Jeff Gilbert), 98 bottom (Jeffrey Blackler), 121 both (Arcaid), 122 & 123 (Kpzfoto), 161 (Ronnie James), 166 & 167 (Edwin Remsberg), 172/173 (Mike Johnson), 180 (Image Broker/Karl F Schofmann), 181 (Jennifer Dunlop), 192 (Linda Kennard), 200/201 (Pawel Bienkowski), 202 bottom (Ephotocorp/Shashank Mehendale), 203 top (Robert Preston Photography), 208 (Reynold Sumayku)

Dreamstime: 16/17 (Ferenz), 36-37 all (Mshake), 39 both (Sherman Cahal), 82/83 & 84 top (Vaakeval), 85 (Milla 74), 94 top (Irimaxim), 102/103 (Semenov 80), 104 top (Mulderphoto), 105 (9parusnikov), 106/107 (Olga355), 110 (Mulderphoto), 111 top (Kravtzov), 120 (Petroos), 124/125 (Rangpl), 130/131 (Vicsa), 132 bottom (Vladimir Zapletin), 134/135 (Pompil Umaran), 136 (Mirco 1), 142/143 (Seerhii Datsinko), 152 top (Fabian Plock), 156/157 (Xboulenger), 168/169 & 174 both & 175 bottom (Fabian Plock), 178/179 (Dmitry Ometsinsky), 186 (Yuliab), 194/195 (Plotnikov), 197 (Bluchiavari), 203 bottom (Leonid Andronov), 209 (Samrat35), 214/215 (Ravi John Smith)

FLPA: 162/163 (Ariadne Van Zandbergen)

Getty Images: 6 (UIG/RED & Co/Francesco Cassalo), 26 (Roy Dakin), 38 bottom (Tom Szczerbowski), 76/77 (Sean Gallup), 99 (Oli Scarff), 152 bottom & 153 (Thierry Orban), 154 & 155 (AFP/John Wessels), 187 (AWL Images/Ivan Vdovin), 196 both (Light Rocket/Leisa Taylor), 206/207 (Gamma-Rapho/Jean-Michel Turpin), 217 (Universal Images Group)

Globallookpress.com/Alexey Grachov: 7, 66, 67 top, 84 bottom

iStock: 14 (Angie Dawson), 20/21 (Eric4x4), 28/29 (Shane Cotee), 140 (Konoplytska), 176/177 (Marta Tari)

Shutterstock: 8 (Jon Marc Lyttle), 10/11 (Reisegraf.ch), 15 (Sabastien Delgado), 18 (CMOR Images), 19 both (Rafal Cichawa), 22/23 (THP Stock), 27 (Philip Sunkel IV), 34 (Sherman Cahal), 38 top (Sue Smith), 40/41 (John McCormick), 42 & 43 (Gary Yim), 44/45 (Purplexsu), 46.47 (John Bilous), 60/61 (Lev Levin), 64/65 (Christian Lipovan), 68/69 (John Ingall), 70/71 (Phil Daint), 74/75 (Alexey Grachev), 78 top (Roy Pedersen), 78 bottom (Dimitrios Vlassis), 80 (Reflex Life), 81 (Pixeljoy), 86 (Anna Tamila), 87 (Sergio Pereira), 88/89 (Christian Balate), 92/93 (Petr Skornak), 94 bottom (Treasure Galore), 95 (Sebastien Coell), 96/97 (CinaedKSM), 100 (Nadezhda Bolotina),m 104 bottom (Pe3k), 108 both (Hristo Uzunov), 109 (Iryna Savina), 111 (Vladimir Mulder), 112/113 (Istvan Csak), 114/115 (Vjacheslav Shishlov), 116 & 117 (Mantvydas Drevinskas), 118/119 (Anya Newrcha), 126/127 (Vadim Fedotov), 128-129 all (Liliia Belaya), 132 top (Psarntik), 133 (Vladmir Mulder), 137 (Nenad Nedomacki), 138/139 (Lals Stock), 141 (Kamien Czanka), 144/145 (Vladimir Mulder), 146 & 147 (Hanna Photo), 148/149 (Stefano Carocci), 150 (Archphotos), 158/159 (Khaled EIAdaway), 160 (Jukka Palm), 164/165 (Mike Awwad), 175 top (Jurgen Wallstabe), 182 (Archphotos), 184/185, 188 (Victor Karasev), 189 (Svetlana Eremina), 190/191 (Matt Grant), 193 (Chetansoni), 198/199 (Waj), 202 top (Sambhu Mishra), 204/205 (Ram Kay), 210 (Evgeny Drablenkov), 211 (Mundosemfim), 212/213 (Sean Pavone), 216 (Amirul Syaidi), 218/219 (Junpinzon), 220/221 (RCB Photography), 222/223 (Harry Kiim)